THE
$10 BILLION
JOLT

CALIFORNIA'S ENERGY CRISIS:
COWARDICE, GREED, STUPIDITY AND
THE DEATH OF DEREGULATION

JAMES WALSH

SILVER LAKE PUBLISHING
LOS ANGELES, CALIFORNIA

The $10 Billion Jolt
California's Energy Crisis: Cowardice, Greed, Stupidity and the Death of
Deregulation

First edition, 2002
Copyright © 2002 by Silver Lake Publishing

Silver Lake Publishing
2025 Hyperion Avenue
Los Angeles, CA 90027

For a list of other publications or for more information, please call
1.888.638.3091. Outside the United States and in Alaska and Hawaii,
please call 1.323.663.3082. Find our Web site at **www.silverlakepub.com**.

Library of Congress Catalogue Number: Pending

Walsh, James
The $10 Billion Jolt
California's Energy Crisis: Cowardice, Greed, Stupidity and the Death of
Deregulation
Includes index.
Pages: 366

ISBN: 1-56343-748-1
Printed in the United States of America.

acknowledgments

Silver Lake Publishing is a nonfiction house that specializes in topics including insurance, business management and personal finance. It's based in Los Angeles and has dealt with regulatory issues in the financial services industries. So, when California's electric utility market came unraveled after a four-year flirtation with something Sacramento politicians called "deregulation," it was a natural topic for us to cover.

I use the word *us* because—although the structure, analysis and tone of this book are mine—the staff of reporters and editors at Silver Lake has done a lot to help me.

Steve Son assisted with research and interviews. This assistance included a few interviews that put hard questions to touchy people. Steve lived to tell the tales. Kristin Loberg, Christina Schlank and Megan Thorpe helped make sure that the narrative was coherent...and that this complicated story remained understandable.

My brother, Campion Walsh, has followed the energy markets for a decade as an analyst and journalist. He also passed on some useful data and opinions.

Although I believe in the efficiency of free markets, I've tried to keep ideology and opinion out of this book. Living with this topic for several years, I'm certain that the facts of the story make the best case for true deregulation.

James Walsh
Los Angeles, California

contents

The $10 Billion Jolt

California's Energy Crisis:

Cowardice, Greed,

Stupidity and the

Death of Deregulation

A TIMELINE OF CALIFORNIA ENERGY DEREGULATION

1935:
➡Congress enacts the Public Utility Holding Company Act to check Depression era abuses by 16 interstate power companies that controled 75 percent of the power generated in the U.S. The companies are broken up and barred from expanding beyond core electricity businesses.

1973:
➡The United States stands by Israel in the Yom Kippur War. Angry Arab countries cap exports of their oil, sparking the first of two "energy crises" in successive years. Electricity prices jump. Many large utilities respond by building nuclear power plants, with price tags in the billions of dollars.

1974:
➡The energy crises have a big effect. For the first time since the war-to-peace transition year of 1946, Americans use less electricity than they had the year before.
➡The California Legislature creates a second commission to regulate electric utilities. The California Energy Commission is charged with licensing new power plants and developing energy-efficiency standards.

1978:
➡Responding to energy shortages of the 1970s, Congress enacts the Public Utility Regulatory Policies Act, which encourages growth of small, unregulated independent power producers. The big news lays buried in a little-noticed section of the law—the Qualifying Facilities Provision. A qualifying facility (QF) is anyone who can rig a windmill or dam a stream to generate a sprig of electricity. The new law says utilities have to buy these bits and pieces of power. In California, regulators see QFs as the wave of the future.

Early 1980s:
➡Congress agrees to deregulate the natural gas marketplace. After some initial volatility, natural gas prices drop substantially.
➡California experiences a violent backlash against nuclear energy. The state Legislature enacts a moratorium on construction of nuclear power plants in state and passes another law making it easier for municipal utilities to invest in nuclear plants in other states. The model is set for not-in-my-backyard (NIMBY) politics.

Mid-1980s:
➡Most of the nation has more electricity than it needs. Politicians and bureaucrats worry about the big price tags and long-term contracts related to giant coal and nuclear power plants built during the energy crises of '73 and '74. These "stranded costs" put some utilities in financial trouble and made the industry leery about new construction, especially when facing opposition from local residents and environmentalists.

1988:
➡️Saddled with high stranded costs and low energy prices, a regulated utility—Public Service of New Hampshire—does the unthinkable and files for bankruptcy protection. States, which in some cases have guaranteed the costs of power plants, begin to discuss utility deregulation as a method of eliminating their liabilities related to stranded costs.

1991:
➡️A report from the North American Electric Reliability Council (NERC) says that voltage problems in the North American grid are due in large part to the intensive use of long-distance transmission lines between remote power plants and areas of high demand. Industry analysts see this as another argument for deregulating or "privatizing" electricity.

1992:
➡️Concerned about its own potential liabilities and low energy costs, the California Public Utilities Commission (CPUC) orders review of "trends in the electricity industry." This is seen by most industry insiders as a step toward deregulating the electricity market.
➡️In Washington, Congress passes the federal Energy Policy Act, which promotes competition in the wholesale electricity market—where companies sell power to one another. The law orders utilities to open their transmission lines to competitors and independent producers for wholesale power transactions.

1994:
➡️California emerges from a stubborn recession with electricity prices among the highest in the country. Media outlets focus on the number of companies leaving California because of high "infrastructure" costs—including electricity.
➡️In April, the CPUC issues a "Blue Book" report, outlining a plan for deregulating the state's electricity market. The plan is patterned in many ways after the privatization of the electricity industry in Great Britain a decade earlier. Shortly after the Blue Book is released, California's three largest utilities lose nearly $4 billion in stock value.

1995:
➡️The Federal Energy Regulatory Commission (FERC) weighs even more liberalized rules for wholesale power transactions. Utility mergers intensify.
➡️California's major utilities help kill a state plan that would authorize the creation of new power plants sufficient to power 1.4 million homes. The utilities argue that they can buy sufficient power cheaply from plants in surrounding states.
➡️California's Governor Pete Wilson says that the state's utilities have become "bloated under regulation" and calls for deregulation. This gives political cover to various self-interested groups that had been pushing for deregulation.
➡️In December, calling the system "fragmented, outdated, arcane and unjustifiably complex," the CPUC votes to open California's electricity industry to competition. The vote is largely symbolic, because the state Legislature must agree. But most state politicians seem inclined to follow the CPUC's lead.

1996:

➡ Since only a handful of state politicians understand the mechanics of utility regulation, maverick Democrat State Senator Steve Peace ends up leading the legislative project.

➡ In a rush to pass a deregulation bill, California legislators and regulators make a series of mistakes. They underestimate the state's power needs. They force utilities to sell power plants without allowing them to secure long-term supply contracts. And they freeze retail rates.

➡ In July and August, two major blackouts interrupt power to millions of Californians…and others, up and down the West Coast. The blackouts are caused by short-circuits in the overtaxed regional power grid.

➡ Peace's bill, called AB 1890, is approved by both houses of Legislature without a single "no" vote.

➡ In September, Pete Wilson signs AB 1890 into law. California's electricity market will be deregulated gradually over four years. To make the change politically palatable to consumers, lawmakers roll back electricity rates by 10 percent and freeze them for four years for the 27 million people served by the three big utilities.

➡ The new law creates two private agencies, the Independent System Operator (ISO) and the California Power Exchange (CPX), which will manage and facilitate the open markets for buying and selling electricity.

➡ In December, fearing that it's falling behind states like California, the FERC adopts new rules to speed up utility merger approvals.

1997:

➡ California utilities rush to sell off power plants and restructure their corporate ownership in anticipation of the January 1, 1998 open markets.

➡ In September, marketing companies are allowed to start campaigning for customers for the January 1, 1998 open market.

➡ In December, the CPUC announces that the start of open-market wholesale trading and retail competition will be delayed by at least two months. Computer problems are blamed for the delay.

1998:

➡ In March, open wholesale trading and retail marketing begins. The CPUC issues regulations to protect consumers from fraud and market abuses. To operate in the state, "energy marketers" must provide clear information on price, service and generation sources; use a standard bill format; provide proof of technical, operational and financial capability; and post a $25,000 bond.

➡ The ISO takes over daily management of the parts of the power grid owned by the big three utilities.

➡ In November, the Coalition of Consumer Advocates places Proposition 9 on the California ballot. The initiative would undo substantial parts of AB 1890. It loses dramatically, gaining the support of only about 1 in 4 voters.

1999:

➡ World oil prices collapse to $10 a barrel amid an Asian currency crisis. The cheap oil causes hardship in some places, but is good news for most of the world—and particularly the booming United States. Energy demand rises.

➡In a whiplash effect, energy companies are caught without enough inventory; prices jump. California's wholesale electricity market, heavily dependent on power generated from natural gas, is caught in a pinch. Spot prices top $300 per megawatt hour, up from just $25 eight months earlier.
➡According to the complex rules of AB 1890, San Diego Gas & Electric (SDG&E) is allowed to deregulate consumer prices earlier than the other utilities. Within a few months, customer bills triple.

2000:
➡The SDG&E experience scares the wholesale electricity market. Wholesale prices, which had been about 3 cents per kilowatt-hour before AB 1890 became law, climb briefly to $1.50 per kilowatt-hour.
➡In April, the prices that SoCal Ed and PG&E are paying on the wholesale market rise above the prices they are allowed to charge consumers. State law forces them to continue selling electricity at a loss to more than 9 million of customers. They borrow and buy on credit to cover their losses.
➡SoCal Ed sues the FERC in federal court, in an effort to force it to curb wholesale prices. Governor Gray Davis publicly demands that the FERC curb prices.
➡In May, the ISO issues its first Stage Two Alert, meaning power reserves on the state grid have dropped below 5 percent of demand.
➡In June, PG&E customers in the San Francisco Bay Area suffer relatively small rolling blackouts, which the utility blames on "localized voltage problems."
➡In July, SoCal Ed and PG&E file emergency motions seeking federal authority and guidelines to sign long-term contracts with electricity suppliers, in contravention of state law.
➡The California Legislature passes an emergency law, capping consumer rates in San Diego. The law returns San Diego to smooth operations.
➡The FERC launches an investigation into price manipulation in California's wholesale electricity market.
➡The California State Assembly passes a bill that sets a deadline for local governments to object to proposed power plant projects. The bill gives opponents 180 days to lodge any complaints; previously, there had been no time limits.
➡A CPUC report warns Governor Gray Davis that the Bay Area power outages and high San Diego electricity prices are "a precursor of what lies ahead for California's economy over 30 months." It recommends allowing big utilities to sign long-term contracts.
➡The Legislature passes a resolution, stating that electricity prices are threatening "the financial viability of the electrical corporations" and directing the CPUC to issue a report on "the most effective mechanisms to protect consumers from price volatility."
➡The CPUC allows SoCal Ed and PG&E to sign long-term contracts, subject to review of reasonableness. Both companies soon file proposed contracts, but the CPUC is slow to respond.
➡In September, Governor Davis signs legislation that accelerates the power plant siting approval process. The new law reduces the California Energy Commission (CEC) licensing process from 12 months to 6 months and creates a "green team" to help provide guidance and assistance with the permitting process.

➥ Moody's Investors Service changes the outlook for PG&E and its parent corporation to negative from stable.

➥ In October, PG&E files a document with the FERC stating that it has cash flow shortfalls of "astounding" dimensions.

➥ In November, FERC issues an order rejecting Davis' call for wholesale price caps. The highly detailed response recommends California encourage the utilities to enter into long-term contracts with generators.

➥ In December, the ISO declares its first Stage Three Alert, which means reserves have fallen below 1.5 percent and blackouts can occur without further notice.

➥ The FERC approves a "flexible rate cap" of $150 a megawatt hour, but suppliers can charge more if they can prove a higher price is warranted. Davis had asked for a firm cap of $100 a megawatt hour.

➥ Davis and legislative leaders meet in Washington, D.C., with Energy Secretary Bill Richardson, FERC Chairman James Hoecker and others. Davis argues for federal wholesale price caps. He doesn't get them.

➥ Richardson averts rolling blackouts by ordering 12 West Coast generating companies to sell power to SoCal Ed and PG&E—even though their credit ratings are plummeting. Even after the order, California doesn't have enough electricity in its system.

➥ PUC President Loretta Lynch announces the commission is reversing its stance and would consider raising retail electricity rates.

➥ To resolve the energy shortage, the ISO removes its $250 per megawatt hour cap on bids for electricity. Prices soar higher; and some additional electricity flows in from out of state. Debt mounts at SoCal Ed and PG&E.

2001:

➥ SoCal Ed and PG&E say they've lost nearly $13 billion since June 2000 to high wholesale prices they are barred from passing onto ratepayers. They also say that they are close to bankruptcy.

➥ Electricity and natural gas suppliers, alarmed by the utilities' poor credit ratings, refuse to sell to them, leading the state to start buying power for the utilities' customers.

➥ An unusually high number of power plants are shut down for maintenance and repairs, reducing the supply of electricity.

➥ In January, rolling blackouts are ordered in California for the first time—because of insufficient power on the grid. Davis declares a state of emergency.

➥ The incoming Bush Administration indicates that it will not continue the practice of forcing regional power companies to sell to California utilities.

➥ With most trades occurring elsewhere, the CPX shuts down.

➥ Davis orders an $800 million energy conservation plan that includes an order requiring every retail business in the state to curtail outdoor lighting during non-business hours.

➥ The CPUC announces a three-month rate increase of 10 percent for SoCal Ed and PG&E customers.

➥ The FERC approves PG&E's corporate restructuring, undertaken to protect assets from the utility's credit problems. This is widely seen as a prelude to bankruptcy.

➥ The FERC orders that the board of directors running the ISO be replaced with "nonstakeholders" appointed by the governor.

➡The California Legislature debates a bill that would have the California Department of Water Resources (CDWR)—a state agency—purchase electricity on an ongoing basis for the non-creditworthy utilities. The bill would also spend $500 million to purchase electricity on an interim basis and sell it to consumers through the utilities.

➡In his "state of the state" speech, Governor Davis strikes a frenzied tone and threatens to seize power plants and run them himself, if necessary.

➡The legislature approves the plan for having the CDWR buy electricity for the utilities, although the plan allows for consumer rate hikes. Davis signs it into law.

➡In April, PG&E declares bankruptcy.

➡In June, the Bush Administration relents and sets regional price caps for what power companies can charge California utilities.

➡In September, the California Legislature approves a series of agreements that will keep SoCal Ed out of bankruptcy.

introduction

The story of California's ill-fated experiment with deregulating its electricity marketplace is a complicated one—as most failed economic experiments tend to be. Among other things, it involves:

- scores of politicians, bureaucrats and corporate executives;
- lots of industry-specific jargon (consumers are "ratepayers," power companies are either "generators" or "marketers," the difference between "wholesale" and "retail" is a big deal, etc.);
- government agencies that bicker about overlapping authority; and
- economic theories that are hard to explain until something terrible happens.

Perhaps the best way to start a book about electricity deregulation is to boil the issues down to the most basic equation: how electricity is made and how it gets to homes and workplaces. To that end, consider one detailed example.

The San Onofre nuclear power plant is located on the shore of the Pacific Ocean in the far northern section of San Diego County. U.S. Interstate 5 passes within 1,000 yards of the plant, so tens of thousands of cars driving between San Diego and Los Angeles pass it every day.

From I-5, two of the plant's three reactor domes are clearly visible against the blue of the Pacific Ocean. Half a dozen high-voltage power lines run from each of the domes, over the freeway and inland—up into the hills east of the plant. The lines—carrying extremely high-voltage electricity—are clearly powerful, even to the casual observer. They compare to standard power lines the same way that a bright orange commercial extension cord compares to a plain brown household extension cord.

One can evidently carry more juice than the other.

Technically, the entire 84-acre San Onofre power plant is located within the massive Camp Pendleton Marine Corps base. But the Marines leave the plant alone. It's owned jointly by the parent companies of two utilities: Southern California Edison (SoCal Ed) and San Diego Gas and Electric Company (SDG&E). SoCal Ed owns 75 percent of the plant and operates it on a day-to-day basis.

San Onofre is one of the oldest active nuclear power plants in the United States. Its first station started operating in 1962 and closed in 1992. Its second and third stations are both licensed to operate until 2022. They each generate about 9 billion kilowatt-hours of electricity a year.

A kilowatt-hour is a somewhat artificial measure of electricity. It represents 1,000 watts of electrical power used for one full hour. This would be the equivalent of burning 10 hundred-watt light bulbs for one hour. In the electricity industry, it's generally agreed that a kilowatt-hour is the amount of electricity that an average residential home uses in an average hour.

So, that's a kilowatt. What's a *watt*?

A watt is a standard unit of electrical power; it equals the use of one joule[1] per second. In other words, a watt is used to specify the rate at which electrical energy dissipates. As watts are used, they have to be replaced—in order for an electrical system to maintain its power. Beyond a watt and kilowatt, there is also another standard measure of

[1] In simplest terms, a joule is a unit for measuring energy. It is the amount of energy expended as work if exerting one Newton of force over a distance of 1 meter. (This is often expressed as the equation: $1 \text{ J} = 1 \text{ kg} * \text{m}^2/\text{second}^2$)

electricity—the megawatt. Simply said, a megawatt is 1,000 kilowatts…or 1 million watts.

Power is energy transfer per unit of time. And electrical power is usually measured in watt (W), kilowatt (kW), megawatt (MW), etc. Electricity doesn't store very well, so the energy transfer that makes up power needs to be happening all the time.

The two active generators at San Onofre each generate a lot of power—well over 1,000 megawatts during peak hours. That means that each generator can provide enough energy to power over 1 million households.

Likewise, the plant's operating needs are large. Their reactors require more than 200 rods of atomic fuel; the reactors' cooling systems pull in as much as 4,100 gallons of sea water a minute to keep the pipes cool.

Although the nuclear technology implies more, San Onofre is basically a huge steam turbine plant. The nuclear reactors heat water to the point that it becomes steam—which, in turn, spins a huge magnet inside a copper housing. The faster the magnets spin, the more electricity the plant generates.

It's useful, sometimes, to think of electricity in terms of a single watt. It's produced inside the domes of the San Onofre plant—and then caged with thousands of siblings in the condensers and substations— effectively, big batteries—on site at the plant.

Once enough watts are assembled, the plant managers transmit the electricity across I-5 through the big power lines. The watt travels across the big lines as part of large groups going very fast. It goes up into the foothills above the power plant, where it heads in one of two directions: north to SoCal Ed or south to SDG&E. Most of the time, the watt will travel north.

On its trip north, the watt will stop and be stored in at least one additional substation, where it can again be gathered together with

other watts (many of these have come from other power plants). In the local substation, the watt is repackaged into smaller, slower moving groups. These smaller, slower groups are designed for moving into homes and small businesses.

From the local substation, the watt moves on—through smaller, local power lines—to the end-user. Homes and workplaces can pull as many watts from the system as they need to light lights, run appliances and warm or cool their spaces. Each home or workplace connected to the power system has an electric meter that works like a subway turnstile, counting each watt as it passes.

The watt that was originally generated at San Onofre and heads north may end up spilling out of the grid in the form of heat or static electricity wasted along the way...but, most likely, it will end up passing into a home or business in or around Los Angeles County. There, it can do many things—charge the motor of an appliance or heat the filament of a light bulb.

In all, the trip from the power plant to a residential home can take as little as a few minutes.

An important thing to remember, though, is that electricity is a little like a shark. If it isn't moving, it's dying. Electricity is not a hard asset like a pen or a pair of shoes. It's intangible and it doesn't store very easily. As a result, it has to be generated anew every few minutes—to maintain a producer's wattage on any of several co-op transmission systems.

The process of moving a watt of electricity from a power plant to a home highlights the three elements of the electricity business: generation, transmission and distribution.

The San Onofre nuclear power plant is an example of the generation element of the electricity equation. In other places, a plant may burn coal or natural gas or even jet fuel to spin the magnets and make the watts; it may also use wind or water energy to do the job. And, in some cases, a plant may use solar energy. Whatever the specific technology used, generation is the making of the watts.

The big power lines leading out of San Onofre—and the substations in which the watt may wait along its way—are the transmission element of the equation. Big power lines and substations can move electricity from city to city, from state to state and even from country to country. Taken together, these big power lines and substations are called the "power grid."

Different companies or government agencies own different pieces of the grid in various locations. In some businesses, having so many different entities owning pieces of one large asset might be problematic; but electricity companies tend to be cooperative. Because revenues and profits have traditionally been fixed by law, competition doesn't normally interfere with transmission.

The local power lines and meters that measure the watts going into a home or workplace make up the distribution element of the equation. This is the "retail" end of the business—and the only part that most consumers ever notice.

In many ways, the transmission grid in most states acts like a big power pool. Generators are paid based on the electricity they put into the grid; distributors pay for how much they take out. If Distributor X buys watts from Generator Y, there's little certainty that the watts taken out are precisely the same ones put in. But government rules meant that precision wasn't necessary. Prices and terms of sale were fixed, so—as long as the number of watts taken out of the grid matched the number put in—everyone was happy.

But this happiness came at a price. The heavy government regulations meant that reliability was more important than efficiency. In any business, complete reliability is expensive; it usually requires some overproduction or excess inventory. In the electricity business, this was doubly true—because electricity doesn't store well and has to be generated all the time.

The smooth, cooperative marketplace required heavy government regulations that encouraged inefficiency and steadily increasing prices.

Historically, the three elements of the electricity business—the generation, transmission and distribution—were all performed by the same company, the vertically-integrated utility that thrived in the United States after World War II. These old-school companies were essentially government-sanctioned monopolies, controlling geographic areas completely. This legal monopoly structure masked the inefficiency of the business.

But free economies loathe inefficiency; and the United States was, mostly, a free economy. By the 1980s, some energy industry insiders were complaining that prices had crept too high; that the time had come to deregulate the electricity business and start pushing for better efficiency—and a whole new set of rules.

They argued that prices would be cheaper for end-users if one company owned the power plant, another owned the transmission grid and a third owned the local power lines and meters. Each of these owners would push for the lower costs at each stage of the equation. And there would be hundreds of other owners just like them, all over the country, pressing prices down even further.

The deregulation argument has always been a compelling one. Capitalism is a dynamic thing—and it usually best served by markets that have the fewest governmental restraints. But free markets and dynamic capitalism can be tough on businesses and consumers.

Having operated under heavy government regulation for generations, a deregulated electricity industry was going to be a clash of cultures…and a lot more.

1

April 1996:
The Feds vs.
the Californians

In April 1996, the bizarre tale of California's "deregulation" of electricity began with an appropriately bizarre case of the regulatory tail wagging the political dog.

For years, two regulatory agencies had been battling a bureaucratic turf war: the Federal Energy Regulatory Commission (FERC) and the California Public Utilities Commission (CPUC). The battles were inevitable. Essentially, these two agencies overlap in authority, with the FERC in charge of interstate issues and the CPUC in charge of matters within California.

What was so notably bizarre about April 1996? The Feds, following the lead of the California regulators, ordered major changes in the rules for how electricity was sold at the wholesale level—*wholesale* being the price that the companies which generate energy charge the companies which distribute energy into homes and businesses.

The FERC changes came as debate raged in California over reform of the state's electric power industry. Electricity prices in California were among the highest in America, and the population was surging. Proponents of a basket of reforms loosely called "deregulation" wanted to change the California electricity market from a collection of regional monopolies to an arena for aggressive capitalist competition.

Competition was a new concept in the electricity business. Traditionally, utilities had generated, transmitted and distributed their own elec-

tricity. But, since the end of World War II, demand for electricity had grown faster than supply. As a result, independent generators had cropped up in most areas to supplement production.

The Feds' changes focused on the transmission part of the electricity equation. They required public utilities to open their transmission lines to competitors and to share information about available transmission capacity. The new rules didn't require public utilities to sell off assets—but did require that they separate their transmission and power-marketing functions.

This is like the difference between using AT&T as a long distance telephone carrier and another, like Verizon, for your local services. The call takes place over a single line, even though the service provider changes. You switch from one company to the other while using the same hardware. The new FERC rules aimed to set a similar structure. Utilities had to offer independent generators or resellers the same access to transmission lines that they used themselves; they even had to charge themselves the same fees that they charged the others. In exchange for this open access, the utilities could charge enough to recoup any stranded costs (expenses they'd been forced to absorb under earlier rules) related to the transmission lines.

These *stranded costs* would turn out to be a recurring issue.

FERC staffers defended the changes as consumer-friendly, arguing that the new rules would save consumers between $3.8 billion and $5.4 billion a year. Still, the California regulators were leading the way. The FERC rule changes not only supported the California reforms, they actually mirrored them. The Federal bureaucrats were in the unusual position of playing catch-up to state bureaucrats.

A Little History

Historically, the federal government regulated wholesale power rates and state governments regulated retail rates—those charged to consumers. The energy deregulation movement, which started in the late 1980s and gained momentum throughout the 1990s, threw all of the traditional rules into question.

The FERC and CPUC were bound to butt bureaucratic heads in this environment.

The CPUC was established in 1911, during one of the state's reform periods, to oversee railroads operating within the state. By the mid-1990s, the CPUC also regulated telecommunications, electricity, natural gas, water and passenger transportation companies. It has always been a political entity: The governor appoints its five commissioners, who must be confirmed by the state Senate, to six-year terms.

In late 1995, the CPUC voted by a narrow margin to let the state's power-generating industry set electricity rates according to market forces rather than regulatory order. Industry insiders, regulators in other states and the media all decided that this was the decision that would set electricity deregulation in motion all around the country.

The CPUC decision wasn't the same as a specific plan (that would come later in 1996). But it signaled to the lawmakers in Sacramento that the regulators would support a deregulation plan. It also put the California regulators in the front position, nationally. As a regulator in another West Coast state said:

> The whole energy market had agreed that deregulation was coming. It had already come to most other regulated markets. In our case, it was a situation where everyone was waiting anxiously for the first group to make a move. California was the one that did it. Once they announced that they were moving to a deregulated market, it wasn't just talk anymore. Everyone else pretty much fell in line.

This explains why the Feds felt pressure to one-up the CPUC. They didn't want to be seen as trailing behind the states. (This had happened to federal regulators in other markets, with considerable political fallout.)

Rule-Making and Price-Setting

The CPUC's mission seemed simple: It was trying to create a framework to bring down electric rates. And there was good reason for

this; during the 1990s, Californians paid electricity rates that were on average about 50 percent higher than the rest of the nation. A long history of regulated prices, strict environmental laws and some expensive nuclear power plants had gradually run up the rates. Still, part of the CPUC's charter was to assure *reasonably-priced* energy for Californians.

Of course, the other part of its charter was to provide *reliable* energy. These two missions involved some inherent conflicts.

On a mechanical level, these conflicting missions meant that the CPUC had to consider two elements to reform the electricity market. First, it had to deal with rule-making—the structure of competition in the marketplace. Second, it had to deal with price-setting—the assurance to consumers that they wouldn't pay too much for their electricity.

Some energy industry types (and some consumer activists) argued that the CPUC should address both elements from the start in any reform plan that it considered. But the regulators didn't do this. They focused first on how to structure competition...and put off until later how to manage prices.

That would turn out to be a mistake.

The Big and the Little

Residential consumers weren't a big part of the early thinking on reform. In 1994 and 1995, the CPUC's focus was on structuring a system in which large, commercial energy users could shop among electricity suppliers for the best prices. Think about how much energy, for example, Wal-Mart or Costco uses to keep business moving; certainly these corporate giants would learn how to best negotiate deals when it came to energy.

A system whereby the big guys could shop for energy suppliers would dismantle the pricing and production controls that had been in place. The commercial customers would be able to switch from supplier to supplier on relatively short notice or blend simultaneous deals with several suppliers—all according to their larger and complex needs.

This shopping around would create a "real-time" competitive market for electricity; and just about everyone believed that the real-time market would press prices down for everyone.

This model would have been *true* deregulation. However, the real-time concept got little support in the political arena. Consumer advocates complained that ordinary people wouldn't have the size or savvy to negotiate good deals with suppliers. And environmental groups complained that high-cost alternative energy sources—wind, solar, geothermal—would be abandoned as buyers and sellers searched for the lowest prices.

So, the CPUC rethought its plan. In the spring of 1996, it announced a proposal to create a state-run electricity pool, to begin operations within 24 months. Generators would send their juice into the pool; big corporate users or energy marketers who'd resell the electricity would buy juice from the pool. There would still be bidding and selling; but it wouldn't be truly deregulated.

The CPUC plan was based on utility reform that had worked successfully in other countries—notably, Great Britain. However, the British model had included a number of factors different than California's. For one thing, the British model proposed to be a reform—not a deregulation. For another, it didn't have to contend with multiple regulatory agencies and diverse political interests.

The California Plan allowed the five commissioners of the CPUC—all political appointments—to reach a compromise solution that gave each some small victories to claim. It was a committee decision. Exactly the sort of thing that you might expect when regulators are on the forefront of deregulation.

The CPUC's Plan

In truth, the CPUC couldn't demand deregulation…or even regulatory reform. Only elected lawmakers could do that. But the CPUC could influence actions that lawmakers took by organizing itself in ways that would support particular kinds of legislative reform. This kind of influence is typical of the political process that takes place in

any capitol (in California's case, Sacramento; in America's case, Washington, D.C.). The bureaucrats indicate to politicians what reforms will work…and the politicians shape their reforms to match the signals given by the bureaucrats.

In the late spring of 1996, the CPUC announced its version of the California Plan—which would, among other things, abolish two independent watchdog departments that had traditionally challenged utility companies' requests for rate increases and monitored compliance with regulatory mandates: the Division of Ratepayer Advocates and the Division of Administrative Law Judges would break down into new departments.

Consumer advocates immediately objected, claiming that any independent analysis of the CPUC's actions would be ineffective because the two departments' staffs would report to different supervisors.

The CPUC insisted that the proposed changes would promote "efficiency, effectiveness, accessibility and accountability." And, though the CPUC still had to defer to elected lawmakers, it was taking a big initiative by being the first entity to suggest specific reforms…and to define the terms of the debate.

A Nice Try for Palm Springs

While the CPUC was trying to influence legislative reforms on the state level, the Feds were working hard to establish their own imprint on the California electricity market. But the actions they took would end up blurring the definition of deregulation.

The problem was that the Feds seemed more concerned about their relative bureaucratic power than making sure the right reforms were being made.

Through the mid-1990s, the City of Palm Springs had been exploring the prospect of starting its own electric company. Given that the city, which lies about 100 miles east of Los Angeles in the desert, is known for its hot days and year-round AC needs, establishing its own power company seemed like a good idea. But Palm Springs had neither the

time nor the financial resources to build its own power plants and distribution grid, like most municipal utilities—such as Los Angeles— do. But, with deregulation the hot topic of the day, Palm Springs figured it didn't need to do all that. Instead, it could simply buy energy from generating companies on the wholesale market and resell it to residents and businesses within its city limits. This was something that people in the electricity business called a "muni-lite"—a government-owned utility that didn't own hard assets.

The only hitch: Palm Springs would have to transport the electricity from the wholesalers to its city limits. In the Palm Springs case, this would mean convincing—or compelling—SoCal Ed to make its transmission lines available.

SoCal Ed wasn't inclined to support this process. The residents and businesses in Palm Springs were SoCal Ed customers; the muni-lite would take their customers away.

Palm Springs and SoCal Ed went to the FERC to settle their disagreement. Why did Palm Springs and SoCal Ed go to the Feds instead of the state regulators? Because the crazy quilt of laws governing electricity sales required federal action.

The Feds and the Energy Act

The Energy Policy Act of 1992 gave federal regulators the authority to order utilities to make their transmission lines available for wholesale sales from power companies to other utilities, municipalities or electric cooperatives. This meant that electric transmission lines were regulated by the federal government, while local electric distribution lines were regulated by the states.

In a March 1996 filing, Palm Springs asked the FERC to order Edison to provide transmission service over its lines for electricity purchased from other power generators.

The Feds heard the arguments on both sides and, in the early summer of 1996, they ruled against Palm Springs—concluding that forcing SoCal Ed to transmit power for a muni-lite was not in the public

interest. Why wasn't it? There wasn't one consistent answer. Generally, the gist of the matter seemed to be that the FERC wasn't comfortable supporting instability in the energy market. This sent mixed signals to the industry. On one hand, the Feds were saying they'd support open access; on the other, they were refusing muni-lites.

Why was a muni-lite unstable? Because SoCal Ed said it was. The Feds were still used to taking their cues from the big utilities. And SoCal Ed's logic seemed to be that, without its own power plants, the Palm Springs muni-lite wouldn't be able to deliver reliable energy. (Ironically, SoCal Ed was months away from backing a state reform that would require it to sell *its* power plants.)

In the wake of the decision, SoCal Ed praised the FERC in the language of political partisanship. "We're gratified by the unanimous ruling" said its vice president for public affairs. "We're pleased that the Commission has taken a principled approach to this issue."

There was nothing particularly principled about the FERC's decision. And SoCal Ed's exaggerated rhetoric showed that the dispute was more a political fist fight than a principled debate. Consider this description of the Palm Springs proposal, as described by SoCal Ed:

> The city attempted to become an electric utility by owning only duplicate customer electric meters, rather than using legitimate means of becoming a utility by building its own electric system.... By law, this wholesale transmission—known as "wheeling" of electricity—is available only to legitimate utilities, and not to "sham utilities" like the one Palm Springs proposed to create.

There definitely was something gratuitous, even for a press release, in those phrases "legitimate means" and "sham utilities." This shows how willing the big utilities were to fight when they feared that their turf was threatened.

SoCal Ed went on to say:

> Had Palm Springs prevailed, most consumers throughout the nation would be vulnerable to an unfair shifting of electricity costs. The

FERC ruling also upholds a basic constitutional principle—the appropriate compensation by governments for the taking of private property. By its decision today, [the] FERC has spoken out against cities circumventing laws that protect private utility property....[The] FERC's landmark decision characterizing muni-lite attempts as "sham" wholesale transactions upholds the integrity of existing utility systems and provides an essential foundation for the fair and orderly transition to a deregulated electric utility marketplace.

The thing to remember is that the FERC felt pressure to keep up with the CPUC and on the cutting edge of energy deregulation. Conventional wisdom held that deregulation—no matter what specific shape it took—was the wave of the future and would result in two contradictory things: Lower prices for consumers and bigger margins for energy companies. Even the regulators were swept up in this belief.

Common Beliefs and Consequences

The power that most government regulatory agencies hold comes from consumers' beliefs that the government:

1) has the interests of consumers or "the people" at heart; and

2) is smart enough to recognize behavior that will hurt consumers.

Politicians like to talk up the first point. But looking after consumers is no great boast, just about everyone in public service can rightly claim that. The second point, however, is the problem. One of the dirty little secrets of regulatory politics is that government agencies don't always recognize behavior that will hurt consumers.

As California meandered from one regulatory miscue to another, en route to the market meltdown of early 2001, the regulators on both the federal and state levels consistently misjudged what the market—and the consumers they were supposed to be protecting—needed.

In shaping the California Plan, state regulators had decided that big utilities couldn't compete directly for consumers. Their role was going to be limited to transmitting electricity from generators to end-

users (ironically, this was precisely the kind of arrangement that Palm Springs had sought and been denied).

But, over time, the CPUC backed away from this position—just as the FERC had in the Palm Springs case.

In late 1997, the CPUC ruled that marketing subsidiaries set up by the state's big utilities (called "affiliates" in industry jargon) could compete in the newly deregulated energy market. This was something that the utilities wanted very badly…it would give them the chance to maintain a large presence in the marketplace.

Strings Attached

Typically, the CPUC's decision came with various bureaucratic strings attached. The affiliates would have to comply with strict regulations to "level the playing field" with independent energy marketers. The rules were supposed to prevent confusion that might give the utility affiliates an advantage over lesser-known startups or providers moving in from other states when the energy market was fully deregulated.

The utilities and their subsidiaries would have to maintain separate financial records, offices and corporate structures; a utility couldn't offer customers a service or rebate conditioned on their doing business with its subsidiary; and utilities could not help the affiliates with marketing—things like putting flyers in billing statements.

The affiliates could use their sister companies' logos in advertising, but only if they disclosed clearly that they were not the same company and that they were not regulated by the CPUC.

These rules set up an absurd structure of regulatory requirement that only a regulator could support.

And not all of them did. There was dissent among the five members of the CPUC over whether the whole allowance-with-strings-attached idea was any good. CPUC Chairman Gregory Conlon didn't like the idea of marketing companies using the names and logos of established utilities. But the pressure from the utilities was too much. The utilities

rallied big energy users and manufacturers to come to their support; their basic argument was that the affiliates were competitors and restricting their activities would be anti-competitive.

Again, in the wake of a tactical victory, the utilities made exaggerated claims of free-market idealism. PG&E Vice President Dan Richards praised the commission for a decision that would promote "vibrant competition."

But this wasn't what resulted.

The utilities had a track record that suggested they'd use regulated money to fund unregulated marketing campaigns. An audit of PG&E by the CPUC's Office of Ratepayer Advocates—which would soon be dismantled under the California Plan—showed that $33.7 million of ratepayer money had been used improperly to subsidize affiliate activities, most during the audit period from 1994 through 1996 as utilities prepared for deregulation. (PG&E pledged to repay any funds improperly collected through these cross-subsidies from ratepayers.)

In retrospect, the CPUC decision to allow utility affiliates to operate in the unregulated market was foolish. The logic of the decision was a double negative: The CPUC wouldn't not allow the affiliates to market energy.

Interested parties could spin this decision as a move toward free markets. And, taken completely out of legislative, political and economic contexts, perhaps it was. But context is everything in deregulation...and context is what doomed the CPUC's efforts.

Public Utility Holding Company Act

So why were the Feds trying so hard to follow the CPUC's dysfunctional lead? Why wasn't the FERC able to see through the double negatives and press release rhetoric—and help California achieve some kind of true free-market reform?

The answer was, in part, the 1935 Public Utility Holding Company Act (PUHCA).

PUHCA restricted multistate utility holding companies from moving beyond geographic bases or core activities. The law was supposed to prevent utilities from growing too powerful…and non-utility companies from moving into the electricity business.

This rule worked well in the regulated era; but it became a big problem as deregulation approached. Multistate utilities argued that PUHCA gave single-state operators unfair advantages. Single-state companies could avoid federal red tape.

At the federal level, regulators weren't sure what to do. Arguments for and against PUHCA both claimed to be best for consumers. On one side, repeal of the law would allow more players into the market and encourage the kind of "vibrant competition" that everyone believed would be good for consumers. On the other side, PUHCA needed to be kept around until utilities were forced to open their territories to retail competition. Otherwise, the repeal of PUHCA might allow abuses like the concentration of market power and risky, speculative investments at ratepayers' expense.

In the end, the prevailing opinion in Washington was that PUHCA was an obsolete law, surpassed by an industry that was moving inevitably toward deregulation. So, even though PUHCA remained on the books and the Feds were legally obligated to step into many energy industry disputes because of it, the smart people at the FERC looked for ways to get around the law and participate in deregulation.

Corporate Clout

The federal-plus-state regulatory structure ensured ongoing bickering between the FERC and the CPUC. Several years later, when the California Plan was resulting in exploding rates, the FERC declined to step in. While acknowledging that rates had become "unjust and unreasonable," the FERC reported that it was "not able to reach definite conclusions about the actions of individual sellers." Rather than take an aggressive stance—and investigate charges of market and price manipulations—the Feds suggested a complex system that would allow California utilities to save money by bypassing the state-run "deregulated" electricity market.

California Governor Gray Davis accused the FERC of acting "to ensure unconscionable profits for the pirate generators and power brokers who are gouging California consumers and businesses."

FERC Chairman James Hoecker countered with a criticism of the CPUC and politicians like Davis. The California Plan "was a disaster in its application—no question about it," Hoecker said. "In my view, competition has not failed in principle...because it was never well-conceived or fully tried."

Even with a crisis looming, regulators on the federal and state levels still preferred to bicker with each other.

In the meantime, three of the CPUC's five commissioners were attending an emergency public hearing, held before two administrative law judges in downtown San Francisco. The three listened quietly to a parade of witnesses, ranging from angry consumer activists calling for reregulation to defensive utility executives begging for the right to charge more money.

The judges were weighing the pros and cons of a proposed rate increase that SoCal Ed and PG&E insisted that they needed to stay solvent.

The Feds supported the rate increase. And that position was probably more realistic. But the CPUC commissioners opposed the rate increase. One of them went as far as to call the increase "the end of the legitimacy of deregulation in California."

But reality had so far surpassed anything that either the CPUC or FERC could do that the regulators' rhetoric missed the point. Deregulation in California had never been legitimate.

The hearings in San Francisco were a bureaucratic turf war more than a reaction to market forces. SoCal Edison had counted on its federal connections to make the rate increase happen; it had started mailing notices to consumers that announced rate increases. This made the CPUC bureaucrats furious.

At one point during the hearings, one of the CPUC commissioners attacked a SoCal Ed attorney for his company's presumptuous actions: "It is quite astonishing that you would choose to ignore our rules and procedures on such an important matter."

The SoCal Ed lawyers countered that the utility had sent the mailings because law requires the utility to notify customers within 45 days of any application to the CPUC to raise bills. That argument was, technically, correct—but it didn't seem to do much good.

Realizing that the California regulators were going to cling tightly to the 1996 reforms, the utilities tried to move the debate to the federal level. One of their tactics for doing this was to sue the FERC. SoCal Ed charged—in federal court—that the FERC's failure to control wholesale electricity prices had "pushed Edison to the brink of financial ruin."

In short, SoCal Ed hoped that a federal court would order the FERC to trump the CPUC's rulings.

The tactic worked, sort of. In December 2000, the FERC ordered a partial restructuring of California's electricity market. Long-term fixed-price contracts were a key element of the restructure order, in which the FERC aimed to move the state's utilities away from reliance on volatile spot markets for their power.

But—ironically—some state politicians had wanted even more. Gray Davis had asked the FERC to place federal wholesale price caps of $150 a megawatt-hour on electricity (market rates at that point were almost 10 times as much). Essentially, these price caps would have allowed California's dysfunctional system to stay in place. Rather than fixing one state's crazy scheme, they would have forced the whole country's electrical system to enable it. The Clinton Administration was not inclined to do this...and its time was winding down.

The FERC wasn't going to bail out the CPUC, so California regulators were soon admitting that they would have to approve some form of rate increase. They'd been on the cutting edge of deregulation but they'd screwed it up. Now they were going to have to be on the cutting edge of repairs.

Rate Increases

In January of 2001, the CPUC approved a temporary 9 percent price increase for customers of SoCal Ed and PG&E.

A few days earlier, the Feds had agreed to step out of the turf war…and to allow the CPUC to work out the deal. The Feds admitted that, with ongoing negotiations between state policymakers and power providers, an FERC action would be "confusing at this time."

Why the change of postures? In part, it was because of the new man heading for the White House. Coming out of the controversial 2000 U.S. Presidential election, George W. Bush stated plainly that his FERC wasn't going to get involved in price caps that would bail out the state regulators.

"Price controls would be a short-term delay of a needed solution," Bush said, calling the California Plan "flawed" and to blame for the threats to power supplies and the poor financial condition of utilities. "California is going to have to address and correct the law that has caused some of this to happen," he concluded.

Bush underscored his position by naming Curt Hebert, a long-time price control opponent, as the FERC's chairman. Hebert held the line against price caps, arguing that they "distort" the marketplace and ultimately lead to higher prices by stifling competition. He reiterated the Bush Administration's position that California would have to solve its market problems without federal help.

Although the FERC had little direct authority over how California regulated its electricity market, the Feds did wield considerable regulatory clout over interstate transmission. Hebert said that the Bush Administration wasn't going to force energy generators to sell electricity to California utilities—as the Clinton Administration had done.

The 1950 Defense Production Act gives the president authority to compel companies to put aside their financial interests in the name of national security. Under this law, President Clinton had signed a memorandum the day before he left office declaring a "natural gas supply

emergency" in California. His energy secretary, Bill Richardson, in turn, ordered companies to continue shipping natural gas to California until January 23, 2001.

The new energy secretary, Spencer Abraham, extended the order for a few weeks—but Bush allowed the authorization to expire after that.

So, the CPUC had few choices. It had to orchestrate some form of rate increase. In a statement issued after it allowed the higher rates, the CPUC stressed the "need for cooperation to maintain stability and avoid bankruptcy of California utilities and assure the long-term regularity of market conditions."

But the 9 percent increase—even combined with a 10 percent increase that was already scheduled for the following year—wasn't enough to make up the difference between wholesale prices and what the utilities could charge. The CPUC's small increases were small steps in the right direction…but bigger steps were going to be needed.

By one calculation, based on SoCal Ed's losses during 1999 and 2000, electricity rates would have to increase some 76 percent in order for California utilities to break even.

PG&E continued to lobby the Bush Administration to extend the federal order that forced natural gas firms to continue supplying the financially stricken utility. And it looked for political help in its bid. Senator Dianne Feinstein, who'd been critical of the FERC's refusal to issue price caps, introduced legislation to force the FERC to establish caps when it finds "unjust and unreasonable" wholesale rates are being charged by energy suppliers. But her proposal was fuzzy about who would determine what wholesale prices were "unjust and unreasonable."

This kind of fuzziness was exactly what the system didn't need. The whole California mess had started because the regulatory apparatus was supposed to determine subjective matters like "just" and "reasonable." Dianne Feinstein? Gray Davis? A band of consumer advocates? FERC? The CPUC?

Regulators aren't good at enforcing these subjective societal goals; when they're working effectively—and that's not always—regulators are good at making the mechanics of a system run smoothly.

Anyway, Feinstein's fellow senators weren't likely to support her plan. It was a highly self-interested proposal, which would have forced natural gas companies in other states to sell their product with little prospect of getting paid. Senators from those other states would have been foolish to agree.

Rolling with the Blackouts

With the Bush Administration taking a hard line, the Feds were no longer in the position of watching the CPUC and California politicians experiment with harebrained schemes.

The final switch in the balance of power came in late January and February of 2001, as rolling blackouts in California were becoming big news in California and elsewhere.

The FERC stated plainly that power suppliers could not be forced to bear the risk that they wouldn't get paid for sales to California's (or any state's) grid operators. The ruling came in response to a request from the California grid operator that federal regulators waive requirements that buyers in California's electricity market be creditworthy. To the new FERC, this was a childish request by an agency which had been spoiled by the previous administration.

California complained that the FERC's refusal to continue forcing the sales was a "clear violation of its charter." But, like Dianne Feinstein's proposal, these arguments fell on deaf ears.

The pressure was on the CPUC to act decisively to repair its broken electricity markets. In Sacramento, California Republicans blamed the worst of the energy woes on the CPUC, saying it could have let utilities enter into long-term contracts before the companies' credit ratings were downgraded to junk-bond status.

From the beginning of the California experiment, the CPUC had forced the utilities into short-term energy buying. This was supposed to assure reliable supply. (Of course, not letting the utilities pass these market prices on to consumers defeated the purpose of the exercise.)

Even after the CPUC begrudgingly allowed long-term contracts, it reserved the right later to void the contracts. So, the utilities had little reason to do the right thing.

By the time the blackouts were at their height, the balance of power among the regulators had shifted. And, in fact, this shift was part of the reason the blackouts were happening. The Feds were no longer trying to follow California's regulatory lead; now, they were pressing the CPUC to clean up the mess it had made. That would be difficult.

Cutting Job Cuts

The particular, eccentric view that California regulators took toward the energy sector would take a long time to change. In many instances, California regulators remained stuck in their subsidized economic world view. The best example of this came in February 2001, when an administrative law judge for the CPUC issued an order that had all the reason of King Lear railing against the waves.

The administrative law judge John Wong proposed that the CPUC block plans by PG&E and SoCal Ed to lay off nearly 3,000 workers to save costs. Keep in mind that, in early 2001, these utilities were heading fast toward insolvency.

PG&E had about 18,800 employees and planned to eliminate 1,000 jobs as part of a $180 million savings program; and SoCal Ed had about 13,000 employees and planned to cut 1,850 jobs. Wong wrote that layoffs already made and cuts in overtime hours "have reduced the level of service below what customers expect as an adequate, efficient, just and reasonable level of service."

This answered the questions raised by Dianne Feinstein's bill. Administrative law judges would decide what constituted "just" and "reasonable."

Wong's proposal was largely the work of several utility workers' unions. It would order PG&E and SoCal Ed to rescind layoffs that might affect service levels in answering calls, power outages and service problems and monthly readings of meters.

Quoting documents submitted by PG&E, Wong said the 325 job reductions so far and others that were proposed by the company would delay or defer such things as gas and electric connections for new business, repairs to electricity lines and sending bills to customers. In addition, Wong said PG&E's decision to cut overtime in the unit that handled customer calls was already causing headaches.

Of course, Wong didn't offer any suggestions for how the utilities would stay in business while losing tens of millions of dollars a day...and keeping large payrolls. His powers as an administrative law judge didn't extend into forcing banks to loan PG&E money or natural gas companies to sell SoCal Ed fuel on a "pay when you can" basis. The FERC had already shut down those sweetheart deals.

The ludicrous proposal had to be approved by the commission to go into effect. It wasn't.

Drawing Conclusions

Ultimately, what conclusions can a reasonable person draw about the manner in which regulators acted before, during and after the California electricity crisis?

They behaved badly, of course. And they were often politically motivated. There were a number of bureaucratic turf wars going—sometimes simultaneously. These are the obvious details.

On a broader level, another issue comes into focus. The regulators—both the Feds and the Californians—couldn't make up their minds about whether they trusted deregulation. Sometimes they doubted market forces completely—like when they discouraged utilities from hedging their price risks by purchasing derivatives. Other times, they naively expected "the market" to drive down consumer prices and sort out the problems of a major marketplace transition by itself.

Finally, on the broadest level, it becomes clear that regulators are like junkies. They are tied inextricably to the markets they influence; and separating them is tough. No matter what the law says...no matter what voters want...regulators will cling hard to their positions. To expect regulators to willingly participate in their own demise is unrealistic.

They have a hard enough time cooperating with each other to maintain their control.

In this context, the most useful conclusion is that any regulatory structure is bound to doubt the efficiency of market forces. To expect the FERC or the CPUC to recognize and support true deregulation was foolish. Bureaucrats know that market pressures are their rivals—as are other bureaucrats—each seeks economic control. None wants to see the others succeed.

The very fact that the regulators called the California Plan "deregulation" shows they had no idea what that word meant.

2

May 1996:
The Theories that
Shaped the
California Plan

In May 1996, Citizens for a Sound Economy (CSE)—which, until that point, had been an obscure Washington think tank—published a report entitled *Customer Choice, Consumer Value: An Analysis of Retail Competition in America's Electric Industry*. The report analyzed the nation's electric power industry and concluded that federal electricity deregulation would be good for energy companies and consumers.

The report was written by Michael Maloney and Robert McCormick, two Clemson University economists who argued that, by removing legal restraints on competition among electricity generators, federal and state governments could expand market share for "efficient" utilities and slash the average consumer's bill by 43 percent.

The ideas discussed in the CSE paper weren't new. But the paper's timing was perfect: It came out just as political, regulatory and financial factors moved into a position to act on energy deregulation. The paper, like many briefs for deregulation, knew what it didn't want more than what it did. Still, it should have been part of a theoretical framework in which the debate over deregulation took place. Unfortunately, the debate over deregulation wasn't theoretical.

Citizens for a Sound Economy

The debate was political. Congressman Dan Schaefer, a Colorado Republican and chair of a House Commerce subcommittee, used the CSE report as the basis for a high-profile effort to bring competition into an industry made up of lots of local monopolies.

Within a few months, Schaefer introduced legislation that would give all consumers in the United States the ability to choose their electricity service by the end of 2000. His bill shocked the tightly regulated industry. Traditional alliances within the $200 billion-a-year business fractured, as energy companies slightly for or against deregulation found themselves pressed to extremes.

"The number of economic interests affected by this are simply staggering," one expert with the Natural Resources Defense Council (NRDC) told an East Coast newspaper. "In terms of combined economic and environmental impact, it may be the most important bill put forward in this decade."

As during any period of political transition, strange alliances formed from the confusion. The NRDC—usually a vocal critic in big industry—teamed up with giant utilities in New England and the Atlantic Coast to argue for pollution restraints on low-cost, coal-fired utilities in the Midwest (who, in turn, eyed New England as a fertile market for their cheap electricity).

The weeks and months after the release of the CSE report were the time for free market advocates to press for real deregulation. But the time passed—and California ended up moving toward a weird hybrid of deregulation and centralized planning.

What were these people thinking?

Nothing…or certainly not enough. The entire California episode was marked by a noticeable lack of a well-considered, theoretical structure. Bad results were bound to follow.

Utilities Are Forced to Sell

Through the spring and summer of 1996, the trend in California—and much of the rest of the United States—continued to move toward "deregulation" of energy markets. The only question in most people's minds was: How to apply the theories of deregulation to the realities of the energy marketplace?

One of the great benefits of deregulation, California politicians boasted in 1996, would be choice. Everybody from supermarket owners to apartment dwellers would be able to pick the company that purchased their electricity and mailed the monthly bill.

Giant utilities that once controlled electricity from turbine to toaster would do nothing but maintain wires.

May 1996 saw the first trading of ideas that would later result in the ill-fated California Plan. These ideas may have made sense individually. Together, they made a convoluted mess. They included:

- forcing utilities to sell off their own power-generating plants and related holdings;
- requiring utilities to buy power on an open spot market subject to hourly price fluctuations;
- forbidding utilities to pass on higher costs to consumers.

In retrospect, the outcome seems obvious: The utilities' debts would grow to the point that energy suppliers no longer want to sell power to them, fearing that they may not pay.

What were the people who built the California Plan thinking?

Nothing. At least nothing consistently. The California Plan always lacked theoretical spine; it was always a patchwork of unconnected parts.

In the U.S., the original theory had been that utilities had a "social contract" with customers. Under this contract, the utilities agreed to

build enough power plants to generate a sufficient amount of electricity to supply ratepayers' needs and to maintain the reliability of the transmission systems—the wires, poles and switches.

In return, the utilities were granted monopolies and a guaranteed rate of return that would allow them to recover investments in their systems and make a healthy profit—much of which was paid out in stockholder dividends, making utilities safe investments. Remember the game *Monopoly*? Buying the utilities (and railroads) is always a safe bet; anyone who lands on your property pays you an equal dividend every time.

Because the regulatory scheme allowed utilities to recover their costs, plus a profit, in many cases the utilities made higher profits by operating more expensive plants. Low prices weren't a priority.

Deregulation fever arose in the late 1970s, when the federal government stepped out of the way so that airlines could compete head to head. That deregulation effort resulted in some early successes, some spectacular failures, some angry labor unions and some industry consolidation. But what it did without any doubt was lower the cost of flying for Americans. On that one critical count, airline deregulation was a success.

In the years after airline deregulation, Americans elected a President—Ronald Reagan—who was ideologically committed to the effort. Between Reagan and the cheap tickets offered by PeopleExpress, it was hard to argue against freeing up competition in other fields. Railroads, trucking, telephones—these industries were all deregulated in turn. The government agencies designed to set prices and negotiate terms of business were dismantled or reduced. Entrepreneurs like Frank Lorenzo, Philip Anschutz and Craig McCaw swept in and pressed for greater efficiency. Prices to consumers went down...and the entrepreneurs became billionaires.

The Anti-Business of Utilities

In the mid-1990s, the electricity industry in the U.S. seemed in dire need of efficiency. Nearly 100 years of heavy government regulation

had warped electrical utilities into a kind of anti-business. The economics of the utility sector were bizarre. A badly-run electric utility suffered little for its managerial incompetence; its profits were set in advance by law.

Said another way, a utility that controlled costs and sought efficiency earned little or no extra profit. In fact, the politicians and bureaucrats who set the profit margins for utilities looked at greater efficiency as an anomaly to be avoided. Predictability was preferable—it made rate-setting easier.

In this anti-business environment, California's electricity market was dominated by three big utilities: Pacific Gas & Electric, Southern California Edison and San Diego Gas & Electric. These big three were each investor-owned. Their shares traded on major stock markets. Their shareholders expected—and traditionally received—regular profit distributions in the form of dividends. After all, the companies operated in a fixed market. (Beneath the three giants existed a number of city-owned municipal utilities, the largest of which was the Los Angeles Department of Water and Power.)

The big three controlled about 75 percent of the California electricity market. The munis controlled the other 25 percent.

Prior to deregulation, each of the big three utilities controlled a vertical market. Together, they owned almost all the power plants and the means of transmission and distribution of electricity in California. And they were content to charge rates and earn profits as allowed by the CPUC.

This set up may have been great for the anti-entrepreneurs who managed the utilities and the bureaucrats who made the marketplace. Adding to the oxymoronic nature of the business, they openly conspired to maintain slow expansion and steady (though small) increases in rates.

But this was a bad deal for consumers—especially big ones. Slow, steady growth and profits had a compounding effect on end-users.

By the mid-1990s, Californians were paying as much as 50 percent more for power than their counterparts in other parts of the country.

As California staggered through a recession in 1995 and 1996, pundits pointed to the high energy prices as one reason that new businesses were avoiding the state...and existing ones were moving out.

In California during the mid-1990s, electricity cost consumers about 11.4 cents per kilowatt-hour. In Wyoming, with its acres of inexpensive coal-fired plants, it cost just 6.2 cents per kilowatt-hour. Theoretically, deregulation would allow a consumer in Anaheim to sign up with some power company from Cheyenne and save 45 percent on the electric generation part of the power bill.

In general, deregulation was supposed to break through the lazy management and upward drift of energy prices in California.

California policymakers—the loose affiliation of politicians, high-ranking bureaucrats, editorialists and academics—figured that entrepreneurs would create hundreds of new companies to lure customers away from utilities by offering cheaper electricity or electricity generated in environmentally friendly ways.

The theory was that open markets would enable new energy providers to break into the market—and lower prices. They would also absorb the risk of volatile electricity prices, giving customers stable rates.

The country's experience with airlines, trucking and telephones seemed to bear out the simple equation that deregulation equaled lower prices.

Realities of a Volatile Market

The strength of this simple belief blurred the realities of price spikes and transition periods. And it informed a series of assumptions that would later prove wrong...and disastrous. Specifically:

* Deregulation equals competition, which equals lower prices. The California Plan hinged on wholesale prices falling as a result of competition. The CPUC made it a condition that the

utility companies sell off at least half of their fossil fuel generation plants; but the wholesale sector that emerged in their place was not the competitive market that policymakers had expected. Rather than filled with dozens of scrappy generators selling energy, the wholesale market was an oligarchy—controlled by a few major players.

- Energy consumption is easy to predict. The California Plan assumed static levels of demand for energy. This was the least defensible part of the process; politicians and bureaucrats should have known better from their own experience. Energy demand is a spiky thing. It correlates with trends in the overall economy—except that its swings are more extreme. California policymakers seemed to forget that they were standing in a recession as they discussed reform in 1996; an economic recovery would send consumption levels way up. And so it was. During the late 1990s, energy demand growth in California was twice the national average—the equivalent of needing electricity for a new city of nearly 1 million people annually.

- The private sector can always find a way to make money. In this context, state policymakers had blind faith in private sector energy companies. The bureaucrats assumed that a freer wholesale energy market would trump California's environmental restrictions on building new power plants. It didn't. The environmental restrictions and state/county/city permitting hassles continued to prevent plants from being built. Existing plant owners saw the hassles and the planned spot market for wholesale energy deals as a recipe for inadequate production—and fat profits. And they were right.

So, the theoretical framework that shaped the California Plan was a strange hybrid of big assumptions taken from traditional free-market ideology and smaller assumptions taken from the warped confines of a century-old regulatory bureaucracy.

The main, twisted conclusion of the hybrid ideology: That you can deregulate one end of a market (in California's case, the wholesale end) while leaving price caps on the other (the retail end).

You can't.

A Lopsided California Plan

Why didn't anyone in a position of influence see that the theoretical framework behind the California Plan was warped?

In fact, some did. But, by May 1996, the state politicians were so clearly moving toward a plan that arguing against it seemed pointless; the struggle was over which details would be approved by the legislature and signed by the governor (Pete Wilson, at that point).

And many of the people best positioned to warn against hybrid deregulation theories were in the electric or natural gas sectors—and they were more interested in how they could game the monstrous results of hybrid theories.

Besides, there was a shining example of conceptual patchworks and compromises that worked. In the later 1980s, Britain had opened its power sector—and it had done so by combining free-market ideology with so-called "smart regulation."

Following Britain's lead, California planned to create a statewide power pool that would buy electricity from various sources, including existing power plants. Customers would have the choice of buying power from the pool, from independent sources or from their existing utilities. Under this program, most customers would receive two bills, one from an electricity supplier for the power they bought and another from their utility for moving it to their homes.

California's reformers mentioned Britain often…without taking into account some important differences between California and Britain.

Differences Between California and Britain

It was foolish for the reformers to use Britain as a prime example that California could emulate. For one thing, their respective reserve capacities were much different. Britain had enough reserve to manage its way through a transition and related demand spikes.

California didn't have any meaningful reserve capacity.

In Europe, deregulation had not resulted in reliability problems. But credit for that belonged to excess capacity more than brilliant management. California had neither.

Another critical difference was that California had allowed politics to interfere with deregulation of the retail market. Rather than allowing prices to fluctuate, politicians froze electricity rates for a few years—supposedly in the interests of the consumer. But that gave consumers no reason to cut power use even when wholesale prices soared.

The hodge-podge of deregulatory philosophy also blinded California to resistance nearby states would show. Implicit in California's plans was the ready availability of natural gas or electricity from states like Washington, Oregon and Idaho.

This assumption may have reflected a regional arrogance that California shows in many economic and political matters. (The policymakers in those other states certainly believed this.)

Some Major Points

The aim of deregulation is simple: To free the markets so more companies can compete, which should drive down prices. In a truly free market in which decision-makers have perfect information, thousands of independent transactions inch toward the most accurate pricing for the most efficient use of resources.

But those two assumptions—"truly free" and "perfect information"—are extremely hard to achieve. Some say they're impossible.

The California situation quickly proved to be deregulation that wasn't working properly. The problem: The deregulation was incomplete. The market wasn't truly free. State-regulated utilities were ordered to sell their plants and forbidden to enter into long-term contracts that could hedge against sudden price fluctuations.

These same utilities had price caps on what they could charge customers, so they couldn't pass the higher fuel costs on to customers. As a result, they ran through their financial resources and eventually didn't have the money to pay for the natural gas.

Economists will argue that, if you don't have truly free markets, perfect information—even if it can be achieved—isn't enough to assure efficiency and lower prices. But, as if to assure that its plan would fail, California took a series of steps to obscure market information as much as possible.

It did this by enacting a series of legislated price decreases. Consumers were told that they would see an immediate 10 percent savings on their electric bill and enjoy fixed rates until January 2002. Then, electricity rates were scheduled to drop a total of 20 percent.

The scheduled price decreases prevented useful market information from getting to most decision-makers. California bureaucrats weren't just capping rates; they were commanding that the market move in the direction they bade at the times that suited them. From a free-market perspective, these edicts were nothing short of insane.

Or, as the *Wall Street Journal*'s editorial pages noted: "That isn't deregulation. It's California's popular Santa Claus theory of economics."

The price caps and reductions encouraged excessive use—running air conditioners full-time while wholesale generators faced skyrocketing prices for fuel. Caught in the middle, the big utilities borrowed heavily—counting on state and federal energy regulators to bail them out of any serious problems. So, even PG&E and SoCal Ed were working with profoundly imperfect information.

And every megawatt they bought and resold generated a loss that pushed them closer to insolvency.

Dollars and No Sense

Again, the theories behind California's moves seemed based more on dollars than economics. Each year, the state's businesses and consumers paid $23 billion for electricity. (Nationwide, the number was $212 billion a year—more than twice the nation's long-distance telephone bill.)

The rich irony of the theory behind the California Plan is that it did more than miss a few key things…it actively and precisely headed the state down the road to catastrophe. The dramatic price increases were the result of critical misjudgments by the CPUC and make-a-deal state politicians like Pete Wilson. The most critical of these misjudgments were:

- A gross underestimation of demand as the state's economy came to life after years of recession and California's burgeoning computer-based businesses ate up electricity at rates unheard of in the old economy.

- A failure to anticipate that energy companies could easily exploit a mechanism designed to ensure an even flow of electricity. By holding back electricity and selling when the system was desperate, they could earn double the going rate.

- A faulty assumption that deregulation would prompt more competition right away: Hundreds of companies were expected to serve homeowners, but they didn't materialize. At times, a few power plant owners effectively controlled the price of electricity.

In their attempt to foster competition, the designers of deregulation traded a monopoly in which the government set rates for a new marketplace in which prices can fluctuate.

No Reps for the Little People

The California Plan wasn't driven by free-market activists—or even reformers who wanted lower prices for all consumers. It was driven by large, commercial users who had the means to negotiate aggressively and purchase power from the lowest bidder. That's why they were so sure "deregulation" would result in lower prices—for them—because they had the manpower and buying leverage to assure good deals.

In late 1997, for example, Ralphs Grocery Company—a large supermarket chain based in Southern California—announced that it had chosen New Energy Ventures as its full-service energy partner in the deregulated electricity market.

Ralphs operated 344 retail stores as well as distribution and food pro-cessing centers that required large amounts of electricity to operate refrigeration equipment, pumps, fans and processing equipment. "With tens of millions of dollars a year in electricity bills in our California stores, it is essential that we maximize our competitive advantage through lower energy costs and improved energy services," said one Ralphs executive. "Recognizing that our rates would be frozen at existing high levels until 2002 if we took no action, we reviewed our options with our present utilities and the major power marketers."

The deal meant that Ralphs would opt out of the utility pool arrange-ment.

New Energy Ventures achieved savings for its customers by aggregat-ing (combining) their energy buying power and using high-tech meter systems that allowed corporate customers to track energy use—even among various locations—in tiny detail.

About the same time that Ralphs was announcing that it would work directly with a new-economy power generator, McDonald's Corp. announced that it was sticking with one of the big utilities—namely, PG&E.

Under a contract valued at $180 million, PG&E would offer discounted rates to more than 800 McDonald's restaurants in California. Its abil-ity to buy energy that was both cheap and reliable was important to the big fast-food chain. (The contract did not apply to some 400 Califor-nia McDonald's outlets served by municipal utilities.)

"McDonald's is known for their operational efficiency and purchasing skill, so winning their confidence is a significant accomplishment," a PG&E executive said.

But, if larger commercial users essentially opted out of the traditional utility market, the utilities would have to spread fixed costs over a smaller base. If those users fled from the utility systems, the departures could exert upward pressure on residential rates that could prove po-litically unbearable. At the same time, everyone seemed swept up in the press for deregulation.

The CSE Paper Takes a Few Hits

That didn't mean consistency among the experts, though. The CSE report mentioned at the start of this chapter was far from being considered a universal breakthrough; many economists took issue with CSE's conclusions. A group including J. Gregory Sidak of the Washington, D.C.-based American Enterprise Institute (AEI) made an especially strong objection in a letter sent to House and Senate Energy Committee Members, which stated:

> On its face…, the estimate by Professors Maloney and McCormick of savings to consumers and growth for the economy on the order of $2 trillion sounds improbably high. Much of the report rests on a projection of a 42 percent increase in consumption resulting from significant price reductions that the authors assume will occur. That projected increase seems very high relative to the effect of past price changes on electricity consumption. Furthermore, the projections that Professors Maloney and McCormick provide of GDP growth are based on one unreplicated study of the relationship between energy use and labor productivity. They assume that long-run increases in GDP can be achieved only two years after the initiation of retail competition, which seems improbable in light of the experience on deregulation in other industries.

> …it would be premature for the Subcommittee to accept their claim of a $2 trillion increase in GDP.

> That conclusion is reinforced by the report's relative disregard for matters of network reliability. Contrary to the assumption of Maloney and McCormick, it may be infeasible to run generators on summer peak-demand levels throughout the year without incurring substantial increases in fuel and maintenance costs. Before accepting the report's estimates of consumer benefits, the Committee should be assured that Maloney and McCormick have not based their estimates on assumptions that entail a hidden cost to the nation's electricity system in terms of diminished reliability.

> Like Maloney and McCormick, we welcome competition in the electric power industry. Unlike them, however, we reject the propo-

Pennsyl-

sition that the good intentions of reformers—even those seeking to replace regulation with competition—justify either denying the government's share of accountability for creating the problems now facing the industry or repudiating the protections that the government promised to investors in electric utilities under principles of contract and property law.

The AEI raised several valid objections, which would later sound quite prophetic—especially its prediction of "diminished reliability." But these complaints were lost in the busy noise of the ill-conceived move for "deregulation."

Even the two groups as different as the CSE and the AEI ended up sounding more alike than different. They were both for deregulation of electricity markets—the only question was who was more intense. And that's about where the debate existed during the spring and summer of 1996.

Looking Back

It would take five years for a more complete critique of the theories of 1996 to come out. In early 2001, the Reason Public Policy Institute (RPPI), a research organization based in Los Angeles, made a more sober reckoning of what had happened. But, by that time, the California electricity market was already staggering.

The report, *Powering Up California: Policy Alternatives for the California Energy Crisis*, offered a series of market-based recommendations to reform the troubled reforms. In it, RPPI argued that approaches involving "re-regulation" would have little or no effect on the price spikes, threats of blackouts and looming bankruptcy of the state's two largest private electrical utilities.

Drawing upon an extensive analysis of the national utility deregulation movement, the report compares California's failed restructuring attempts with successful deregulation efforts in other states like Pennsylvania, Rhode Island and Massachusetts—where consumers enjoyed lower electricity rates.

The report concluded that California's energy market was "not a deregulated market at all, but a politically charged minefield they do not know how to navigate."

Why was this so? Why wasn't there any well-thought-out plan for navigating a useful deregulation? The answer may lie in the situational philosophy behind regulatory politics. Bureaucrats were making decisions that visionaries should have. They inched reform along and reached compromises when bold strokes and firmly-held convictions were what the marketplace needed.

In California, through the spring and summer of 1996, the grind of politics trumped economic theory—as it sometimes does. But, for the next five years, economic theory got its gradual revenge—as it always does.

Deregulation efforts are susceptible to these problems. Its activists tend to position themselves as permanent "contras"—against an existing status quo. They focus on reducing existing regulations; and they celebrate any reduction. But this focus leaves markets exposed to replacement systems that are even worse.

3

June 1996:

Lobbyists Define the

Shape of the Plan

With regulators more worried about bureaucratic territory wars than the health of the marketplace and a flimsy economic framework behind it, how did the move toward market overhaul keep its momentum?

One word: *Lobbyists.*

Lobbyists—the opportunistic band of lawyers, former politicians and staffers and industry moneymen that influences legislation in state or national capitols—usually have an agenda of their own in political matters. This agenda may be only glancingly related to the issues of public concern; its focus is usually making more work for...lobbyists.

A lot of political noise is made about the effect that lobbyists have on government policy-making in Washington D.C. But, for pure bare-knuckled influence peddling, you usually have to head out to the state capitols. Places like Little Rock, Tallahassee—and Sacramento.

The legendary California politician Jesse Unruh once said, in reference to dealing with lobbyists and contributors: "If you can't eat their food, drink their booze and screw their women, and still vote against them, you don't belong in this business." That quote made the history books, and clearly points to how nasty politics can get when lobbyists climb into the game.

The Exchange of Dollars for Influence

Billions of dollars would turn on the details of implementation—the precise form and timing that the move to deregulation would take. The flimsy theoretical framework of the issue also meant that Republicans and Democrats split nontraditionally on these matters. Very few people knew what to make of the issues…except that deregulation was a good idea. (As it turned out, even this agreement was a product of some subtle lobbying.)

It was easier to look at the big "deregulation is good" picture, than it was to study all the minor details involved in the process of deregulating realistically. Once everyone agreed that any form of deregulation was good, the lobbyists had an even better chance than usual of influencing outcomes.

In several key ways, the Sacramento lobbyists fit perfectly in the environment that defined the California energy debate in the summer and fall of 1996. Lobbyists work best when focused on procedural matters, which meant that they understood and responded well to the regulators' turf battles. Lobbyists avoid—and are sometimes disdainful of—honest political belief; so they didn't mind the lack of a realistic vision that the California energy market suffered. They bored into the details of "deregulation" and created a series of smart parts that—when put together—weren't really deregulation at all. Each part, however, satisfied a paying constituency.

The lobbying dollars told the story of just how high the stakes were during 1996. The three big investor-owned utilities—SoCal Ed, PG&E and Sempra—spent $4.3 million on lobbyists and pumped more than $1 million into political campaigns during the year. The money went beyond any single lobbyist or campaign. It permeated Sacramento for months.

When the reforms were finally passed, the dollars had done their jobs. The exchange of money for influence, which is a lobbyist's reason for being, had worked. Their status was secure.

What would result four or five years down the road hardly mattered. In fact, if it was trouble, that would mean more work for lobbyists.

Astroturf Organizations

SoCal Ed had started its lobbying campaign in Sacramento in early 1996—not long after the CPUC had made its initial commitment to pursue some form of deregulation. By the summer, the effort was in full force to rig the Plan so that the huge utility could gain something from deregulation. Rigging the Plan meant creating corporations, or parent companies, through which the utilities could transfer assets and shield themselves from losses. SoCal Ed also spent its money setting up so-called "astroturf" organizations—groups that seemed to be grassroots organizations but were actually corporate mouthpieces.

SoCal Ed gave $75,000 to Consumers First, a group based in Orinda, California, designed to fight the free-market plan. Most of the money went to underwrite a video warning consumers that regulators planned a form of deregulation that would help only big business. The video didn't mention that homeowners and small businesses might form buying groups or coops that could negotiate the same favorable deals.

These well-funded mouthpieces argued against the straight, free-market plans being suggested by some CPUC board members; instead, SoCal Ed money—with help from the smaller Sempra—pushed for the British "power pool" plan. This plan would create a statewide power pool that would buy electricity from various sources, including existing power plants. Customers would be able to choose power from the pool, from independent sources or from their existing utilities.

Some legislators in Sacramento complained that the financial and lobbying resources unleashed during the summer of 1996 were "overwhelming" and "brutal." In a later report, the CPUC would complain that "Edison zealously advocated and lobbied for the enactment of [the California pseudo-deregulation bill], knowing full well that [it] froze rates and created risks for utilities."

Why would a utility support—what's more, actively encourage—a bill that could bankrupt it? Because it thought the status quo was worse.

SoCal Ed knew what it wanted—namely, the ability to transfer assets to its corporate parent, Edison International. And it got that. By transferring assets, it could shield itself from potential losses. The utility knew that the process of deregulation would create a period of instability, and it didn't want to lose anything while this happened—especially if bankruptcy loomed in the future.

PG&E Backs Direct Access, No Pool

Unlike SoCal Ed's efforts to help formulate a plan and support a statewide power pool, PG&E didn't do much lobbying right away. Conspicuously, PG&E—the largest of the state's big three investor-owned utilities—stayed out of overwhelming money politics during the summer of 1996. It backed direct access, or the customers' right to buy from the cheapest source, without a pool. In this effort, PG&E had allies with some industry lobbying groups, such as the California Manufacturers Association (CMA) and the Manufacturers and Technology Association.

PG&E proposed freezing its electric rates for five years and accelerating depreciation on most of its utility generation assets, including the Diablo Canyon Nuclear Power Plant. PG&E said its plan would shorten the time needed to restructure the state's electricity market by as much as four years.

The CMA went as far as to issue a public statement praising PG&E's support of something closer to true deregulation. In the statement, CMA President Bill Campbell said:

> This is a very bold and gutsy step by PG&E, and a welcome signal to California manufacturers. Competition is the only real force that will drive down the high cost of electricity in California—and the only way to nurture the economic expansion needed for new jobs and new economic vitality. We applaud PG&E's plan. We view it as one more positive step toward improving California's business climate.

PG&E's plan would probably have worked better than the California Plan. Some economists and business people realized this. Unfortu-

nately, no one seemed to realize *how much* of a difference PG&E's plan would make. CMA had played a key role in convincing the CPUC to make the decision to pursue free markets. But, like most industry lobbying groups, it made the erroneous assumption that any deregulation was good deregulation and would bring down electricity rates. It didn't grasp the importance of keeping alert to the entire equation when monkeying with regulated industries.

The summer of 1996 was a high time for hired guns in Sacramento. The big utilities were the real leaders of the lobbying effort; industry trade groups like CMA—thinking the hardest part was over—were standing on the sidelines of the game.

The reform plan that was eventually passed did include language that allowed big business to deal directly with generators, but few businesses ever took the chance. At most, only 13 percent of the industrial market contracted for its own power. One reason was that the process was made too complex. The utilities erected a number of impediments or countered offers by rival energy sellers with lower rates.

To Divide, Conquer...and Keep the Feds Out

SoCal Ed and San Diego Gas & Electric (SDG&E) weren't entirely alone in this process. They had some allies from the push for deregulation at the federal level that had been going on for months in Washington, D.C. There, groups like the Electricity Consumers Resource Council (ECRC), representing several dozen of the nation's largest users of electricity, had worked with SoCal Ed's corporate parent.

The ECRC had been created to argue for direct access—PG&E's plan. It was funded by large corporate and government entities that believed—rightly—that they were subsidizing residential consumers in many markets. Still, the ECRC tried to position itself as a grassroots campaign. John Anderson, its organizer, said it held "umbrella group" meetings with consumer groups, natural-gas companies, school-board representatives and homeowners associations. This focus or rallying broad support diluted its advocacy of direct access...and made it more like a cheerleader for any reform.

The focus of the lobbying in Washington was on keeping as much of the deregulatory effort as possible at the state level.

Edison Electric Institute (EEI), which was not directly connected to SoCal Ed, represented some 180 utilities and had a war chest of more than $4 million—dedicated to keeping the Feds out of deregulation. EEI hired three former congressmen as lobbyists and snapped up a number of economists; all of these wise men argued that Congress should move slowly, leaving the main burden of deregulation to the states. EEI also funded several public affairs programs on television and radio; through those channels, it stressed its commitment to "clean and efficient energy solutions" and other euphemistic nostrum.

In addition to the ECRC and EEI, there was the Electric Utility Shareholders Alliance (EUSA), also a grassroots organization. EUSA was designed to build a coalition of industry groups—many from the agricultural sector—opposed to federal tampering with electricity markets. According to William Steinmeier, chairman of EUSA, "Ordinary Americans want the federal government to stay out of issues that are best handled closer to home."

Steinmeier acknowledged that some of EUSA's money came from utilities, though he declined to offer details.

In retrospect, it's clear that aggressive utilities like SoCal Ed and SDG&E took a divide-and-conquer approach to their lobbying efforts. The first focus was to move as much decision-making as possible from the federal to the state level; the second focus, then, was to grind the state-level legislation into a mishmash of divergent goals. This would give them the financial cover they needed to move money around.

In California, they largely accomplished this. Their lobbyists won.

The CPUC Takes Charge in California

By the fall of 1996, the deregulation debate had moved clearly into the state arena. In California, the ongoing battle between the CPUC and the FERC had tilted in the CPUC's favor. The CPUC was making the important decisions for how the reforms would take place.

In other words, the seeds of the eventual disaster were being sown.

SoCal Ed was sharpening its lobbying knife, working aggressively to convince the CPUC to see things its way. And even PG&E had backed away from its more principled stand for true free markets; as long as it could salvage some direct access, it would be content with whatever the more aggressive contrivances SoCal Ed wrought.

The utilities and their lobbyists realized that, with little ideological consistency defining terms, the California Plan was going to be defined—even more than most laws—by the details of implementation. These details of implementation were why the lobbyists swarmed.

Lobbyists helped craft the California legislature's position that the wholesale side of the electricity business (the dealings between the generators of energy and the marketers of energy) could be deregulated while the retail side of the business (the dealings between marketers of energy and end-users of energy) remained regulated.

Why were the expensive lobbyists promoting such a ludicrous plan? The simple answer: Their clients paid them to.

So, why were the clients—largely the big three utilities—paying lobbyists to promote a plan that would eventually bankrupt…themselves?

Answer: Because the utilities had been regulated for so long, they'd become the spoiled teenagers of the American business scene. They wanted immediate gratification and long-term efficiency. Their immediate concern was that the reform plan allow them to operate in the free-for-all of a deregulated market—while moving their cash reserves and net worth to corporate affiliates that were not involved in those markets. SDG&E, for example, became a subsidiary of Sempra Energy, which itself was created in 1998 through the merging of Pacific Enterprises and Enova Corporation. Out of PG&E came PG&E Corporation in 1997.[1]

[1] The utility holding companies can be very stubborn about the protocol of referring to them—instead of their "operating units" (the actual utilities). This is largely corporate pretense, though. The utilities are the significant assets of the holding companies—so, to avoid confusion, the book uses the utilities' names as much as possible.

The lobbyists, again, were effective. California politicians allowed the reforms to follow the course set by the spoiled utilities.

So, the outrage of the early work on California's deregulation wasn't that the partial deregulation would cause problems; everyone who knew anything about the industry and the program could predict that. The outrage was that the utilities knew they'd be flirting with insolvency…and were more interested in moving their assets out of reach. They'd take their chances with bankruptcy courts—and assume that the state would bail them out when the time came.

Strategic Misdirection

The lobbyists wielded more than just the petulant behavior of corporate teenagers. One of the most effective tools that smart lobbyists use is strategic misdirection. If a legislative issue has clear weaknesses, a lobbyist will sometimes work hard to point politicians and the media in other directions.

The utilities' lobbyists did a lot of this. As a result, people—even experts—consistently misapplied their scrutiny and comments. Throughout 1996, there was much discussion and debate over all the wrong issues:

- How quickly should "real competition" be phased in? Quickly (within two years) or slowly (between five and 10 years)? The truth was that real competition wasn't part of the plan at all. Only the wholesale end of the business would see it.

- How many rate cuts should there be for consumers? And how often should they happen? There weren't any real rate cuts. The much publicized "automatic 10 percent" cut that was publicized from the early going was a facade—it was to be financed by taxpayer-guaranteed bonds.

- How will the state prevent big utilities from manipulating market prices? This was a sham issue that was supposed to protect the utilities from charges of unjust enrichment. And, in the process, they agreed to the serious mistake of selling their power generating plants.

All of these misunderstandings were the deliberate, effective result of lobbying efforts by firms in the employ of SoCal Ed.

By the way, it's not necessarily manipulation when the largest players in an industry sector influence prices. That can be economies of scale—critical mass working naturally on a free market.

Like an indulgent parent, the Sacramento lobbyists gave the spoiled teenagers what they wanted. And, true to their nature, the spoiled teenagers did more harm—to themselves—because they didn't really know what they wanted.

The misdirection was so complete that even contrarians missed the right points on which to be contrary.

What Big Utilities Sought

Some worried that because California's big utilities had more political clout than their would-be competitors—and certainly more than the consumer groups—they would be allowed to keep their monopolistic grip on the market. This turned out to be a silly concern. The utilities didn't care about keeping their "monopolistic grip." They wanted, in descending order, to:

- protect the cash they had on their books already;

- separate their "operating units" from their corporate parents;

- remove every asset of value from the "operating units";

- position the "operating units" to leverage regulatory concessions by threatening bankruptcy;

- increase margins by decreasing the production and marketing costs of electricity; and

- make the industry more efficient.

Another bit of artful misdirection that the lobbyists used to position debate was the matter of consumer choice. Much was written about individual consumers choosing between competing suppliers. In fact, the California Plan set prices so sufficiently that choice at the consumer level didn't involve much difference.

The utilities "have a lot of political muscle," griped Mike Peevey, a former president of SoCal Ed and president of New Energy Ventures, an energy marketing start-up angling to compete in the brave new world. "They're going to string this thing out as long as possible."

By June 1996, they already had.

Compensation for Stranded Costs

Moving beyond pricing and corporate structure issues, the California politicians and bureaucrats turned their attention to stranded costs—huge, failed investments forced on companies by regulators who thought they were assuring steady services. Nuclear power plants were one example of these failed investments; long-term contracts to buy wind and hydroelectric power at above-market rates were another.

The utilities argued that these costs should be reimbursed immediately—to those entities (largely, utilities) that had been forced to absorb them in the first place.

EEI argued that utilities should be compensated for these stranded costs; they were investments undertaken on the understanding that they would earn a fair return, before there was any talk of competition. Of course, few industry segments saddled with ill-advised investments felt entitled to being bailed out by the government.

But all sides were used to the bail-outs. In Washington, several key groups—the FERC, the Energy Department and various congressmen—had accepted the argument that there should be some sort of compensation for stranded costs. So the debate moved on to how much the compensation should be and how it would be paid.

This was another subtle victory for EEI's lobbyists.

Some cost recovery was becoming a political reality. But the idea that the utilities had been forced into ill-fated investments for which they deserved to be made whole was another misjudgment. According to Peevey, the utilities' demands were "absolute and utter baloney." Thanks to the lobbyists, the baloney prevailed.

There were serious economic concerns about the stranded costs issue. Foremost among these: that SoCal Ed and PG&E would exaggerate their stranded costs to manipulate the plan's cost-recovery formula. This, in turn, would make it prohibitively expensive for more-efficient competitors to enter the California market. "It's the strategy that any smart-thinking monopolist would employ," said the executive of an out-of-state utility that was considering a move into California.

The Reform Plan Becomes Law

The California reform plan was passed into law in September 1996, but the battle for influence of energy policy was hardly done. The immediate effect was that the front lines moved back to Washington, D.C.—where the FERC and the U.S. Congress were considering legal changes that might undo the California Plan.

In Washington, the debate was slightly more balanced than it had been in Sacramento. The campaign pitted power-producing giants eager for new business, such as Houston-based Enron Corp., against traditional utilities such as SoCal Ed and Chicago's Commonwealth Edison. While the debate was ostensibly about consumer choice and lower prices, there was once more a lot of lobbyist spin and misdirection. Consumer advocates worried that end users would be trampled as industry behemoths struggled over shares of the $208 billion-a-year market, though the specific worries once again turned out to be focused on the wrong points.

In Sacramento and Washington, the dollars involved in the lobbying effort were daunting. For all of 1996, the top two dozen players in the energy deregulation debate spent more than $40 million on lobbyists. Millions more went into research, polling, television advertising and laying astroturf—developing grassroots organizations.

Through EEI, utilities were lost in a lobbyist-hiring bender as 1996 turned into 1997. Most of the $11.1 million EEI spent on lobbying during 1996 had gone to influence the deregulation question. The group, heavily supported by utilities, wanted the Feds out of the question. More lobbying was expected in 1997, with a number of mergers and consolidations in the industry tempting regulatory scrutiny on the federal level.

The smartest people within the utilities sector had worries about what California had done. While even experts tended to focus on things that proved to be non-issues (like the speed of conversion to free markets), they sensed something was shaky about the California Plan. This sense may have simply been institutional conservatism—some utility executives, used to being regulated, feared suddenly throwing open the industry to unfettered competition. This could damage them.

"You hire these lobbyists and they just take off spinning, like some crazy spider," said one EEI member executive. "There are times when you wonder who's working for whom."

Adding to this pressure, EEI's lobbying was financed by a special assessment on its utility members amounting to $3.8 million a year— so it went ahead, regardless of member trepidation.

Lobbyists for Small Consumers

EEI was far from alone. The push for deregulation on the federal level was also being coordinated through weekly meetings at the offices of the National Retail Federation. The retailers were a key part of Americans for Affordable Electricity—which might sound like an astroturf organization but was actually more legitimate than some. It included power generators, energy-consuming industry groups and commercial and residential user groups. The group was formed partly at the behest of congressional Republicans fighting for real deregulation—and against the rigged plans that utilities often sought.

AAE was at least matching the spending of the utilities, said head lobbyist John Motley. On top of an annual budget that reached near $4 million, each member of the coalition donated the time of its public relations experts, lobbyists, lawyers and policy experts. Enron, for one, contributed an ad campaign that cost nearly $20 million.

Like most of the health care reform lobbying that had occurred a few years earlier, the energy deregulation lobbying only sounded like it was designed for consumers and end-users. In fact, almost all of the efforts were designed to sway a relatively small number of politicians, bu-

reaucrats and other policy wonks. Even the TV and radio ads that were bandied about were intended more as a threat for what might run in the middle of the country than a plan for what actually would.

AAE formed task forces to deal with the media, to lobby lawmakers directly, to coordinate grassroots lobbying and to draft technical papers. But, in the late 1990s, the utilities had been lobbying longer and more effectively.

Hidden Worries Become Real Problems

By late 2000, California's energy market was starting to show signs of problems. There had been a number of near-blackouts...and the big investor-owned utilities were hemorrhaging red ink. These electricity interruptions had nothing to do with the energy crisis, and were merely mechanical problems (e.g., downed transmission lines or blown transformers), but they punctuated the concerns.

But the lobbying action was still in Washington, D.C., where the nation's largest energy providers were squaring off against EEI and other utility groups; millions of dollars were being spent on each side of the fight over deregulation. The amounts had exploded.

In 2000, the amounts being spent by energy companies on campaign donations and traditional lobbying had reached at least $50 million. The price spikes that had occurred during the summer of 2000 had filled energy generators' coffers...and there were profits to be protected. Generators spent lavishly: Reliant Energy spent $1.6 million on political contributions and lobbying during the 2000 campaign season; Williams Cos. spent $1.4 million; Enron Corp., $1.2 million; and Duke Energy, $985,000.

According to filings at the Federal Election Commission, Sempra Energy—the parent company of SDG&E—spent $70,000 on congressional races. Sempra also gave $302,750 in soft money to political parties and spent $1.2 million on lobbying. And Sempra was the smallest of the big three California utilities.

The vast amounts pouring into Congress over deregulation made it less likely that legislators would pass a new law quickly. That might only turn off the spigots. One legislative analyst with the Center for Responsive Politics noted:

> Members of Congress are getting so many campaign contributions from energy companies that there's little incentive to move a bill through. Important legislation can get stymied in Congress sometimes because there are so many sides to the issue, everybody's giving money and nobody in Congress wants the money to stop.

And, of course, there was an oil state governor running for President in 2000. George W. Bush's campaign was a big beneficiary of energy-company contributions. Enron alone gave $113,800 directly to Bush and donated $1.1 million to soft-money funds that fed into Republican campaigns. (Enron also gave $360,000 in soft money to the Democrats.) Other energy companies chipped in more than half a million dollars to the Bush campaign.

Bush would claim—especially after Enron's collapse—that the campaign contributions and lobbying never resulted in favorable treatment for Enron. But the appearances were certainly suggestive.

Money Gets Thrown Around Like Candy

In the meantime, in California—with an energy crisis looming—an army of energy and utility officials treated lawmakers, aides and commissioners to thousands of dollars worth of dinners, drinks, concerts, country-club greens fees and hard-to-get basketball tickets.

The dining experiences ranged from food and beverages at a Hooters restaurant in Arizona to lunches in Barcelona, Spain and Dublin, Ireland.

California State Senator Steve Peace spent the most time socializing with energy representatives—26 times since early 1999. The same companies picked up the tab an additional 26 times for Peace's staff when the El Cajon Democrat was elsewhere.

Entertaining powerful figures was a fact of life in Sacramento. But consumer advocates said that they were troubled by the cozy ties between energy officials and the people responsible for California's electricity policy.

Beyond the personal benefits for policymakers and staff members, critics note that ratepayers and public-interest lobbyists rarely enjoy the same quality time with public officials.

Lawmakers and staff are allowed by state law to accept as much as $300 in meals and gifts from a single source. Anything above the limit must be repaid out of personal or campaign funds.

SoCal Ed and PG&E dispersed tickets to Sacramento Kings games more than 40 times. But nothing compared with the time Peace and his aides spent with energy executives. On June 27, Edison officials picked up a $386.53 dinner tab at Morton's in Sacramento.

A week earlier, Peace and his top aide, John Rozsa, dined at the trendy Esquire Grill across the street from the Capitol.

A month earlier, it was SDG&E's turn. The company bought Peace a baseball ticket to see the Sacramento River Cats, a week after he was treated to lunch. And there was golf. In 2000, Peace and his son had played at the private Bighorn Golf and Country Club near Palm Springs. The $220 total greens fees for father and son were paid by SoCal Ed officials.

Peace reimbursed most of the energy interests who paid his way. In August 2000, just as the energy crisis emerged as a top priority in the legislature, Peace wrote a check to SDG&E's holding company— reimbursing the company for the social outings during the first two quarters of 2000. The check covered his spending, as well as his staff's, according to SDG&E spokesman Art Larson.

But Peace didn't have to reimburse the $94,500 in campaign contributions he had received from energy interests during 2000.

Peace was far from the only California politician picking up the energy industry's influence money.

As California was heading for energy problems, Gray Davis was greedily collecting money from the disparate players who'd influenced the reforms under his predecessor. There was little ideological consistency to the grab. Davis collected $464,000 in campaign donations from energy generators, marketers and utilities between the time he took office in January 1999 and June 2000. On the other hand, he collected more than $113,000 from unions representing electrical workers, including many who worked for utilities, during the same period.

SoCal Ed gave Davis $105,000; PG&E gave him $72,500. Enron gave him $42,000. The utilities also kept a large stable of Sacramento lobbyists close to Davis; PG&E is among the clients of his 1998 campaign finance chairman, Darius Anderson.

Anderson, a good friend of Davis's, knew how to spin the wheels of politics between the public and private sector. He became the poster boy for Sacramento lobbying, known for connecting powerful people together for the sake of someone's interest. After his corporate communications work with the Ralphs/Food 4 Less Foundation, he advised Davis during his gubernatorial bid and founded a consulting firm for lobbying, strategic planning, events planning and fundraising in California. Among his clients are British Petroleum, General Motors, Calpine, Microsoft and the Port of Oakland. Anderson remains the best example of the Sacramento political establishment that supported California's ill-conceived plan.

Scrambling for Protection During Reform

In 2001, as California tried to crawl back from the brink of an energy meltdown, many of the same interests—like the state Chamber of Commerce and the Manufacturers and Technology Association—that had pushed electric deregulation in 1996 were trying to ensure that they got special treatment during the reform of the reforms.

Some groups were involved because they were financially threatened by the energy crisis; others hoped to use the state's energy woes to their advantage.

At the center of the lobbying was a desire by oil companies, grocers, farmers, manufacturers and department store chains to win back the right to choose their power supplier or generate their own power.

The right to direct access was eliminated in early 2001 under emergency legislation that put the state in the power-buying business.

Depending on how lawmakers restored that right, the loss of those big energy customers to other energy suppliers meant California's larger households and small businesses—who couldn't contract directly with generators—would feel the most pain from future rate increases.

Rather unseemly, in terms of retail politics.

The unseemliness didn't stop powerful groups like the state Chamber of Commerce and the Manufacturers and Technology Association from taking their best, shameless shots at preferred treatment. They— with the backing of electricity generators—were pushed hard for the right to buy energy direct from generators.

Other groups wanted different things from the energy mess. For example, schools want to have themselves removed from power grids, like fire and police stations, so their lights would stay on when outages occurred. Members of the International Brotherhood of Electrical Workers, which represented employees of utilities such as PG&E, wanted their pensions guaranteed should the utilities go bankrupt.

The energy industry lobbying had some other, less direct effects. For one, it wrought havoc for environmental protection.

Lobbyists for the power generators threatened that a public power authority in California might scare off private investors reluctant to compete with the state.

Winston Hicox, director of the California Environmental Protection Agency, said the gap between supply and demand could be greater than 5,000 megawatts this summer, given that other Western states probably won't be sending as much electricity to California, and that the state's own production of hydroelectric power might be low.

Calling conservation steps "incredibly important," Hicox said the state needed to cut use by at least 7 percent to avoid blackouts.

But California's experiment with pseudo-deregulation had created more than just the simple good-versus-bad dynamic to which the energy industry was accustomed.

A Marketer's Perspective

In January 2001, Craig Goodman of the National Energy Marketers Association released a white paper describing the marketer's perspective:

> Deregulation is not a failure. California Style Deregulation is a failure. California was first and could have established a model for other states to follow. Unfortunately, a number of political compromises made supply shortages and price spikes inevitable.
>
> Deregulation can work only when consumers are assured that new supplies will be available to meet their growing demand. This has not happened in California.
>
> The combination of energy economics and energy politics clashed in California to produce a series of classic economic missteps. In the face of strong and growing demand for power, no new power plants were built. Price cuts were legislated at the same time that tens of billions of dollars in stranded costs were allowed into rates. Energy sellers and buyers were prohibited from doing business with each other and all energy purchases and sales were mandated through a state run monopoly.
>
> In response, wholesale prices grew to meet demand and, at the same time, retail prices were capped. This is a recipe for disaster in any market. …Now, we have California declaring Stage Three energy emergencies with rolling blackouts imminent, a utility cash flow and credit/confidence crisis, taxpayer and consumer revolts against both high prices and utility bail-outs, environmental construction hold ups, and politicians threatening to expropriate private generating

assets that utilities sold when values were high and shortages were foreseeable.

...Leadership is needed at both the state and federal levels. California must lower the costs and risks associated with building new generation in the state. The U.S. and global economies cannot afford blackouts in Silicon Valley or anywhere else in the country. California deserves better. America deserves better. ...When markets get distorted so that price competition cannot occur everyone loses, consumers, taxpayers, utilities, governments and suppliers.

Goodman's letter was a more straightforward approach to lobbying. It was trying to state a position clearly...and hoped that the clarity would attract support on its merits.

Too bad the more cynical, misdirecting—and, ultimately, more effective—lobbying tactics had already set the tone for influence in the energy sector.

A Final Thought

The fact that SoCal Ed's version of pooled power marketing trumped PG&E's more direct deregulation proved that the semi-permanent political establishment in Sacramento prevailed over disinterested economic logic. The California Plan was a triumph for the army of independent lobbyists—like Darius Anderson—employed quite effectively by SoCal Ed to work the law-making machine.

The emphasis on the details of influence was a classic example of missing the forest for the trees. No one seemed to realize that SoCal Ed was pushing for a suicide course.

4

August 1996:
Steve Peace—A
Dedicated Worker,
an Unlikely Villain

One temptation in putting together any history of a political and economic meltdown like the California energy crisis is to blame the bad events on one individual. The theory is that compelling stories need compelling villains.

But this story defies that sort of character identification. The California energy crisis was created more by a confluence of economic forces and a lack of charismatic leadership than any one specific person's evil plotting. (In this way, the energy crisis was like the savings-and-loan meltdown of the late 1980s…lots of shady operators, but no one person to blame.)

How do you identify a lack of good leadership…a cipher? To paraphrase A.C. Doyle's *Sherlock Holmes*: Eliminate all of the people who weren't around when bad decisions were made and whoever's left—however improbable—is the likely culprit.

Sherlock's P.O.E. Points to San Diego

The process of elimination in this story leads to a California state senator from the San Diego area named Steve Peace. You may remember him as the recipient of some lobbyist-funded sports tickets and greens fees in the last chapter.

Peace chaired the California state senate's Energy Committee, which drafted the main deregulation bill that eventually became the Califor-

nia Plan. While the various lobbyists representing the utilities (especially SoCal Ed) and the big energy users had each drafted the particular parts of the bill that concerned each group, Peace was the head mechanic who assembled the pieces.

Peace believed in "deregulation"—that is, the power of free markets to drive down prices. At the same time, he was something less than the libertarian deep thinker he purported to be; he was an opportunist. And he was heavily influenced by the perks that the utilities passed his way.

The Death March

Of course, Peace didn't operate by himself in Sacramento. During a frenzied month of August 1996, he held marathon sessions to hash out these terms of the California Plan. These meetings—which started on August 5 when the politicians came back to Sacramento from their summer break and finished by August 28—often went through the weekends and late into the night. They involved sleepy or bored legislators who wanted to be seen as savvy about deregulation...but who trusted Peace's industry-backed understanding of how the various parts were supposed to mesh.

So, despite years and months of discussion, the whole plan was put together in about three weeks.

Because he was working so hard, Peace got a pass from the media. Reporters regarded him as a policy wonk—as one Sacramento veteran described him, "too knowledgeable to do anything really bad and too boring to cover" in detail.

This meant that Peace was free to operate as he pleased. Lobbyists compared him to a drill sergeant as he shepherded the complex legislation through the committee. The politicians and media people assigned to watch the legislative meetings—which sometimes happened two or three at a time—through the hot summer afternoons in August called them the "Steve Peace death march."

The investor-owned utilities, the big energy users and their lobbyists enjoyed easy access and insider status. In the final weeks, Peace sometimes ordered lobbyists out of the room, telling them to return in 15 minutes with their issues resolved. They would then tell the legislators what the "deregulation" bill should say. One fellow state senator described the process as "group dynamics at its best and worst."

As often is the case with legislative staffers, some of Peace's people passed back and forth through the revolving door of the Sacramento career track. A prime example: David Takashima, who'd been Peace's chief of staff during the 1980s left to work as a lobbyist for SoCal Ed in the early 1990s. In July of 1996, Takashima returned to Peace's staff to help write the deregulation bill. (He'd later leave again, to work for PG&E as "director of governmental affairs.")

The Bill Gets a Name: AB 1890

In late August, a conference committee comprised of the Assembly members and three state senators approved the resulting legislation, a complex document of more than 150 pages.

According to the intricate etiquette of legislative politics, Peace ended up not being the final author of the bill, which originated in the state Assembly as AB 1890. Everyone, nonetheless, in Sacramento knew he was the man who made the reforms happen.

When the reforms finally passed into law, the assemblyman who was the final author of the bill said:

> This bill would not have passed out of both houses with no negative votes had it not been for the determination and tenacity of Steve Peace.

At the time, it seemed like a compliment.

An Eccentric Man, A Careful Politician

Steve Peace was serious enough that he wanted to move on to a higher office but eccentric enough that he moonlighted as a producer

of low-budget films (his most famous was the campy 1970s comedy *Attack of the Killer Tomatoes*…and its several sequels). He had a reputation as a brainy, caustic lawmaker willing to take on the most complex issues. Witnesses recalled him referring to a senior senator as a "senile old pedophile."

A graduate of UC San Diego, Peace was a staffer for two Democratic legislators—Wadie Deddeh and Larry Kapiloff—before being elected to the state Assembly in 1982. He was part of the "Gang of Five" (alongside colleague Gary Condit) that tried unsuccessfully to topple then-Speaker Willie Brown.

After reaching a rapprochement with Brown, he was elected to an open seat in the Senate in a special election in 1993 (and would be reelected easily in 1998).

In Sacramento, Peace had been antagonistic toward Big Water—becoming one of the major critics of the Metropolitan Water District of Southern California—but friendly to Big Energy. Utility companies had contributed to all of his campaigns—and paid for dinners and golf outings. At one point, Sempra Energy hired Peace's film company to make a video about its corporate strategy for the future.

In the early 1990s, when SoCal Ed attempted a takeover of SDG&E, Peace publicly opposed the move but then criticized a bill that would have blocked it. The takeover was bitterly fought by most San Diego officials, some of whom charged that Peace was covertly trying to help SoCal Ed. The deal was ultimately rejected by the CPUC as bad for consumers.

Selling His Soul in Price Reductions

Peace didn't forget that consumerist lesson. During the busy weeks of August 1996, Peace based his operating philosophy on a simple premise: The deregulation plan that the CPUC had suggested a few months earlier didn't do enough for consumers.

This approach gave Peace strong political cover, even though the plan he was actually bolting together did more for energy companies and corporate customers than average citizens.

Specifically, Peace complained that the CPUC proposal would not reduce rates for individuals and small consumers until 2005. He also argued that the CPUC had been too generous to utilities in how it handled stranded costs. To simplify the CPUC's suggestion, it offered the utilities $36 billion more in retail prices for seven to 10 years before allowing the market to set prices.

Peace's plan transitioned to market prices more quickly. Over a five-year period, starting in January 1998 and running through 2002, the legislation established a free market for electricity governed by a state-run power exchange that would sell electricity at the same rate to all buyers.

That was the free market portion of the plan; there was also a political hack portion.

Running against the notion of a market-driven price structure, Peace's plan also offered all residential and small business consumers an immediate rate reduction of at least 10 percent. After the transition period, ratepayers could expect further rate relief—in the range of another 10 percent or 15 percent.

"To say this was schizophrenic would be putting it mildly," grumbled one executive with an out-of-state energy company. "The mandated price reductions were proof that [Peace] was selling his soul. You can't deregulate and set prices at the same time. Something's got to give. And free markets are more fragile than political hand-outs."

AB 1890 did echo some parts of the CPUC proposal, but Peace—the elected politician—was savvier about building consensus. While many industry, trade and consumer groups opposed the CPUC proposal, most of Sacramento's dealmakers supported Peace's bill.

Peace never lost sight of political considerations. To motivate his sleepy colleagues, he told one local newspaper:

> This is a war against the largest and most well-financed industry in the world supported by the largest and most well-financed government in the world....

A war against the powers of the industry? Peace had the support of SoCal Ed (enthusiastically) and PG&E (tactically).

Like the CPUC plan, AB 1890 permitted the utilities to recover many costs associated with bad investments such as nuclear power—although Peace cut more than $9 billion from what the CPUC would have allowed. The utilities would get their money back quickly, by issuing state-back bonds to recoup the remaining $27 billion. The bonds would be paid off with a "competition transition charge" applied to every monthly electricity bill.

According to Peace:

> What we basically had to do was attempt to negotiate a deal whereby the big businesses agreed to stay on and pay their share of the non-economic (stranded) costs. To do that, we had to get the utilities to negotiate down—in other words discount—what they were willing to collect on their non-economic costs.

In other ways, Peace's plan was more generous to the utilities. For example, early in 1996 the CPUC had ruled that SoCal Ed couldn't pass along to consumers costs associated with costly long-term natural gas contracts it had made. AB 1890 would overturn that decision, granting SoCal Ed the authority to pass on to consumers as much as $150 million related to those deals. (Ever the ingrates, SoCal Ed executives considered the offer a defeat; they'd asked for $400 million.)

Handling the Stranded Costs

In general, under Peace's plan, the utilities could collect money for stranded costs only until the end of 2001. But the legislation contained some specific exceptions—such as Sempra and SoCal Ed's investment in the San Onofre Nuclear Power Plant. The utilities could continue to collect costs for San Onofre until 2003; consumer advocates complained that this could mean an extra $120 million to $350 million paid by consumers.

The politicians were especially proud of their solution to the stranded costs issue. The CPUC had planned to stretch recovery of those costs

out as far as 10 years; AB 1890 financed them with bonds that would be repaid in five years.

As AB 1890 headed out of the conference committee and to the Assembly and Senate, Peace made sure that it had broad support. The early response to the bill was positive. Commentators acknowledged the breadth and depth of the detail. It sought to deregulate the electrical industry, phase out monopolies held by California's three largest utilities, open the delivery of electricity to competition and give rate cuts of up to 20 percent to homeowners and renters.

Frequently, the proposal was compared to telephone deregulation—because of its combination of wide scope and intricate details. But Peace insisted that the bill offered protections for small consumers that hadn't been part of laws that opened the telephone industry to competition:

> Our effort was to attempt to make sure we don't revisit the kind of horror stories we saw in the telecommunications restructuring, where it took 20 years to make the transition and there were a lot of dislocations that occurred in the process. This is designed to reduce costs to all consumers of all classes and simultaneously bring stability to the system.

Also, the bill contained what Peace called an "anti-slamming" provision intended to prevent switching from one company to another without the customer's knowledge (this was a common problem among long-distance telephone services). Third-party verification would be required before a switch could be made.

While Peace and his allies argued that the bill would lower costs, a few (and only a few) consumer advocates questioned that optimism. Some consumer advocates complained, a bit reflexively, about the number of special exceptions made for particular utilities or generators.

Most analysts applauded the plan, though. Prodded by the same lobbyists who'd help draft AB 1890, commentators described the scheme

for transferring stranded costs to bonds as principled. Besides, if anyone questioned Peace's commitment to consumers, all they needed to see was the mandatory 10 percent cut in electricity rates for residential and small commercial customers by 1998.

The rate cut was funded by a new type of bond created by the legislation. (More on that later.) And the bill scheduled a second 10 percent rate cut in 2002, after the bulk of the utilities' $28.5 billion in stranded costs had been paid off.

The bill also provided safeguards to ensure continued maintenance of the overall transmission grid and required a public review in the event of any outage affecting more than 10 percent of the customers in a given service area.

Peace hoped to achieve his version of deregulation in tandem with an overhaul of the CPUC to position the long-standing regulatory agency to respond more quickly to a rapidly evolving competitive electric market.

Still, from the moment AB 1890 came out of committee, consumer groups were flummoxed. Peace and his fellow committee members had certainly relied heavily on energy industry lobbyists. And there was that revolving door of staffers moving back and forth between government and the energy industry. But did any of this mean that Peace and the others were tools of the electrical industry? Or did diligent Peace and his committee defy the odds by convincing bellicose special interests to agree on a plan that improved upon the CPUC plan and did better by consumers?

Rate Cuts Funded By Bonds

The California Public Interest Research Group (CalPIRG) issued a statement that complained about "the strategy of convincing Californians they are getting their bills reduced when they are really getting ripped off."

True, under the Peace plan, residential and small commercial ratepayers were promised a 10 percent rate cut. But that rate cut was penny wise

and pound foolish. For one thing, the rate cut was funded by state-back bonds. In other words, the customers would be borrowing to give themselves lower rates.

The matter only looked worse when examined more closely. The rate cut was guaranteed only through a four-year transition period that ended in March 2002. That was when the utilities would have to give up the fixed prices designed to pay off their stranded costs.

After March 2002, rates would be expected to drop another 10 to 15 percent—though they could increase at that point, if market conditions demanded.

At that point, the rebate bonds would still have six more years of payments to make. But their prospects for being paid would be questionable, because they'd be connected to cashflows no longer set by the state.

A four year discount financed by a 10 year note? Not a good deal.

…or maybe not so bad, said Peace. If stranded costs came in under projection or could be paid off sooner than expected, the bonds would be retired early, possibly even before the end of the transition period.

CalPIRG called the plan to pay the $27 billion in stranded costs a "bail-out at its worst." The group said Peace had received $14,487 in campaign contributions from the three investor-owned utilities between 1994 and 1996, while Jim Brulte—the co-author of the AB 1890—had received $29,896.

Peace countered that CalPIRG had not been present during the lengthy committee hearings that produced the legislation. He said none of the consumer groups that attended the hearings opposed the bill.

Indeed, two other consumer advocacy groups, San Francisco-based Toward Utility Rate Normalization and San Diego-based Utility Consumers Action Network, issued a joint statement saying the plan was better for residential and small business customers than the CPUC version.

Still, others agreed with the angrier CalPIRG. Harry Snyder, the west coast energy specialist for Consumers Union, argued that this was a bad deal. The rebate bonds forced consumers to borrow money to give themselves a short-term savings.

Bill Passes with a Sense of Urgency

Nevertheless, by the end of August 1996, California was poised to become the first state to deregulate electric service. Peace had prepped everyone effectively: AB 1890 would eventually sail through both houses, unopposed.

Most consumer groups went from opposed to neutral in the end. Although they still grumbled about the various bonds and the scheduled repayment of stranded costs, consumer advocates realized that the goodwill voters felt toward deregulation was strong. They simply believed that deregulation always meant lower prices. And the consumer advocates—like the unanimous legislators—didn't want to be on the wrong side of that belief.

The legislators who approved the California Plan without hesitation didn't show any change of heart when it came to paying the bill. Legislation clearing the way for the first of several bond issues breezed through the Senate without opposition and drew just five "no" votes in the 80-member Assembly.

Maybe there should have been more hesitation. Maybe someone should have pointed out that true deregulation doesn't require tens of billions of dollars in state-backed borrowing. None did. And the bill went to Governor Pete Wilson, who'd indicated he would sign it. As urgency legislation, AB 1890 would take effect immediately and allow the bond sales to begin within 45 days.

Consumers would be able to buy electricity from anyone they chose on January 1, 1998. But during the four-year transition, SoCal Ed, PG&E and SDG&E would continue to collect substantial surcharges to cover stranded assets.

As August wound down, Steve Peace was about to pull off one of the biggest legislative achievements in modern California history. He might have been exhausted; but his future in politics seemed very bright.

A Rushed Bill, A Shaky Beginning

In the fall of 2000, the world looked much different to Peace. His reforms had taken longer to implement than anyone had expected, finally limping into place in the spring of 1998. The mechanics of the hybrid system were problematic from the start. The state-run power exchange didn't work as smoothly as it was supposed to.

The deregulated wholesale end of the business had seen prices rise steadily, which meant the fixed prices on the retail end were causing utilities to lose money. In the early stages, the utilities didn't seem to mind some losses—as long as they were able to recoup their stranded costs.

But, as the stranded costs were recouped, the markets seemed to get worse instead of better. This was particularly embarrassing to Peace because the first investor-owner utility to pay off its stranded costs was Sempra, which ran SDG&E. Right in his own backyard. SDG&E had always had far smaller stranded costs than either SoCal Ed or PG&E, so it would be the first utility truly free to set its retail rates according to wholesale market prices.

The result: Electricity prices in San Diego doubled. Rather than causing lower prices, Peace's reforms had sent prices rocketing higher.

Critics gloated that there was poetic justice in Peace's own constituents being among those first hurt…and worst hurt…by electricity price spikes. Peace blamed the price surges on the state's shortage of electricity, greedy out-of-state power producers and federal regulators who declined to referee the new market. But he defended the legislative process he guided as fair, honest and open.

He tried to keep a long-term perspective, insisting that his reputation would be made on the "pro-business, pro-jobs, pro-environment,

pro-consumer" plan. "The net result will be hundreds of millions of dollars in ratepayer savings," he predicted. The Plan was "a good work product. It's not what caused the problems."

In a different interview, a testier Peace said that California's electricity market was "broken." But he still insisted that his plan was not to blame.

Time eventually wore down that claim. By the end of 2000, Peace had been burned badly enough by the high prices in San Diego that he started calling for more direct government intervention, price fixing…and even the repeal of his reforms, which had been passed unanimously in the legislature. He made a complete about-face, calling for a return to the days of the regulated electric utility monopoly provider.

Peace joined a popular movement in the San Diego area that urged consumers to delay payment of their SDG&E bills in protest. But this move backfired, striking many San Diegans as tricky and opportunistic. Having the prime architect of a "deregulation" program bailing out to join a consumerista movement didn't bode well for the stability of the program. Energy industry pros worried that Peace's moves would invite more, not fewer, blackouts and threaten reliable electricity in both the short and long term.

Blaming Problems on the Feds

In November 2000, a group of prominent California Democrats concerned about the energy crisis announced plans to create a $2 billion reserve that would allow the state to pursue a number of options, including building or buying power plants.

Peace was part of this group—even though most of its suggestions would undermine the program he'd put in place. His explanation: The problems were still all the Feds' fault. He said the reserve would be available if "federal regulators fail to curb electricity bills" that had soared in recent months.

Peace suggested that the state might be forced to consider dramatic steps—such as taking over the transmission system or existing power plants. He'd gone from champion of deregulation to socialist and nationalizer in a few years.

And there was a hint of conspiracy theorist in his statements. He said energy providers had apparently convinced the FERC that electricity prices had to be kept artificially high in California to provide an incentive to build new power plants. He alleged that the state and federal regulatory agencies had undermined his plan.

"Frankly, the pitch of the energy companies back in Washington is nothing short of extortion," Peace said at a news conference. That's why he was calling for the energy reserve.

Unless federal regulators stepped in, Peace warned, the reserve might be needed if angry ratepayers placed an initiative on the ballot in 2002 that resulted in a rollback of the deregulation plan. He also argued that blackouts and other severe problems had been narrowly avoided as far back as 1996—when the Legislature rewrote the deregulation program begun by the CPUC.

For a few months leading up to the 2000 elections, Peace had kept a low profile. The California Plan was clearly heading for problems…and the Democratic campaign gurus didn't want it to become an issue. So they ordered Peace to stay under wraps.

But, once the election was over, Peace started talking to the press again. He claimed he had a number of ideas for averting further problems.

In addition to proposing the reserve, Peace was working with attorneys to recover excessive profits made by energy firms the previous summer as the price of electricity had soared. Blaming the out-of-state energy generators, he said:

> If any of those people think that Californians are just going to sit down and allow $6 billion to be stolen out of the state by a bunch of thieves, they are kidding themselves.

Peace said he expected the massive lawsuit, which might be joined by California and other states, to take years as it worked its way through the courts. "We will pursue that until my last breath, if that's what it takes," he said.

In a letter to the CPUC, Peace urged the regulatory agency to deny a request from SoCal Ed and SDG&E to bill ratepayers for losses related to high out-of-state fuel and energy prices. He said the two utilities should be ordered to exhaust legal remedies to recover their losses from the energy providers.

Peace Declines a Higher Office

By early 2001, when the worst of the energy crisis hit California, Peace's change was complete. He spoke enthusiastically in favor of the public power bill—urging the governor to seize the state's power plants, many of which were owned by Texas companies.

"This is the only choice the kidnappers have given us," Peace said. Either take control of the generation plants "or raise the Lone Star flag to the top of the Capitol and give up the ghost."

The rhetoric was heated, but Peace was close to a freeze out. He was facing term limits in his state senate seat; and the results of the California Plan made a higher statewide office unlikely.

He'd formed an exploratory committee in 2000 to run for secretary of state in 2002. He filed documents with the secretary of state terminating his committee. But, in late January 2001, Steve Peace decided not to seek a higher office. Peace's chief of staff, Dan Howle, said the energy crisis and the furor over the 1996 deregulation bill played "little, if any" role in Peace's decision.

Peace had risen to chairman of the Senate Budget and Fiscal Review Committee. His exploratory committee had raised a total of $326,495 and spent all of it, including giving $50,000 to Senate Democrats' election campaigns, $103,000 to his own Senate committee and at least $39,000 to a polling company during 2000.

He'd also given $90,000 to his own video company, Four Square Productions, Inc. Four Square produced a video available on Peace's Web site that defends his involvement in the electricity bill.

Predictions of doom for other politicians who favored deregulation had proved wrong.

Conventional political wisdom held that skyrocketing electricity rates in San Diego County would hurt the reelection of state Senator Dede Alpert and the congressional campaign of Assemblywoman Susan Davis. But they didn't seem to have any effect.

Alpert, who'd voted for the 1996 bill and represented much of San Diego, found herself in the cross hairs. Electricity hadn't been on anyone's political radar screen as recently as June 2000; suddenly it was the only thing anyone was talking about.

Alpert said:

> I've never seen anything like it. I don't believe people can understand it if they haven't been physically present in the places affected by this. It dominates every conversation, everybody's thoughts. I can't even begin to imagine the entire state like this. It would be devastating. It would be prudent for everybody in this state to pay very close attention and figure out how to deal with this.

Alpert won reelection easily and Davis unseated Rep. Brian Bilbray.

Alpert and Davis, however, were only bit players in deregulation, compared to Peace, considered the father of the 1996 bill. He'd been someone that his colleagues looked to for expertise about the complexities of the energy business.

From Peace's perspective, the utility mess hit at a particularly bad time: just as he was planning to leave his district in the suburbs south of San Diego and run statewide in 2002 for secretary of state.

Former Assemblywoman Denise Ducheny, a Peace ally and would-be successor to the state Senate seat, said the onetime wunderkind—he'd first been elected to the Assembly in 1982 at age 29—was beginning to think of life after politics.

Wondering Where to Go Now

Although there are no polls on the issue, discussion about how badly the energy controversy had hurt Peace politically became a major topic in local political circles.

Peace fought back by producing a 12-minute documentary distancing himself from the debacle. The video didn't do much to advance his case.

A few weeks before his announcement to terminate his committee for seeking a higher office, Peace explained his ambivalence to public life:

> Every Christmas, Mr. and Mrs. Peace have a conversation to decide if Mrs. Peace is going to let Mr. Peace continue in politics. If that conversation were happening today, I'd have a tough time with it.

Steve Peace wasn't a corrupt political or venal man in any textbook sense. But he was an active player in a legislative system that was institutionally corrupt. In such a system, it's easy to finger-point to the person at the helm—the one pivotal to the workings of a new law—and it's hard not to see that person as anything but part of the system's corruption.

Still, justice seems to have been served. Peace championed a bad law—and he paid for that with his political career. There may have been no way of predicting the fallout of his ideas, or the manner in which deregulation led to nowhere but failure. Being a politician often has its price.

The shame was that Peace didn't use his real work ethic and political skills to promise a better...truer...deregulation package. In other words, he could have been a better politician.

5

While Steve Peace was browbeating his sleepy Sacramento colleagues into passing his Frankenstein's monster of a reform bill, the rest of the energy sector still had some doubt about what California would actually do.

There was a growing consensus among power company executives that the California Plan would mean that days of the vertically integrated utility were over. The old standard would be replaced by three types of business: energy generation companies, which would be competitive and unregulated; transmission companies, which would be heavily regulated; and distribution companies, which would be moderately regulated. Each type of business would have its own issues and agendas.

Some groups were so anxious that they couldn't wait—they started to makes changes in anticipation of the California Plan.

During the summer months of 1996, some groups within the energy sector prepared by doing everything they could to influence Peace and the other state pols negotiating the California bill. Other groups prepared by turning inward—redefining goals and reorganizing operations. Still others prepared by turning outward—breaking off old alliances and looking for new ones.

Some did all three.

Internal Discord at EEI

The Edison Electric Institute, while keeping up the outward appearance of solidarity and focus, roiled with internal discord. At EEI's 64th annual meeting, a surprising number of splinter groups challenged the organization's lobbying efforts. The prospect of deregulation had highlighted the conflicting interests among member companies. And the dividing line was money.

On one side stood utilities that sold power significantly below the national average of 6.91 cents a kilowatt-hour. They believed that their shareholders were best served by an immediate end to the nation's power monopolies. On the other side stood "high-cost" utilities with uncompetitive generating plants that faced potentially huge write-offs in a deregulated environment.

Caught in the middle, EEI sided with the utilities that faced the greatest risks from deregulation—the high-cost operators. This was the approach that EEI had taken with its lobbying in Sacramento; it pressed for stranded cost solutions that its own low-cost members would not have supported.

"[EEI] cannot represent all the companies in the industry if they simply stick to positions that support the high-cost utilities," said an executive from an Illinois utility.

The trade press had been buzzing for months with reports of coalitions and counter-coalitions forming to end-run the EEI. Each coalition pushed a different agenda with regard to the timing and terms of deregulation. And a few high-profile utilities had resigned from the organization—a move that would have been unthinkable five years earlier.

Peace as a Staunch Consumer Advocate

All of this discord had would-be competitors of monopoly utilities squealing with glee.

Part of the reason that the industry was so anxious was that Peace was making the most of the political stance he'd taken as a staunch consumer advocate.

He corralled the California legislature into rejecting the first reform plan put forward by the CPUC—which was described by some media outlets as "a multibillion-dollar plan by utilities, oil companies and steel plants to change the way electricity is sold." It did have the support of PG&E, SoCal Ed and some of California's biggest employers.

Peace described the CPUC plan in terms that simultaneously damned it and reiterated his status as a consumer advocate:

> There is a limited degree of value for residential and small commercial ratepayers in this deal. Until you are able to embrace a proposal that brings a benefit to residential ratepayers in the form of an actual rate decrease…we're not going to get to the other issues.

Peace's remarks came during a hearing before the joint committee working on the transition to a free market for electricity. The committee's hearings were a rare flashpoint of business and politics. For utilities, billions of dollars were at risk—as they lost their monopoly status and were forced to compete against other electricity generators.

Money Talks Like a Politician in California

The overwhelming factor that influenced how California dealt with energy "deregulation" was money. Through 1996, the state's electricity rates were the highest in the nation; this meant that the ability to shop for the best rates among an array of electricity suppliers was a bigger deal for Californians than people in other states.

Was consumer choice really served by any other ideas floating around Sacramento during the summer and fall of 1996?

Peace's plan called for rates to remain frozen for five years, instead of following the decline expected in electricity prices. This would provide extra revenue for the utilities, estimated at $27 billion—which would be used to ease stranded assets.

The three investor-owned utilities would levy a gradually diminishing "competition transition charge" for the first five years of the plan. This meant, effectively, that they would continue to inflate ratepayers' bills by one-third, less the guaranteed 10 percent rate cut.

Even with these financing mechanisms, the shift to a free market would not come overnight. The Peace plan satisfied big corporate energy customers (called "big dogs" by most Sacramento insiders) by phasing in a free marketplace between 1998 and 2002. During that period, utilities would send their electricity to a power exchange, which would in turn sell it to buyers. Each year, more and more buyers would be allowed to break away from the power exchange and buy power from the generator of their choice.

Under the deal, utilities agreed to freeze the rates they charged for electricity for the five years the power exchange was in existence.

A Dangerous Assumption: Prices Will Drop

Of course, Peace's entire plan was based on the assumption that electricity prices would drop.

As Peace planned it, the big dogs could pay off their share of the utilities' stranded costs in five years and then would be free to shop competitively. Residential customers could get an immediate rate reduction and pay off their share over 10 years.

The bill that passed the California legislature on September 1, 1996 was largely disguised as a consumer-protection measure—promising customers a 10 percent cut in rates.

By allowing consumers to ask for outside bids competing with their traditional utility—even if this process would wait five or 10 years—California pols embraced the chaotic logic of the market over the cold logic of bureaucracy.

Everyone involved supported the plan because "the chaotic logic of the market" was supposed to deliver lower prices. This was a given...an

article of faith. Even grizzled veterans of the armed services or state regulatory bureaucracies believed deregulated markets would lead to lower retail prices.

These simple givens summed up the reason that almost every state in the union was considering some kind of electric deregulation. According to a study done for the Competitive Enterprise Institute, if they all went through with it, their consumers could save $24 billion a year.

But nothing could be simple in California. The pols had decided that the people wanted lower electric bills—and that this wish was achievable in a state with substantial surpluses of generating capacity and rates much higher than those of surrounding states. Or so everyone thought.

In September 1996, the lawmakers created a mockery of a market in electric power and labeled it "deregulation." In practice, the law would control supply and demand as tightly as a centrally-planned economy.

Too Much at Once

Encouraged by consumer advocates, environmentalists and the utilities' lobbyists, the lawmakers unanimously enacted a plan that required an Independent System Operator to be so efficient that ratepayers would be guaranteed an immediate 10 percent reduction in electricity bills—plus keep utilities so profitable that they could retire the debts covering stranded costs.

To make matters much worse, the plan required investor-owned utilities to sell most of their generating plants and deal with the new owners on the state-managed spot market.

People in a position to judge the plan—utility executives, credit analysts and bankers—all knew this plan tried to do too many conflicting things at the same time. It sounded like a loser from the start.

The first argument that any advocate of deregulation will make in a debate is that intricate regulatory plans usually fail to anticipate mar-

ket trends correctly. Those that depend on accurate predicting are headed for trouble from the start.

Such was the case in California. Energy demand grew more rapidly than the legislature expected—even in the first year of the plan. Meanwhile, California continued trying to impose restrictions on the operation of fossil fuel plants and letting political extremists drag out the process of awarding permits for new plants and new transmission lines.

In all, the supply of electricity grew more slowly than demand. The regulators could work their controls as actively as possible; but they couldn't prevent an inevitable reckoning. They could only delay it.

The Inner Politics of Peace and Wilson

In the meantime, Peace was working overtime on a plan that would satisfy every interested group and shake the industry up enough to change inevitably.

Although the utilities, big power users, environmentalists and consumer advocates seemed difficult to reconcile...or even to satisfy, the pressure Peace felt to get a bill passed was intense. Among many others, California Governor Pete Wilson let Peace's staffers know that he—Wilson—wanted a deregulation bill he could sign into law.

Wilson, a vain and ambitious politician even by politicians' standards, wanted to run for president in 2000. But Wilson had a number of shortcomings as a national candidate in the Republican Party. One was his reputation as a difference-splitting, non-ideological moderate. This profile worked well in California; but it meant a lack of status among free-market conservatives in the national GOP ranks.

So Wilson, whose term was going to be up in 1998, needed an issue that would establish him with the free marketers. Peace's work on electricity was the closest such bill, so Wilson leapt on it.

Peace and Wilson were members of different parties; but Sacramento—like most state capitols—is a small town. Peace realized that giving Wilson a free-market issue would buy influence for a couple of

years at least. Peace had been good at brokering support for his plan by adjusting it to give people what they wanted. Wilson, who simply wanted something to sign that he could call "deregulation," would be easy to bring aboard.

Wilson had started out in San Diego politics becoming its mayor during a period of rapid growth in the 1970s. He moved up through Congress and the U.S. Senate throughout the 1980s. Through his career, Wilson had cautiously defined a political persona that Californians—and, someday perhaps, Americans—would support. He held forcefully to a few key beliefs, including support of the death penalty and low taxes. Beyond these few boundaries, he was an opportunist—supporting legislative compromises that would alienate the fewest voters.

His move to the California governor's mansion was a calculated effort to round out his resume for a presidential bid. He'd watched the strongest national candidates of recent years—Reagan and Clinton—move from governor to President.

An Illusory Mandatory Rate Cut

Mechanically, one of the most ridiculous elements of the California Plan was the mandatory 10 percent rate reduction for all consumers. Even without this political rebate, the Plan would have been problematic; with it, the plan became impossible.

Cutting rates only reduced the amount of money the utilities could recoup to pay off stranded costs—so, as part of the law, the state agreed to float $7.4 billion in 10-year bonds to pay for the rate cut. (This was in addition to the larger issue of bonds—as high as $28 billion—designed to finance the stranded costs themselves.)

Together, the rate-cut bonds and the stranded cost bonds accounted for about 45 percent of a ratepayer's electricity bill. This debt service was the main reason that ratepayers wouldn't get much out of deregulation—other than a 10 percent rate cut.

In short, the mandatory rate cut was an illusion. It was financed by state-backed bonds, which shifted the ultimate cost of the rate cut back to ratepayers (or, at least, taxpayers) again.

It was like transferring $100 from one savings account to another...and then trying to convince people that you were $100 richer.

For the average consumer, there would be little—if any—savings from the California Plan. As one consumer advocate said, having just read the entire document:

> For it to make any sense, there has to be a significant savings, and I don't see that happening soon. I'll probably just wait for now and avoid all the B.S. that always comes with changing (service).

This shouldn't have been a surprise to anyone who'd read the bill. Large commercial users—industries, factories, school systems, retailers and the like—had always been the focus of the reforms. They were the customers that energy companies in a deregulated market would rush to serve.

Residential customers didn't represent a large enough portion of the market to be worth the sustained marketing effort that would go into selling electricity. So, the absurdly financed 10 percent rate cut was just the price of admission that utilities were asked to pay in order to negotiate directly with the "big dogs."

The fact that the utilities were able to talk the Sacramento pols into having the state cosign for a loan (namely, the bonds) to pay for this admission showed who was influencing the reform process.

Two-Dimensional Economics

Behind all of the lobbying and positioning was the widely held assumption that any form of deregulation would result in lower prices for all electricity consumers. This optimism—which was the closest thing to a theoretical framework that the California Plan had—also suggested that residential customers would benefit indirectly as cost savings created for large commercial users drove all prices down.

The theory behind this optimism—common to most deregulatory efforts—was that competition would produce lower prices and new services that will benefit the economy in general.

And the optimists seemed to have some market momentum on their side. Although California remained more expensive than most states, the cost of electricity throughout the United States had been trending downward for most of the 1990s. The optimists argued that the mere prospect of widespread competition was leading to the savings.

This boast—even if it were true—shows that deregulation advocates tend to see economic issues in two dimensions when they really exist in three.

The downward trending electricity prices of the 1990s had broader effects than merely lowering monthly bills for California residents. They also scared most generators (who, at that time, included the utilities) away from building new power plants.

Some political partisans claimed that the hesitation to build new plants was a reaction to California's difficult environmental protection laws—and that may have been part of the explanation. But the greater truth was a combination of prices and regulatory barriers—together, from a cost-benefit perspective, they made California a risky place to build expensive power plants. So, the state was facing a supply shortage even before Steve Peace brought his plan out of committee.

The Details of a Faulty Plan

AB 1890 passed both the state Assembly and Senate unanimously in the third week of September 1996. In its own language, AB 1890 would "restructure the California electric utility industry" and "implement retail direct access."

The California Plan required:

- divestiture of power plants (except hydro and nuclear) by the investor-owned utilities;

- recovery of stranded costs via a Competition Transition Charge on customer bills until 2002;

- a 10 percent rate reduction (financed by issuing bonds that will be repaid by a charge on customers' bills over a 10-year period);

- a rate freeze at 1996 levels for small and residential customers for the transition period of four years;

- continued energy efficiency and renewable energy programs and low-income customer programs funded by public purpose program charge on customer bills; and

- numerous protections from any detrimental effects of the restructuring aimed at small consumers and utility employees.

The Plan also created an Independent System Operator (ISO) that would operate the transmission system and a Power Exchange (CPX). The CPX would operate a wholesale power market through which investor-owned utilities—but not municipal utilities—would buy the power needed to serve their customers.

At the time, media coverage focused on the choices that would be available under the California Plan and the scheduled rate cuts that would benefit all consumers. Opinion polls at the time indicated extremely high support for the Plan.

What the media coverage at the time didn't emphasize was the schizophrenic nature of the California Plan—that it deregulated the wholesale end of the market but not the retail end. And it didn't mention that the state was already lagging behind in development of new power plants. These two factors, combined, could lead to big price spikes; but no one in a position of authority granted that possibility much credence.

Everyone agreed that deregulation meant lower prices. And everyone assumed—wrongly—that the California Plan was deregulation.

On September 23, 1996, Pete Wilson ambitiously signed AB 1890 into law. At the ceremony, Wilson said:

We've pulled the plug on another outdated monopoly and replaced it with the promise of a new era of competition.

In retrospect, Wilson had no idea what he was signing.

Wilson's Tarnished Reputation

Wilson's lack of ideology caught up with him. His standard practice of mixing a few strong stands with a general tendency to compromise failed him in his last few years as governor. He decided to stand strong against illegal immigration and government benefits for immigrants (legal or not). This decision backfired disastrously, leaving Wilson and his party tarred as anti-Hispanic racists.

His decisions to agree quickly to compromises on other matters lead to the electricity problems and—on a completely separate note—changes to state election laws that weakened the major parties.

In all, the approach that had worked for Wilson as a mayor, congressman and senator failed him as governor. He left office with a damning reputation as both strident and ineffective. He didn't survive the early cuts in the 2000 Presidential race.

Several years after he'd signed AB 1890, Wilson offered his warped perspective on the matter:

> I take credit for having been the driving force to launch deregulation. Do I regret having pushed for deregulation and signing the bill? No, quite the contrary.

In his defense, Wilson made these comments before the worst of the California energy crisis had come to pass. Still, they show a man clueless…and apparently unconcerned…about the harm he helped bring about.

Proposition 9 Tries to Undo Some of 1890

Although September 1996 was the critical month for politicians passing stupid laws, the hilariously bad choices continued in the years leading up to the rolling blackouts of 2001.

Two years after Wilson signed AB 1890 into law, a coalition of consumer advocacy groups succeeded in getting an initiative on the fall 1998 California ballot. Proposition 9 would have substantially un-

done AB 1890, reregulating the state's power systems and reducing consumer rates by as much as 18 percent.

The utilities waged a ruthless and effective campaign against Proposition 9. The main elements of the Sacramento establishment were still supporting the California Plan. Most of the politicians in the state either opposed Proposition 9 or stayed silent on the matter.

And, even though the pricing trends were starting to suggest problems, most of the people in the energy industry still believed the California Plan would allow for more growth and bigger profits. So far, the utilities were doing well and moving profits up from their operating units to their corporate parents—and out to shareholders in the form of dividends and special payments.

No one in the industry wanted any changes. The state's three big investor-owned utilities spent $37 million to defeat the proposition 3 to 1.

A story—perhaps apocryphal—was that in one phone conversation a lobbyist for one of the big three utilities gave a consumer group staffer a county-by-county projection, which turned out to be eerily precise.

Junkets and Laissez-Faire Inaction

As 1998 passed into 1999 and then 2000, a kind of "live for today" ethic took over the management of the utilities. After the downward trend of the 1990s, wholesale energy prices started moving up. California didn't have enough new production online to influence the supply; and AB 1890 had forced them to sell most of their generating plants to energy production specialists like Calpine, Dynergy and Enron.

With storm clouds gathering on the horizon, the utilities turned to power politics to squeeze out as much time as they could to make money and pass it up to their parents. Through 1999 and 2000, CPUC members and select politicians were whisked around the world on "fact-finding" junkets—at least partly paid for by the energy companies—to places like China, England, Italy, Spain and Brazil. These trips allowed industry officials to forge relationships with regulators and policymakers.

Technically, the utilities donated money to the California Foundation on the Environment and the Economy, a nonprofit group that funded the annual two-week trips.

In 1999, Commissioner Carl Wood, a former Edison worker, went to Ireland, Spain and Germany with energy lobbyists and state lawmakers. The trip cost $9,060.

These freebies probably wouldn't have been enough to sway a specific CPUC decision or gather support for a controversial bill working its way through the legislature. But they weren't intended for that; they were simply meant to buy laissez-faire inaction while the economic sun was shining.

Free Markets Don't Mean Lower Prices

One of the signs that the California Plan was a bait-and-switch job on California residents was the relentless emphasis on rate reductions from politicians and industry experts during its early years. Anyone who studies deregulation—even slightly—knows that free markets aren't consistent with guaranteed savings. On average, over long periods of time, free markets usually result in lower prices for consumers. But these lower prices don't follow any pre-arranged schedule. After all, a pre-arranged schedule is basically another form of regulation.

It was nothing more than political spin that AB 1890—with its mandated rate reductions—was called a "deregulation" bill. It wasn't.

Of course, the various opinion polls that showed widespread support for deregulation were just more political cant. Consumers don't care much for deregulation; they care about lower electricity bills. That's why Peace, Wilson and other politicians supported the canard that deregulation and rate reductions could be part of the same process.

It was like the children's story *The Emperor's New Clothes*; no one dared speak the truth—that deregulation can't guarantee specific savings.

Proof of this abuse came a few years after AB 1890 was passed, when the California market was beginning to career off course.

A group organized by UC Berkeley economist David Teece issued a position paper criticizing the governor's efforts to tweak the program with minor fixes "wrongheaded and dangerous." The paper went on to say:

> California is confronting an unprecedented electricity crisis, which threatens to wreck its economy and cause collateral damage throughout the West.... An essential element of the solution is to raise retail prices. Unfortunately, there is no other way out. Either retail prices go up, or the frequency of rolling blackouts will accelerate.

Teece also warned against making the state a major electricity purchaser or having it sign long-term contracts for power—both popular ideas for solutions. It wrote:

> Now is precisely the wrong time for the state to commit to long-term contracts for a large portion of California's electricity needs, since below-market prices now can only come at the expense of above-market consumer prices in years to come.

This paper was the single child pointing out that the Emperor had no clothes. Reaction in Sacramento was harsh…when it was voiced at all.

Teece was making simple observations and suggestions. What he didn't seem to understand about the California Plan was that it had never been a true deregulation plan. It had been a rate-reduction diversion that would allow California utilities to break out of their high cost-structures…at the state's expense.

Bush Keeps Finger Pointed at California

The agent that eventually forced an end to the political game-playing in Sacramento was an unlikely one.

George W. Bush was portrayed, with some accuracy, as a big friend of the energy industry when he ran for President in 2000—the same race Pete Wilson had fancied himself winning. But, when he took office in January 2001, Bush faced the worst parts of the California energy crisis. And he slapped the state into a somewhat reasonable path to reform.

"California has a faulty law on its books. And it needs to correct it," Bush told CNN. He suggested that his administration might relax some environmental regulations to encourage energy production in California—if the state scrapped the half-regulated market.

Bush believed that California was a cautionary tale—a warning that the United States must seek out new supplies of energy and encourage new power generation and transmission.

Other politicians were less constructive in their criticism. Congressional Republicans, who'd seen California turn into one of the nation's most Democratic states, blamed state officials for passing a "greedy" and "unrealistic" law (though they usually failed to mention that the law was approved by a GOP-controlled Assembly and signed by a Republican governor).

One of the most vocal critics, Senator Gordon Smith of Oregon, complained that his state was being set up as "an energy farm" for California.

"I'm afraid that my consumers and my voters are not very sympathetic to California," agreed Senator Larry Craig of Idaho. "We will work in the short term to solve their problems, but if their solutions for the short-term do not address…their long-term needs we will grow less sympathetic and a good deal more angry."

Most of the senators agreed with Bush that the immediate solutions to California's problems lay in Sacramento, not Washington. California politicians had asked Bush to apply federal price caps to the wholesale electricity market. He said no—that would only enable the bad law to continue.

Supporters of price caps—largely the same utilities and big commercial users who'd helped draft AB 1890—argued that the caps could be structured in such a way as to ensure a reasonable profit for generating companies. Bush still said no.

In Sacramento and elsewhere around California, consumer advocates were way past a genteel debate over price caps. They were calling for state ownership of utilities. The movement's motto was "public power now."

But that was too wacky an idea even for California politics.

6

October 1996:
Stranded Costs
Would Always Be
the Problem

California utilities, like others elsewhere, were forced for decades to sign contracts for overpriced power generated by independent generators. In most cases, these overpayments were necessary to assure complete reliability; in a few cases, they were the result of pork-barrel politics. Whatever the case, deregulating the industry required covering these costs somehow.

Once the politics among regulators and the politicians were cleared away, the main economic issue that influenced the California Plan—and all that followed—was stranded costs. This is something that remains true in every place that considers utility deregulation: Stranded costs define the form and fate of the program.

Stranded Costs Defined

What exactly are stranded costs? Even the answer to that question is a matter of some debate.

For the purpose of this book, "stranded costs" means money that regulated electric utilities spent on overpriced (often nuclear) power plants and high-priced, long-term "third-party" contracts to buy power from alternative energy sources like wind, solar and cogeneration.

Why did the utilities sign these stupid deals? Because the politicians and regulators forced them to—and the utilities expected to be reimbursed through the ratepayers over time.

The investments were made with the assumption that these plants would operate cheaply compared to plants powered by fossil fuels, whose prices were expected to increase. The "problem" was that fossil fuel prices *plummeted* in the 1980s. By then, the utilities had already invested an enormous amount of money into alternative sources of energy.

Natural Gas Versus Coal

Electricity generators in the United States had traditionally used either natural gas or coal to run their plants. Natural gas burns cleanly; but the plants that burn it are relatively expensive to build and operate. Coal causes pollution; but the plants that burn it are cheaper and easier to run. Furthermore, natural gas prices tend to spike up and down (somewhat like gasoline prices) while coal prices remain relatively steady.

Through most of the 20th Century, utilities in the U.S. used some combination of burning natural gas and coal. When the cost of fuel spiked up, the utilities suffered the losses in the short term, went to the regulators for permission to increase their rates by a few pennies per person and counted on recouping the short-term losses over several years. This was one of the central elements of the "social contract" between utilities and their customers: The utilities would build the power grids to connect every business or residence and smooth out the spikes in energy costs for consumers. In exchange, the utilities insisted on being protected with monopoly status by state governments. Otherwise, competitors would rush in when profits were high—but rush out when they weren't.

The governments agreed. Through the first half of the 20th Century, electricity was still a new thing in most parts of the country, so the social contract was not a problem.

By the late 1950s, electricity was no longer a new thing for most Americans. People were used to their coffee makers, vacuums and electric typewriters. Issues shifted from getting everyone on the grid to en-

couraging them to use electricity more—for cooking, heating water, air conditioning and entertainment (TVs, stereos, etc.).

With fuel prices relatively cheap, this was a great time to run a utility.

A Move to Clean and Efficient Energy

The early 1970s saw a major energy crisis in the U.S.; fuel costs jumped up. It was also a time of increased political interest in environmental issues; the drive to reduce things like smog and acid rain pretty much began during this decade (photographs that point to the Los Angeles basin's infamous smog problem are often from this decade). The result was a lot of political pressure on regulators—who, in turn, put pressure on utilities—to move toward "clean and efficient" energy. It was the first time that Americans began to think about using less energy. (And, as it turned out, California pioneered a lot of the anti-pollution reforms that helped improve the air and waters.)

When the politicians pressed the regulators for clean and efficient energy, the regulators turned around and pressed the utilities to pursue alternatives like nuclear energy (extremely expensive to build, but clean and a steady fuel source), wind and solar (cheap and clean, but not very efficient) and long-term contracts with for traditional (no effect on pollution, but usually cheap).

The utilities agreed—but insisted that the regulators allow them to recoup these additional investments with higher prices or special rates charged to consumers over long periods. Some of these long periods would last up to 40 years (the average operating life of a nuclear electricity plant). The pols and bureaucrats were so anxious to show voters that they were doing something about the energy crisis that they readily agreed.

In California, the political pressures were particularly strong. As a result, deals were made to satisfy political interests…and electricity rates started rising above the rest of the country. Nuclear plants (San Onofre and Diablo Canyon in Northern California), windmill farms and other massive transmission lines started appearing.

By the time the building spree was over, California utilities had spent nearly $30 billion building power plants that everyone knew from the start cost more to run than simple plants using natural gas or coal. But the utilities had a deal. They could charge more than a free market would allow, in order to cover the higher costs.

If customers were free to jump to other power companies, these long-run costs would be stranded with the leftover customers. And their rates would shoot up. If they abandoned the utility, the stranded costs would be dumped on the utility's owners...or lenders.

Billions in Stranded Costs by 1996

In August 1996, with AB 1890 on the verge of becoming law, the big three investor-owned utilities told state legislators that their stranded costs would be about $29 billion.

The figures came in response to a request from Steve Peace's joint conference committee on restructuring.

PG&E estimated its stranded costs at between $10.5 billion and $14 billion until 2001 under the utility's plan for accelerated depreciation, which would speed up the paying off of debt by 14 years. It said nuclear stranded costs and the cost of paying third-party power generators each would cost about $5.5 billion.

SoCal Ed estimated its stranded costs at about $13.5 billion by 2005, but would not provide the rationale behind this calculation.

SDG&E estimated its costs at $1.35 billion. About $760 million of its stranded costs were attributable to the San Onofre nuclear plant and $450 million to long-term contracts with third-party suppliers.

All three estimates sparked heated debate.

One of the most difficult aspects of dealing with stranded costs is that almost no one can agree how they should be defined.

How do you determine the value of nuclear power plants and other utility assets? Such items aren't usually sold on the open market, so it's tough to get a reliable idea of their fair market value. Some economists argued that the only way to deal with the question was to force utility companies to sell the plants—and find out what they would bring on the open market.

Shrouded in accounting tricks like depreciation and industry-specific tax breaks, the real size and weight of stranded costs of even a single utility are impossible to calculate. And, because utilities have every reason to exaggerate stranded costs (to justify their continued higher rates), their numbers are usually best treated with healthy skepticism.

(What should be counted as stranded cost? Only investments in bricks-and-mortar assets…or other costs, too?)

With AB 1890 pending, SoCal Ed tried to expand the definition of stranded costs. It argued that the cost of restructuring—related worker severance and retraining—was part of its total stranded cost figure.

SoCal Ed shamelessly insisted that the CPUC "resolve utility employee concerns" about restructuring and protect them from "hardships" that may fall on the workforce during a market shakeout.

A SoCal Ed spokeswoman confirmed that the utility saw employees themselves as an asset whose costs may be "stranded" during the restructuring process, similar to costs of physical generating plants.

This kind of argument had convinced some industry experts to doubt any distinction between what is and isn't a stranded cost or any prudently incurred investment under regulation, which would likely become a severe financial burden in a deregulated power market.

A Mixed Number of Years for Recovery

In its final form, AB 1890 allowed for full recovery of stranded costs over several years. It did this in a complex way, dividing stranded costs into three different categories—and spreading the costs among shareholders and consumers. There was no exact date of full recov-

ery; different elements of the plan allowed for a different pathway to recover certain costs. Still, the overall schedule remained fuzzy.

The three categories listed in AB 1890 that would divide the stranded costs were:

1) the costs of building nuclear plants and other generation facilities, which were recovered through a so-called competition transition charge;

2) the continuing operating cost of nuclear plants, which retail customers in California would subsidize with a 3.8-cent charge for each kilowatt-hour on their monthly bills;

3) costs associated with long-term contracts to purchase power under the Public Utilities Regulatory Policy Act of 1978; if power under these contracts costs more than the market price, the difference could be collected from distribution customers.

The competitive transition charges, or CTCs, meant that residential customers would get the mandatory 10 percent rate decreases dictated by law—but that would be all. Even if market forces drove energy prices lower, the CTCs would bring them back up again.

Only when the stranded costs were paid down, would households see prices fall. Which utilities would thrive in the new environment? The winners would be low-cost generators, with small stranded costs, whose managements cut operating expenses and expand markets.

California policymakers defended the price controls by pointing out that if a company like SoCal Ed were forced to absorb all of its stranded costs ($5 billion-plus from nuclear power plant investments and $7 billion-plus from mandated contracts to buy alternative energy) energy and financial markets around the country would be destabilized. And this instability would work against lower prices generally.

Prudent, Verifiable and Legitimate

The Edison Electric Institute, a Washington trade group representing the nation's investor-owned utilities, issued a statement saying that re-

covering stranded costs "represents sound public policy and provides for an equitable transition to competition." EEI noted that key policymakers supported stranded-cost recovery.

While the coalition said other deregulated industries weren't permitted to recover stranded costs, EEI listed several instances where deregulated industries—such as railroads, airlines, trucking and telecommunications—were allowed to recover transition costs, or the costs related to these industries having to go from a regulated to a deregulated status.

But the stranded costs issue struck many consumers as a scam. Consumer advocacy groups latched onto the issue as a solid tool for turning people against deregulation.

Perhaps that should be "against AB1890." Again, it's hard to call any system, with as many price controls as this one had, "deregulation."

The FERC had paved the way for this complex stranded costs recovery several months before AB 1890 passed, when it allowed deregulated utilities to levy "exit fees" on consumers who leave their local power companies.

The FERC's order required wholesale electricity customers to pay the exit fee to utilities with whom they had contracts to cover the utilities' costs of building plants and installing transmission lines. In short, the FERC allowed utilities to recover the stranded costs, as long as a utility demonstrated that the costs were "prudent, verifiable and legitimate."

The commission wrote:

> Once the existing uneconomic assets and contracts are behind us, all wholesale customers will be better able to shop for power and reap long-term benefits of competitive supply markets.

The FERC preferred direct assignment over other forms of cost recovery on a wholesale level because it transferred costs to those who caused utilities to incur them, though the recovery of retail stranded

costs would ultimately be up to public utility commissions in each state. The FERC would allow stranded costs to be paid through a one-time, lump-sum exit fee or an amortized lump-sum exit fee. The same charge could also be paid as a surcharge on the customer's electricity transmission rate (the "long distance" part of a deregulated electricity bill).

Immediately after the FERC decision, the CPUC voted to require electricity users who stopped buying power from PG&E and the other investor-owned utilities to pay the CTCs (competitive transition charges). The commissioners said the fee would prevent big industrial users from "evading their share of the costs of shifting" to a competitive market in electric power.

The cost was supposed to cut both ways. CTCs would be borne by customers of both the longtime monopolies and their new competitors to reimburse utilities for investments in plants and equipment that haven't been paid off.

Bailing Out on Ratepayers

Nationally, how big was this problem? Utilities and others estimated that stranded costs could be between $200 billion and $300 billion. An estimate by Moody's Investors Service pegged the total at $135 billion; the tab was about $88 billion, according to DRI/McGraw-Hill, a consulting firm.

Whatever the final number, the "stop the bail-out" coalition said reimbursing the industry for bad investments "would constitute one of the largest transfers of wealth in U.S. history."

It didn't take long for this proposition to start bringing out detractors. Groups ranging from the conservative Heritage Foundation to the environmentalist Friends of the Earth joined forces to fight attempts by the utility industry to recover the costs. Shareholders, not consumers, should pay for utilities' "unsound" investments, said Adam Thierer, economic policy fellow at the Heritage Foundation. He estimated that the industry's investments cost electricity consumers from $200 billion to $300 billion—between 1990 and 1995 alone.

Citizens for a Sound Economy, Friends of the Earth and Public Citizen all sent representatives to a press conference to announce a concerted campaign to fight utilities that sought to pass along costs to consumers. They planned to publish a series of reports to lawmakers on how much economic damage the scheme would do.

These partisans claimed that California ratepayers would "fork over" $28 billion if regulators certified "a bail-out plan" passed by state lawmakers.

The utilities didn't like these statements. *They* rolled out spokesmen to vilify the notion that they should absorb the costs of investments made when they were operating under government control. To do so, they argued, would leave them at a disadvantage to companies entering the marketplace for the first time.

Moreover, rates would go down even if stranded costs were passed along to ratepayers, said one energy regulator in an Atlantic Coast state. "You need a compromise that treats both ratepayers and shareholders fairly."

The Mechanics of Recovering Those Costs

California's $28 billion stranded cost figure was the best estimate experts could come up with that takes into account all the so-called "uneconomic value" at SoCal Ed, PG&E and SDG&E.

AB1890 only seemed to worsen the impact of the bad decisions. For example, regulators wouldn't know how wasteful a PG&E power plant was until they knew what the market price of power was after other generating companies sold their electricity. If the PG&E plant produced power at a cost of 5 cents a kilowatt-hour but other power generating companies start selling electricity at 2.4 cents, then that PG&E plant would be uncompetitive to the tune of the difference.

The legislators who voted unanimously for AB1890 agreed that the utilities could recover their stranded costs from ratepayers. But there was one catch. Lawmakers gave the California investor-owned utilities only four years to do so.

So, the utilities' lawyers and lobbyists had to use every advantage they could find—or manufacture—to recover their stranded costs.

First, there was the 10 percent rate reduction. That might not have sounded like a way to pay off stranded costs, but it was. A group of state agencies were floating $7.4 billion in bonds and using the proceeds to finance the rate cut and pay off some of the Big Three's stranded costs. There was an alchemy of financial elements to this deal; with $7.4 billion in stranded costs paid off, even the wackiest utility would have substantially stronger books and qualify for lower interest-rate credit.

By paying less interest to bondholders, ratepayers would wind up spending less to pay off the bonds. The CPUC—which supported the deals—calculated the savings at about $562 million.

For the first four years of the plan, utility rates were frozen at 1995 levels. The rate freeze is important because it allowed...at least initially...the utilities to keep rates at an artificially high level. (Electricity generating costs were actually going down due to reduced natural gas prices, low inflation, the expiration of expensive power contracts and improving efficiencies.) Thus the utilities, while collecting the same amount from ratepayers for four years, were expected to have lower costs. That meant higher profits to recoup stranded costs.

Another way the utilities could pay off stranded costs was by selling off assets. AB 1890 required them to sell off some of their power plants in order to foster competition among generators.

If they were getting more than book value for their plants, the extra money would go to pay off stranded costs.

Depreciating Expensive Assets

When a company invests in a capital asset such as a power plant, it depreciates, or deducts, a portion of the cost every year from revenues. This reduces the company's earnings, taxes and the book value of the asset.

The San Onofre Nuclear Generating Station, owned by SoCal Ed and SDG&E, was a great example of how stranded costs accumulated.

In 1996, SoCal Ed had about $2 billion still invested in the plant; SDG&E had about $700 million. Under the old regulations, they were able to charge those costs—plus a built-in profit of 10 percent a year—to customers for at least 10 more years.

For several years, the utilities and the CPUC had been discovering deals that would lower the amounts being passed on to consumers. But the talks hadn't gone very far.

AB 1890 added a whole new timeframe to the discussion. The utilities only had four years to restructure San Onofre's cost structure— or it was going to be producing electricity at an uneconomic cost.

For their part, opponents of the continued operation of San Onofre argue that the non-competitive plant should simply be mothballed and written off. They argue that ratepayers would be forced to pay more than $5 billion in above-market electricity prices over the next eight years under the terms of the original settlement.

The same factors affected the Diablo Canyon nuclear power plant, which belonged to PG&E. PG&E claimed that, if it went to a free market right away, it would not be able to charge enough to recover the costs of Diablo Canyon and still be competitive. PG&E had been planning to spread out the depreciation of the nuclear power plant's remaining $3.8 billion book value through the year 2016. After AB 1890 became law, it only had a few years to charge as much as it could for Diablo Canyon electricity.

The Price Tag on Non-Nuclear Debt

Not surprisingly, the utilities favoring increased competition tended to be those with the fewest stranded assets. SDG&E, which had always been smaller and more frugal than its larger siblings, didn't have anywhere near the problem with stranded costs that SoCal Ed and PG&E did. So, it didn't have to make as many desperate arguments.

In late 1997, the CPUC announced that a recent audit found the utilities as having $4.03 billion in outstanding costs that would hamper their ability to compete as the state's electricity market opened up to competition.

The audit was part of the effort to determine the costs the utilities would be allowed to pass on to consumers as part of deregulation.

PG&E had the biggest burden, with $2.8 billion in these non-nuclear transition costs, followed by SoCal Ed with $1.1 billion, and SDG&E with $130 million.

It was the first time a price tag had been attached to the utilities' non-nuclear general debt. And these numbers added to the array of other values that had been thrown around the previous years. Everyone seemed to come up with different values for stranded costs, non-stranded costs and the general debt that these utility companies would have in the face of deregulation.

The utilities would be allowed to recover this non-nuclear debt through the CTC surcharges on monthly bills between January 1998 and December 2001. The CTCs had to cover both nuclear and non-nuclear stranded costs—so they were large. On most bills, they would account for nearly three-quarters of the total. The actual cost of generating electricity was only about 25 percent of the total.

The CTCs were a key part of the California Plan. Lawmakers said the charge would help the state's utilities recover the massive investments they had been required to make under regulation—and gird them to compete with nimble out-of-state competitors.

And the CTCs were inescapable: A San Diego ratepayer who switched to an out-of-state supplier would still be forced to contribute to pay off SDG&E's $130 million in stranded costs.

The utilities pointed out that passing on stranded costs was nothing new. What was new was the ticking clock.

No Sound Economics

The decision to allow the recovery of stranded costs was a political one. Economic analysis couldn't be used to make the call on whether the costs should be recovered because, if they were not recovered, there would be no economic efficiency effect.

Typically, however, the politicians tried one more time to make an economic case for allowing the recovery of stranded costs—albeit not a very strong one. In its 1996 Economic Report of the President, the President's Council of Economic Advisers wrote:

> ...there is an important difference between regulated and unregulated markets. Unregulated firms bear the risk of stranded costs but are entitled to high profits if things go unexpectedly well. In contrast, utilities have been limited to regulated rates, intended to yield no more than a fair return on their investments. If competition were unexpectedly allowed, utilities would be exposed to low returns without having had the chance to reap the full expected returns in good times, thus denying them the return promised to induce the initial investment.

> A strong case therefore can be made for allowing utilities to recover stranded costs where those costs arise from after-the-fact mistakes or changes in regulatory philosophy toward competition, as long as the investments were initially authorized by regulators.

To Recap

Stranded costs were the trickiest part of AB 1890—and would be in any deregulation program. In the case of the California Plan, because the question of deregulation was so poorly defined from the start, the question of how to handle the stranded costs also became blurry. Who would pay? And how much could the electric industry encourage continued development of cleaner sources of energy with such a high price tag?

Utilities insisted that they were guaranteed recovery of investments incurred under the regulated regime.

Most of the states that had moved toward retail electricity competition provided utilities the right to recover their investments, typically through state-supported bonds funded through a surcharge attached to electricity sales.

John W. Rowe, president of New England Electric System, wrote:

> Those who advocate less than full recovery [of stranded costs] should support full deregulation. Utilities like mine eagerly would embrace the opportunity to have an upside on our wires under full deregulation, which would offset the downside for our generators.

He hit on a critical point, some parties wanted partial recovery of stranded costs…and limited or qualified deregulation. This wasn't deregulation at all. But it was the California Plan.

7

December 1996:
The Mechanics
Under the CPX
and the ISO

From the earliest stages, the *how* of the California Plan was problematic. Talking about "deregulation" in political terms is one thing—moving an industry that's used to specific instruction about how to operate to a free market is another.

Restructuring Under the CPUC Plan

When the CPUC first suggested the move to deregulation (which it wisely called "restructuring"), it offered a plan that pulverized the traditional top-to-bottom order of the regulated electricity business. Among the key points of the CPUC plan:

- Creation of a wholesale power pool into which generators would sell electricity; prices would be set hourly, or half-hourly, in a spot market similar to a stock exchange. The investor-owned utilities would be required to sell power into this exchange; others could participate voluntarily. The others might include municipal utilities, retail groups and individual customers.

- Creation of an Independent System Operator, or ISO, which would operate the transmission lines that would remain the property of the utilities. The ISO would control the system, scheduling the delivery of power and ensuring that demand was met. Technically, the independent system operator would be separate from the power exchange.

- Utilities would retain control of their distribution systems for customers who choose to remain utility customers. Customers who bought special computerized meters would be able to take advantage of lower-cost power generated during off-peak periods, such as in the middle of the night.

- Customers would have three choices. Buy power from the utility in much the same manner as before; enter into so-called "hedging contracts" for power at a set price with anyone willing to assume the risk for price fluctuations on the wholesale level; or buy power through a direct contract with a power generator (so-called "direct access").

- All rates would include a public-goods charge to finance research and energy-efficiency programs.

When the debate moved into Steve Peace's committees, the politicians used the first two CPUC suggestions as the basis for the state-mandated plan. AB 1890 created the California Power Exchange (CPX) and the California Independent System Operator (ISO), which would play important roles in managing the "free" competition.

When the bill passed into law, the CPX took the form that the CPUC had initially suggested. December 1996 saw the first steps toward turning the CPX and ISO from theoretical ideas into actual state agencies.

The CPX and the ISO System

The California Plan required that investor-owned utilities buy all of their power on a day-to-day basis from the CPX. The CPX had been designed to prevent secret deals between investor-owned utilities and wholesalers. But the pricing system used by the CPX was screwy. Prices for each hour were set at the highest accepted bid; this was intended to prevent collusion—but all it did was invite bidding games and drive up prices. Because most transactions on the exchange's trading floor were for the next day, the market was extremely volatile and subject to price spikes. And the public had no access to the identities of those buying and selling power.

The theory was that the exchange would provide the most transparent prices, since every buyer and seller had to operate through it. Then, if there were any shortfalls or surpluses in the state, the ISO would make up the difference.

In this way—and others—the ISO ended up charged with doing even more than the CPUC first imagined.

Responsible for assuring a stable source of electricity, the ISO could buy electricity directly from generators, side-stepping the CPX. It also had the authority to initiate emergency alerts and, if necessary, rolling blackouts. By law, the utilities and power generators had to comply with ISO directives.

Electricity was moved throughout the state on a 26,000-mile network of power lines carrying current at up to 500,000 volts. The electricity was then "stepped down" in a series of substations and transformers for different levels of use in industry and in homes.

From its high-tech headquarters in Folsom—which reminded some observers of a NASA mission control center—the ISO essentially acted as a traffic cop for the system of high-voltage lines and stations that made up California's power grid.

ISO workers monitored the flow of electrons. To avoid blackouts, they could make sudden purchases of electricity without regard to price.

Keep that "without regard to price" thing in mind.

The CPX and ISO system was supposed to protect consumers from the power-plant construction fiascoes and long-term contracts that had led to high-priced power over long periods.

So, the process of selling electricity was supposed to follow a rigidly-structured plan:

1) Consumers would buy electricity from the power-generating sources or through private power companies—though all electricity was sent through the state-managed grid and power

lines. So, it was unlikely that the specific watts of power sent to a given house were the same watts of power sent by the provider.

2) Power companies submit schedules via computer of how much power they will need the next day and match that to a power source. As long as each power company provided as much energy as its customers took out, the system would balance.

3) The CPX, acting like a commodities market, controlled the flow of power, matching supply with demand and setting the market rate for electricity each day.

4) The ISO coordinated the flow of electricity through the state's complex power grid. It ensured that all power companies have fair access to move electricity. It also made up for any short-falls or other imbalances.

Setting up the deregulation framework was expected to cost at least $315 million. That included $130 million for software and computer systems and hiring more than 300 workers to run the new market. The target date for switching to the CPX/ISO system was January 1, 1998.

The Beltway Bandits Back the ISO Alliance

In late 1996 and early 1997, private sector technology companies vied for some of the $315 million.

Two big information technology companies—ABB Power T&D Co. and Perot Systems Corp.—joined forces to create the ISO Alliance, a limited liability company designed to make the new marketplace happen. Both ABB and Perot were typical "Beltway Bandits," private-sector bureaucracies-for-hire that specialized in making ambitious government programs run.

A few months after Pete Wilson signed AB 1890 into law, the ISO Alliance announced that it had been awarded a contract worth approximately $48 million to implement "one of the most critical new business systems that the State of California will need to operate its electricity markets under deregulation."

The new systems would help the state administer the bidding, scheduling, settlement and transport of electricity. As the ISO Alliance noted:

> In essence, they will function for electricity a lot like an air traffic control system does for airplanes. The systems will allow the state to effectively schedule and manage the usage of its power grid to ensure reliable service, much in the same way an air traffic control system coordinates take off and landings at airports to maintain order and manage congestion.

The ISO Alliance would provide a Web-based public interface for the scheduling coordinators, the scheduling infrastructure and scheduling applications modules (bidding, publishing and power applications), and oversee the procurement of settlements, billing and credit and administration modules. All systems would run on Digital Equipment Corp.'s 64-bit Alpha computers.

In the breathless language of corporate information technology, this all sounded impressive. But one thing seemed strange: For a system that was supposed to deregulate an industry, the terms "control," "schedule," "order," "manage" and "oversee" were occurring an awful lot.

The Gaming of Energy Providers

Wilson, Peace and the other lawmakers had a kind of superstitious faith that—left to its own devices—competition within the CPX would drive prices down. They seemed willfully ignorant of the highest hourly bid problem. Also, some industry insiders pointed out that the two-agency setup encouraged generators to offer less power to the CPX and wait until the last minute to sell power to the ISO, which out of desperation would have to pay higher prices.

Since the demand predictions of the day-ahead market were almost always wrong—almost always too low—a lot of power would end up being purchased by the ISO. As a result, power generators would make more money selling their electricity to the ISO, which would become a way to bypass the competitive price set by the electronic auctioning on the CPX.

Indeed, the two agencies turned out to be rivals; and the more power that generators reserved to sell through the ISO, the less was available through the regular market. At the same time, the utilities were not allowed to make their own arrangements to purchase power or shop for lower prices.

The results took about a year to manifest themselves. The summer of 1999 offered the first proof that the conflicts between the CPX and ISO—and the gaming of energy providers—had turned the California Plan into a mockery of deregulation.

Jockeying for Power

The ISO was designed to handle about 5 percent of the electricity consumed in California; but, at times during the summer of 1999, the volume was 30 percent. As predicted, power generators often offered less power than needed, so that they could submit higher bids later when the ISO is forced to pay stiffer prices for emergency power.

On certain hot days (when ACs around the state were running on full blast), ISO workers watched the state's power grid strain. With only hours to spare before undersupply caused blackouts, the ISO traders—self-described "grid jockeys"—would desperately call power generators as far way as British Columbia and Arizona to buy electricity.

In the summer of 1999, such purchases cost as much as $1 million a day. Utility executives insisted that the problem was too much regulation. Instead of a free market, they were having to deal with the worst of several sets of regulations.

Generators insisted that they weren't to blame for the mad scramble. They were just playing by the mad rules. Utilities, for their part, often played the game by ordering less power from the CPX than they needed—for fear that big orders would drive up the overall market price to prohibitive levels.

The CPUC refused to let utilities sign long-term contracts with energy providers in part to guarantee the CPX enough business to survive.

This was bureaucracy run amok—government regulators insisting that for-profit companies use inefficient government services...in order to sustain those inefficient services.

ISO Becomes the De Facto Energy Exchange

By the summer of 2000, the system was clearly heading for melt-down. The daily tab for the ISO's hourly energy purchases was reaching as high as $100 million. The supply of energy on the CPX remained thinner than ordinary needs would suggest.

In May, wholesale prices on the CPX rose for the first time above what the utilities were allowed to charge customers. In a free market, the utilities would have simply raised the prices they charged customers; in a regulated market, wholesale suppliers would have been ordered to freeze their prices just below retail.

The California Plan was neither...so an impossible market condition continued—in fact, got worse—all summer.

The mandatory participation by investor-owned utilities gave the CPX an unusual nature. In short, it was highly sensitive to product supply. When there was a surplus of electricity on the market, the CPX would effectively control costs, because the sellers would tend to underbid each other to unload their energy to reluctant but captive buyers. When there was a shortage, the market would respond excessively. The utilities, with nowhere else to go, would bid prices up wildly.

And that's exactly what was happening during the summer of 2000. Prices went through the roof; and the CPX became a joke. The ISO, in its role as the maker of emergency balance, had become the de facto energy exchange. Its grid jockeys were trained to buy power at any price.

As the CPX sputtered and crashed, a growing number of critics began to sneer at the exchange's problems. One of these critics was sitting on the CPUC. Richard Bilas, a CPUC commissioner, said he never liked the idea of mandating a single exchange in which investor-

owned utilities had to buy their power. He said the CPX/ISO system reminded him of the old Soviet Union, "where leaders declared that they were going to move to a market economy and then appointed a group of central planners" to figure out how to do so.

In July, SoCal Ed and PG&E filed emergency requests with the CPUC seeking authority to sign longer-term contracts directly with generators to protect themselves from the CPX's surging prices. The case was bolstered by a report that Governor Gray Davis (who succeeded Pete Wilson) had requested from the CPUC and the Electricity Oversight Board; the report clearly said the state's spot markets were exacerbating price spiking and that contracts between the utilities and power generators were needed.

In August 2000, the CPUC relented and relaxed the rules that prohibited investor-owned utilities from entering into contracts directly with power generators. The new rules stated that utilities could sign contracts that lasted until the end of 2005. The utilities had been trying for years to get this kind of latitude—as long as the deal met a loose definition of *reasonableness*.

Some state economists feared that signing five-year contracts at $50 per megawatt hour could harm the economy. But, as the utilities noted, at least the new deals would keep the light on.

Or so everyone thought.

Long-Term Contracts Aren't the Panacea

The relaxed rules eased the market pressures for a few months. But they were too little too late to solve the big problems. Trouble came quickly again in December 2000.

That month, the FERC ordered the ISO board to be replaced by seven independent members. The old board had been a large (26 members) group drawn heavily from utilities and for-profit generation companies. In fact, it had been chaired by Jan Smutny-Jones, execu-

tive director of the Independent Energy Producers Association, a trade association whose members generated about 24,000 megawatts of power in California.

"There are people on the ISO governing board who have a direct financial interest in the policies they set," said Severin Borenstein, a professor of business administration and public policy at UC Berkeley.

The Feds said that an overhaul of the ISO's management would be an important step toward a solution. They implied that the foxes had been put in charge of the electricity hen house—but even that cliche didn't do justice to the extent of the problem. The CPX/ISO system was inefficient to its core. Oversight wasn't the problem; the system was unworkable.

All sides agreed to the cosmetic change. In the words of PG&E's official statement on the matter, "to restore public confidence, we agree with state and federal officials that the ISO board needs to be independent."

In exchange for this change, the FERC invoked a federal order requiring out-of-state power generators to supply electricity to California. U.S. Energy Secretary Bill Richardson issued the order, specifically, because a faulty transmission line had resulted in power reserves of less than 5 percent of capacity in California. (Power reserves of less than 5 percent make accidental blackouts dangerously likely.)

The federal order required power generators in other states to sell excess juice to California—but it didn't regulate *how much* they could charge. An analogy: The government forces banks to give people credit cards...but doesn't tell the banks what credit limits to apply or interest rates to charge.

This was not a good idea. It turned the out-of-state suppliers into loan sharks. Wholesale electricity prices spiked up over $150 a megawatt hour (just a few months earlier, people had been worried about $50).

As part of its order, the FERC also said that it wouldn't renew the tariff that allowed CPX to operate. This effectively killed the CPX.

For nearly three years, the CPX had been the place where SoCal Ed and PG&E had purchased most of their power. But, when the price of that power rose above what the utilities could charge customers, everything fell apart quickly. The utilities defaulted on payments to suppliers; and suppliers stayed away because they feared they would not get paid. Near the end, the CPX suspended SoCal Ed and PG&E because they weren't paying their bills; the suspension was, essentially suicide.

In its final days, the CPX traded little more than 30,000 megawatt hours a day—down from more than 800,000 megawatt hours at its peak.

Squeezing Every Last Megawatt

Such was the environment that led up to the worst blackouts of the California energy crisis. When times got tough, people panicked.

The failure of the CPX and wounding of the ISO created a mentality among energy suppliers and utilities that was a lot like a run on a bank. The ISO—having lost what little power it ever had to control costs— soon couldn't get enough power bids into its markets even at $250 a megawatt hour to meet grid demands.

Power generators had a perverse incentive to drive wholesale prices over $250 a megawatt hour. According to the Plan, once that threshold was exceeded, the state's single-price auction would be jettisoned and bidders would receive whatever prices they individually sought (though they'd have to file reports justifying their bids).

All the while, the order from Richardson at the Department of Energy meant that power suppliers were selling electricity directly to SoCal Ed and PG&E at astronomical prices. Remember, the order forced them to sell...pricing issues were much less rigidly limited.

Mark Ryland, a state assemblyman from Southern California, echoed the sentiments of most of the Sacramento pols in blaming the regulators:

> The CPUC apparently believed that it could correctly predict what the market for electricity would be, and that the CPUC should not only continue its regulation of the utility companies, but should also attempt to regulate the market itself. …The final blow came with the adoption of a pricing theory which, combined with these other measures, virtually insured that electricity costs would spiral upward.

Governor Davis lashed out publicly against the ISO, saying that he believed it was failing to do everything it could to find enough electricity when supplies were tight. He whined that, when the ISO declared power alerts, wholesale prices rose and helped generators who served on its board.

ISO chief executive Terry Winter responded in deed rather than words. Frustrated that his grid jockeys were consumed with endless haggling for spare megawatts to avoid daily blackouts, Winter went behind Davis's back and appealed to federal regulators to lift the price caps on electricity sold in California.

The feds agreed; but the move backfired.

Banks Say No to Loans, Blackouts Begin

Davis and his staff had been quietly negotiating with two investment banks to guarantee loans to ensure the state's utility companies remained solvent, buying more time. Once the banks heard the price caps had been lifted, exposing them to unknowable losses, they backed away from the loans.

In January 2001, the system was still spiraling toward failure. The ISO was issuing dire warnings just about every day, through the first days of the month. Its grid jockeys did an admirable job of finding odd lots of electricity…regardless of price.

Jim Detmers, the managing director of operations for the ISO, told the media that he was convinced blackouts would be unavoidable because the power supply was running a reserve of only 2 percent more than current demand. Part of the problem was that a number of generators were scheduled to shut down in December and January for maintenance—since the winter months were usually marked by lower demand.

Another problem: A winter storm had caused a near shutdown of PG&E's Diablo Canyon nuclear power plant. The storm had caused waves of nearly 20 feet and forced massive beds of kelp into the big pipes that drew in seawater for cooling the plant. Operators had to cut output to 20 percent—a loss of some 2,000 megawatts for the state.

Despite all of this, the ISO traders managed to find enough energy to avoid blackouts. But even their skills had limits.

On January 18, the ISO ordered its first intentional blackouts. A cold snap in the Northwest had increased demand there and reduced the amount of energy that California could import. "We seem to be running out of magic," said ISO spokesman Patrick Dorinson.

The blackout only lasted a few hours—by mid-afternoon, the ISO grid jockeys had found excess supply from a supplier in British Columbia. Nevertheless, the first step in a problematic pattern had begun.

The immediate cause of the blackout was a relatively short segment of the statewide power grid called Path 15, a 90-mile link between the Central Valley towns of Los Banos and Coalinga where capacity problems imperiled the entire state system.

It is at that point that the SoCal Ed and PG&E systems connect. Like a two-lane freeway tunnel suddenly taking on three lanes of bumper-to-bumper traffic at rush hour, Path 15 proved inadequate to the task of delivering electricity from occasionally watt-rich Southern California to often watt-starved Northern California.

Looking to the Courts for Rescue

With blackouts a reality, the state's role in electricity purchasing continued to grow. Many suppliers balked at doing business with the ISO over fear that their payments could be caught up in utility bankruptcies. Soon, the state was buying between one-third and one-half of the electricity that wasn't either generated by SoCal Ed and PG&E or already pledged to them under long-term contracts.

And the ISO was still buying the rest, at costs that were averaging $400 to $500 a megawatt hour.

In early February, SoCal Ed and PG&E defaulted on nearly all of a $684 million bill due to the ISO. As a result, the ISO told power sellers that they would get just 2 percent of the money owed them by the utilities for electricity sold during the previous several months.

The ISO had been able to require generators to sell surplus power because of the federal emergency orders. When the new year, however, brought a new President to Washington, the new administration did not renew the emergency authority after February 6.

The ISO asked electricity suppliers to commit in writing to serving California if called on in an emergency, regardless of whether they were being paid. This didn't go over well. Houston-based Reliant Energy, which supplied about 5 percent of California's power at that point, responded by filing documents in federal court, arguing that the ISO could not force a company to sell electricity to balance its grid without assurances that the company would be paid.

Reliant said the ISO owed it $260 million for past electricity purchases; it said it would sell power to California's Department of Water Resources—because the state's own credit backed those sales. But it didn't want to sell any more power to the ISO.

A series of court rulings followed. One Sacramento federal judge ordered Reliant and two other companies to continue providing emergency power to California for at least five more days.

The ISO sought a preliminary injunction—an order of open-ended duration—forcing the suppliers to sell it electricity. The suppliers countersued the ISO and the Department of Water Resources, claiming that the ISO and DWR were working together to enable the state to acquire power below market price.

Several weeks later, a different federal court ordered the power companies and the ISO to agree to a standstill while the FERC decided how money and debts would be allocated among exchange members.

About the same time the utilities were stiffing the ISO on their energy bills, the governor asked San Francisco attorney and political fixer Michael Kahn to take over the reins at the ISO—whose future and financial wherewithal were very much in doubt. Conflicting rescue plans were being proffered in Sacramento and Washington as well.

"We walked into a maelstrom," Kahn told his four colleagues on the ISO board, all newly appointed by the governor—as part of the deal with the FERC—in the midst of the ongoing crisis.

Although few doubted Kahn's legal skill or good intentions, the fact that he and most of the other new ISO board members lacked experience dealing with utilities was viewed as a major negative.

The best chance that the ISO had at a sustained future was in a utility bail-out plan being suggested by some Sacramento pols.

The ISO Seeks Grid System

Throughout the whole crisis, most of the actual electricity grid—the physical power lines, towers and substations—had remained the property of SoCal Ed and PG&E. The ISO had been in charge of using the system…but never owned it.

California State Senate President John Burton, another San Francisco Democrat, had championed the idea of buying the grid from the utilities. In exchange for the pink slip to the power lines, SoCal Ed and PG&E would be absolved of all the debts they owed the ISO.

For weeks, Davis and other lawmakers had debated which utility assets they would take in exchange for helping SoCal Ed and PG&E out of their financial straits. Ideas ranged from an equity stake in the utilities to control of their hydroelectric plants and transmission lines.

Burton settled on the transmission lines—worth between $3 billion and $4 billion—as a way of solving the growing crisis.

Some energy experts say it had been a mistake for the utilities to sell their power plants in the late 1990s and that it would be a mistake to sell the 26,000-miles transmission system in 2001.

PG&E officials were against selling the lines—noting that they generated nearly $400 million in annual revenue for the company and cost roughly one-fourth of that to maintain. But Democratic leaders insisted that, if the utilities expected a bail-out, they'd have to give up something.

Also, owning the grid would give the restructured ISO something profitable to do. At long last, the agency would have both the authority and the means to…regulate the California electricity market.

The ISO's problems were always tied closely to the shabby theoretical framework that had stood behind AB 1890. Since the Plan itself was badly thought-out, the mission of its primary agency was always in doubt.

Doug Heller, assistant director of the Foundation for Consumer and Taxpayer Rights, said Wilson, Davis, Peace and the other politicians had set up the ISO the way it was because "it and the regulators were so transfixed with the idea of the free market that they ignored the tremendous leverage they were handing over to the private energy companies."

He added, "Because the ISO has a mandate to keep the lights on and procure power when the utilities are short, [it] used its mandate as justification for gouging consumers."

Why didn't someone in a position of power stop this before it became a crisis? Several players could have (Gray Davis, any one of the big generators, the CPUC, the FERC…). But everyone involved took a legalistic stand—AB 1890 didn't give *them* control of the system.

Ironically, the person who forced a reckoning on the California market was the new president, George W. Bush. This was ironic because Bush had been criticized as beholden to Big Energy, which had donated heavily to his campaign.

Politicians and bureaucrats are rarely forceful enough…or effective enough…to change the directives of industries. In the era of the superstar CEO, it might be reasonable to expect the head guys at Duke Energy, Reliant Energy or Enron to step up and say loudly that the California Plan was dysfunctional to its core. (To its credit, Reliant Energy did try to point out the problem—but it didn't make the kind of bold, public step required.) The truth was that these guys stood around whistling, because they were making big paper profits. Effective managers, maybe—but not visionary market leaders.

8

September 1997:
The Marketing Blitz
That Never
Quite Happened

Through most of the months after Pete Wilson signed AB 1890 into law, the popular press focused on two aspects of the Plan:

1) that "deregulation" would, simply by occurring, result in lower prices; and

2) that the restructured electricity market would result in scores of aggressive marketing companies taking over the consumer end of the business.

Neither assumption came to pass. The first didn't because the particulars of the California Plan meant a partial deregulation instead of a truly free market. The second didn't because...well, it was never likely to happen in the first place.

Still, it remains impressive how completely and consistently newspaper columnists and pundits believed that energy companies would use the marketing tactics of long-distance telephone services to sell power.

The Salesmen of Energy

The summer and fall of 1997 looked forward to the January 1998 launch of deregulated electricity markets. Talking heads couldn't resist the easy prediction that mimicking the long-distance telephone sector, electric and gas suppliers were preparing a major marketing blitz. These self-proclaimed experts carried on about the direct mail

that would choke mailboxes, cold calls that would interrupt dinners and salespeople who would set out on foot...selling door to door.

The energy marketers were usually middlemen. They'd contract with a generator to buy power...and then sell it to consumers, delivering across newly open power lines. In a few cases, the energy marketers were new subsidiaries of utilities or generators.

Some companies would offer a fixed price for a year's service; others would offer lower basic rates, with surcharges for heavy use. Some companies would push convenience, bundling electric and gas service in a single package; others would sweeten their offers with freebies—memberships in discount buying clubs or warranties on appliances.

The law enforcement community suspected there would be some problems...but it wasn't sure precisely where they'd crop up.

Wisconsin Attorney General James Doyle, head of the National Association of Attorneys General, said that his group was forming a task force to monitor the practices of electricity providers as they enter the deregulated market.

Doyle said consumers would need to be wary of misleading ads about rates, hidden fees, illegal switching and various multilevel marketing schemes. He pointed out that the Internet was chock-full of patently bogus pyramid schemes involving the sale of electricity.

It's Not About the Residential Customers

All of this focus on consumer marketing missed the real impact of the California Plan on energy companies' marketing strategies. The energy marketers didn't care very much about residential accounts; they focused their marketing efforts on business accounts—and larger ones, at that.

Big commercial users accounted for as much as two-thirds of the total energy used in California. Clearly, the power companies' notions of marketing went beyond hiring telemarketers to call people during dinner.

Enron quickly signed on with the Northern California Power Agency, a cooperative of 11 cities that included Palo Alto and Santa Clara. The Texas energy giant agreed to act as a broker for the members' surplus power and find low-cost power in the open market for the co-op to buy.

New Energy Ventures Inc., a Los Angeles-based company started by former SoCal Ed President Michael R. Peevey, quickly signed up more than 60 clients, including Rand Corp., office buildings owned by investor Samuel Zell, the Robinsons-May Department Stores Co. and several private colleges.

Survey Points to Consumer Ignorance

California utility executives said they weren't worried about these corporate co-ops; they felt there was little risk that they'd lose millions of consumers. SDG&E, in the midst of a multibillion-dollar merger with Southern California Gas Co., said it was more focused on how to use the $1.2 billion it was going to save over 10 years, as a result of the merger. Officials at both SoCal Ed and PG&E claimed that most deregulated power would be purchased through the newly established CPX. Besides, the promises made by the aggressive marketers were often silly exaggerations.

At least that last statement seemed to be true.

Released in the fall of 1997, a Utility Consumers Action Network survey of more than 130 registered new electricity providers found only about two dozen offering electricity to small businesses and residential consumers.

The survey criticized the companies that planned to market to residential accounts—concluding that most of these companies were promising more than they could likely deliver and that the viable offers weren't as valuable as they might seem.

Specifically, the survey found about eight companies making claims that exceeded reasonably expected benefits or provided extremely

vague terms. Several of the companies making the most unrealistic offers turned out to be multilevel marketing companies—as interested in recruiting participants as in actually selling electricity.

One of the main issues that the survey discovered was that most of the marketing companies were counting on people to be uninformed about the details of the California Plan. The most immediate consumer benefit of the Plan was the 10 percent rate decrease for all California customers—yet most of the residential marketing materials that the survey reviewed claimed that 10 percent savings as their own.

The survey pointed out:

> Only the power generation part of the business is being deregulated, however, which accounts for 25 to 30 percent of a typical consumer bill. Other charges, including those for distribution and transmission, will continue to be collected by local utility companies, which will retain their monopolies in power grids even as they exit the business of producing power.

Understanding that only the power generation business would be open to competition was key to a question that consumer advocates said should be asked of any company soliciting new electricity business: Is the suggested savings a reduction in the cost of the electrical commodity, or is it a reduction of the entire electricity bill?

The six companies (including Enron, Christian Energy Electric Co. and GTC) making offers that the survey found credible were offering savings of 2 to 4 percent below the CPX price for electricity. Companies offering bigger savings had significant credibility problems.

The survey also concluded that Green Mountain Energy Resources and Enron—both of whom were marketing "green" or environmentally safe power—had the best consumer literature. It said Green Mountain literature was "thorough and understandable," while Enron offered a fair amount of detail.

So, at least in California, Enron scored well on truth in advertising counts. Go figure.

Enron's Free Electricity Offer

Enron—which had run generic, brand-building ads during the January 1997 Super Bowl—was one of the few big power companies that stated from the beginning that it intended to market to residential and small business consumers in California. One of Enron's marketing pitches was that it would offer "two free weeks" of electricity to people who switched over.

This was, technically, a valid offer. But—as the Utility Consumer Action Network had found—it counted on consumers to be fairly uninformed about the details.

Enron's two-free-weeks offer didn't mean half off of a monthly bill. It only applied to two weeks of electricity; in most cases, the actual electricity charge was less than a quarter of a total monthly bill. Transmission, distribution, capital investment and other charges usually made up the rest. The fees charged to repay stranded costs were a large part of these *other* expenses.

People weren't used to looking so hard at their electricity bills. Before the California Plan was passed, the monthly bills that residents received combined the various charges into a single rate. But the new rules required the utilities (who'd still do most of the billing) to send "unbundled" bills that itemized the various charges.

Marketers like Enron were counting on residential consumers to be so confused by the itemized bills that they didn't pay attention to specifics—and just jumped to the bottom to see what they owed.

The pundits should have talked more about this aspect of marketing abuse; it's where more problems lay. In fact, it also applied to the public's reaction to the California Plan in general—*everyone* skipped the details.

Adjusting the Schedule

The predictions about Wild West marketing in California were based on two things: the accelerated opening of the residential market in

California and the experiences that Pennsylvania and New Hampshire had already had with their versions of deregulation.

The California Plan had originally set January 2002 for the opening of residential accounts to deregulated electrical service. The idea was that power companies could focus on larger business accounts first— and iron out any bugs in the system on these big, sophisticated buyers before moving to Joe and Jane Sixpack.

However, some politicians and consumer advocates were never satisfied with that schedule. They believed—correctly—that the power companies only cared about the big business accounts, anyway. If they could focus on those first, they might never get around to the small residential accounts.

So, in early 1997, the CPUC adjusted the schedule. It made January 1, 1998 the opening for all electricity sales in California—to commercial and residential accounts alike.

Pennsylvania had also passed an electricity deregulation bill; it was to take effect about a year ahead of the California Plan. Generally, the Pennsylvania plan was less complicated than California's; it would be hard not to be.

Anyway, the Pennsylvania plan was closer to true deregulation. (And Pennsylvania wasn't alone. New Hampshire had launched a small pilot program earlier, too.) But it had resulted in some pushy marketing. Power companies there had taken out full-page newspaper ads promising "Cool Savings!" and "Free Power!" They'd hired telemarketers to call during dinner. They'd sent out a lot of junk mail, rented billboards and bought TV and radio commercials.

Pennsylvania politicians had whisked the huge deregulation plan into law with almost no public debate, quietly attaching it to a tax bill. Activists tied up the plan in court, until the state's biggest utilities agreed to a compromise guaranteeing all of its customers rate cuts of 10 percent through 2000, followed by smaller cuts.

As in California, the politicians and consumer activists had been lulled into complacency by promises of rate cuts.

And, as in California, the big power companies were focusing more on wholesale business than on retail consumer business. Enron offered to write Peco (Pennsylvania's largest utility) a $5.5 billion check for its stranded costs in order to reach Peco's big commercial accounts. This was a daring move—of course, given Enron's later problems, it may have been simple insanity. In any event, Peco's chief executive officer accused Enron of "prostituting the regulatory process" and consumer groups labeled the plan dead on arrival.

Mean Marketing Takes Shape

The New Hampshire program resulted in even more aggressive selling. The state allowed about 3 percent of its customer base, chosen by lottery, to pick their own electricity suppliers. So, the state's dominant utility, Public Service Co. of New Hampshire (PSNH) faced off against some 30 competitors, both local and from out-of-state.

The sales pitches included pledges never to rely on nuclear fuel, discounts for conservation and free insulation. One company, Unitil Corp., even tried to make an issue of out-of-state ownership. "Unitil," its ads proclaimed, "a New Hampshire company working for New Hampshire."

Xenergy Inc., a unit of New York State Electric & Gas Corp., planned to provide energy-management services to as many as 2,500 customers as part of a partnership with in-state start-up Freedom Energy. The services included free insulation, remote controls to turn on kitchen appliances and itemized, online billing services that would "show the customer exactly how much it costs to run the basement fridge."

Freedom Energy also took a grassroots approach to marketing, printing up direct mail and arranging for seminars, ads and telephone sales that emphasized its familiarity with New Hampshire and its staying power.

California-based Working Assets rewarded all comers with the promise that 1 percent of monthly sales would go to an environmental group of their choice. Working Assets also offered an electricity portfolio that did not rely on nuclear power or on power generated from the controversial Hydro-Quebec Canadian system that critics claimed had been environmentally destructive.

Granite State Electric's television commercials promised "clean, responsible energy at tremendous savings." Green Mountain Energy Resources promised that its power was generated from "clean, renewable resources that create almost no air emissions."

Central Vermont Public Service handed out 500 free kilowatt-hours. One company dangled an $18 bird feeder; other lures ranged from shower heads to blue spruce seedlings.

Of course, the inducement that New Hampshirites wanted to hear most about was price. Consumers in the state paid about 11.3 cents per kilowatt-hour for electricity, among the highest rates in the country and well above the national average of 6.9 cents.

The state's regulators predicted that the deregulation program could produce immediate rate cuts of about 10 percent—a figure that seems to bubble up in just about every deregulation plan. Companies like Enron hinted they could cut even more.

Deregulation's popularity among consumers rested on such promises.

Peddling Power and Using the Media

Back in California, the media focused on the slightly self-referential story of how energy companies were using the media to market themselves.

Although the start date of deregulated sales was January 1998, the CPUC allowed registered companies to begin advertising and marketing on July 1, 1997.

This was presumptuous, since many major technical questions related to the start date remained unanswered. But the selling had begun. For a $100 filing fee, any company wanting to take on state utility giants like SoCal Ed and PG&E could get in on the ground floor, peddling power to the state's 10 million customers. The CPUC estimated that as many as 1,000 new suppliers had expressed interest in providing services in California—though only about 100 had paid the $100 fee and registered. (Many decided that the opportunities weren't sufficient to warrant the effort—and some found that it wasn't as easy as it had sounded to get into even the marketing end of the business.)

Companies like Enron and Georgia-based Southern Co. were among the first to market their brands statewide in television and newspaper advertisements. They avoided specifics entirely—focusing instead on getting their names into people's minds.

California Power & Light Co., a start-up company based near San Diego and designed explicitly to take advantage of deregulation, was marketing to residential customers. It promised savings of up to 20 percent over 1997 prices. The Christian Energy Electrical Co., based in Lynwood, California, focused its efforts on signing up churches by offering to match mission contributions made by church members.

Green Mountain Energy Resources offered discounts to customers who ride bikes or car pool to work, buy low-energy light bulbs or quit smoking.

Some of the busiest sellers were unregulated marketing subsidiaries of the state's largest utilities. Edison International, the parent company of SoCal Ed, created Edison Source as its marketer; PG&E Corp. created PG&E Energy Services. These marketers advised residential customers to avoid the confusion of the new market and simply take the 10 percent reduction that was mandated for all customers of the major utilities.

Power Marketers and Who's Who

The first rounds of energy marketing also pressed the CPUC to reconsider some of its regulations. Importantly, the CPUC decided to allow power generators perform customer services—including billing and meter reading.

This was something that the utilities had fought, arguing that it would allow outside providers to "cherry pick" the more affluent customers. Their real interest was in keeping at least the service end of the business as their own.

The CPUC agreed to set up regulations to prevent cherry-picking…and eventually agreed to delay the customer service change indefinitely.

To protect consumers from "slamming," the practice of moving customers to new producers without their knowledge, the CPUC required all prospective outside power providers to register with the state. Also, a series of educational programs under CPUC supervision began in September 1997 to inform customers what they have to gain or lose by buying power from marketers.

But the most controversial decision had to do with names.

The CPUC barred companies affiliated with the investor-owned utilities from using their parent companies' brand names and logos. This caused a strong response from SoCal Ed and PG&E.

According to M. William Brier, a vice president of Edison Electric Institute:

> It's as though the government forbids you to use your own name and people in your community could not recognize you. Californians are going to be confronted by a dizzying array of energy companies that can't be easily compared to their current electricity provider who is forbidden by this order to market their services effectively. Customers lose under [the CPUC] order… .

Nearly three out of four Californians polled also said it was important to know which company was actually supplying their electric power. The EEI claimed that the CPUC order would obscure this information.

But the most useful information for making energy buying decisions was nowhere to be found in the California residential electricity market. People who really wanted to save money would have to pay a lot closer attention to their usage patterns.

Much like long-distance calling (and here the comparison did work), electricity prices were cheaper in the off-peak hours—"easily" half the cost of peak rates, predicted Stanford University economist Frank Wolak. Consumers who could take advantage of that, via changed habits or timed appliances, would benefit the most.

Opportunistic Middlemen Emerge

Enron, which had started out as a natural-gas distributor in Texas, was the biggest and most aggressive of the breed. (Although it had moved into power generation, too, with several acquisitions.) Enron was everywhere that deregulation took place, making big offers and generally convincing people that it was an omnipresent industry powerhouse.

Some industry analysts were duly mau-maued. They talked about branding being key in the electricity business…and predicted that consumer-focused companies like Wal-Mart or Mastercard could exploit their brand-name recognition to market electricity. The gurus also predicted that power companies might add services like programming customers' appliances to run only at hours when rates are lowest. Or they might fit air conditioners with computer chips that alert users when a unit was using too much energy and needed adjustment.

And, in the unified marketing theory that intrigued everyone, the experts talked about bundling electricity with cable-TV and long-distance phone service.

These ideas appealed to people like Richard C. Green Jr. Green was CEO of Missouri-based UtiliCorp United, a utility that was moving aggressively into new markets—both geographically and industrially. Green said: "Our corporate idols are McDonald's, Southwest Airlines and Wal-Mart because they are fun, convenient and low cost."

Green bought into the branding theory. UtiliCorp concocted a brand name—EnergyOne—for its off-price service. And, following the lead of the New Hampshire providers, UtiliCorp advertised the new service on a hot air balloon.

Other utilities hired brand managers and marketers away from companies like Procter & Gamble to help build their brands.

Branding, Building ID and Shunting Blame

Do consumers really care what brand of electricity they use? One often-cited analogy compares deregulated electricity to gasoline. They are both commodities that everyone needs and buys according to price. Branding is a far secondary factor—and usually only works in connection with services like financing (gas company credit cards) or car maintenance.

In other words, no. Consumers don't care about branding of commodities. This explained the other big trend in the electricity business—which had been going on steadily through 1996 and 1997: Mergers. The combination of companies like SDG&E and SoCal Gas on the West Coast or Baltimore Gas and Potomac Electric on the East Coast were all about driving down the production cost of electricity in order to offer lower rates to consumers.

As one industry veteran said, "There's no marketing plan better than 3.5 cents a kilowatt-hour."

Generators like Wisconsin Power & Light focused on this strategy. The utility was one of the lowest-cost power generators in the country, with an average of 2.6 cents per kilowatt-hour. CEO Erroll Davis was so keen to get deregulation over and done with that he had little sympathy for his colleagues who were hamstrung by high costs.

Davis argued that utilities had enjoyed mandated rate increases to cover the cost of all kinds of dumb investments—just about every expense could be added to the rate base charged to consumers. There was no incentive to economize. On the contrary, he said:

> Your new desk goes into the rate base. This is the only industry I've ever seen where you can increase your profits by redecorating your office.

In this regard, few people envied SoCal Ed head John Bryson. (Technically, Bryson was CEO of Edison International, SoCal Ed's corporate parent.) He was stuck with some very high costs, including a nuclear power plant that produced electricity for more than 7 cents a kilowatt-hour. He also had to carry a large number of high-cost contracts with a number of small companies that make electricity from "renewable" sources like wind power.

SoCal Ed estimated that, in a truly free market, the price of electricity could fall to between 3 and 5 cents a kilowatt-hour. At that price, between $5 billion and $10 billion of Edison International's assets, including the nuclear plant and the wind-power contracts, would be money losers. So, SoCal Ed had little reason to complain about the complexity and inefficiency of the California Plan. It was hiding a lot of problems behind that complexity.

But SoCal Ed noticed how much advertising other energy companies were doing—to build brand identity, etc. In a crafty move, it bought ad time, too; the main difference was that SoCal Ed's ads—full pages in California newspapers and TV or radio spots—talked more about what it wasn't (namely, at fault for any problems) than what it was for.

This ended up being the largest and most consistent marketing campaign of the California energy market during the late 1990s and early 2000s. Long after the scrappy marketers had abandoned California as too hopelessly dysfunctional to allow profits, entrenched giants like SoCal Ed and PG&E kept promoting the theme that it wasn't their fault.

Whether the campaign worked was difficult to determine. Consumers who saw or heard the ads usually got the message: Electricity prices were going up, and customers didn't have much say in the matter.

Those same customers didn't necessarily believe the utilities were guilt-less.

Bryson, whose lobbyists had shaped AB 1890, appeared in the TV ads, somberly telling consumers that the newly deregulated market is catastrophically broken. "Without prompt action from state officials," Bryson said, "Edison will soon be unable to purchase power for our customers, and power interruptions will occur."

That kind of statement seemed to be prepping the public for coming rate hikes. With some level of rate hike appearing imminent, the company focused on influencing public opinion and insulating itself from blame.

In this effort, the best approach is usually to get a specific message out to customers before they have a chance to form negative opinions. Changing someone's opinion after they've formed it is much more difficult.

The somber Bryson ads ran in Southern California—its base of operations—and Sacramento. SoCal Ed doesn't sell electricity in Sacramento. In the state capitol, it had always been a buyer.

9

November 1997:
All the Tricky
Bonds

While the popular media repeated lazy clichés about energy market-
ing meaning more dinner-time telemarketing calls, a lot of real action
took place in the financial markets. One of the trickiest parts of AB
1890 was how it used various kinds of bonds—state-guaranteed and
other—to finance various kinds of activities.

Why Public-Owned Utilities Didn't Dereg

Bonds and other forms of corporate borrowing issued by govern-
ment-owned utilities have traditionally been safe places to invest money.
A cornerstone of conservative financial investing, they are usually tax
exempt and essentially (if not literally) guaranteed because local gov-
ernments either own or control the utilities doing the borrowing. As a
result, the bonds pay relatively little interest.

Most utility bond investors are small fry. By one estimate, 75 percent
of the owners of these bonds are individuals and only 25 percent of
those have incomes exceeding $100,000. They invest in the things for
reliable, tax-free returns.

One of the reasons that AB 1890 left government-owned utilities like
the Los Angeles Department of Water and Power (LA DWP) alone
was that deregulating those utilities could cause major financial prob-
lems. It could—in some cases—endanger the tax-free status of their
bonds. And, for some bonds, the loss of tax advantages could be
retroactive.

This meant that, if a public utility like the LA DWP were forced into free-market competition with for-profit energy companies, its bond-holders could end up owing the Internal Revenue Service taxes on what they assumed was tax-free income.

This would cause huge problems…and political fallout.

When California was restructuring its electricity market, the LA DWP and several other government-owned utilities asked the IRS to clear up the rules for how bonds would be treated in a deregulating environment. The Feds didn't do this, so the state simply excluded the government-owned utilities from the Plan.

At the time, the LA DWP thought this was a bad thing.

But government-owned utilities aren't the only electricity companies that issue bonds. State-regulated utilities like SoCal Ed and PG&E do; loosely regulated generators like Enron, Dynergy and Duke Power do, too. These companies usually aren't backed by state guarantees—at least not directly—when they issue bonds. Many people, however, don't make that distinction.

Historically, the heavy regulations that controlled the electricity business worked like a government guarantee of borrowing that companies like SoCal Ed and PG&E did. Because the utilities' prices and profits were fixed, their ability to repay corporate debt was easy to predict. And, if they got in serious financial trouble, the regulators would be there to broker solutions.

What's more, states sometimes set up agencies that broker or partially guarantee loans and financing for companies in heavily regulated industries. Think of the programs like student loans or Small Business Administration financing—but for huge companies. The financing may be a private-sector, for-profit transaction; but the government helps make it happen.

Income from investor-owned utility bonds was taxable. But the bonds were considered safe, so they paid relatively little.

The big difference was that the California Plan could do things to these bonds…things that ultimately made them less safe.

In fact, the California Plan was quite inventive about how it used the not-so-safe-anymore bonds.

Grandfathering In Tax-Free Bonds

Periodically, government-owned utilities asked the federal government to allow tax-free bonds to be grandfathered in—that is, granted permanent tax-free status. Most government-owned utilities had covenants with bondholders that required them to take "every reasonable measure" to prevent loss of the bonds' tax exemption.

In exchange, some government-owned utilities even offered to make their future bonds taxable. They just want protection from retroactive changes.

The investor-owned utilities fought these proposals vigorously. They considered the threat of retroactive taxes a good barrier that kept government-owned utilities out of the competitive arena. One Washington D.C. lobbyist for the investor-owned companies went as far as saying: "They want to rearrange the deck chairs ahead of deregulation so they can build new capacity on the backs of the American taxpayers."

An interesting choice of words: "rearrange the deck chairs." It's usually part of the phrase "rearrange the deck chairs on the Titanic"— meaning futile activity as disaster looms. Did this tasseled loafer realize how accurate his choice in words was?

The investor-owned utilities had a strong political ally in Alaska Senator Frank Murkowski, a Republican who was chairman of the Senate Energy and Natural Resources Committee during the late 1990s. In 1997, U.S. Treasury Secretary Robert Rubin was considering allowing government-owned utilities like the LA DWP to grandfather in the tax-free status of their old bonds. This would reverse the so-called "private-use rules" established by federal regulation, which limited

the amount of power that could be sold under contract to a private entity from a power plant or transmission line financed with tax-exempt debt.

Government-owned utilities like the LA DWP wanted the private-use rules relaxed, arguing that they treated transmission lines like a toll road while deregulation made them a freeway. If Rubin relaxed the private-use rules, the LA DWP could have joined the ISO.

But Murkowski warned Rubin against changing the legislative intention of the 1986 federal law on utility bond tax status by "administrative fiat." Any reconsideration of that law should be done by Congress, Murkowski said.

In short, Murkowski believed that it was fundamentally unfair to allow utilities that had built generating plants and transmission lines with tax-free money to go head-to-head against companies that don't have the funding advantage.

In a round-about way, the dust-up between Murkowski and Rubin got back to the question of how to treat stranded costs. It also highlighted another relevant issue: the different power dynamics between politicians and bureaucrats. In Washington, a few strongly worded warnings from a powerful politician like Murkwoski froze the bureaucratic moves of Rubin's Treasury Department. In Sacramento, politicians like Steve Peace and Pete Wilson took their instructions on energy policy from the bureaucrats at the CPUC.

As Rubin deferred to Murkowski's warnings, it was little wonder that the federal bureaucrats at the Treasury Department and the FERC (a unit of the Commerce Department) envied their equal numbers in California. In the context of setting energy deregulation policy, politicians took instruction from the CPUC. California was a bureaucrat's paradise.

Bonds Pay for Rate Reduction

So, the LA DWP and the smaller government-owned utilities in California were out of the Plan, the ISO and the tax ramifications of AB

1890. The investor-owned utilities like SoCal Ed and PG&E considered this a tactical victory; so did generators like Enron, Dynergy and Duke.

AB 1890 had made some specific requirements about rate cuts for consumers...and allowed some general guidelines for how these rate cuts would be financed. On the federal level, the Treasury Department had—by not acting—given the California Plan final regulatory say. So, in late 1997, the California bureaucrats and energy companies put the details of the financing in place.

The first and most important rate cut required by the California Plan was an immediate 10 percent reduction, due when wholesale competition started on January 1, 1998.

By the industry's reckoning, a 10 percent rate reduction for all affected consumers would cost between $5 billion and $10 billion in lost utility revenue over the four-year life span of the cuts. According to AB 1890, this up-to-$10 billion bill would be paid for with bonds issued by the utilities through the state-administered California Infrastructure and Economic Development Bank.

At $10 billion, this would be more than double any previous state bond issued in California history. And, since—strictly speaking—the bonds were utility bonds, they weren't subject to voter approval. It was a very slick deal. (And the "$10 billion" in the title of this book.)

The bonds would be paid off over 10 years from special charges added to ratepayers' monthly bills. If that seems like circular logic, congratulations for paying attention.

The value of the immediate 10 percent rate cut had been exaggerated from the start. It was a short-term reduction financed by a smaller, long-term increase. It was like refinancing a four-year loan into a 10-year loan in order to lower the monthly payment. It reduces the monthly payment...but you'll be paying interest for a long time...and ultimately, more money.

Securitizing Utilities

Steve Peace insisted that ratepayers would benefit from the rate-re-
duction bonds, which he described as "state sanctioned." It was cer-
tainly true that—for the short run—the California Plan would lower
the monthly rates paid by customers of SoCal Ed, PG&E and SDG&E.
Peace pointed out that the de facto 10-year refinance was a low inter-
est rate, so it would be a net benefit to consumers.

But the rate reduction wasn't a rebate; it wasn't sending cash back to
ratepayers. It was merely reducing monthly bills by 10 percent. So,
where was the $10 billion raised by the bonds actually going?

To the utilities.

The 10 percent they were giving up from revenues came from the
portion of electricity bills intended to recoup stranded costs. The $10
billion bond offering would give them a big chunk of cash to retire
these costs—as well as the cost of short-term energy purchases—
instead of several years of higher cash flow.

This process is called *securitization* and it's very popular among in-
vestment banking types. Through the 1980s and 1990s, Wall Street
used securitization to repackage everything from home mortgages to
student loans.

The idea is to change the way companies account for assets and cer-
tain kinds of debts in their financial reports. PG&E still owed hundreds
of millions of dollars that it had borrowed to build the Diablo Canyon
nuclear power plant. Securitization allowed it to pay back that money
and redefine Diablo Canyon as a securitized asset.

In the real world, this was simply a form of refinancing—like refinanc-
ing the mortgage on a house. Because the new bonds were "state
sanctioned," PG&E was getting a better interest rate than it could on
its own.

Plus, there was another, more obscure benefit.

In the world of financial accounting, PG&E was able to make itself look much stronger by removing the old debt from its balance sheets and reclassifying Diablo Canyon as a different kind of asset.

The securitization required complex financial formulas to predict future revenue streams from the related assets; it also required legislation that made the arrangement irrevocable. That was one of the things that AB 1890 provided through the use of the state infrastructure bank.

What, exactly, was this bank?

The California Infrastructure and Economic Development Bank had been establish by earlier legislation (*not* AB 1890) as a mechanism for financing development of companies doing business in state regulated industries. It wasn't a bank in any traditional sense; it existed to extend the state's strong borrowing power to private-sector companies—in this case investor-owned utilities like SoCal Ed and PG&E. If those utilities floated the bonds themselves to pay off a portion of the stranded costs, they'd have to pay bondholders a higher interest rate, as high as 9.6 or even 11 percent.

The state-sanctioned bonds don't cost as much, only 6.4 percent because of their AAA-rating. The bonds provided up to $3.5 billion for PG&E; $3 billion for SoCal Ed; and $800 million for SDG&E

The resolution approving the issuance of bonds had been approved by the Infrastructure bank's three-member board.

The Bonds Hit the Market and Sell Through

In late 1997, as the bond package was working its way toward the financial markets, a confederation of consumer advocacy groups filed a lawsuit to prevent the utility bonds from being issued and the rate reduction from being made.

Three consumer organizations called the reduction an illusion and said the bonds' finance charges would probably exceed any savings. But

the court, without comment, refused to interfere with the bond sale or order the CPUC to reconsider the issue.

So, the state was free to float up to $10 billion in bonds to be repaid by residential and small commercial customers over 10 years. At the same time, businesses and consumers would have to pay off the balance of about $28 billion in stranded costs. Even with the bond issue, a Competition Transition Charge (CTC) accounting for about 45 cents of every retail dollar would go toward recouping stranded costs.

Again, for clarity, this 45 cents was separate from monies required to repay the rate reduction. But consumer advocates were more concerned with the investment banks that surrounded the big bond issue than the bonds themselves.

The investment banks' compensation had yet to be worked out; but they were clearly going to make millions of dollars because of the issue's unprecedented size. Still, state officials insisted that the relationships didn't represent a conflict of interest because the firms were only being asked to help the state with bonds, not assist in a transaction that would directly benefit energy companies or utilities.

All that the state bureaucrats said was probably true. But the critics' concern wasn't so much about outright fraud or abuse. It was about the subtle, incremental corruption of an expanding old-boy network that bottle-necked access to capital.

Why would this be a problem?

Again, the damage was from subtle influence. To guarantee that monthly bills were big enough to cover the bonds—which was essential if Wall Street would bless the plan—rate increases might be necessary. This would erode the consumer focus of the Plan.

Another problematic goal that Wall Street would seek: long-term contracts with power sellers, lowering and steadying the price paid for over a third of the utilities' electricity supplies. But AB 1890 called for utilities to stick to the CPX's daily markets.

So, from even before the bonds were offered, the investment bankers were already taking fees and pressuring for consumer-unfriendly modifications.

The rate-reduction bonds sold quickly in early 1998. They bubbled along without any problems until the energy crisis hit its full, fetid bloom three years later.

Different Kinds of Bonds

The biggest worry that consumers had in late 2000 and early 2001 was the solvency of the investor-owned utilities. The utilities were more concerned about the tens of millions they were spending on the spot market every day than the tens of millions a month they were spending on bond service.

In the midst of the crisis, California's new governor, Gray Davis, proposed a utility bail-out that would take the form of a state purchase of the transmission lines that—though administered by the ISO—remained the property of the utilities. This deal would require more state-backed bonds, although no one was exactly sure what form they would take.

The purchase of the transmission lines would cost as much as $9 billion.

In addition to this amount, the state was considering so-called "revenue bonds" that would raise more money with which the utilities could recoup tens of millions that they'd been spending every day. This could mean another $10 billion to $12 billion.

The bonds would technically be corporate bonds, but they would be paid off with yet another surcharge on utility bills—a so-called "dedicated rate component"—which would also have to be guaranteed by the state.

SoCal Ed and PG&E's corporate bonds had been downgraded to the point that they slid into junk bond status. But both companies had also issued tax-exempt municipal bonds on an emergency basis through

the California Pollution Control Financing Authority. Most of those bonds were insured when they were issued. Though the bonds continue to pay interest, experts' opinions vary about the safety of these holdings.

Because all the bonds contemplated as part of the state's rescue plan were revenue bonds not backed by the state, but by money from ratepayers, they would not increase California's outstanding tax-supported debt.

Nonetheless, California would support the sale of all the bonds with the exception of the utilities' debt bonds. This time, the bond offering was going to involve a figure as high as $20 billion. And the investment banks were gathering around state offices again.

More than half of the 26 financial firms hired to oversee the bond issue reported business ties to utilities and energy companies—including many of those at the center of the state's power crisis.

The companies disclosed the relationships when they applied to state Treasurer Phil Angelides for participation in the lucrative bond deal. Angelides said he didn't believe the ties posed any actual conflicts of interest.

Instead, he said, the disclosures reflected the market reality of a large bond issue—that the only people with any real know-how in the highly technical undertaking are already in the business.

This is a common remark that state financing agencies make: In order to retain the best talent for getting the bonds sold, they have to pay fees to firms that have possibly conflicting relationships. "They have relationships all over the place. We wanted to know because we wanted to be fully informed," Angelides said. "The reality is, we need people who have financial strength, depth and breadth, and the fact is that any company that has that has numerous relationships."

J.P. Morgan Securities, the firm chosen to serve as senior manager on the bond issue, said in its application that it did not believe it had any

conflicts from other business deals. Morgan still listed numerous recent and ongoing business relationships it had with private utilities and energy companies that had earned it tens of millions in fees. The work ranged from mergers and acquisition assistance for SoCal Ed and PG&E to debt underwriting for generators Reliant Energy and Enron.

Many Conflicts of Interest

Lehman Brothers, one of the five firms chosen to be co-senior managers, disclosed that it had been an advisor to energy giant Dynergy on a recent multi-billion dollar merger with Illinova Corp. Lehman was also serving as an advisor to another major energy supplier, AES Corp., on a $3 billion acquisition of Midwest utility holding company Ipalco Enterprises. Furthermore, Lehman had served as an advisor to PG&E on its $840 million sale of Texas Natural Gas.

Morgan Stanley Dean Witter, one of the firms chosen to help sell the bonds, listed hundreds of business relationships with utilities and energy companies. Most involved debt and equity offerings for public power agencies.

To guarantee the bonds—thus making them attractive on the market—the bill would have authorized the state Public Utilities Commission to raise rates.

Rates for residential customers, however, could go up only if they exceed their "baseline," or minimum power allowance, by more than 30 percent.

SoCal Ed calculated that about half of its 4.3 million customers would face a rate increase under the plan unless they reduced energy consumption. That provision was roundly attacked by some consumer advocates, who called it a bail-out of the utilities.

Still pending were proposals to rescue utilities from the huge spot-market debts they had accumulated through the end of 2000. These debts were the reason that energy companies had stopped selling them electricity…and the reason there was a lot of loose talk about bankruptcy.

With legislative approval, the utilities could again issue bonds backed by the state to recoup their power-buying costs. And, again, these bonds would carry a lower interest rate than what the utilities would normally pay. The bonds could be paid off through fees charged to the private generating companies that move power through utility-owned (and soon state-owned) lines.

Bond-Based Bail-Out as Balance Sheet Games

Consumer advocates said they would again fight the bond plan because the generating companies would pass on the fees to consumers.

A Standard & Poor's official said the state-backed bonds would enable the utilities to move the power-buying debts off their balance sheets, freeing the companies to borrow more. Of course, that's what they were supposed to have done in 1997. The balance sheet games certainly seemed like a short-term solution...if that.

Some people involved in the bail-out negotiations said the new round of bonds would definitely be a part of the governor's proposal, whether he announced it immediately or later.

Talk of a bond-funded bail-out invoked unpleasant memories for consumer advocates. They made the legitimate point that another generation of bonds would be a temporary fix and that—three or four years later—all the parties would be back in the same place talking about yet another bond-based bail-out.

Throughout the process, the Davis Administration was hesitant to make any forceful comments or to take any decisive action—even if that meant simply issuing more bonds. At one point in early 2001, a trio of Davis Administration officials met with reporters to sketch the state's financial picture. When a reporter asked Ted Gibson, chief economist for the Finance Department, how energy prices this year might affect the state's overall economy, Gibson was quickly cut off by his boss, Finance Director Tim Gage. Gage acted only after the governor's cabinet secretary, Susan Kennedy, leaned over and whispered something into his ear.

While Gray Davis dithered over how to proceed, other state politicians offered their own proposed fixes.

Treasurer Angelides proposed the creation of a new state power authority that would float $10 billion in bonds to pay for construction of its own power plants, help others build or remodel power plants with low-interest loans and perhaps even purchase transmission facilities from utilities.

However the state went—with a plan from Davis or the suggestions Angelides had already made—there were going to be more bonds issued to keep the utilities solvent through another transition. The risk of simply repeating the same mistakes seemed very real.

Arrogance Hiding Behind Details

The state-sanctioned bonds that financed the California Plan and its aftermath are the best example of the sort of bureaucratic arrogance that hides behind government financing schemes. The investment bankers and state agency employees who arrange the details of these schemes are often more interested in their relationships with each other than the best deal for consumers.

Of course, the bureaucrats agree that the details are their job—and big-picture issues of what's best for consumers are for politicians to decide. The investment bankers say the same thing…they just wear nicer suits.

In all, this kind of bureaucratic blame-shifting is the reason that deregulation is popular—it gets rid of bureaucracies. The fact that bureaucrats were controlling the California Plan was the best proof it wasn't deregulation.

10

January 1998:
The Short Delay
That Spoke Volumes

Everything related to the competitive wholesale market portion of the California Plan was pegged to start on January 1, 1998. The bonds, the CPX, the language of the marketing pitches... .

But, as the date approached, there was trouble afoot. The computer systems that the CPX and ISO were using to manage the trading and transfer of electricity were acting up.

Glitches Go "Unheard"

In early December, the ISO started running simulation tests on the grid management programs. These were the tools that would direct the flow of electricity around the state—as required by trading that was to take place each day on the CPX.

In the simulations, market information was submitted to the ISO for moving power over the grid. The tests checked whether the electricity moved to the right place in the right amount, whether the electricity was billed as it should have been and whether power plants responded to alternative energy delivery plans if particular generating plants were shut down. The ISO's goal was to get seven consecutive days of simulation testing to perform as originally envisioned for the market.

For the first two weeks of practice, things seemed to go fine. Then on December 16, a series of glitches occurred in the system's computer network. Word slipped out into the media that the ISO was having computer problems.

At first, the ISO was cagey about exactly what was wrong. A spokesman made several public statements that combined specificity about "operators and dispatchers," "market issues" and the system's "control area" with vague denials ("I haven't heard of any glitches") as to whether the system would be ready to go in a few weeks.

Operators and dispatchers were the grid monkeys—technicians who made sure that electricity flowed through the grid at the right time to the right places.

Market issues were the whole range of demands that the CPX and ISO expected to face once CPX trading started.

A control area was a region responsible for power plants and transmission operations managed by a single operator. The control area scheduled interchanges with other control areas and maintained proper voltage levels on transmission lines within its borders.

"I haven't heard of any glitches" is a common political evasion; the spokesman starts using his own personal experience as the measure of what he knows. The spokesperson also hopes that reporters will state that as the institution's official position.

Evading the problems couldn't continue for very long. The governing boards of the CPX and ISO had a telephone conference call set for December 22 to discuss the status of the system.

Glitches Get Heard

The conference call didn't go very well. The rumors about computer glitches were true.

On December 23—a little more than a week before the free trading was supposed to begin—the CPX and ISO announced formally that the opening of the day-ahead electricity auction would be delayed until at least March 1. Power would be supplied by the state's major utilities until that time.

The decision was made by the CPX Board of Governors, based upon the recommendation of CPX chief Dennis Loughridge who'd consulted with the ISO executives, the investor-owned utilities and the other market participants. The previous two weeks of tests had showed a multitude of problems with the way the agencies' computers tracked power sales and settled accounts.

Loughridge offered this comment about the system:

> There are no fundamental flaws. Our systems are functional but have not been adequately tested. Our employees and contractors are extremely dedicated and focused on opening the market as soon as possible while assuring we do so in a credible and sustainable way.I think the problem lies squarely with just running out of time. [T]he number of things that had to go right, the number of things that had to be sequenced, in the end, overwhelmed us. ...We have yet to accomplish end-to-end full market simulation.

He went on to explain that, earlier in the year, the CPX had established a test program and criteria for success. Since testing began, system performance had steadily improved. However, with sequential testing, when one system failed, the remaining systems could not be tested.

The tests would continue—every day—at the CPX's main trading facility in Alhambra, an eastern suburb of Los Angeles.

The problems didn't catch everyone by surprise. Months earlier, Mike Florio—a consumer advocacy lawyer who sat on the boards of the CPX and ISO—had described the January 1 start-up date as overly ambitious. Florio had predicted that problems with very complicated computer software would undermine and delay the start. He said at that point that a more likely start-up date would be in "March, April or even May."

The ISO's version of what caused the delay was, again, a little more cagey. A spokesman said the delay would last "between a few weeks and a few months, but hopefully more like a few weeks." He also said that the delay stemmed from problems setting up and coordinating

the activities between the CPX and itself. He pointed out that the agencies had only been created in January...and only been fully staffed since midsummer.

The two agencies had hoped to conduct full-scale, glitch-free tests for seven consecutive days. But, they weren't able to get to four days of real-time tests before glitches arose.

One spokesman said that the ISO and the CPX would spend "the next three months" fixing software bugs and testing their complex new computer systems. Others quickly chimed in that the plan was to spend two months debugging the systems and between one and four weeks testing the repairs.

The fuzzy timeframe made some observers nervous. Different sources seemed to believe different things about whether the delay would take two months or three. Or more.

Reasons for the Glitches

Some sources shrugged the problems off to technical conflicts that occur whenever companies try to link several different systems. According to this explanation, there was no single reason for the delay— just scores of communications bugs that needed to be ironed out.

Other sources offered a more problematic explanation. They said that, from their earliest days, the CPX and ISO each built its own computer software system—and didn't communicate with each other about what they were doing. This scenario suggested that the problem was bureaucratic turf battles more than simple technical issues.

Politics or no, the CPX and ISO systems had to connect. Once a market price for electricity had been established on the CPX's trading floor, the information had to move instantly to the ISO.

Asea Brown Boverie (ABB), a large Swiss-Swedish information technology firm, was hired to build a communications bridge between the CPX and ISO systems. ABB completed its custom software package

on schedule by early December. Still, the two agencies had not been able to debug and coordinate the two systems.

It wasn't enough to create the new software; the agencies also had to test how it would perform in a power market that didn't exist yet. This was a bigger challenge than most of their IT vendors were accustomed to facing.

Another problem—though not as major as the communication breakdowns—was that the CPX's computer system simply wasn't working fast enough. Trading on the power exchange was scheduled from 6 to 11 A.M. daily for electricity to be delivered the following day. Although confirmation of transactions was targeted for no later than 1 P.M. on each trading day, the system was taking several hours longer to get the information to the market participants.

The system failed to supply prompt confirmation of energy deals and to interact properly with the ISO system. This seemed to shift the crux of the fault for the problems to the CPX—something that ISO staffers didn't hesitate to point out.

Despite the delays, California consumers still got their 10 percent rate reduction on electricity bills starting January 1. (The bonds financing the rate cuts didn't run into any computer problems.)

As January 1 came and went, the CPX and ISO began a public relations effort that coincided with their technical effort. The delay was a major embarrassment; the agencies wanted to minimize its effect on their credibility in the marketplace. They were right to be worried about their credibility.

They explained that the failure to meet the original deadline was not a reflection on the CPX and ISO but on the unrealistically short deadline imposed by the Sacramento politicians.

But most of the key decision-makers believed that the deadline wasn't the problem. P. Gregory Conlon, the new president of the CPUC, defended the January 1 date as "aggressive" but not unrealistic. He believed that the computer problems could be fixed quickly and that the new plan would be active in early January.

The agencies expected to use two months to identify and correct software problems. During March, they expected to complete a final market demonstration test and give a 15-day notice of the new intended start-up date—in case it would be earlier than March 31.

Delays Cost Lots of Money

The delay was going to cost money. How much, no one was really sure. If the start-up didn't happen by March 31—and one state official put the probability of success at only 70 to 90 percent—the agencies would face another major problem: they'd be broke.

Ultimately, consumers would have to foot the bill for the additional costs—as they did for all costs related to the California Plan. Simply said, the CPX and ISO were generating no revenue during the three-month delay, though they were fully operational and staffed. Decision-makers at each agency estimated that this would mean a loss of $15 million for the CPX and roughly $30 million for the ISO.

There was also the uncertainty that the March 31 deadline would work. If the agencies weren't running by that point, they'd probably have to borrow more money to stay in business. Because the CPX had a spending authority of up to $85 million and the ISO of about $215 million, they could do this but be left thinly capitalized for their first year of doing business.

Some people preferred to think of the cost of delay in terms of how much each day meant.

By this standard, an ISO spokesman said the delay would cost the ISO about $300,000 a day because it won't be able to charge customers—the new energy providers—to transmit power. That loss would be amortized over a 10-year period, along with most of the financing that applied to transition costs.

However long the write-offs took, the costs would eventually be passed on to ratepayers.

Loughridge estimated that the CPX's loss would be about $110,000 a day. Initially, that could be absorbed in its contingency budget; but, if the delay lasted more than a few weeks, the exchange would have to look at passing on the expense.

Outside critics argued that the agencies' estimates were too low. The Utility Reform Network, a consumer advocacy group based in San Diego, estimated that the cost of the delay could run as high as $1 million a day for the CPX and ISO combined. This was essentially double the estimate that the agencies themselves had offered.

A handful of consumer advocates welcomed the delay as a chance to reconsider the entire Plan. But their arguments were lost in the ripple effects that the delays had on energy companies, utilities and larger commercial energy users.

More Than One Delay

The delay complicated business activities connected with the move to the California Plan. For example: PG&E had planned to sell several power plants effective January 1. Proceeds from those sales were supposed to help pay off some of its stranded costs debt and, eventually, reduce rates. The power plant sales had to be extended until the CPX and ISO were ready to regulate the new market. Therefore, the repayment of the stranded costs would wait. And the credit toward ratepayer accounts would wait.

The delay also put on hold delivery contracts signed by new power providers that had been courting residential and commercial users for the months leading up to January 1. A spokesman for Enron, which had already signed up 15,000 California customers, said the delay might jeopardize future sales. Other marketers were also upset about the delay, saying it would cost them large sums in lost revenue and additional overhead. They'd have to wait three months before customers who had signed up with them could be switched—and several made noises about suing the State of California to recoup monies lost during the delay.

Of course, commercial consumers were frustrated. They had been counting on the access to cheaper power from the more than 200 suppliers that recently registered with the state. This was the reason that the big business lobbyists had supported AB 1890 as it was stitched together in the summer of 1996. Now, they were beginning to wonder whether their support had been misplaced.

According to one Sacramento lobbyist with ties to the California Manufacturing Association:

> The Plan had never had the free-market true believers behind it. It had always been a scratch-my-back proposition. Everyone involved thought they were going to get something for themselves. In the planning stages, this all hung together. But the 1998 delay was the point at which people started to doubt.... Were they really going to benefit from the plan? Other than self-interest, there wasn't much support for what was going on.

This realization was the most important result of the delay. And it was a bad one.

The Feds Ask for a Notice of Commencement

The announcement of the delay also brought more regulatory scrutiny from the Feds. California had been the first state in the nation to mandate that the generation and sale of electricity be thrown open to competitive markets, ending nearly a century of regulated rates by monopoly utilities. Within the regulatory community, this trend-setting set California up as a target.

Within 24 hours of the CPX and ISO announcement, the FERC ordered California's electricity deregulation architects to give advance notification to the federal utility regulator at least 15 days before electric industry competition in California could commence.

This 15-day notice meant that the CPX and ISO were going to have to make sure the system would actually work before they announced the opening of trading. (Some staffers at the FERC were worried that the California agencies would try to "jam a buggy system down the throats" of the marketplace. That's why they pushed for the advance notice.)

The FERC order, dated December 23, established the parameters for parties to file comments to the regulator on the rescheduled date to begin electric competition in California. The FERC also outlined a number of issues on which it wanted more detailed updates—including the sale of power plants to others previously announced by PG&E and SoCal Ed.

In the bureaucratic language of reproach, the FERC wrote:

> The commission has consistently shown great flexibility in addressing filings in this proceeding, notwithstanding severe time constraints and changes in the proposals. As we move forward, the commission requests that the California participants assist us in maintaining the regularity of our processes by timely filings and advance notice.

Additionally, the FERC said it was looking for comments on a range of technical issues—including the details of agreements by the ISO to use PG&E, SoCal Ed and SDG&E's systems control facilities to oversee management of their power grids.

The FERC used the delay to gain some political advantage over the CPUC and the other California regulators. After following in the CPUC's reforming footsteps for almost five years, the FERC had the chance to establish itself as the sober voice of reason in the deregulatory arena.

According to one FERC staffer:

> There had always been a kind of envy, maybe even resentment, about how much independence the CPUC had. The policymakers in California seemed to take their advice, rather than just give orders. And this allowed [the CPUC] to act as much like policymakers themselves as mere regulators. The 1998 delay was a serving of humble pie for them.

This comment speaks volumes. Infighting among bureaucrats and regulators is probably a foregone conclusion in a multibillion-dollar marketplace. Not much news in that. The best signal was the envy that the FERC felt because the CPUC was able to regulate more effec-

tively. This was occurring in an environment that was supposed to be heading away from regulation.

Clearly, the bureaucrats in Washington and Sacramento saw a different side of the California Plan than the casual observer might. They knew that the Plan wasn't about deregulation; it was about a different kind of regulation, which was in some ways even more centrally controlled than the system it was replacing had been.

Seeds of Disconnect

As the first weeks of 1998 grinded by, the relations between the CPX and ISO began to take on a more distinct coloring. In the early planning stages of the transition, the agencies had acted like close partners—if not twins—united in their plans and tactical positions. During the delay, however, tensions mounted and power shifted toward the ISO.

CPX and ISO officials were authorized by the state to spend up to $300 million to create the two new agencies. But by operating without revenues for three more months, these agencies would consume all the cash available to them. Staffers at the CPX hinted that they'd probably go through their contingency funds and need more money.

Throughout January 1998, California's three big utilities had advanced the CPX and ISO the money to get started. The utilities had already been hit up for extra money once before, during the fall of 1997, when the transition budget ballooned from $250 million to $300 million.

The money borrowed from PG&E, SoCal Ed and SDG&E was to be repaid from service fees that would eventually be passed along to consumers in their monthly bills.

Therein lay the seeds of disconnect between the CPX and ISO. The ISO would not have any difficulty raising money, since its long-term source of repayment was certain. Power companies in California would always need to move power over the "grid" of high-voltage transmission lines—and would always pay for the privilege of doing so.

The CPX was another story. Utilities were only required to sell and buy power from it for four years. After that, generators could sell power in whatever manner they wished. If the CPX had money problems and marketplace credibility problems, it would have a hard time surviving past the first few years.

In early 1998, rival commodities markets were already appearing— including the Automated Power Exchange in San Jose, which said it could execute power trades more cheaply and easily than the yet-to-function CPX. These smaller exchanges aimed to put the CPX out of business. The higher the CPX's cost basis, the easier that mission would be.

So, the pressure was on the CPX to ensure that its systems were all working before trading started. System failures after the start date would not only cost more to fix…they would also cost the CPX credibility that it was already lacking.

CPX officials wanted to be absolutely sure communications were all in sync and had been tested several times before it would file the 15-day notice with the FERC. Staffers put the odds of that happening before the end of March at 50/50.

And, even if the two agencies were able to meet their new deadline, it was unclear whether one or both would have enough development capital to weather the start-up phase of their business plans. In this environment, staffers at the ISO began to distance themselves from their equal numbers at the CPX. They began to raise questions about "management focus" and "capital position."

The knives were out among the bureaucrats. Battles between the CPX and ISO might have seemed like second nature to the staffers of each agency; but they really were partners in a complex experiment. They needed each other to thrive in order for both to survive. The delay clouded that common goal—and the relationship never quite recovered.

The various interested parties to the California Plan were starting to have doubts about the value of the whole exercise. Going back to the

summer evenings when Steve Peace pushed his compromise plan through the lobbyists and committees, a confederacy of self-interest had formed. The delay was this confederacy's first test. It survived, but it was shaken.

The investor-owned utilities—the original backers of AB 1890—still supported the Plan. They wanted to be rid of their stranded costs and free to compete on the basis of market-driven prices. They were willing to pay fees and suffer delays to get through the transition. Nonetheless, the delay made most of the executives at SoCal Ed, PG&E and SDG&E suspect the transition was going to be more difficult than they'd hoped.

Ready, Set...Go

The CPX, the ISO and their expensive IT consultants worked the bugs out of the trading and management systems by mid-March 1998. The agencies gave the FERC its 15-day notice, as required.

March 31, 1998, was a Tuesday. The CPUC issued the final order officially opening the electric industry market to competition for all consumers in investor-owned utilities' service territories as of that day.

Control of about 75 percent of the state's transmission lines was transferred to the ISO. Power was now bought and sold on the CPX.

But the damage had been done.

11

While the foundations of the political, regulatory and corporate confederation that supported the California Plan began to erode, most Californians paid scant attention to the technical glitches that caused a slight delay.

Most ordinary citizens—in fact, even most informed citizens—held a few basic impressions about deregulation. These included:

1) all deregulation was the same; and

2) all deregulation resulted in lower prices for consumers.

Beyond that, few people cared about the tiny details of how deregulation was brought about.

Several consumer advocacy groups knew better. They'd paid attention to—and, in some cases, attended—Steve Peace's marathon committee meetings in Sacramento during the summer of 1996. They'd read the CPUC and FERC paperwork bickering back and forth. They'd talked to staffers at the CPX and ISO.

These consumer advocates came away from these contacts convinced that the California Plan was no good for average people. Fundamentally, they were right. But they weren't good at articulating their opposition—and they weren't able to prevent the Plan from taking hold.

A New War, Another Proposition

The mechanism that the Coalition of Consumer Advocates chose to fight the California Plan was the ballot initiative. This is the distinctively Californian practice of putting specific pieces of legislation before the voters in the form of a "proposition" on which they vote "yes" or "no." These propositions can overturn legislation and court decisions; they tend to attract the most controversial issues—things that politicians and jurists are hesitant to address directly.

The most famous of these tools was Proposition 13, the 1978 measure that radically restructured California's property tax system. Prop 13 cut California's notoriously high property taxes by 30 percent and then capped the rate of increase for the future. More recently, the state passed Proposition 103—an insurance reform package that cut rates and reregulated the industry.

Prop 103 was relevant to the electricity market, too: Several of the key players in the Coalition of Consumer Advocates were involved in the crafting and passage of Prop 103.

As things turned out, however, these consumer activists were fighting a new war with the last war's technology.

Proposition 9

In June 1998, the Coalition gathered enough signatures to qualify Proposition 9—an alternative reform plan—for the November 1998 ballot. The initiative would prohibit recovery of stranded costs for nuclear plants, prohibit stranded cost recovery surcharges on consumer bills and provide a 20 percent rate cut.

Prop 9 was opposed by the investor-owned utilities, the business community and industrial groups. The Coalition seemed to revel in the enemies it had made.

"The money stakes are overwhelming, more than $1.56 billion a year— that's more than half the state's corporate income tax," said Michael

Shames, head of one of the Coalition member groups. He went on to say:

> If the system doesn't work properly, the money will go instead to large industrial consumers. That's the kind of corporate welfare this country is committed to ending, not to spending.

Among the criticisms the Coalition made about the California Plan:

- Large players—either commercial users or generators—could manipulate prices to their advantage.

- The market plan fails at step one, the independence of the Independent System Operator, by allowing large players to dominate and create circumstances that allow gaming and abuse of market power.

- The deep pockets that would pay for the large players' advantages are those of small consumers who cannot make themselves felt in the structure.

- The proposed protocols created "poison pills" that would limit the viability of the California Power Exchange.

- The system lacked incentive compatibility in bidding and scheduling protocols, which creates conditions that allow major players to inflict moral hazards on smaller players.

Indeed, these points may have been true, but the best way to describe the California Plan's inadequacy was as watered-down half-deregulation. To complain that it was the work of nefarious corporate greedheads didn't have as much effect.

Besides, who were the greedheads? The utilities had the biggest influence on AB 1890, but they weren't in a position to profit from the California Plan. Energy generators were in a position to profit—but they also faced big risks. And, they hadn't had as much influence on the crafting of the Plan.

California's consumer advocacy establishment—call its members *consumeristas*—was so enmeshed in left-wing political posturing that it couldn't make the effective criticism.

Preteen Consumeristas

Consumeristas have a hard time dealing with deregulation. Often, they base their criticisms of regulated markets on corrupt or ineffective regulators. This, then, puts them in an awkward, enemy-of-my-enemy alliance with free marketers. The emphasis on lower prices is another link between the strange bedfellows.

Going back to early 1996, California consumer advocacy groups found themselves in this hard position. For several years, San Diego-based Toward Utility Rate Normalization (TURN) had gotten easy publicity by issuing an annual "report card" on how the CPUC was handling regulation of the electricity market.

In the early years, TURN bashed the CPUC mercilessly. It flunked the commission on just about all fronts. Then, Steve Peace started making noise about actually doing something about this—deregulating electricity and moving the CPUC out of the market entirely.

With this prospect suddenly looking plausible, TURN changed its tune about the CPUC. By 1996, TURN was avoiding giving the CPUC an "overall grade" and explaining that it didn't want to encourage legislative efforts to abolish the commission. More specifically:

> Despite TURN's criticism of the CPUC, the group believes consumers would be worse off without a commission to regulate the state's investor-owned energy and telecommunications companies.

If nothing else, Peace seemed to have called TURN's bluff.

At their worst, groups like TURN have a hard time articulating a coherent philosophy about reconciling business and public policy goals. They want low prices...but heavy use of green power. They want union workforces that are never reduced...and "progressive" management. They want market forces to press prices downward...while executives have limits on salary.

In short, they want everything. It's little wonder that people outside of California call the state childish.

Even at their best, consumeristas aren't free marketers. They're reformers. They're okay with regulation; they just want to make sure it's their version of regulation.

Nader vs. Corporate Socialism

The Leon Trotsky of the consumerista movement (to mix cultural references) is Ralph Nader. Nader had been involved in the California Plan for a long time.

During the summer of 1997, while the first effects of the California Plan were being felt in the industry, Nader visited to join a last-minute effort to derail the Plan.

The Naderites argued that electricity rates would go up—rather than down—when the California Plan took effect. And, in an unusual twist, they turned out to be right; though for the wrong reasons.

They believed that the state-sanctioned bonds that were funding the electricity rate cuts unfairly benefited the utilities. Why? Because the plan allowed the utilities to borrow at state rates.

Consumers Union, the left-leaning not-for-profit, chimed in—calling the bond sale a "Trojan tax." Consumers Union complained that the bonds only served to bail utilities out of bad business decisions. The group made this claim, even though it knew that California utilities had operated under a highly regulated environment for years...and had been encouraged by the regulators to make those bad decisions.

Ultimately, California's energy crisis had less to do with the mechanics of borrowing on behalf of utilities than with the commercially uninformed executives shaping the industry.

Still, Nader and his fellow consumeristas were busy putting the most negative possible spin on electricity deregulation. They called it corporate welfare. They warned direly of rate increases to come. Nader himself said:

This is capitalism turned upside down to corporate socialism. The utilities want to be bailed out in order to compete.

He clearly disdained the impression that consumers would save under the California Plan. Again, he was right for the wrong reason; his analyses were almost all politics…and almost no economics. He harped on the bonds as a sweetheart deal, but he seemed ignorant of what half-deregulation would do to the utilities.

Still, Nader lashed out at Steve Peace, saying:

Senator Peace has declared war on electric consumers in the state of California. He has facilitated a deviously complex formula to shift massive costs from investors to ratepayers.

In August 1997, while politicians in Sacramento approved the bonds, Nader's coalition came out against them. Passionately, if not coherently. The coalition—which included the groups Consumers Union, TURN, Californians Against Utility Taxes (CUT), the Utility Consumer Action Network (UCAN) and California Public Interest Research Group (CalPIRG)—tried to argue that the whole issue was politics. It didn't realize the issue was more fundamentally one of money.

The Coalition's Alternative Program

In November 1997, the same Coalition started circulating what would become Proposition 9 on the fall ballot the following year. This initiative would slash electric utility bills by 20 percent.

The groups were outraged by the California Plan that left ratepayers saddled with a multi-billion dollar nuclear bail-out and inflated electric rates for residential and small business utility customers.

According to consumer advocate and former Nader protegé Harvey Rosenfield:

The Legislature foisted a $30 billion tax on California consumers, forcing us to bail the utility industry out of their ridiculously expen-

sive nuclear power plants. That tax will cost every consumer over $300 a year. It's time to send a signal to Sacramento that we won't take a back seat to the big utility companies and their slick lobbyists who have bamboozled an amateur legislature. California's initiative process was put in place to end the abuses that resulted from the domination of our legislature by the robber barons of the last century. Things haven't changed much in the past 100 years.

His rant was joined by Nettie Hoge, executive director of TURN, who said:

This initiative will correct the most unjust aspects of the electric restructuring plan passed by the California Legislature last year. That plan will not serve the interests of small electricity consumers. Through this initiative, we hope to give real benefits to residential and small business customers who were ignored in the previous deal.

The Coalition's alternative program included the following five key provisions:

1) A "genuine electric utility rate reduction" of 20 percent for residential and small business customers. (Under what the Coalition called "a clumsy effort to fool the public," AB 1890 contained a "purported" rate reduction of 10 percent.)

2) A measure preventing utilities from passing on to consumers the burden of paying for past bad investments in nuclear energy. "The construction of nuclear power plants resulted in a waste of billions of dollars that the utilities want ratepayers to pay in full so that utility companies can lower their rates for big industrial clients."

3) Stringent limits on ratepayer reimbursement of other past bad investments by forcing the Public Utilities Commission to reexamine recovery by the utilities of all other non-nuclear generation costs. Consumers could be charged only to the extent necessary to allow utilities the opportunity to earn a reasonable rate of return.

4) A ban on ratepayer-financed schemes for the alleged rate reductions enacted by the Legislature by prohibiting the utilities from charging their customers for those reduced rates through added surcharges or "taxes" on residential and small commercial bills.

5) Protection of the privacy of utility customers by banning the sale of customer bill information and other marketing data, including sales to direct mail and telemarketing firms that want to target electricity customers.

Voters Disappoint the Consumeristas

The consumeristas were high with excitement over the new ballot initiative. Unfortunately—for Nader, Rosenfield and their staffs—the excitement was met with a big yawn from average Californians. Only a tiny percentage chose to switch to new power suppliers.

Barely 20,000 of the 9.9 million customers who bought their electricity from the state's three big investor-owned utilities had decided to dump their hometown suppliers in favor of competing companies. That response fell significantly below the number industry officials expected in the nation's largest electricity market.

Despite a $100 million public-education campaign ("an insult," according to one consumerista) by the state and major corporate advertising efforts, consumer apathy was the rule. Why? For starters, residential and small-business customers would get a 10 percent discount automatically even if they stuck with their present utility—and new power providers couldn't offer much more to residential customers.

A national survey conducted by Makovsky & Co., a New York investment relations firm specializing in utilities, found that 51 percent of those surveyed didn't believe they would benefit from electricity deregulation.

The survey presented a picture of "a confused and skeptical public," said Jeff Dennard, a senior vice president with Makovsky & Co.

Mad and Militant

Again, many of the consumeristas' complaints had a hint of truth in them. Their problem was that the driven consumeristas were so political that they ended up obscuring their own best images and pictures.

Harvey Rosenfield, who'd drafted Proposition 103 in the late 1980s, argued that consumers were paying too much to finance lower electrical rates. So, he called in some old friends and old marketers and created a series of similar reforms.

Maybe too similar. Once in effect, deregulation would allow consumers to choose their provider of electricity similar to the way they now pick long-distance telephone service.

As an example, Rosenfield offered a copy of itemized charges on his own office bill from SoCal Ed. The $120.15 tab for February 1998 showed that Rosenfield received a $12.02 discount through the state-mandated rate reduction program that began in January. But the bill also said that Rosenfield paid $16.16 in financing costs "associated with the required 10 percent rate reduction."

This was a common experience, said Steve Linsey, a senior economist with the Office of Ratepayer Advocacy:

> The finance charges are high initially but should grow smaller as the principal on the bonds is reduced. Over the 10-year period in which the bonds will be paid off consumers should benefit, if only slightly. ...Itemization of charges on customers' bills is required by the deregulation law that was passed by the Legislature in 1996 and went into effect in January.

Still, Rosenfield seethed. In late 1998, he suggested that the state might need to seize power plants through eminent domain to make sure there is an adequate supply of electricity. "Use the National Guard," he said.

Flamboyant stuff, to be sure; but the public still didn't take the bait. It was too much inside baseball—for people who made their livings on state politics in Sacramento.

Moreover, the consumeristas had a nasty habit of fighting battle amongst themselves.

Rosenfield and Shames

As young lawyers in the 1970s, Harvey Rosenfield and Michael Shames had worked with Ralph Nader organizations and then went on to found separate consumer groups. In the late 1990s, they were both involved in the effort to reform (or re-reform) California's electricity market—although from opposite ends of the rather narrow political spectrum occupied by consumer groups.

Rosenfield threatened to put a public-power initiative on the ballot and blasted Governor Gray Davis—"Giveaway Gray,"—for bailing out the utilities and failing to seize the power plants. Shames, of the Utility Consumers Action Network, focused on more practical goals. He prepared a detailed plan for a state purchase of the utilities' transmission system.

Shames summed up their difference in styles:

> Harvey has never been a big fan of mine. Brothers and families sometimes fight. It's been known to happen. ...there are two schools of thought about consumer activism. One is to be a constant critic, remain on the outside and "throw bombs" in an attempt to move things your way. The other is to build coalitions, solve problems, compromise and make things happen.

Prop 9—drafted in part by Harvey Rosenfield—went before the voters in November 1998. They rejected it overwhelmingly—73 percent voted to keep the California Plan in place.

Voters just couldn't seem to get too worked up about the mechanics of deregulation. They wanted it...but they were content to leave the details to the politicians and regulators.

Arguing for Bankruptcy

The defeat of Prop 9 dealt a major blow to Rosenfield and his street-theater approach to public policy issues. He'd occasionally be quoted making some bomb-throwing comment about rampant greed or coming in with search warrants. But he was out of the mainstream debate.

In December 2000, as the worst of the market meltdown was still approaching, a group of consumer advocates held an unusual summit meeting with utility executives. The consumer advocates argued that they feared rates could rise sharply for consumers who relied on SoCal Ed or PG&E. They worried that rate hike requests were masking an attempt to pass along the full cost of huge wholesale price increases to consumers—which could raise SoCal Ed's rates by 80 percent or more.

Officials for the two utilities vehemently denied any such plan...at least as a conscious goal of their operations.

The debate emerged on the second day of emergency CPUC hearings to consider SoCal Ed's request for a 30 percent rate hike and PG&E's request for a 26 percent increase—both much larger than anything that AB 1890 had considered in that timeframe.

The giant investor-owned utilities said they would go bankrupt if they weren't quickly granted relief from sky-high wholesale electricity costs.

Ralph Nader, back in California after his Green Party presidential campaign, was among those turning out for the hearings. Nader and other consumer advocates maintained that the California Plan had been an unmitigated disaster for ratepayers and caused an energy crisis that gripped the state for months.

Echoing suggestions of some local consumer advocates, Nader argued for bankruptcy—saying that it would not disrupt electrical service and would simply lead to the replacement of top utility executives with the "frugal supervision" of a bankruptcy court.

But Nader undermined his credibility with a piece of stunning naivete. He flattered the LA DWP for putting "human need over corporate greed"—apparently because it had left its rates alone. He didn't seem to realize, however, that the LA DWP had been happily profiteering during the crisis by selling extra power to other utilities for astronomical prices.

His comments were informed more by political grandstanding than by informed experience. And when a dogged policy wonk like Ralph Nader is grandstanding, there's not much chance for informed debate.

Political Spin and the Blame Game

When the blackouts started in early 2001, the consumeristas were thrown into even deeper confusion.

David Horowitz, for example, the television news consumer advocate who'd made a name for himself with the *Fight Back!* series in the 1970s and 1980s, taped a series of TV ads sponsored by the Edison Electric Institute that dissed other consumer advocates.

In the ads, Horowitz said:

A few activists…think letting utilities fail is part of the solution. They're dead wrong. Letting utilities fail…would cost us more, not less. We've got to fight back and keep the lights on!

Consumeristas like Rosenfield sneeringly dismissed Horowitz as a hack and a whore…but no one seemed to know where the truth lay. By early 2001, consumer advocacy in the energy sector had broken down to little more than political spin and the blame game.

Certain consumer groups had loathed California's utility companies for decades. Now that these utilities were drowning in debt, the activists smugly suggested they "be allowed" to go bankrupt.

That would solve nothing. And—despite what Ralph Nader said—it would likely result in more blackouts.

Utilities' creditors, the private power companies, would have no trouble convincing a bankruptcy judge exactly how much they were owed. A court would eventually order the responsible parties, the consumers and businesses who used the power, to pay up.

Consumer activists' retort—that utilities should bear all the wholesale rate hikes because they supported deregulation—didn't hold up as an honest approach. State lawmakers, the people's elected representatives, supported deregulation unanimously. Some consumer groups, such as UCAN, supported it, too. The problems with the California Plan couldn't be blamed entirely on utilities.

Californians Seem to Back the Plan

The most surprising result—and one that confounded consumeristas: Despite the confusion, most Californians still favored deregulation, as long as it meant competition and choice among residential electric utility service providers. This conclusion came from a special report issued by the consumer polling firm J.D. Power and Associates.

While more than one-half of Californians admitted they didn't thoroughly understand deregulation, 64 percent believe that the state should continue to support the California Plan. Of course, the survey didn't draw a distinction between "deregulation" and the California Plan.

Another interesting point: More than half of the Californians surveyed held the state responsible for the crisis. They also expected state officials—starting with the governor—to take appropriate action in order to resolve the situation. They seemed to realize—almost instinctively—that the utilities and power generators were looking out for their own interests; and that the politicians were supposed to be protecting the public.

A key element of the energy crisis was the nearly $13 billion debt among the investor-owned utilities for power purchases made during the summer of 1998 and winter 1999. While some study respondents thought that local utilities should pay the debt, nearly twice as many thought the state should pay (14 percent versus 24 percent).

That was an unexpected outcome.

Another Poll Points to Cynicism

A separate Los Angeles *Times* poll found that Californians overwhelmingly favored building new power plants—even if they were constructed near their homes—but most opposed using state bonds to buy electricity for cash-strapped utilities.

Eighty-three percent of those surveyed favored construction of more plants, as long as they were not nuclear powered. More than half favored buying hydroelectric plants or power lines from private utilities.

The survey also revealed that two-thirds of Californians didn't support deregulation (a difference from the Power & Associates survey), and a majority of those surveyed thought Governor Gray Davis had done a good job handling the crisis. But they gave poor marks to the state Legislature, state regulators and the utilities for their roles in the state energy shortage.

The respondents opposed the use of state bonds to buy electricity that cash-strapped utilities couldn't purchase because they were mired in debt. Three out of four people surveyed wanted new power plants, even in their own communities, but they didn't want to rely heavily on nuclear-generating plants.

About 63 percent of poll participants said the energy crisis was the state's biggest problem, but 57 percent of them didn't believe there was a shortage of electricity.

In all, there seemed to be a startling reservoir of cynicism about the crisis. More than half of those polled, or 54 percent, said that they did not believe there really was an electricity shortage. Nearly 40 percent said they strongly disapproved of the behavior of the state's investor-owned utilities…and an additional 20 percent disapproved somewhat. Perhaps not surprisingly, 66 percent said they disapproved of the 1996 state Plan.

They saw this as an isolated failure of legislation; they believed in deregulation, generally.

A third poll found that nearly 60 percent of California voters believed the power shortages that led to blackouts were mostly a ploy by energy companies to raise rates.

The survey by the independent Field Poll had this striking finding: Nearly two-thirds of California residents preferred an occasional blackout to higher electricity costs.

That was a hopeful sign for proponents of true deregulation. It showed that Californians understood—and were willing to bear—the real costs of lower rates. But it was a serious threat to the political orthodoxy of the consumeristas crowding around on the American Left.

Maybe Californians weren't so childish after all. Maybe it was the politicians and consumeristas who believed in Santa Claus economics.

12

September 1999:
Investors Feel
the Effects

Throughout the first two years of the California Plan, the investor-owned utilities worked hard to keep their investors happy. This was a tough job. Utility investors weren't big fans of deregulation. Even a partial deregulation effort like the California Plan would put an end to the steady profits—and steady dividends—that utilities had traditionally offered.

Utility executives did what they could to assure steady performance during unsteady times. Before AB 1890 took effect, they restructured as holding companies (which were, specifically, what shareholders owned). When the California Plan started, they transferred cash out of the utilities to maintain dividends. By 1999, however, this was getting difficult to maintain.

One of the key disputes that colored the debate over stranded costs was whether investors or ratepayers should bear the cost of the bad investments. And, frankly, the question seems a bit absurd. In what other business could it even be suggested that customers pay retroactively for a company's bad decisions?

But this is the nature of a regulated business. Management assumes that it will be bailed out of the bad decisions it makes. And, more importantly, investors believe their money is absolutely safe...and their profits are absolutely guaranteed.

Shocked Investors

No group involved with the California utilities had a more extreme reaction to AB 1890 than investors in SoCal Ed, PG&E and SDG&E. The smart investors rightly saw the reforms as the end of locked-in profits; the not-so-smart investors didn't—and acted with utter shock when their "safe" investments started to tank.

The effects of Steve Peace's Frankenstein of a bill were felt even before the thing was signed into law. In the early months of 1996, a panicky stock market knocked nearly a billion dollars off the value of PG&E shares. Analysts, fund managers and other professionals realized that competition was reaching the state's power industry ahead of schedule.

The event that triggered the fall in PG&E Corp.'s stock price was the company's announcement that it planned to freeze rates for five years and then open rates to full competition by January 2002. This was a schedule that would put PG&E into the thick of deregulation four years sooner than the CPUC's suggestion. From a marketing perspective, this was a smart move. Customers weren't likely to wait for regulators to let them get cheap power, especially since PG&E's prices were almost 50 percent above national rates.

So, all of the smart guys had started moving out of the California utilities through the summer and early fall. And they were right to do so. PG&E Corp. stock fell from around $28.25 a share in January 1996 to around $20 a share in September, when then governor Pete Wilson signed AB 1890 into law. And things got even more volatile after that.

Why Dividend Cuts Hurt

In late 1996, PG&E did another honest—but problematic—thing. It announced that it was cutting the dividend on its stock by 39 percent from an annualized $1.96 per share to $1.20. While the cut had been expected, the size was more than most experts had predicted. This was a major blow to utility investors. (SoCal Ed had cut its dividend about 18 months earlier.)

At the same time it announced the dividend cut, PG&E also announced a 38 percent drop in its quarterly profit—and it predicted that its profit would continue to fall in the coming quarters.

Dividends—the profits that publicly-traded companies send to their shareholders—have long been the reason that investors were attracted to utility stocks. Because of the heavily regulated nature of the business, utility profits were considered safe and reliable. Even if they didn't blast up the charts like high-flying tech stocks or conglomerates, utility stocks churned out the steady dividends. They were safe for "widows and orphans." Seniors have historically invested heavily in utility stocks and bonds, drawn by their relatively generous yields and the long-held belief that they are safe investments. (Think about the *Monopoly* board game again, and those safe utility—electric company and waterworks—purchases.)

The majority of SoCal Ed's 325 million shares outstanding were owned by individuals, many of them retirees. As a result, the people who invested heavily in these stocks often had a child-like trust in their reliability.

Deregulation—even a warped version, like the one California was enacting—cuts straight through the heart of this reliability. Utilities facing deregulation are driven to conserve cash for the competitive battle brought on by looser laws.

And credit rating agencies applauded the move to conserve. One utility analyst at Standard & Poor's called PG&E's cut "positive" and suggested it would lead to an upgrade of PG&E's credit rating on Wall Street.

Asked for an explanation of the dividend cut, PG&E turned back to the stranded costs issue. The California Plan set a strict agenda for recovering investments in nuclear plants—PG&E had invested heavily in its Diablo Canyon nuclear plant in San Luis Obispo County.

Ironically, PG&E had been making money on Diablo Canyon through the 1990s. After some early difficulties, the plant had been running

smoothly enough that it entered guaranteed contracts with other West Coast utilities. Those contracts were not allowed by AB 1890, which offered instead the faster interim period during which PG&E could recoup its nuclear energy investments.

This was the deepest irony of all. California's "deregulation" plan actually further regulated the sale of energy produced by some nuclear facilities. PG&E walked away from profitable sales from Diablo Canyon in order to participate in the stepped-up recovery scheme for stranded costs.

What would a smart investor make of this move? To the extent that AB 1890 allowed utilities to recoup stranded costs in a few years—yet keep possession of the facilities—an investor might be happy. But investors smart enough to follow the news were more worried about the expected decrease in retail rates than anything else.

Widows and Orphans Feel the Crunch

Most savvy investors looked at a statistic called the *yield* when evaluating utility stocks. To simplify slightly, the yield is the amount of the utility's annual dividend divided by the current stock price.

This is a very conservative way to evaluate conservative stocks. (Most growth companies don't pay any dividend, so yield analysis for them is moot.) Historically, the average electric utility yield was about 6 percent. This figure had a self-correcting nature. If conservative utility investors believed a company's yield should be higher, they would sell the stock—thus, lowering its trading price and increasing the yield for other buyers.

But everything had been turned on its head in the wake of the California Plan. PG&E's announcement of lowering its dividend didn't result in a lower stock price—it resulted in a rally that sent the stock from around $21.50 a share to around $24.00. Few investors knew what to make of this.

Traditionally, utilities have been regarded as defensive stocks for tough times because they tend to perform very well in turbulent periods. But

times were generally good in the U.S. economy during most of 1996 and 1997. And smart investors were uncertain enough about the ultimate results of the California Plan that they stayed away from the big California utilities.

Although senior citizens are often portrayed as financial naifs, many watch their investments greedily. And they don't like it when dividend machines become speculative ventures. The investor affairs departments at both SoCal Ed and PG&E heard quickly from their small investors when the respective dividend cuts were announced. "There were a lot of angry phone calls," recalls one PG&E staffer. "And some tearful ones. The amount of reliance these people felt for the stock was amazing. The problem was that no one could say where things were headed."

Another constituency—that was equally trusting—were employees of the utilities. At SoCal Ed, about 24 million shares were held by current employees. Some had invested their entire retirement savings accounts in the company—because it was safe.

This is a common theme in the energy industry. Some investors— including some people working in the field—have such myopic visions of the business that they pour all of their financial resources into their own company's stock. As any financial advisor will tell you, concentration in even a safe investment is an unsafe proposition.

Rethinking Utilities as Investments

The months after Pete Wilson signed AB 1890 were better for the California utilities as investments. The savvy investors had made their moves before the bill became law. And the phase-in period that followed looked—to outsiders—like it was proceeding smoothly.

Again, the conventional wisdom assumed that the California Plan was a traditional deregulation program...and that this meant lower prices. A surprising number of investment pundits offered lazy-man's opinions about how the California market would become a highly competitive arena in which low-cost providers pressed electricity bills down.

Hundreds of group-think articles talked about utilities becoming marketing pests: huge discounts for commercial users; for homes and small businesses, calls during the dinner hour; free trial deals; toasters, cell phones and other tchotckes to those who'd switch.

Clearly, none of these people had actually read AB 1890.

Investors didn't seem to mind the shallowness of the popular wisdom. Besides, there had been a number of mergers among energy and utility companies during 1996 and early 1997. Mergers usually meant upward pressure on stock prices—and they did for both SoCal Ed and PG&E during 1997. Both stocks trended up over the year; both ended about where they had been two years earlier, at the beginning of 1996.

This stasis lulled many small investors into a faulty complacence. "I know there are a lot of mergers going on, but I don't know much about the deregulation," one elderly investor told a local newspaper. "I just kind of ride along."

This was not the right investment strategy to bring into an industry that was being deregulated. But it does show how blindly loyal the small utility investors were. Utility executives kept the faith by paying out dividends—even though, by 1999, their biggest operating units were losing money.

The mergers and other activities were the result of energy companies coming to terms with the reality that deregulation would mean a separation of the three elements of the electricity business—generation, transmission and distribution. In some cases, the deals were based on strategies of focus: Companies were selling off operations in one element to concentrate on another. Or they were acquiring others to complete their integration of all three elements. Some would be just power generators, others just distributors. Many would pour money into capital expenditures connected with growth...instead of paying steady dividends.

Dividends seemed very much a thing of the past.

Historically, most dividend cuts were a result of financial difficulties, but in late 1996 some companies made the move for a very different

reason—to reposition themselves for the future, which includes new investments.

Utilities as Growth Stocks

A whole new class of securities tied to stranded costs was expected to emerge. And the reconfiguration of the utility industry posed interesting investment options.

Conventional wisdom held that companies focused on transmission and distribution were likely to remain regulated—and likely to continue as monopolies, given the expense required to enter those markets. The same conventional wisdom held that energy generating companies, which would be selling a commodity in deregulated markets, were likely to be highly volatile as investments.

The result was that smart investors started looking at utilities more like growth stocks and less like the lazy, predictable securities they had been. That would be a painful lesson for many investors.

The period between early 1998 and the end of 1999 was one of steady improvement for California utility stocks. True, they'd cut their dividends; but they were profiting from what some money managers called "the Enron effect." This was the idea that a handful of energy companies were leading the charge into free markets, which would be a capitalist free-for-all. Furthermore, since California was ahead of the other states in terms of enacting "deregulation," its utilities were on the cutting edge of the cutting edge.

In truth, 1998 and 1999 saw no improvement in the assets underlying the California utility stocks. The companies were recouping stranded costs as quickly as they could and selling electricity generated by other companies was proving easier than some had expected. But prices were so staunchly fixed that fat profits weren't possible…and the companies were busy selling their own generating facilities off to comply with the new laws…and to finance dividends they couldn't otherwise afford.

"I'm smarter now," says a former PG&E executive:

> The fact we were selling off generating facilities and kind of just treading water financially should have raised some red flags. If you sell off your best hard assets, you ought to be making huge money. We were selling off just to stay even with the marketplace. And we were happy that our power plants were bringing as much sales as they were. We'd convinced ourselves they were worthless. ... Were we ever wrong!

Some strange economic trends helped the outlook.

In late 1999, utility analysts said, the dividend yields on utility stocks were higher than bond yields, because those stock prices were so low. Technology was flying, so investors pulled out of utilities and went into technology.

So, utility funds had to get creative. They were suddenly full of telecommunications companies and unregulated power-generation companies. The funds owned foreign power plants and energy generators. They had to deal with electric companies that were still regulated, although the markets around them were deregulating.

They looked at California as the great hope for deregulation. And they supported the relatively high price of stock in California utilities.

In 1999, Pete Wilson surrendered the governor's seat in California to Gray Davis—a ruthless but outwardly bland pol who would carry on Wilson's practice of splitting the differences (large or small) in California law.

Hell Breaks Loose When Wholesale Spikes

In late 2000, after a summer that teetered on the edge of an energy debacle, California again faced an energy shortage that—on some days—came close to threatening blackouts among 15 percent of California's 24 million utility customers.

Although the blackouts hadn't started yet, it was clear to industry insiders that AB 1890 was merely a time-delayed explosion waiting for the right set of triggers to make it happen.

Wholesale energy prices hadn't dropped as much as Pete Wilson and Steve Peace had assumed they would. In fact, SoCal Ed and PG&E were both borrowing money to make up the difference between stubbornly high wholesale prices and regulated low retail prices. The borrowing couldn't last forever…but the utilities were confident that something would bring equilibrium to the marketplace.

And, just in case something didn't come along, the utilities had restructured themselves. They'd set up or expanded parent corporations that received profits but maintained a legal distance.

Standard & Poors, the rating agency that monitors companies' financial health, warned that the California utilities were on the verge of bankruptcy and risked bond downgrades to junk status unless something was done to stem the losses.

Despite all of this, a stunning number of the small investors were sticking with the utilities in their non-specific optimism.

But circumstances turned against this optimism. A cold snap in the Pacific Northwest started a chain reaction that pressed wholesale electricity prices very high—40 times what they had been a year earlier…and all hell broke loose.

Share prices of the parent companies, Edison International and the PG&E Corporation, fell as much as one-third between the beginning of December 2000 and the end of January 2001.

A CPUC audit of SoCal Ed's books noted that only stringent cost controls and the suspension of payments on pending bills kept the utility from running out of cash in early 2001.

The audit also confirmed that between January 1996—two years before the start of deregulation—and November 2000, the utility transferred about $4.8 billion of net income to its parent, Edison Interna-

tional. The parent used almost all of that money to pay for dividends and share repurchases for the benefit of its own shareholders.

State auditors did appear to endorse—at least indirectly—one consumer advocacy group's proposal to apply $2 billion in profits SoCal Ed had earned from selling power from its own generating plants to the debt of more than $4.5 billion it had incurred in buying power at unprecedentedly high prices.

The change would have the effect of reducing the so-called "undercollection" to $2.5 billion. But it would also delay the point at which the utility could demand an end to the rate freeze.

Fending Off Bankruptcy

In January, California lawmakers considered the politically dicey proposition of electricity rate hikes. The increases were only the first part of a package of laws aimed at saving California's investor-owned utilities and restoring stability to the state's reeling electricity marketplace.

State negotiators were also discussing long-term power contracts for the state with nearby electricity generators. These deals would result in energy prices far lower than those the state has been paying on the spot market.

Drops in the stocks of PG&E Corp. and Edison International caused problems all around. The state's power troubles, which included state-ordered blackouts, caused the Dow Jones utility index to lose the gains it had been building since August.

Wall Street analysts applauded these moves, saying that the utilities appeared to have survived their brush with bankruptcy and were worthy of investment. One Merrill Lynch & Co. analyst said the prospect of a legislative solution had reduced the risk of bankruptcy on the part of Edison and PG&E to less than 25 percent from "50/50ish." Shares of the companies rallied slightly on this report.

In addition, Sempra Energy—the recently-formed corporate parent of SDG&E and Southern California Gas—reported a smaller-than-

anticipated decline in fourth-quarter earnings and forecast improved profit for 2001, boosting its stock.

Sempra said that its fourth-quarter profit fell 10 percent from a year earlier as it grappled with the state's power crisis. But the company emphasized that it remained much stronger financially than California's two other strapped investor-owned utilities, a view echoed by analysts. Even so, the SDG&E unit was asking the CPUC to place a surcharge on customers' bills over the next five years so the company could recover the shortfall between soaring wholesale market prices for electricity and its customers' capped rates—the same problem that plagued its northern neighbors even more severely. (The surcharge, if approved, would work out to about $11.50 a month on top of the typical residential bill of $72.)

Like its peers, Sempra was trying to expand its unregulated divisions that trade energy and other commodities, provide wholesale power generation and operate overseas.

But with the bulk of its business still in providing power to Southern California, the company's outlook remained tied to the state's electricity crisis.

SDG&E's customers had become the first in the state to pay the full cost of energy under the 1996 deregulation law, because the utility sold its generating plants faster than the others. In the summer of 1999, this meant that electricity bills in San Diego County tripled. Public outrage was immediate—and political response was fast. After consumers howled that their bills were soaring, state pols rolled back and again capped electricity rates for all but the largest commercial and government customers.

Huge Profits for Power Generators

The problems were a boon to power generators such as Duke and Dynergy Inc., which had the energy that California lacked. Whether the stock market gains for the likes of Duke and Dynergy and the losses for PG&E and Edison would hold up rested on how the power crisis would be resolved.

However, Duke and its rivals, such as Reliant, Dynergy and Southern Energy, were not sure they'd be able to count on California for big profit margins in the future. They would lose if the state moved back toward more regulation—for example, if legislators capped the prices that generators can charge for supplying power to California utilities.

In late February, Moody's Investors Service issued a report written by analyst Dan Aschenbach that said:

> Absence of progress on the state's proposed solutions to the California power crisis could worsen the power crisis and begin to seriously threaten the health of the economy.

> In addressing the energy crisis, the state has put forward a three-pronged solution, which allows it to assume a larger role in the electricity business—a rare and controversial stance that is not unprecedented... .

California planned to stabilize the two major investor-owned utilities' wholesale power costs by having the Department of Water Resources (DWR) enter long-term bilateral contracts with power suppliers and by resolving the utilities' short-term debt problem via the purchase of their transmission assets and the setting of rates.

Repairing a Dysfunctional System

All of these moves had their intended effects on the investor community. In one of the biggest surprises of the entire failed California Plan life cycle, the stock prices for SoCal Ed and PG&E held up (albeit at prices nearly half of what they'd been before AB 1890 passed) through the blackouts and political outrages of early 2001. This remained so throughout—including through PG&E's bankruptcy filing.

"It's proof that these Ma-and-Pa Kettle investors really have the long-term in view," says one New York-based stock broker. "They believe in their bones that the government will bail out a utility before it liquidates. And it looks like they're right."

The plan to detoxify the utilities from the effects of the California Plan was a kind of bail-out. But to call it a "180-degree" reversal was to exaggerate. The Plan was never deregulation to start; its repair was not re-regulation. It was merely the repair of a dysfunctional system.

In the meantime, the stocks chugged along…held by investors so loyal that they ignored immediate matters.

13

December 1999:
The Munis

The California Plan gave the state's 30-plus municipal utilities a two-year grace period to decide whether to open their service areas to competition. If they decided to compete, they'd then have 10 years to blend into the competitive markets.

Although most public utilities were expected to let competitors into their territories, none rushed to throw open its gates. They took full advantage of the grace period to trim their debt, cut overhead and learn as much as they could about the California Plan's version of a free market.

While the market for electricity sold through investor-owned utilities spiraled toward a major meltdown, government-owned utilities—pointedly excluded from the California Plan—did quite well. The government-owned utilities (often called "municipal utilities" or "munis") remained, essentially, regulated the whole time. More importantly, they were allowed to keep their power plants and long-term contracts for buying or selling power. So, as the rest of the California market faced price spikes, the munis saw the chance to sell any extra power they had to the ISO at big profits.

Residential ratepayers of Southern California's six major munis—Los Angeles, Pasadena, Riverside, Glendale, Burbank and Anaheim—all enjoyed lower electricity rates than did customers of SoCal Ed, PG&E and SDG&E. They'd kept that edge even after the investor-owned utilities cut rates by 10 percent, as mandated by law.

Preparing to Stay Regulated

Originally, the LA DWP—the largest muni in the U.S.—wanted to be included in the California Plan. It didn't join for several reasons, primarily because its tax-free bonds could be taxed retroactively if it entered the deregulated market.

As long as the LA DWP had a monopoly in the nation's second-largest city, it could operate profitably despite a heavy debt burden, a huge workforce and a host of inefficiencies that made its cost of producing electricity higher than the (high) regional average. But, starting in 2003, the California Plan called for broader competition—which would add munis to the free-market mix. At that point, the heavily-subsidized LA DWP would be cut to shreds by ruthless competitors.

The conventional wisdom was that the LA DWP would end up suffering. Deregulation would make the investor-owned utilities all around it lean and efficient—and they'd chip away at the lumbering muni's franchise with aggressive marketing and low prices.

What followed was a period of management upheaval. Through 1996 and 1997, the LA DWP went through several general managers and a number of consultants. It laid off some employees and tried to revamp its customer service functions. It looked forward to 1998 and competitive markets with dread.

One of the biggest worries that the LA DWP had was a major stranded cost: a 1,660-megawatt power plant located in southern Utah. Technically, the plant was owned and operated by the Intermountain Power Agency (IPA); but the IPA was a co-op controlled by several West Coast munis. And the LA DWP was the biggest player among these.

The Intermountain Power Agency

The IPA's origins traced back to the early 1970s, when the Arab oil embargo sent shock waves rolling through an industrial world long accustomed to cheap energy. Shortages of imported oil sparked lines at gas stations and sent energy prices skyrocketing.

Under pressure to reduce emissions from oil-fired power plants that polluted the air in the smog-plagued Los Angeles Basin, the LA DWP began searching for out-of-the-way places to build power plants. If nothing else, desolate Delta, Utah was out-of-the-way.

The LA DWP and municipal utilities in Burbank, Glendale, Pasadena, Anaheim and Riverside were locked into contracts to buy power from the IPA through 2027 at prices double the current market rates.

The rates were high not because of inefficiencies at the coal-burning plant; the IPA had built the big plant with 100 percent debt financing...in other words, with bonds. The investment bankers who'd arranged the bond financing had required the co-op members to enter ironclad contracts as security for the bonds that financed construction of the plant and a major transmission line that carried the electricity into Southern California.

According to the so-called "take or pay" contracts, even if the utilities didn't need the energy or could get it cheaper elsewhere, they still had to pay the IPA. In the LA DWP's case, the contracts amounted to liabilities of about $2.6 billion.

The LA DWP was also a partner in the Southern California Public Power Authority, which—like the IPA—had financed a large nuclear power plant in Arizona.

Freeman as Trustee

In the summer of 1997, Los Angeles Mayor Richard J. Riordan thought he'd found a good solution to the management instability at the LA DWP. He named S. David Freeman to run the big muni.

Freeman had a lot of experience. He'd headed the Tennessee Valley Authority and power authorities in New York state, Texas and Northern California. In 1996, the CPUC appointed Freeman the so-called "trustee" charged with setting up day-to-day operations of the CPX and ISO. Most people in the know credited Freeman with keeping scores of contractors and lawyers fired up for that big task.

Under Riordan's directive, Freeman acted quickly, saying that "we will go broke" if the LA DWP didn't slash more jobs and reduce its huge burden of debt. In November 1997, the LA DWP's commissioners unanimously approved a sweeping plan to make the utility more competitive. Freeman also won the commission's approval to remove three top managers, so he could put in place his own management team.

In addition, Freeman was granted extraordinary authority to negotiate long-term deals to supply power to the utility's biggest customers, a crucial element in the LA DWP's effort to fend off competitors eager to capture major industrial and commercial operations in the city.

Since it hadn't participated in the California Plan, the LA DWP could keep its generating facilities and sign cheap long-term contracts for natural gas and other supplies. Using historical pricing models and his own experience, Freeman predicted that the big muni would have to lower its cost of generating power by reducing its operating costs and paying down $4 billion of its $7.5 billion debt by 2003 (its participation in the IPA accounted for $3.3 billion of the debt). Otherwise, it wouldn't be able to lower its rates sufficiently to meet competition from other utilities.

On the investment in the IPA plant, Freeman said the LA DWP had been run in the 1970s by "people who felt they knew the future and essentially tried to lock it in. They made an error in judgment. It turned out to be wrong, real wrong."

Freeman said he needed to recruit people with an entrepreneurial, cost-cutting approach to assist him. He also noted that "DWP's management structure is not chock full of [those] people."

The commissioners were eager to give Freeman a vote of confidence; but the employees felt differently. When Freeman walked into a crowded auditorium to explain his plan to the rank and file, he was booed loudly and needed security guards when he left.

Things Look Up for the LA DWP

In late 1999, it looked like Freeman had been wrong when he called those plans wrong. The contracts that looked expensive in 1996 looked like a bargain in late 1999. And they looked like a gold mine a few months later. By early 2000, things had changed dramatically. SDG&E's ratepayers, the first to be exposed to market forces, faced a doubling, even tripling of their electric bills. Meanwhile, the LA DWP's 3.8 million customers could rely on low rates—with a 5 percent cut coming—and a large power surplus.

Freeman and his management team deserved some credit for the turn-around. They were using the deregulated market for surplus sales and debt relief. In fact, since 1996, they'd halved the LA DWP's debt—and planned to be debt-free within two years. Moreover, the LA DWP's recently-approved 10-year, $1.7 billion capital program would provide 2,900 megawatts of new generating power. At that point, LA DWP was content to stay apart from the ISO.

The LA DWP's healthy position, however, was the product of the same long-term policy and investment decisions that Freeman had called "wrong, real wrong."

Stumbling Into Riches

As electricity prices on the CPX exploded past $1,000 a megawatt hour, the LA DWP was in a position to make a windfall. It had already made more than $200 million in 1998 and 1999 by selling surplus power to the state's stained transmission grid. Becoming more than competitive, the LA DWP made a $402 million profit in 2000. It could easily sell an average of 1,200 megawatts a day indefinitely.

The profits would allow LA DWP to pay off its $4 billion power plant debt by 2003.

Fawning stories started appearing in the press about Freeman's genius and savvy. He was "an eccentric native Tennessean" and "a tough and wily negotiator" with "a rich history in the energy world." This

was largely hype. If not for the tax status of its bonds, the LA DWP would have joined SoCal Ed, PG&E and SDG&E in the ISO death spiral—before Freeman even came aboard as general manager.

Aside from the lucky move of avoiding the effects of AB 1890, LA DWP's energy sources—through the IPA and elsewhere—were mostly coal-burning, hydro and nuclear plants. Unlike most electricity generators, the municipal utilities weren't shocked by the high natural gas prices of 1999 and 2000.

In short, the LA DWP had stumbled into riches. In the lobby of its headquarters, a large digital scoreboard kept track of the muni's campaign to erase its debt. Through 2000 and 2001, the number ticked downward sharply.

At City Hall, there was some disagreement over what to do with the proceeds. Mayor Riordan feuded with Freeman over the prices that the LA DWP charged outsiders. The mayor thought that 15 percent over cost wasn't enough; he wanted the big muni to meet its timetable of eliminating debt by 2003.

Riordan worried about the investor-owned utilities—not that they'd devour the LA DWP but that they'd go bankrupt and stiff the city for the hundreds of millions they owed. When Riordan was quoted saying that San Francisco deserved "no mercy," it emphasized his profit-driven perspective.

Riordan was reassured slightly when Gray Davis issued a declaration of emergency that guaranteed the debts. At that point, Riordan supported a LA DWP plan to build a $400 million plant that could serve 400,000 out-of-towners—as long as the state guaranteed purchases for five years.

Riordan got his way on the pricing a few months later, when the LA DWP brought in about $1,400 for each of the nearly 1,000 megawatt-hours it sold daily in early February 2001. Officials said the prices—which would be paid for with taxpayer money through the Department of Water Resources—reflected the cost of natural gas on the spot market.

If this sounds familiar—and ironic—it's because the LA DWP acted like an aggressive marketer. It didn't get out-marketed by the big investor-owned utilities, like some had predicted. The critical shift occurred because it was able to keep its power plants. Controlling generation is key to power in a rising commodity market.

The main question that remained in 2001 and 2002: Could the LA DWP keep it going? If the electricity crisis of early 2001 was just a market irregularity caused by unworkable laws, would those problems be fixed...and would the LA DWP end up in the same trouble that had been predicted for it years before?

Surviving Deregulation

Questions about the LA DWP's future headed one direction; questions about the other munis lead another.

The success that the LA DWP enjoyed through 1999 and 2000 made a lot of other municipalities—from San Francisco to San Diego—consider starting their own utilities.

In the far-north city of Redding, economic development officials touted their public utility as a reason for Silicon Valley businesses to move north. In San Francisco, city officials liked the idea of starting a municipal utility. But San Francisco voters had, fairly consistently, taken a dim view of public power. In 1982, voters rejected a measure to study the concept after being told it would cost $700,000 to explore the idea...and $1.4 billion to complete. (PG&E considered its San Francisco transmission system worth $1 billion but said it wasn't for sale.)

Near Los Angeles, West Hollywood city officials wanted to dump SoCal Ed and move to the LA DWP or their own utility.

In the San Diego area, where customers watched their electric bills triple during 2000, the city of San Marcos passed a resolution to form a municipal utility. San Diego County and the cities of Chula Vista and Escondido also studied the idea.

Of course, there were some major differences between Los Angeles—with millions of customers and billions in annual revenues—and San Marcos, which would have fewer than 100,000 customers.

Public utilities tend to have lower rates because they don't have to make profits or pay taxes, can borrow at lower rates and have access to federally-subsidized power projects. If they are large enough to qualify.

SMUD's Losses

Most California public utilities weren't as big or as fortunate as the LA DWP. They faced uncertainty over conservation and possible blackouts because they generated little power themselves, instead they imported it over the same power lines serving everyone else.

The Sacramento Municipal Utility District (SMUD) lost $68 million due to the summer of 2000's soaring wholesale power costs; but the losses were absorbed by reserve funds so customers wouldn't see a rate hike. The 512,000-customer SMUD—a third of the size of the LA DWP—was on the same rickety power grid as PG&E. It suffered three blackouts in early 2001.

In 1997, SMUD planned to pay down a significant amount of its stranded costs in order to lower rates to projected market levels in 2002. Its management expected to accomplish this without increasing rates, due in large part to its increasing ability to take advantage of low-cost market purchases.

SMUD purchased more than half of its capacity from the spot market. Its largest generating resource was a 650-megawatt hydroelectric plant that provided relatively low-cost power; however, its output varied widely, depending upon water conditions.

Deals Between Small Munis and Big Utilities

In the spring of 1997, SoCal Ed approached Riverside city leaders with a proposal to take over the municipal utility.

Riverside planned to open its borders to "phased-in" competition starting in January 1999, pending City Council approval. The city had already approved a 2.85 percent rate increase in 1997 and another hike of 5 to 7 percent was likely over the next year. But Riverside officials weren't sure this would be enough.

The following month, the Anaheim City Council voted to spend $150,000 to study whether it should entertain similar offers. In many ways, Anaheim's utilities department—including 150,000 residential customers—was on much more solid ground than those of some other California cities.

With Disneyland, Anaheim Stadium, the Anaheim Convention Center and an industrial belt of factories including Delco and Boeing in its territory, the utility serves a power market that is more than twice as large as that of any other city in Orange County.

Anaheim's utility generated more than $300 million in revenue in 1996. More than $11 million of that went to the city's general fund, helping to pay for police and fire protection and road building, among other city services.

The Anaheim Public Utilities Department was founded in 1895, when the city's first electric power plant bathed the downtown in light. More than 100 years later, it was the only city in Orange County that produced its own power.

Although the California Plan did not apply directly to municipal utilities, a free market would force munis to compete to keep their customers. If Anaheim's biggest electricity customers chose to buy their power from private companies, the city could lose an estimated $120 million a year in revenue.

And if the city's utility were privatized, profits would go to shareholders, rather than to the city.

Like other municipal utilities, Anaheim's was heavily in debt. Spurred by the oil crisis of the early 1970s, municipal utilities in California and

across the country invested heavily in nuclear and coal power plants. In 1980, Anaheim invested $214 million in the San Onofre Nuclear Generating Station, near San Diego, making it a 3 percent owner of the plant. Five years later, Anaheim invested $704 million in the Intermountain Power Agency.

Those investments, combined with others in various generation plants, electricity transmissions lines and the money the utilities department borrowed to build its own office building, left the Anaheim utility more than $1 billion in debt.

In November 1997, the Anaheim City Council voted to seek partners or buyers for its 103-year-old electric utility as it braced for the deregulation of the industry.

Public Utilities Department officials sent out 58 information packets to private companies that might be interested, including SoCal Ed.

Odds and Ends to Opening Up Competition

Pasadena, which expected to open up the city to power competition in January 2000, had already raised rates 15 percent across the board, cut 30 percent of its staff through layoffs and attrition and begun selling underused assets. A plan to build a $23 million office building was also scrapped.

Faced with the burden of enormous debt, unproductive assets, high overhead and bankruptcy, Pasadena had little choice but to take drastic action.

The City Council also voted to reduce the "transfer," or share of gross electricity revenue that it pays annually to the city's general fund, to $6 million from $8 million.

Although a new policy was not yet established fully, Anaheim moved toward opening its service area to all power providers by January 2000 or earlier.

The utility, which served 106,000 customers, had been restructuring for several years to prepare for deregulation, refinancing its debt when possible and reducing its payroll by 12 percent since 1990 to the current 400 jobs. Anaheim avoided raising rates through most of the crisis; and it expected to avoid doing so in the future. Anaheim issued a public request for proposals to generate ideas on how it could reduce costs and risks, as well as how to develop new businesses. One possibility: linking its customer base with fiber-optic wire to sell entertainment and telecommunications services.

Burbank Public Service, fully aware of the need to compete with neighboring utilities, would open its service area to competition in 2000.

General Manager Ron Stassi said the utility had reduced its payroll by 40 positions over the previous 18 months through attrition and early-retirement offers. The council approved a 1 percent rate increase to fund public benefits; another rate increase of less than 10 percent was likely over the following year. Stassi said the utility was holding off joining the free market as long as possible because it wanted to see how everything shook out.

Public utilities in much larger areas like Los Angeles, with 3.8 million residents, and its suburbs of Burbank and Glendale, with populations of 106,500 and 204,000 people, respectively, made the same decision to remain in control of their distribution systems. This has also kept them shielded from blackouts and provided opportunities to make money by selling excess power to the ISO.

Service Before Profit

Although the LA DWP was described as savvy and visionary during the January 2001 electricity crisis, the truth was much less flattering. The big muni had stumbled into prosperity because its mission—which put reliable service ahead of profit—had kept it away from the more bizarre elements of the California Plan.

As one, slightly jealous, executive with an investor-owned utility sniped: "They're the Forrest Gump of the industry."

14

During the summer of 2000, the first signs of trouble surfaced in California. The investor-owned utilities—which were losing money but weren't bankrupt yet—had trouble buying enough electricity on the spot market to meet air-conditioner-driven demands. In mid-June, PG&E experienced a few, small blackouts in the San Francisco Bay area when it couldn't get power into its substations on time.

Outsiders Throw a Few Jabs

Although these blackouts didn't take on the ominous meaning that later ones would, they were a sign that the California Plan was having problems. Unfortunately, Californians were in no mood to recognize the signs.

A constant theme of commentary from outside of California about its energy problems was that Californians were childish about wanting large amounts of cheap electricity without having any ugly or dirty power plants in their neighborhoods. The definition of "neighborhoods" was usually extremely broad. As the (very East Coast) pundit Charles Krauthammer wrote:

> Californians refuse to acknowledge that in the real world their desire for one good (an unsullied environment) might actually conflict with another (their desire for hot water in their Jacuzzis).

The indulgence wasn't all about Jacuzzis, either. The flinty *Wall Street Journal* opined:

Along with the rest of the state, the high-tech sector has lived too long in a la-la land where you don't have to do any sort of realistic thinking about your political choices. ...If a cultural flaw is apparent in the state's approach to its troubles, it's one of not facing up to trade-offs.

In public policy circles, this childishness is known as not-in-my-back-yard or NIMBY politics. Californians are often guilty of NIMBY politics—and this attitude pervaded the entire lifespan of the California Plan.

Examples of NIMBY thinking abound; but perhaps the clearest example came in July 2000 and took place on the southern end of the San Francisco Bay.

PG&E's Floating Power Plant

An unusual plan to put a floating power plant on the Bay started sinking as soon as local environmentalists heard about it. The power plant, called Rio Da Luz ("river of light") sailed through the Panama Canal from Texas toward San Francisco, where it was expected to arrive in early August.

The idea for floating a power plant on the Bay was hatched by PG&E after a record heat wave sent energy demands soaring as well as local blackouts. PG&E planned to dock the barge either at San Francisco International Airport or the Port of Redwood City; it would fire up the 95-megawatt plant during critical energy shortages to avert more forced blackouts. According to PG&E's license application, the floating plant would be limited to 200 hours of operation a year.

The barge raised a number of regulatory issues. Least troubling was getting a license from the California Energy Commission—the agency that permitted all power plants in California (and was separate of the CPUC). The Commission had been ordered by the governor to expedite permits for plants under 100 megawatts, sometimes called microgenerators.

More troubling were permits from local authorities in the area where the barge would be located. Local environmentalists complained to the San Francisco Bay Conservation and Development Commission, which agreed that the barge "might" cause pollution. This commission—which had some zoning/development experience but no energy experience—then questioned PG&E's need for the plant.

The barge had been built in the early 1970s. Its plant included four turbine generators fired by jet fuel. Environmentalists said the fuel was dirtier than the natural gas used in modern plants. On the hot days when it would be fired up, it would worsen air pollution. But PG&E pointed out that jet fuel was cleaner than the diesel oil burned by generators at hospitals and many companies during energy shortages.

The Bay Conservation Commission deemed power plants "inappropriate" for bay waters. San Francisco environmentalists, watching this result on their high-definition TVs, cheered the result. They got on their computers and e-mailed friends around the globe to boast of their victory; and they called each other on cordless phones.

And the impression that Californians were childish NIMBYs hardened a little more in the national consciousness.

Ill-Prepared for Self-Sufficiency

The history of NIMBY politics goes back a long way, but it surely ramped up during the 1970s when California essentially froze development of any new power plants. This left the state without adequate generating capacity.

Soon, California was importing 25 percent of its electric energy from neighboring states; and that number would remain steady for almost 30 years.

In the 1990s, when the surrounding states started growing faster than California and needed energy for themselves, it was too late for California to offset the loss by building up its energy infrastructure.

When AB 1890 was bolted together, California politicians like Steve Peace and Pete Wilson assumed—perhaps without even realizing it—that the state could rely indefinitely on surrounding states to meet its energy needs.

Given California's regulatory history when it came to generating electricity, Peace and Wilson built their elaborate house on a foundation of sand. They prepared no contingency plan for when supplies grew tight and prices became volatile.

No Such Thing as a Building Spree

The NIMBY myopia allowed for the simplistic complaint that California's energy problems were the Feds' fault. Through late 2000 and most of 2001, childish Greens from La Jolla to Orinda complained that the blackouts and enormous prices had been caused by the FERC and George W. Bush.

When those arguments didn't hold up, the children shifted gears and blamed "out of state price-gougers" like Enron and Duke Energy. But even California's belated efforts to build power plants wouldn't fix the immediate problem. The building spree was a long-term solution…and the state was having a short-term crisis.

In one of his executive orders, Gray Davis instructed all agencies involved in licensing new plants to submit their findings within 100 days of receiving a completed application. Before that order, there had been no deadline for application reviews. Applications were often bogged down in reviews that lasted years.

In August 2000, Duke Energy asked Gray Davis to speed approval under emergency authority to ease the state's electricity shortage. Duke dangled a proposal to sell fixed-rate energy directly to utilities—company officials said this would protect consumers from price spikes. Duke's proposal was greeted with suspicion by conservationists, who opposed the company's plans to upgrade power plants in Moss Landing and Morro Bay. Duke planned to make the Moss Landing plant the most powerful in the state and to overhaul the Morro Bay plant.

Environmentalists said Moss Landing's cooling water system would hurt fish populations and doubted that Duke's offer of $7 million for wetland restoration would be enough to make up for the harm.

A Duke spokesman, on the other hand, said the company's request to "streamline the permitting process," which he called the "most onerous" in the country, wasn't intended to short-cut environmental review. If the streamlined permitting process were the quid, Duke also offered a pro quo. It asked the CPUC for approval to sell five-year energy contracts of up to 2,000 megawatts at $50 per megawatt-hour directly to the investor-owned utilities. This was a significant break from the current market prices.

Of course, the law in place at that time required energy companies to sell power through the CPX. It explicitly prohibited direct deals with utilities. The economic and political support for that prohibition, however, was crumbling. Consumer advocates—again—argued that the state should simply abandon its two-year-old experiment with energy deregulation.

Old Plants and New Barriers

From 1996 to 1999, electricity demand in California grew by 14 percent, while power supply grew 2 percent. Over a slightly longer period of time—eight years—demand had increased by 25 percent while supply expanded only 6 percent.

By 2000, 65 percent of the state's power plants were more than 30 years old, meaning they needed to be shut more frequently for service. As a result, the state imported as much as 25 percent of its power during periods of peak use.

The last major power plant built in California had been the Diablo Canyon nuclear power plant. Since Diablo Canyon had come online in 1985, the state had grown by 8.2 million people, created 3.5 million jobs and built 2.4 million homes.

Companies that needed steam to make products built smaller co-generation plants. The electricity generated usually went to the local

utility company. Procter & Gamble built one of these plants in March 1997; Campbell's Soup finished a 158-megawatt facility seven months later. No more such plants were built between 1997 and 2000.

So, California was relying on dirty 1950s-era facilities to keep lights on and air conditioners humming. With so much of the state's energy produced by old plants, it had become a classic example of the best (pollution-free energy) being the enemy of the good (relatively clean energy). Peace and the other pols who built AB 1890 had anticipated a building boom for power plants. It never happened. Energy companies said the California NIMBYs put too many barriers in the way. And there was plenty of anecdotal proof of these barriers:

- After AB 1890 was approved in 1996, Reliant Energy bought land to build a 300-megawatt plant near Barstow, next to an existing plant the company owned. In theory, the new plant could have been up and running in a year—but the company backed away from the project, citing regulatory delays. Instead, Reliant looked for locations in Nevada and other Western states.

- Constellation Energy Group was a partner in a proposed $400 million, 700-megawatt plant on the closed George Air Force Base in Victorville. With a local partner, it spent $11 million in design and licensing for the plant. Final construction permits were issued but ground was never broken. A local developer, who was building 4,700 homes nearby, objected that the plant's cooling system would consume enough fresh water to fill more than 65,000 swimming pools a year. He demanded an environmental impact report—for the cooling system, not his 4,700 homes.

Crises Change Behaviors

Why did Californians act so childishly—expecting cheap energy and no power plants in their state? Sheldon Kamieniecki, a professor of political science at the University of Southern California, blamed a pervasive sense of entitlement. He argued that Americans believe that, because they are the most powerful nation on earth:

...everything should be affordable, especially if [like electrical power] it's a basic need. Americans tend not to react to appeals. They will not change [their] behavior unless there is a clearly perceived incentive or disincentive.... . [However] they respond very well to price changes.

Following the logic of this theory, Californians required an economic crisis to change their NIMBY ways. Later, Kamieniecki would say that he saw anecdotal evidence that people were behaving more consistently in the wake of the January 2001 blackouts. Home supply stores reported heavy sales of high-efficiency lightbulbs; demand for retrofitted solar installations was also up markedly.

Also, as 2001 progressed, the easy political posturing against "price gouging generators" lost its effect. Californians were grudgingly realizing that market forces beyond greed were at work. Independent power generators like San Jose-based Calpine realized this was an opportunity to trump the rhetoric of lazy NIMBYs.

NIMBY politics had tried to deny supply-and-demand economics. The results added to a crisis for California. Demand was up because the California Plan capped the consumer price of electricity, thus preventing price signals from restraining demand. The California economy had expanded by 34 percent in the previous 10 years.

Defying official forecasts made early in the decade, California's power consumption grew by a quarter during the 1990s. The most dramatic factor fueling the growth in demand was the digital revolution, spawned in Northern California. As computing power spread to everything from the manufacture of microchips to the frothing of cappuccinos, California defied eco-pundits and state officials who forecasted that the Internet and the "new economy" would inevitably lead to less consumption of electricity. In the Silicon Valley area, consumption was growing at about 8 percent a year.

On the supply side: Power plants were considered dirty, intrusive and ugly. So, California hadn't built one in 10 years. Delays in power plant approvals, usually driven by local opposition, helped put the state in its bind. They certainly had a chilling effect on development.

Power companies were less likely to start projects that they expected would get bogged down in environmental impact reports and other red tape.

A Howling Coyote Valley

Environmental activists always objected to the term *NIMBY*. They argued it was a slander concocted by the power industry and designed to trivialize legitimate concerns. As the power crisis loomed, the activists feared that they were being made scapegoats for the problem—rather than concerned citizens.

They argued that California was on the verge of a lot of bad decisions, borne in an atmosphere of near-panic. But these arguments were disingenuous. Through most of the 1980s and 1990s, environmental activists up and down the California coast prided themselves on delaying the construction of power plants.

NIMBY hypocrisy reached a high (or low) point in a dispute of the proposed 600-megawatt Coyote Valley generator that Calpine Corp. wanted to build in San Jose—the CPU of Silicon Valley. Planned to sit against a hill in the southern part of San Jose—where existing transmission towers already carried power from Canada to Mexico—the $400 million Metcalf Energy Center would direct nearly all of the power it created into San Jose and its surrounding areas. Calpine had already received the licenses and permits that it needed to build the plant from the California Energy Commission. The Commission had endorsed the plant as a relatively clean and efficient source of electricity for an underserved part of the state. But the project still needed local support—and changes to the city zoning regulations, which limited the semi-rural area to office space.

The San Jose City Council vetoed the project in late 2000, even though groups ranging from the Sierra Club to the NAACP. supported it. And even though Silicon Valley was about to suffer the worst of the early 2001 blackouts.

Why such a foolish decision?

The plant faced opposition from Cisco Systems, the leading producer of high-speed fiber-optic networks…and San Jose's largest employer. Cisco argued that the power plant would be an eyesore next to an industrial park that the company was building for 20,000 employees less than a mile from the land being considered for the power plant.

The local neighborhood association—working with Cisco—raised concerns about air quality and "incompatibility with the surroundings." Calpine officials made no secret of their suspicion that Cisco's opposition, rather than the merits of the case, led to the city council's rejection.

The irony and hypocrisy weren't lost on anyone…except, it seemed, Cisco's management. The computer networks that made Cisco a giant company required large amounts of electricity, but Cisco thought the generation of that electricity was someone else's problem.

In the end, state regulators could effectively overrule the city council's land-use ruling. They would support the power plant against the local community's wishes.

Trading Clean Air for More Juice

California had the nation's strictest air pollution rules. The rules had worked; during the late 1990s, the state's skies were cleaner than they'd been in decades.

But the power crisis of early 2001 changed the state's priorities. Amid rising demand and inadequate supply, some 15 new power plants were in the works. Blueprints that once might have been shelf-bound were getting a friendlier look.

Also, the state allowed a number of power plants to exceed their limits of toxic emissions temporarily—until new plants were completed and brought on line. To do so, the plants had to buy "credits" from less-polluting generators, agree to eventually install emission-cutting equipment and/or pay fees that funded other smog-fighting programs.

Of course, the additional costs were dwarfed by the plants' increased profits. Duke Energy was content to pay upward of $35,000 in daily pollution fees at its Morro Bay plant. The number of power plants taking advantage of the raised emission ceilings was growing. For example: In the city of Glendale, California, its municipal power agency wanted to begin operating its Grayson Power Plant at night, boosting output by 40 percent. That would enable the Los Angeles suburb to sell surplus electricity to the ISO. The trade-off, however, would be more smog—at least in the short term. Several groups in Glendale (which, being in the San Gabriel Valley, already had pretty smoggy air) objected loudly.

This sent NIMBYs to the newspapers and the picket lines; but the urgency of the power crisis trumped their protests. Gray Davis triangulated the issue. He'd carefully built up credibility with NIMBYs by backing their childish politics for some 30 years—now he would draw on that political capital by allowing the additional pollution.

Besides, the energy crisis didn't mean Santa Barbara was turning into Calcutta. California still had to comply with the federal Clean Air Act. That law required steady reductions in ozone-forming emissions, such as nitrogen oxides, most often released by generators that burn natural gas. There had been no serious moves in Congress to water down the Clean Air Act for electricity makers. But there was no doubt that an inching retreat was under way in California.

Having Their Cake and Eating It, Too

If there was a silver lining to the failure of the California Plan, it was that it drove a stake through the heart of NIMBY politics. It showed Californians—and most Americans—that hard choices have to be made. You can't have adequate electric power without sufficient generating and delivery capacity.

This was part of the reason why Washington politicians supported Bush's plan to end the federal order requiring suppliers to sell electricity to California.

State officials realized they had to find ways to get around the NIMBY problem. One possibility—suggested by Gray Davis himself—was that the state withhold funds from localities that are particularly obstructive, in the way that the federal government withholds highway funds from wayward states.

Fixing the consumer market was just as important as boosting power generation. Unless consumers could see fluctuations in prices—especially during peak-use periods—they'd have no incentive to save power or to shift their use off-peak. This would lead, and in California did lead, to considerable wastes of energy.

Too many Californians believed for too long that they could have all the energy they wanted as cheaply as they wanted without constructing power plants or transmission lines.

15

As the summer of 2000 inched toward a close, the prices charged on both the wholesale and retail fronts concerned industry insiders.

Pricing has always been the secret center of electricity regulation (and, for that matter, all regulation). Regulators, politicians and utility executives might talk about capacity, convenience and reliability—but what regulation is really about is money.

The Regulatory Compact

The traditional business model of electric utilities was conceptually simple. Local or state governments granted monopolies to individual companies and controlled these companies by regulating how much they could charge customers. Utilities generated electricity and delivered it to customers in exclusive territories.

The main difficulty was that supply had to be able to meet demand at all times, although demand would vary widely from day to day and hour to hour.

The regulators handled this challenge by requiring utilities to generate more than enough power...but allowing them to charge for all of it, regardless of how much they actually sold. The result was tremendous reliability but also inefficiency and waste.

Regulators and bureaucrats called their deal with utilities "the regulatory compact." Like any compact, it put obligations on both parties.

A utility had to:

- Serve everybody in its area;

- Make sure that the power flowed reliably, not in fits and starts;

- Amass enough capacity to meet peak demand, not just average demand;

- Open its ledgers to the state regulators; and

- Charge customers only what the regulators allowed.

The bureaucrats (representing the consumers) had to:

- Fence off a territory and its consumers as the exclusive preserve of a single utility; and

- Make sure that electric rates stayed high enough to give the utility a good shot at a profit.

Traditional utilities were usually required to serve as "providers of last resort"—obligated to buy electricity and keep it flowing to customers in non-economic places or conditions.

This provider-of-last-resort responsibility had two elements. One was a long-term obligation to plan, design and build major generation, transmission and distribution facilities of sufficient capacity to ensure a reliable supply of power to their customers. The other covered daily operation of these facilities, which included running adequate backup generation and transmission in case of unexpected outages. Remember those terms: *capacity* and *transmission*.

In short, the traditional utility business model assumed that the energy companies had to take on business that a for-profit company wouldn't. That's why most of the pricing models weren't based on sales and the cost of sales. They were based on the assets—power plants, transmission lines and other hardware—required to make all of the sales.

Playing in a Flimsy Market

The California Plan made a hash of these traditional structures. First, the CPUC split the integrated electric-power industry into its generation, transmission and distribution components. This created a market for independent power generators; it also opened the economic door to nonregulated players like power brokers and Wall Street commodity traders.

These nonregulated players, operating on the CPX but also in a cloud of deals taking place around the CPX, made up the "market" that was supposed to set prices for electricity.

Utilities would no longer be guaranteed a fixed rate of return or an exclusive service territory. Left to the dictates of the market, they would have to focus on profit per kilowatt-hour as the ultimate measure of where and when they'd sell power. This simple standard had great popular appeal: No more hocus-pocus behind closed doors of CPUC meetings. Either utilities could make money or they couldn't.

But the reality wasn't that simple. The tradition of the regulatory compact blurred a lot of the business that utilities did. Because demand is always unpredictable, high levels of reliability required some overproduction, which ate into profit margins.

Using their knowledge of trends and average use levels, utilities could make steady profits providing most of the electricity a city or town needed. A well-run utility could provide reasonably cost-effective energy for 80 or 90 percent of average use during a given period of time. Providing that last 10 or 20 percent was a risky business, however, even in the best times and circumstances.

Questions: Who would assume providers' responsibilities from the old regulatory compact? Who would make sure that last 10 percent of the electricity a region needed would be available?

Technically, the answer was the ISO.

Practically, the answer was nobody.

With the FERC looking over its shoulder, the ISO was supposed to ensure reliability in the California market. It was supposed to coordinate with the CPX to provide utilities with adequate "spinning reserve" for daily operations, in compliance with reliability standards.

Mechanically, the California Plan prohibited utility companies from entering into long-term contracts with generators, leaving the utilities reliant on spot-market pricing. This was supposed to guarantee business for the CPX; it ended up killing the CPX.

According to the California Plan, the CPX was supposed to be more than just a commodity exchange. It was supposed to be the grease between two hard pieces of the energy machine: the fixed prices the investor-owed utilities could charge customers and the free wholesale market for what electricity generators could charge the utilities.

The CPX wasn't lubricated enough to make these different interests mesh. Nothing could be.

Market Power

The California Plan mistook how easily market power could be concentrated. To achieve market control, a generator needed to own only a significant part of the 10 percent of capacity that represented the "reserve margin"—the difference between reliable power and a blackout at peak demand.

This meant that a generator providing as little as 3 or 4 percent of the electricity traded on the CPX on a given day could signal to other generators what it was going to charge.

As 1999 wore on, prices stayed high even through cooler weather, on weekends and at night—periods when prices usually drop with demand. Consumer advocates worried that this was "market power"—the ability of a supplier to increase prices for a sustained period of time. Electricity sellers could do that by withholding some of the power

they had to sell so there would be less electricity in the market and buyers would be willing to pay more to get what they need.

Frank A. Wolak, a Stanford University economist who studied the California electricity market, estimated that average prices during the summer of 2000 were 37 to 182 percent higher than would be expected in a perfect, competitive market.

Clearly, the market was heading for some kind of reckoning.

Through late 2000, relatively few companies entered the CPX to sell electricity on the wholesale market; many chose to wait and see what the retail price caps would do to the marketplace. This gave each of the ones that did sell there a big influence over CPX prices. A truly competitive electricity market requires lots of generating capacity and—more importantly—lots of generating companies. A regulated market can do fine with a few, vertically integrated companies.

No Sense of Organization or Obligation

When the California Plan separated generation from distribution, no organization with operational capability had an "obligation to serve" and to assure reliability. On paper the ISO was supposed to assure reliability—but the ISO didn't own any power plants.

These factors combined to push up the wholesale cost of electricity, gradually at first and then rapidly during the end of 2000 and beginning of 2001.

The absurdity in front of all this was that the state's biggest utilities— SoCal Ed and PG&E—were barred from increasing the rates they charged consumers.

Some observers compared the situation to the market of airplane tickets. The California Plan made it illegal to buy airplane tickets in advance; unable to lock in a cheap fare weeks or months ahead of time, travelers (the utilities) might be forced to pay exorbitant amounts when they walked up to the gate. The California Plan assumed that, by prohibiting advanced sales, it would force the airlines to offer bet-

ter prices for walk-ups. But, in this case, the airlines stuck to their old pricing structure.

The idea behind deregulation was to cut consumers' costs by giving them a choice in who provided them with electricity. In most regions, however, the tradition of heavy regulation meant there was only one power grid across which to move electricity. No single consumer was ever certain he was getting the same watt that his chosen power company sent. Power grids were inherently socialistic.

In the 1990s, utilities bought power from farther away, through a system of bulk power trades approved by federal regulators a decade before. This was the arena in which brokers such as Enron became major factors.

Although the amount of power consumed nationally edged up a modest 2 percent a year during the late 1990s, that power was being pushed over greater distances on existing power lines, rapidly filling up the capacity of those lines and leaving very little room for disruptions.

California's peak power demand jumped 5,522 megawatts—that's enough for 5.5 million homes—between 1996 and 1999, while generating capacity went up just 672 megawatts.

Giant Teapots Boiling Water

Capacity is always a challenge for a regulated market. It's basically a technical application of supply and demand, the functional relationship between the two.

Free markets will sometimes have capacity problems, when companies get out of synch with demand.

True free marketers accepted power outages as a sign of an efficient system. A system that never blacked out was one that was generating too much electricity—like the regulated systems of earlier years.

But that "true" is the key misunderstanding to the whole California Plan.

True free marketers make lousy politicians. Elected pols and the bureaucrats they appointed had a hard time accepting the blackouts. The costs—in terms of angry voters—was too high.

No matter how Steve Peace tried, he couldn't remove the politics from the energy market.

Electric utilities weren't discretionary services like airline travel. Most people think of electricity, water and gas for heating as essentials...to which they have rights...provided by the government. And the very word "utility" suggests a special deal between providers and users.

An electric power plant is really a little more than a giant teapot. It burns fuel to boil water, which make steam that turns a turbine and generates electricity. There are only so many ways to boil water.

In the late 1960s and 1970s, electric utilities focused on building larger power plants. For a while, this boosted the industry's efficiency; but, at a certain point, the bigger teapots become unwieldy...and not so efficient.

Asset-Based Management

As the 1970s wore on, some huge power plants were actually less efficient, costing more to generate a megawatt of power than the smaller plants they were replacing. In effect, these plants were built on spec. The utilities hoped that the huge size would work as a kind of leverage; if fuel were cheaper, the big plants would become wildly profitable.

Furthermore, if fuel became more expensive, the utilities could ask the bureaucrats to raise rates.

This was the environment that made nuclear power attractive. Once all of the engineering and safety issues are resolved, nuclear power is inexpensive. A giant nuclear power plant could, in theory, be extremely profitable. The problem was that the engineering and safety issues were not so easily resolved. They grew like weeds in the nuclear facilities, driving costs way up.

California's two nuclear power plants, which provided about 20 percent of the state's electricity, suffered massive cost overruns that were largely passed on to consumers. PG&E's Diablo Canyon plant was estimated to cost $400 million, but ended up costing $5.8 billion. The San Onofre plant, jointly owned by Edison and SDG&E, was budgeted at $1.3 billion but cost $4.3 billion.

The failure to economize was the most frustrating characteristic of regulated utilities. Regulators allowed the utilities to earn a fixed rate of return on their assets—which the industry blithely came to call "asset-based management."

The more money that a utility spent adding generators and other assets to its local power system, the more money the company made. Thus, cost overruns on nuclear plants didn't bother executives of the regulated utilities. In fact, they stood to profit more greatly from over-runs—as long as the regulators approved the expenses.

In the case of nuclear plant development during the 1970s, the regulators were under pressure from elected politicians to develop alternative energy sources. So they signed off on just about anything.

It was Erroll Davis's famous quote about "increasing your profits by redecorating your office" writ large.

It may seem that this same point has come up several times in several places throughout this book. It has. The point about the asset-based management bears repeating because it shows better than any other point how utility executives thought. They were raised—professionally—in an environment that was diametrically opposed to free-market profit motive. As one former PG&E executive says, recalling the several years after AB 1890 became law:

We were like mole men who were suddenly tossed into a Palm Springs swimming pool. We had no idea where we were…or what we were supposed to be doing.

Expecting them to change dramatically because several hundred pages of a bill had been passed into law was unrealistic. The best that these

mole men of electricity could do was follow the herd. And that herd mentality only exaggerated the effects of price points and market trends.

A Hard Commodity to Manage

When there's too much capacity, existing owners of supply will probably sell their surplus (in this case, electricity) at only slightly above their marginal costs. For them, any price that exceeds fuel costs helps offset any remaining capital costs.

But these prices usually won't entice many new entrants into the generation market unless they can build plants that generate electricity more cheaply, including capital, than the fuel cost of existing ones.

Electricity is an especially hard commodity to manage—its capacity is often out of balance. Except for tiny amounts in batteries, nobody can store electricity. A utility cannot use its slow periods to stock up on power for busy times.

Instead, a utility has to crank up at the moment of demand. And as the clock and calendar move along their cycles, demand for electricity bobs up and down maddeningly. Demand cycles usually mirror most people's lives—slow during the night, busier in the morning and busiest by mid-afternoon. But even this cycle can be unpredictable.

Somewhere out there, a customer flicks on one more air conditioner—the last air conditioner in the entire area to kick in—and the utility has to come up with that last little bit of juice.

The cost of a power plant that runs only on the hottest afternoons of the summer is, more often than not, quite high. If such a plant operates only 50 hours a year, the cost might be as high as 80 cents per kilowatt-hour; if it runs a hundred hours, the cost might drop to 40 cents.

Few businesses build themselves to serve peak demand. Usually, they design themselves around averages.

For example: A 250-seat theater finds that it could sell 1,000 tickets for each showing of a Julia Roberts romantic comedy. Should it ex-

pand to 1,000 seats? No. For most movies, the extra seats would sit empty, a waste of the theater's money.

But traditionally, a utility had to build its version of that 1,000th seat. It had to build the generating capacity to serve that last air conditioner on that stickiest August day.

To get there, the utilities traded off capital costs and operating costs. This trade-off, which would be suicidal in a free market, was funded by the regulators who offered asset-based returns.

Reaching for Capital

To handle what utilities call their "base load"—the minimum demand year-round, the utilities reached for capital.

They built their base-load plants big and expensively.

Because these plants hummed along all day and all night, all through the year, the utility could spread the cost of building them over more hours of operation. A bonus: The fuel to operate these plants (usually coal) came cheap.

To serve peak demand—to power that last air conditioner—utilities built cheaper plants. Why spend a ton of money on a plant that runs only as a last resort?

The drawback: The peak-load fuel (oil and gas) tended to be more expensive to operate. Thus, the cheaper peak-load plants ran up higher operating costs than the costly base-load plants.

Another option was for utilities to swap more power with each other. Instead of generating high-cost, peak-load power, a utility might buy lower-cost, base-load power from another utility in another region or time zone.

The Concept of Capacity

Setting up a power market with the right price signals requires payments for two electric commodities—energy and capacity. In Califor-

nia, the majority of stakeholders voted not to pay for capacity as long as the reliability was free.

Power markets typically need a capacity reserve of an additional 15 percent beyond peak demand to assure supply meets demand at all times. California set up a market that paid generators to run their plants, but did not set up any market mechanism to pay generators for capacity.

This meant that prices were lower in the short run, but it also meant that prices would eventually explode in a future shortage.

When the California market tipped into a severe shortage in 2000, energy prices soared and volatility exploded at levels that were multiples of what was needed to support new investment. Besides being higher than needed to support new investment, these price increases were also too late.

A properly structured power market cannot rely on periodic shortages and reliability crises to provide timely investment incentives. It needs a capacity payment mechanism, beginning with the simple requirement that anyone selling electrical energy to customers must also buy enough capacity to cover those customers' needs plus a reserve.

Under the California Plan, individual utilities will own and maintain transmission lines but the ISO would have exclusive authority to operate them. These split assignments didn't provide a structure for handling capacity problems.

Capacity, Transmission…and Price Signals

If capacity and transmission are the main factors that control electricity prices, their functional offspring are the price signals that tell players in the market how to respond.

The key to a balanced commodities market is effective pricing signals.

Higher prices are an effective tool for matching demand and supply.

When rates in San Diego more than doubled, power consumption dropped 5 percent within a few weeks.

The efforts to hedge price signals are, by design, intended to obscure pricing signals—the information that people in the industry use to make informed decisions. They also led to some ludicrous conclusions on the part of pundits and observers who commented on the implementation of the California Plan. One of these wrote:

> There's one simple solution to California's power shortage. If the state allowed the utilities to raise rates by another 20 percent or so, plenty of power would immediately begin to flow into the grid. The problem is that nobody wants to pay more. ...you live by deregulation, you die by deregulation, too.

This misinformed quote proves the absurd lengths to which the California Plan had warped people's notions of "deregulation." This confused pundit considered a deregulated market one where the state allowed utilities to raise their rates.

That, however, is a regulated market.

Capping Prices, Hazing Signals

The efforts that the CPUC and the California Legislature took to obscure pricing signals were bad. And politicians and regulators in California couldn't resist making a bad situation worse. Surprised that the market for wholesale power responded to a supply squeeze during the summer of 2000 by raising prices, panicky officials ordered "caps" on those prices.

These caps—the ultimate obscurers of price signals—failed miserably.

Power prices shot up because supply was scarce, and the right solution would have been to let markets respond. When mid-western states suffered similar price hikes a few years earlier, regulators there hadn't

meddled in the wholesale markets; generators responded to the price signals by rushing to add supply.

California regulators pressed for price caps...and chased needed supply out of the state.

This was the latest step in an embarrassing history of miscues. California regulators had been screwing up energy prices for years. In the 1980s and 1990s, miscalculating how high oil and natural gas prices would go, they priced that alternative electricity so high that the state became a Mecca for the green energy industry. By 1994, California was home to 80 percent of the nation's wind and solar energy sources, and utilities were locked into long-term contracts.

SoCal Ed estimated that between 1985 and 2000 it paid $25 billion more for electricity under alternative energy contracts than it would have spent to produce the energy by traditional means—and passed those costs on to its customers.

In order for market competition to work, prices and profits from making electric power have to be high enough to attract new suppliers and reward expansion of power plants. In the long run, this competition results in lower costs for making electricity and better bargains and choices for consumers. In the short run, however, it poses a risk of sharp price swings.

To visualize how the California market worked, imagine a swimming pool that must be filled with water every day.

One supplier offers to fill the pool halfway for $1 a gallon. Another offers to fill up half of what remains for $5 a gallon. The bidding continues until the last supplier offers to sell the final cup. The asking price: $400.

And here's the crazy part: If the final bid is accepted, everyone who contributed water to the pool will be paid $400 a cup, even if they offered to sell for $1 a gallon. So what was the point of the bidding?

An Artificial Market

For legislators and regulators, the political remedy was price caps that temporarily established a top rate for electricity. Competing electricity providers had to come in below those rates or offer customers added services or inducements (such as costlier, "green" electricity from wind power).

The caps effectively limited the amounts companies could charge consumers for electricity during transition periods while deregulation took place.

If these price limits proved to be too low, competing suppliers might not show up. That wouldn't hurt consumers as long as the price controls remained in place.

But in a worst-case scenario, if controlled prices are too low, power suppliers may cut back on plans to build new generators, which could mean shortages and price spikes when controls are lifted in mid-decade.

As a result of the early 2001 energy crisis, millions of Californians were virtually guaranteed to be paying 19 percent more for electricity in 2002 than they were in late 2000.

The CPUC granted a 9 percent rate increase in December 2000 in response to the energy crisis. The 10 percent rate reduction that the Legislature imposed when it deregulated electricity in 1996 was set to expire in 2002, resulting in an equal rate increase. Lawmakers have already stated that they do not expect to renew the reduction.

Also, under terms of the power deals in play, they may well have to pay more to rescue the state's private utilities—although the full amount can't yet be determined.

To smooth out some of the capacity problems that caused the 2001 blackouts, the CPUC tempered the price caps with some loosening of its rules against long-term wholesale energy contracts.

Even though the CPUC loosened the rules about long-term contracts, the state failed to enter into many long-term contracts to lower electricity costs. Suppliers have been unwilling to make long-term deals without seeing the full scope of California's rescue plans, which affects whether they will get paid the money they are owed by the utilities.

As a result, the state's cost of purchasing power continued to be steep—$1 billion per month—raising the possibility that these bonds, which would not be issued until May of 2001 at the earliest, would need to exceed the planned $10 billion.

Because the issue of whether the state could enter into enough contracts to keep power prices within existing rates remained unclear, the state fell back on the price caps.

According to Curtis Hebert, George W. Bush's FERC chairman, price caps create an artificial market:

> The essential foundation must be based on adequate supply, which California doesn't have, and is showing no sign of having in the very near future.

Government-imposed price caps can backfire. When Richard Nixon capped wages and prices in the 1970s, the policy led to a burst of inflation once the controls were removed. Likewise, when the government capped natural gas prices in the mid-1950s through the late 1970s, the move created a dearth of natural gas. Only when the caps were lifted was there a rush of investment into natural gas drilling.

Paying Down the Wholesale Cost

Wholesale rates in October 2000 averaged about 10 cents a kilowatt-hour, double the average cost a year earlier. California utilities capped their rates as part of a deal negotiated with the state that requires customers to reimburse the utilities for costs associated with divesting their generating plants.

In making their calculations, lawmakers, who in the fall of 2000 authorized the sale of *another* $10 billion in bonds for electricity purchases, assumed that a temporary 9 percent rate hike for residential users approved by the CPUC would become permanent.

The utilities responded to the price caps by pressing for an acceleration of the California Plan.

AB 1890 allowed utility firms to seek an end to the rate freeze for their customers once the companies paid off their old power plant debts and other long-term power contracts. As a result, PG&E officials argued that their freeze be declared over retroactive to August 2000, when they claimed those debts had been paid off.

But PG&E officials said they didn't want to expose their customers to the full wholesale cost of power—because of the experience of consumers in San Diego, where the freeze ended in 1999. There, retail electricity prices tripled the next summer and state legislators stepped in to cap retail rates in August 2000. The public outrage still reverberated in Sacramento and Washington months later.

The FERC blamed market deficiencies and defects in California for a supply-demand imbalance that sent wholesale electricity prices shot up in July 2000 to an average of 12.9 cents a kilowatt-hour, more than triple the July 1999 average of 3.9 cents.

So PG&E's plan would let its customers pay off the $3.4 billion in electricity costs from the summer of 2000—as well the high wholesale prices it was paying months later—gradually over five years. The deal was similar to a car loan or mortgage.

Under this idea, the average monthly residential bill would increase from $54.50 a month to $63.50 a month in the first year. While that would amount to a 16.5 percent rate increase, it would be less painful than if PG&E passed on the full wholesale rate, which it estimated could boost those monthly bills by nearly 100 percent to $108.

A PG&E spokesman said that, under the plan "we are essentially going to act like a bank," by lending customers the money to pay down the cost of electricity slowly. Several years later, when more power plants were built in California, competition among those plants was expected to drive down the wholesale price of electricity to the point where PG&E's customers could pay the full cost of that power themselves.

Again, a blind faith in lower prices.

No Science Here

In January 2000, California Congress members in Washington introduced legislation asking for federal price caps; but the bill did not seem to be headed for prompt action in Congress even if there were a glimmer of hope that George W. Bush would sign it.

In early January, the U.S. Court of Appeals in Washington rejected a bid by SoCal Ed to order the FERC to cap prices for wholesale electricity. The FERC argued that the utility's request would not solve the crisis.

The three-judge panel said SoCal Ed "has not demonstrated that its right to this relief is clear and indisputable."

Just hours after its request was rejected, SoCal Ed announced it would cut 1,450 jobs over the next several months.

All of this came a day after state regulators approved electric rate increases of 7 to 15 percent, about half of what SoCal Ed and PG&E had requested.

The two utilities had lost more than $9 billion since the summer of 2000 because of soaring prices for wholesale electricity and the state-imposed consumer rate limits. That, in turn, affected their ability to borrow money to buy power and avert blackouts.

"If we were going to recover our costs, we'd need about an 82 percent increase," one SoCal Ed vice president said. Even that high amount

would only ensure against future losses, not reimburse the company for the money it has spent so far.

Company officials realized that an 82 percent increase wouldn't be politically feasible. At the same time, although a 30 percent rate increase wouldn't cover Edison's increased costs, it would send a reassuring message to wary Wall Street analysts and allow the company to borrow enough money to remain solvent.

This is not science.

Sure isn't. Capping prices didn't make it a science, either.

16

November 2000:
What the
Generators Were
Doing...and How

In November 2000, San Jose-based Calpine Corporation issued a press release reiterating its commitment to building new generation plants to help alleviate California's energy shortage.

According to Calpine Vice President Jim Macias:

> In addition to our 4,700-megawatt energy program currently under way, Calpine expects to announce plans to develop an additional 3,000 megawatts of new capacity in California. In all, we have a program in place to build some 7,700 megawatts of clean, energy-efficient generation in and around California over the next five years, representing a $4 billion investment in California's energy market. ...California's fundamental problem is an antiquated electric power infrastructure, which is threatening reliability. No major gas-fired generation has been built since 1972. As a result, this over-worked, inefficient generation base is frequently down for repair and maintenance. Currently, over 10,000 megawatts of needed capacity is offline for this reason.

Calpine's Building Goals

As of late 2000, Calpine had approximately 26,800 megawatts of base-load capacity and 5,100 megawatts of peak-load capacity in operation, under construction and in announced development in 27 states and Alberta, Canada. The company's immediate goal was to control 7 percent of the country's generating capacity—that would mean generating 70,000 megawatts a year.

Calpine hoped to achieve this more by building its own plants than by buying them from other companies. Building was expensive—but would result in natural-gas fired plants far more efficient than the ones being dumped by struggling competitors.

One of Calpine's strategic development projects was a familiar one: the 600-megawatt Metcalf Energy Center, located in southern San Jose. This was the controversial project that attracted some of the most hypocritical NIMBY objections in a NIMBY state.

Macias also cited another critical component that would help stabilize California's energy market-forward market purchasing:

> One of the key market flaws in California has been the inability of utilities to buy power ahead of time at a pre-determined price. Until recently, California's utilities were largely limited to buying power in the volatile "spot market," and had little ability to purchase power more than one day in advance of their customers' need. …Calpine is prepared to advance the benefits of our future capacity by offering very attractive supply contracts to California utilities.

This was the quid-pro-quo of the new capacity: Calpine wanted long-term deals for selling to California utilities.

Demand Outgrows Supply

Calpine's bureaucratic battles in San Jose reflected only some of the problems generators faced in California. Through most of 1998 and 1999, the California Plan essentially forced generators to sell electricity on credit to SoCal Ed and PG&E—without any strong assurances they'd ever get paid.

With 2000 winding down, capacity started to become a problem for California. California power plants could produce about 45,000 megawatts of electricity—if all were online. But that was a big "if." During peak periods, as much as a quarter of the state's capacity was often unavailable.

Plants supplying 3,000 to 5,000 more megawatts needed to be built immediately. Most generators, however, were hesitant to build these until—as one company put it—"California is in the clear."

In fact, California regulators had approved five major plants and gave permits to four plants in 1999. Prior to that, the last new plant had been approved in 1996—and the power company behind it withdrew the project.

Demand outgrew supply, as power companies waited to see how deregulation would be structured and whether building in California would be profitable.

The investor-owned utilities had maxed out their credit; the retail price controls remained in place; most people in the know predicted massive problems for the California utilities—blackouts at least and bankruptcy at most. And these problems were going to flow downhill to the power generators.

Federal regulators had started making noises that forcing investor-owned utilities to transmit, or "wheel," other generators' power to retail users was unfair to the utilities. That wheeling was the primary reason power generators had any capacity at all left in the California market.

Calpine considered the fight with Cisco Systems over the San Jose plant one of a handful of battles that would define the size and shape of any serious deregulation in California. California was sorely underserved by electricity generation facilities. NIMBYs or no, the state needed more plants. It had fallen asleep at the wheel of energy management—and was weeks away from a rude awakening.

Why California Fell Asleep at the Wheel

Back in 1997, all of the energy talk in California had been about new, so-called "merchant" power plants. These independent plants weren't linked to single utility customers or even single regions. They would sell power mercilessly to the highest bidder.

The plants would still require approval from local governments. But, in the deregulated energy market, they'd no longer need the blessing of the FERC.

The new plant developers, which ranged from independent entrepreneurial firms to consortiums of major utilities and construction companies, hoped they could produce energy cheaply enough to sell it in California's semi-free market.

In the last weeks of 1997, the California Energy Commission accepted the first power plant siting case filed under the new rules of electricity industry restructuring.

The project's co-sponsors, Maryland-based Constellation Power Development and Inland Energy of Newport Beach, proposed that the 680 to 830 megawatt power plant would use natural gas to generate electricity on a 25-acre portion of the former George Air Force Base in San Bernardino County. The application estimated that the facility would cost between $250 million and $350 million to build and would create 350 construction jobs and 20 to 25 permanent jobs.

The application process typically took 12 to 14 months and ensured the proposed project complied with provisions of the California Environmental Quality Act prior to receiving a license to construct and operate. But licensing was only part of the equation. Four years after the Constellation project, the plant still wasn't online.

Ironically, the proposals came at the same time that the investor-owned utilities were in the process of selling off or closing many existing fossil fuel-burning plants that were dirtier than new-generation plants and costlier to operate. PG&E was selling four of its power plants; SoCal Ed had sold even more.

Before the end of 1997, SoCal Ed had sold 10 of its 12 power plants for more than $1.1 billion—more than twice their book value. The gas-fired generating plants had a combined generating capacity of 7,532 megawatts; their book value was $421 million.

Let the Bidding Begin

The plants were sold through an auction lasting several months. The 40 companies involved in the process based bids on a number of factors, including the age of each plant, how the plant technology would affect environmental requirements and possible electricity rates in the deregulated market.

AES Corp., an independent Virginia-based power generator, bought the Alamitos, Huntington Beach and Redondo generating plants for $781 million. Houston Industries purchased four plants for $237 million. A consortium of NRG Energy, a subsidiary of Minnesota-based Northern States Power and Texas-based Destec Energy, bought the El Segundo plant for $87.75 million. Thermo Ecotek, a division of Massachusetts-based Thermo Electron, bought the San Bernardino and Highgrove generating stations for $9.5 million.

The higher-than-expected prices paid by these buyers reflected several things:

- the aggressive depreciation schedules that California utilities followed during their traditional regulatory period;

- the high prices that generators expected would continue in the California marketplace, even after the restructuring took place; and

- the degree to which existing power companies wanted to participate in the freelance merchant plant sales.

A few weeks earlier, PG&E agreed to sell three power plants to energy giant Duke Energy Power Services for $501 million—again, a much higher price than analysts expected.

The price—$121 million above book value—was noteworthy because it signaled that bidders were still willing to pay a significant premium to gain a foothold in California's electricity marketplace. Most analysts had expected the sales price to mimic the book value of $380 million.

Duke executives said their bid presupposed a wholesale price "in the range" of 2.5 cents per kilowatt-hour. Three years later, that would look like a ridiculous bargain.

Under the state's deregulation plan, 170 PG&E employees would continue to run the plants—Morrow Bay in San Luis Obispo County, Moss Landing in Monterey County and Oakland power plant in Alameda County—for two years under contract to Duke Energy. With a combined capacity of 2,645 megawatts, the plants produced roughly one-quarter of PG&E's non-nuclear power.

PG&E planned to sell another five plants next year: Contra Costa and Pittsburg power plants in Contra Costa County; Hunters Point and Potrero power plants in San Francisco; and the Geysers, a geothermal power plant, in Lake and Sonoma counties. Total remaining capacity for sale was 4,718 megawatts. By law, it had to keep its Diablo Canyon Nuclear Plant.

Big Numbers, Deaf Utilities

The utilities were happy that the deals brought more money than expected. Every dollar that the plants fetched above the book or depreciated value was a dollar that ratepayers would not have to pay for stranded costs from other sources during the next four years. The sales showed that top-notch firms—not fly-by-night gamblers—could replace existing utilities as power-plant operators.

However, in retrospect, the utilities should have realized that the higher prices meant other smart players doubted that the California Plan was going to run prices down. The big sale numbers were a price signal of sorts…and, once again, the utilities were deaf to their message.

In the meantime, Calpine—the largest independent generator based in California—looked elsewhere for business. While PG&E sold plants to Duke, Calpine announced that it had completed the acquisition of two plants from the Brooklyn Union Gas Co. for approximately $100 million.

The plants were locked into long-term contracts with three utilities and four industrial customers. But those agreements allowed for the sale of a portion of the output of the plants on the open market.

According to Calpine Vice President Ron Walter:

> This acquisition broadens Calpine's U.S. operating base of low-cost power plants. Equally important, the plants fit well with our strategic expansion plans to target high-priced U.S. power markets progressing toward deregulation. ...Once existing contracts expire, these plants will provide Calpine with a source of low-cost generation. They will also provide a strong base of operation for building new power plants in the high-priced energy markets of the Northeast.

Outside of California, Calpine had acquired a net ownership interest of 729 megawatts in eight natural gas-fired power plants in Texas, Virginia, Florida and New York.

Still Not Enough Juice

Three years later, when Calpine fought to get the San Jose project approved, the state regulators knew California needed more generation infrastructure. It would take until the summer of 2003 before all of the late-1990s construction produced enough wattage to guarantee the state's lights and air conditioners would stay on. And that prediction assumed that the older, dirtier power plants stayed up and running.

Wholesale prices remained stubbornly high. The utilities sold electricity at big losses. The grid monkeys at the ISO and CPX worked hard to keep energy coming into the state. At several points during 2000, they narrowly averted blackouts by paying huge premiums for imported electricity at the last minute.

The CPX imported a growing amount of power from outside of California. And, even before the January 2001 blackouts, industry types were already talking about a crisis of capacity. Politicians from Or-

egon, Washington, Nevada and other nearby states complained about their states becoming "energy farms for California."

Critics liked to point out that it took more than twice as long to license and build a power generator in California as it did in other states, including Texas.

For his part, Gray Davis offered expedited regulatory approval for new power plants in California. He promised no more open-ended application reviews; instead, approvals would be granted within 12 months.

Nine plants had been approved by the California Energy Commission since 1999. When completed, they would boost the state's power generation by 6,278 megawatts—enough for more than 6 million homes. Another 15 plants were in various stages of planning.

The Bakersfield area had four plants in the works; a fifth awaited approval. Despite California's reputation as NIMBY central, regulators said that the planned Kern County plants drew scant opposition from the NIMBYs.

But, for the moment, California still couldn't produce enough electricity to cover its needs. The state and its Frankenstein energy market were vulnerable to capacity problems.

Turnaround Time and Red Tape

"It takes seven years to build a new power plant in California, but just two years in Texas." This aphorism echoed everywhere during the worst of the California blackouts.

In truth, the numbers were exaggerated; but their political effects were real.

Rather than seven years, building a new power plant in California took about four years—two years to prepare an application and get through the permitting process and two to build. The permitting process was

actually limited by law to one year; but state regulators could stop the clock if they felt they needed additional data.

Much of the application time was spent studying and mitigating the ways a power plant could affect its surroundings: air and water quality, species habitats, soil and agriculture, noise, waste management and resources—such as Indian mounds and paleontological sites.

After two years of construction, Calpine's Los Medanos Energy Center—the first major new plant in the state in a decade—was scheduled to go online in July 2001. It would generate 500 megawatts, enough electricity to illuminate half a million homes.

The scale of the 12-acre power plant was colossal. A single blade of one of the giant cooling-tower fans was the size of a small airplane's wing; the electrical switchyard was as large as a PG&E substation.

Besides Los Medanos, new plants in Sutter and Kern counties would go online during the summer of 2001. These plants, combined with small peaker-load plants, would produce about 1,720 extra megawatts.

This wasn't even 10 percent of the 20,000 megawatts guzzled by air conditioners during the hot months.

Generating Fears About the Environment

The blackouts that came in January 2001 added intense political pressure to the building boom. The generators quickly started probing the limits of the California Plan.

AES Corp.—whose late-1990s acquisitions made it the largest private power generator in California—asked for fast-track approval of its plan to bring a pair of mothballed generators back online in Huntington Beach. The move prompted criticism that the company was trying to reap profits at the expense of the environment during the energy crisis.

Indeed, AES's record in California was checkered. It had paid a record $17 million pollution fine in Los Angeles. Its proposed legislation in Sacramento would allow power plant owners to start refurbishing projects without permits. A speedier permit process that would give the California Energy Commission sole oversight, cutting local input, would be pursued as the project proceeded.

Normally, such projects could not go forward until they won complex and time-consuming approvals from an assortment of city, county, state and federal agencies. This was the reason that the Victorville project, which began in 1997, still languished in 2001.

The mothballed generators—each about 50 years old—were taken out of service in 1995 under the former ownership of SoCal Ed. AES said they could be up and running within six months, providing an extra 450 megawatts to help fill the state's appetite for electricity.

Huntington Beach officials, frustrated at the possibility that their voices wouldn't be heard, argued that AES was merely exploiting a crisis that had already earned the company windfall profits. AES had reported a 262 percent increase in net income in the first nine months of 2000. That translated into $420 million.

More directly damning: A group of UC Irvine scientists suggested that the AES plant was a cause of pollution that closed the city's beaches in the summer of 1999. The scientists thought that water intake at the power plant—which used 300 million gallons of ocean water daily as a coolant for its operations—might have combined with currents to pull in bacteria-laden sewage that was discharged miles offshore.

But, after the January 2001 blackouts, policymakers minimized these concerns.

Huge Earnings, a Large Hiccup

The "windfall profits" argument also gained currency as the state worked to speed up its approval processes. AES wasn't the only company that made a lot of money in 2000.

Texas-based Dynergy Inc., owner or co-owner of several major facilities in California, reported a 252 percent increase in earnings from its energy trading unit during 2000. Its profit surged to $355 million, up from $101 million, and provided the bulk of the company's overall profits. While saying the strong performance of its trading unit resulted from expanded North American operations, the company sent mixed signals about its performance in California.

The Houston-based energy marketer, a major power generator in California, said it earned $105.9 million, or 32 cents per share, in the three months before December 31, 2000. This was an increase of 135 percent from the $45.1 million it earned in the same period the year before.

In a statement, Dynergy said earnings from West Coast generation assets were "not material" to its results. Yet company figures showed that California plants accounted for about 12 percent of its income. And company executives, in separate interviews and conference calls, suggested the number could be higher than 15 percent—and north of $50 million in cash.

While Dynergy officials said they were doing everything they could to help California officials solve the crisis, they expected full payment for power provided.

In a prepared statement, chairman and chief executive officer Chuck Watson said:

> I think Dynergy is in a position to capture what I believe will occur in the next several years with a new president that has given several indications he will pursue a national energy policy that will concentrate on natural gas and electricity deregulation, which is right in the sweet spot of Dynergy.

Then the company rushed out an additional statement that "Earnings from Dynergy's West Coast generation were not material." Watson added the California crisis would be remembered as a "hiccup on the road to deregulation."

Despite all of the complaints about slow approval, the constant Stage Three Alerts and intermittent rolling blackouts of January 2001 weren't caused immediately by California having too few power plants. The alerts were triggered by having an unusually large number of plants go offline—reportedly for maintenance, though some cynics thought the power generators were gaming the market to drive up prices...or selling their natural gas supplies on the spot market at a larger profit.

That was an awfully large "hiccup on the road to deregulation."

17

December 2000:

Enron

It's hard to make any review of energy deregulation in the United States without mentioning the short, fast life of the Texas-based energy trading firm Enron Corp. Then again, Enron was such a strange company, it's hard to mention it without warping all perceptions of what *deregulation* means.

During the life of the California Plan, Enron was one of the biggest players in the wholesale electricity market. It produced some electricity in California but more often acted as a middleman, trading energy on the CPX and through the ISO.

It was through this trading that Enron did most of its harm in California. Was this harm criminal? Hard to say. A December 2000 memo from one of the company's law firms certainly made Enron seem guilty. It discussed manipulative trading practices and abusive tactics that Enron traders had used to make money in the California market. But *manipulative* and *abusive* don't always mean *criminal*.

First some history. Enron had started out in the 1980s from the merger of two natural gas pipeline companies. In the mid-1980s, the company lobbied for gas deregulation, beat rivals into new markets, and turned itself into the nation's biggest buyer and seller of natural gas.

The FERC changed the rules starting in 1985, freeing utilities to shop for gas and the pipelines to search for customers. Enron embraced the changes with gusto, rapidly becoming the largest buyer and seller

of gas in North America. It then pushed just as aggressively to open wholesale and retail electricity markets, to the chagrin of the nation's entrenched utilities.

Power Marketing

A key breakthrough was the concept of a natural gas "bank" that enabled Enron to guarantee firm, fixed-priced gas contracts to industrial customers in a market where prices vary by the minute and regional prices differ widely. Enron's economic insight was to pool scores of long- and short-term contracts to eliminate the supply risk and minimize the company's price risk. Although the bank itself didn't take off, pooling contracts and tracking their cash flows enabled Enron to turn them into financial instruments that could be traded aggressively.

The federal Energy Policy Act of 1992 encouraged this kind of development. The law allowed, for the first time, "level-playing-field" access to the transmission grids owned by the utilities, which meant that utilities could no longer keep cheaper wholesale power sources out of their service areas. It spawned a new business category—"power marketer"—and Enron was quick to move into this business.

The new law mandated competition in the wholesale power market, which is the market between utilities or municipal power providers that buy or generate bulk power and resell to the end user. Freedom of access to the end user—residential, commercial and industrial customers—was left to state regulators.

Kenneth Lay, Enron's chairman, worked to transform the company into an opportunistic middleman, trading natural gas, electricity, heating oil, options and futures related to these things, energy-related tax credits and any other energy-related commodity that various parties were willing to buy or sell. Enron owned hardware—power plants, transmission lines or utilities—when it had to; but the company's real focus was on buying and selling.

Moving Losses Off the Books

Enron's spectacular collapse in late 2001 was caused by problems with a series of ill-advised and possibly illegal transactions. Simply

said, the company had a number of business units that were losing money—in many cases, substantial amounts of money. Using some tricky accounting, the company moved a lot of these losses off of its books and into a series of "investment partnerships" that were controlled by Enron insiders. The transfers had the effect of hiding the losses and making Enron seem like a much stronger company than it really was.

Once word of the tricky accounting leaked out into the investment markets (during the summer and fall of 2001) Enron suffered the corporate equivalent of a bank run. Confidence in the company plummeted and big investors sold their Enron shares. The company scrambled to stay afloat. It convinced many rank-and-file employees that they had a sort of patriotic duty to hold on to Enron stock they owned—usually in 401(k) retirement accounts—to support the company.

The scrambling didn't work. In December 2001, amid allegations of criminal wrongdoing, Enron declared bankruptcy. Congressional hearings convened. Consumer advocates around the United States called for criminal prosecutions of Lay and his senior executives.

Relative to Enron's other activities—alleged and admitted—its California operations were pristine. And profitable. If Enron could have duplicated its California operations everywhere it did business, it would have been something close to the company it pretended to be.

Rushing to Deregulation

One interesting element of Enron's activities in California was its blind support of anything called "deregulation" in the energy sector. Lay had carved out a political profile in Washington D.C. and elsewhere as an advocate of aggressive deregulation plans. His vision of the energy market was as a rugged, busy arena in which various savvy firms would do deals and set prices—like the stock exchanges on Wall Street, but with cowboy boots instead of oxfords.

In July 1996, Lay voiced his support of Colorado Congressman Dan Schaefer's Electric Consumers' Power to Choose Act. This bill would

have deregulated electricity markets all across the U.S. The bill didn't go anywhere. But Lay's support of it was instructive. He said:

> While providing choice for everyone, the bill gives the states ample time and authority to deal with such issues as universal service, reliability, stranded costs and energy efficiency. It also makes clear that the benefits of deregulation should not be unreasonably delayed. Consumer choice is the equivalent of a $60 billion to $80 billion annual tax cut. It will reduce costs to all consumers large and small, spur economic development and create new jobs. There is no reason to delay passage of this legislation. ...I congratulate Congressman Schaefer for his courage and his vision in charting a sensible pathway to a more efficient and more equitable energy future.

Two references to not delaying deregulation. Clearly, Lay was impatient to undo the traditional electricity markets.

This impatience seems suspect in hindsight. However, through 1996 and 1997, most people assumed that the companies pushing for deregulation were the ones best positioned to profit from it. So, Lay's political posturing had a commercial effect.

If deregulation proceeded, the payoff would be huge. Enron could add $300 million a year to its profits for each 1 percent share of the retail market it gained. Wall Street analysts predicted that Enron, with revenues of $13 billion in the late 1990s, could easily triple in size.

Enron was spending heavily on services and infrastructure for a free market environment. The head of one rival firm expected Enron to spend up to $500 million to develop its retail business. This was the reason for the rush. The rival predicted: "If it takes 10 years to open a sizable residential market, [Enron is] toast."

Transforming the Energy Market

Enron made much of its commitment to information management as the key to winning the power marketing game. The company defined itself as a model for the integrated energy provider of the future.

Selling primarily to utilities and municipalities, Enron saw its power revenues jump from $1.2 billion in 1996 to at least $3 billion in 1997. That put Enron in a good position for the coming electric free-for-all: The company was by far the biggest player in the wholesale market; its 19 percent of the U.S. market was almost double that of its nearest rival.

Lay and other Enron executives admitted that the power marketing business had very low profit margins, with profits on gross sales typically equal to around 2 percent. However, the early years of the power marketing business promised to offer unusual profit opportunities in the form of what traders called "arbitrage" opportunities.

Enron told everyone who would listen that it was particularly well-placed to reap arbitrage profits because it was becoming dominant early on, which allowed the company to build a bank of valuable data. It would use that data to play regional disparities in electricity prices off against one another, locking in windfall profits.

In California, it was actually able to do this. The problem was that the California Plan was a unique monster, practically built to Enron's needs.

Even in a near-perfect environment, Enron made some boneheaded mistakes. It put a large importance in building a brand identification— which is the kind of things that management gurus congratulate. But brand ID is of questionable value in the low-margin commodity markets where Enron worked.

Lay defended this strategy by saying that he wanted a clear shot at the far larger retail market selling electricity directly to homeowners, businesses and industrial consumers. These end-users had been the preserve of utilities since their inception. Traders like Enron wanted to buy cheap surplus power from utilities around the country, supplement it with power from their own plants and sell it in pricier markets. California was a perfect example.

Campaigning for Deregulation

Enron was doing all it could to hasten deregulation. In the spring of 1997, it launched a $25 million-a-year national ad campaign extolling

the virtues of free markets. Lay said he would spend up to $200 million to argue the merits of deregulated electricity.

Enron pressed the glitzy ad campaign in a bid to build its reputation as an industry innovator in the mold of MCI, Federal Express and CNN—which all took on the establishments in their respective fields and won. This campaign included the ultimate sign of overcapitalized 1990s excess: a Super Bowl ad.

The gambit came at a critical time for Enron. Setbacks in its international markets had cooled the company's profit outlook; and its spending to move into electricity forced Lay to abandon a 1995 pledge to lift profits 15 percent annually through 2000.

Nationally, deregulation was often a one-step-forward-two-steps-back proposition. After a strong start in California, efforts around the rest of the country seemed to be faltering. Schaefer's federal bill mandating open markets had been declared dead by congressional leadership. About the same time, Texas lawmakers suspended work for two years on a bill to open that state's electricity market.

In nearly every state, Enron faced off against utilities that worked hard to prevent or delay competition. So California was the critical battleground.

Enron predicted that it would have $1 billion in commercial power contracts in California by early 1998. Margins are higher for commercial customers because independent generators could bill and meter those accounts directly. Its investors were watching.

Working Hard in California

Months before the scheduled January 1998 launch of the free retail energy marketplace, Enron had more than 400 employees on the ground in California. It planned a large statewide advertising campaign with television, print, radio and direct mail. And it had already proved itself able to play regulatory politics; it had no fewer than 15 attorneys and lobbyists in California to make sure the implementation of AB 1890 went its way.

Enron wasn't about spending money in California. It also used its high-profile stock to make strategic acquisitions. It spent some $37 million to build a 39-megawatt wind farm in Riverside County. This, combined with its purchase of Zond Corp., the leading U.S. producer of wind turbines, and a partnership with Amoco Oil in Solarex, the largest U.S. producer of solar cells, positioned Enron to be a leading player in the market for alternative energy power. The wind farm would be the foundation for Enron's plans to sell "green power" under the Enron Earth Smart Power brand name.

The first farm site was scheduled to begin generating 16 megawatts of electricity in the 1998 third quarter. The second facility would begin generating another 23 megawatts in 1999. The 39 megawatts of electricity produced by the planned wind farm would supply about 50,000 homes if sold on a 50/50 basis.

At least 50 percent of electricity sold under the Enron Earth Smart Power name would be generated from environmentally friendly sources, such as the planned wind farm. The remaining half would be guaranteed not to come from nuclear, coal or oil, but from hydro-generation or natural gas.

Customers who bought power from alternative sources would pay more: An Enron spokesman said the cost for Smart Power electricity would be about the same that customers of investor-owned utilities paid before AB 1890's mandatory 10 percent discounts.

Enron also purchased the Bentley Co., a Walnut Creek-based engineering firm that won a large role this May in a $5 billion federal project to renovate government buildings to cut energy bills. This acquisition helped Enron pad its financial expertise to help customers take the risk out of buying electricity from volatile markets.

Enron fought hard against marketing units of the big utilities. It asked the CPUC to strip the unregulated PG&E Energy Services of its right to use the PG&E name. This effort ultimately failed; but it warned PG&E that Enron was going to fight for market share on every front that it could.

These steps were typical of Enron—and many companies working on the cutting edge of deregulation. They were tactically smart efforts to hedge its position in a specific marketplace. And they were more likely to raise its profile within the industry, adding to a sense of inevitability. Enron was everywhere.

Smart and Savvy Sharks

In California, Enron was aggressively recruiting customers in advance of the January 1998 start of electricity competition. Its marketing campaign included statewide TV ads, telephone solicitations and mailings to more than 2 million households.

The goal was to capture 20 percent of the state's $23 billion electricity market within five years, according to Lou Pai, chief executive of Enron Energy Services, a newly created marketing subsidiary that was spending $125 million to push into new markets.

Taking a lead from deregulated telephone companies, Enron offered Californians two weeks of free electricity and 10 percent rate reductions if they signed up.

However, for all of its apparent advantages, Enron was not a lock to dominate the California market. It didn't have access to any long-term, inexpensive sources of electricity supply. And, despite is marketing and ads, Enron had only a handful of electricity deals in place leading up to the start of the freer retail business.

So, in addition to its efforts to attract residential customers, Enron set its sights on capturing a significant share of the commercial and industrial business throughout the state. It signed an agreement with the Northern California Power Agency—a coalition of municipal utilities, including Alameda, Palo Alto and Santa Clara—to help the agency manage its power generation and energy sales. Enron also made deals with the cities of South San Francisco and Palm Springs as their preferred energy marketer. But these deals meant little certain business.

Delays and Disappointments

When the launch of the restructured competition was delayed from January to March of 1998, Enron changed its tactics to complain to California regulators that their delays were costing it money.

Although they admitted that the company didn't expect to earn a profit in the state in the first few years, the Enron lobbyists argued that the delay meant a "number of customers" it had signed up to receive cheaper energy would lose significant savings. Enron questioned whether a central market mechanism like the CPX was necessary, suggesting that power marketers and consumers deal with each other directly.

Enron Vice President Steve Kean, the head man in California, said:

> We will not be able to sell our commodity and therefore will not be able to capture revenue on the substantial investment we have made in advertising, marketing and establishing a sales force in California. So obviously we want this thing resolved quickly.

Enron estimated that it had signed up close to 15,000 residential clients, after weeks of heavy advertising throughout the state and offering customers various incentives.

Once the CPX and ISO were up and running, Enron found itself much more a wholesaler—selling its energy to the ISO—than a retail marketer. From a financial perspective, this was the right thing to do; after all, the wholesale market was the one that was really deregulated. The retail market was a money loser.

Enron still complained about the money it had invested in the retail market. But these complaints lost their urgency as it became apparent that the wholesale end was where a trader like Enron wanted to be, anyway. (They also disproved any theories that Enron had heavily influenced AB 1890; if it had, it would have realized from the start where the real market was.)

Steve Peace and the other Sacramento pols didn't take the company's carping too seriously. "Enron had been whining and moaning about the bureaucracy [associated with deregulation] and about changing the rules because it couldn't compete," Peace said. "The key here is that they have made the cultural shift to compete on price and that is exactly where we wanted to push the outside competitors in the electricity market."

To most Californians, that's what Enron remained—an "outside competitor." For its part, Enron was content to sell energy to ISO for fat profits while SoCal Ed and PG&E borrowed their way toward insolvency.

Financialization as Profiteering

The events of January 2001 knocked Enron's image in California down a few pegs. As rolling blackouts struck parts of the state and Stage Three Alerts became commonplace, Enron forked over $300,000 to help pay for President George W. Bush's inauguration.

While California's cash-strapped utilities fretted about huge debts, the Houston-based energy conglomerate posted $347 million in profits for the final quarter of 2000. (These profits would later turn out to be bogus.)

Instead of an innovative, pro-consumer market leader, the company was perceived as an out-of-state carpetbagger exploiting the flawed system for hundreds of millions in ill-gotten gains. Enron argued that it had been an early critic of California's deregulation plan...and that it was not profiteering. One of those arguments was true.

Lay blamed the state, both for what he considers a botched deregulation ("very flawed") and for falling woefully behind in fostering new power plants to meet growing demand ("you can't just continue to use more and more of something without addressing the supply issue").

Moreover, Lay argued that price controls would only add to the damage: "History has shown over time that it makes the welfare of our

people less, not more, even though it was supposed to be done to protect the public interest or protect the consumer."

Enron President Jeffrey Skilling said publicly that Californians should have been thanking Enron, not castigating it, for its role in trying to push open the state's power markets. But Skilling's PR sense was none too sharp. His comments only made Enron seem all the more arrogant and manipulative.

The blackouts cast Enron in the uncomfortable role of defending its radical business model. Though often grouped with utilities, Enron produced little power itself and owned relatively little in the way of hard assets. What it had done was pioneer the "financialization" (as opposed to "securitization") of energy. That might impress Wall Street types; but, in California in early 2001, it only made Enron seem all the more the profiteer.

Enron seemed to squeeze profits from a torrent of low-margin trades, in which it bought and sold a variety of contracts. The more buyers and sellers, the better for Enron. Executives like Lay and Skilling claimed that this was the answer to the energy industry's tradition of waste and inefficiency.

Losing the Retail Market

When the giant, entrenched utilities deregulated, scrappy Enron thrived by delivering timely energy and specific products and services (the "green" energy in California) that particular customers wanted most.

On the other hand, executives like Skilling suddenly found themselves under fire about Enron's "exposure" to the California market. Most of its profitable sales were made through the ISO and CPX to SoCal Ed and PG&E. If those utilities went bankrupt, Enron might have to write off some sales.

Skilling insisted that Enron's exposure to fallout from California was minimal. Its biggest business was in the wholesale market, serving utilities and big industrial customers who under federal law already had the right to choose their electricity suppliers.

But that still left the matter of the hundreds of millions pumped into the infrastructure for retail energy sales in deregulated markets. If California went back to a "cost-of-service" model, where utilities simply passed their costs through to consumers, that would cause Enron big trouble on two fronts. It would lose its fat profits from the CPX and ISO sales; and it would have never cracked the retail market.

That's pretty much what happened.

California's Rules Enable Bad Business

In February 2001, Enron Energy Services (EES)—the unit that supplied power to its industrial and commercial customers in California—announced that it was withdrawing from that business and would hand its accounts back to SoCal Ed and PG&E.

Exploding wholesale power prices (from which Enron was profiting), the financial mess facing the state's utilities and the winding down of business at the CPX were all factors behind the move. An Enron spokeswoman explained:

> In California right now, because of the legislative and regulatory uncertainty and because of the financial situation of the utilities, it makes more sense for us, and for our customers, for them to be sourced by the utilities. We're risk management experts. The uncertainty...makes it very difficult to manage the risks because every day is a new story.

The spokeswoman stressed that Enron was not abandoning the market and would continue to sell power to California—through the wholesale marketplace. This was where the bad—and possibly criminal—business was taking place. According to the December 2000 memo (written by one attorney working in-house at Enron and one working for an outside law firm), the company was using a number of tricky trading practices to make money in California.

One of these was called "inc-ing the system." This practice took advantage of the methods the ISO used to pick up energy in the spot market to make up for shortages on the grid. Enron would increase

(this was the "inc") scheduled demand on the grid a day in advance; the next day, when the ISO saw it had a high demand schedule, it would invite wholesalers to supply energy to make up the difference. Enron would step in to help meet a demand spike that it had created.

Another favorite Enron trading tactic was to "launder" energy sales by exporting electricity produced in California out of state and then re-import it. All of this motion allowed Enron to get around the various "soft" price caps that California tried at various times.

Another trading tactic took advantage of the soft caps. Enron would buy power from the ISO for $250 a megawatt-hour—the maximum price allowed at the time—and resell it outside of California for almost five times as much.

Yet another involved creating grid congestion in one part of the state and then relieving it by sending energy in the opposite direction—which the ISO would pay generators to do. The lawyers wrote, shamelessly: "The net effect of these transactions is that Enron gets paid for moving energy to relieve congestion without actually moving any energy or relieving any congestion."

The rest of the marketplace gave Enron cover; the investor-owned utilities made mistakes that hid Enron's tactics. They consistently underestimated their own needs in the day-ahead scheduling, which created real shortages. In this context, Enron could justify its abuses as an attempt to smooth out spikes in wholesale dealings.

To the public, Enron referred to these dealings as *arbitrage*. Privately, following its infantile practice, the company referred to its trading schemes with jokey names like "Fat Boy," "Get Shorty" and "Death Star"—among other *Star Wars* references.

Enron's trading tactics were surely abusive. But were they illegal? Not necessarily. The increased orders that created an impression of shortage on the CPX and congestion in the state's grid were certainly manipulative. But they didn't break any specific statute—at least anything related to AB 1890. (If Enron broke any laws, they were probably federal ones against price fixing and market manipulation.)

ISO guidelines did prohibit "anomalous market behavior" that included: "unusual trades or transactions;" "pricing and bidding patterns that are inconsistent with prevailing supply and demand conditions;" and "unusual activity or circumstances relating to imports from or exports to other markets or exchanges." Enron's tactics fit these descriptions. But the response to these abuses would have been an administrative action from the ISO—not criminal charges.

Even opportunistic pols hedged their rhetoric when the December 2000 memo was made public. In a letter asking FERC to investigate, Gray Davis wrote "Through its greed and possibly illegal manipulation, Enron did incalculable damage to California's economy." That *possibly* spoke volumes. If Davis could have been more certain, he would have been.

AB 1890 allowed for free-market pricing in the wholesale electricity market while keeping prices fixed at the retail level. It allowed for massive profits on that spot market—and even bigger profits if power shortages got worse.

Under true deregulation, companies trying to create wholesale shortages would end up causing so much havoc at the retail level that the games wouldn't last. Angry consumers would revolt. But Californians were insulated, at least directly, from Enron's trading trickery.

The California Plan gave the greedy Texans plenty of cover under which to hide their dirty deals. And the fat profits that Enron made selling electricity to ISO were some of the only "arbitrage" windfalls the company ever had. Almost everything else it was doing was low-margin or money-losing business.

Enron impressed investors and financial analysts with promises of more big hits…but it spent most of its time cooking its financial books. The company needed dozens of California Plans to keep ahead of its trading and accounting games. In the end, only California offered an energy market so well suited to Enron's shenanigans.

18

January 2001:

The Blackouts

New Year's Day 2001 didn't bring much cheer for the California energy markets. The investor-owned utilities—still responsible for bringing electricity to most Californians—were broke. Both SoCal Ed and PG&E issued public warnings in December that they were in danger of running out of money to purchase electricity for customers. They only owned generation facilities (the nukes and other plants that the law hadn't forced them to sell) enough to generate about half of their customers' needs; the rest they had to buy from independent generators. And the independent generators had sold as much electricity on credit as they could.

For months, the grid jockeys at the ISO scrambled—just about every day—to find electricity anywhere in North America. Through the last several months of 2000, they did an admirable job avoiding statewide blackouts. But through November and December, they knew that the system was just a few bad turns away from a failure.

And there was a political element to the situation. Some executives at the utilities (and other people in the energy business) actually said that a statewide blackout might be the only way to seize the public's attention and force Californians to do something about the chronic shortfalls.

Trickling Power

In early December of 2000, the ISO came close to ordering blackouts. Its overwhelmed power grid, hindered by power plants that

were closed for winter maintenance, struggled to meet peak demand. Hundreds of companies—which had agreed to "interruptible" energy service in exchange for discounted rates—were ordered to cut back on their electricity use.

Near the end of the first week of December, the ISO declared a Stage Three Alert—the warning one step below designated blackouts—for the first time since it started managing the California electricity grid. It covered 85 percent of California and its 34 million residents. State-wide demand had reached 31,600 megawatts—almost the maximum available—during the early evening of Thursday December 7th.

The grid monkeys were working overtime. The huge government-run pumps that moved water from Northern to Southern California were temporarily shut down to save power. The ISO secured a promise from the California Department of Water Resources that it would temporarily halt some of the massive pumps that push water into the California Aqueduct; this alone would save at least 500 megawatts of power. (The Department of Water Resources would become involved in the electricity crisis in a more direct way later.)

The ISO also bought some surplus electricity from the federal government.

The reserve level slowly crept back up as the evening progressed. And the ISO didn't have to order any blackouts.

During the next several weeks, the ISO grew accustomed to issuing energy alerts. The three-stage warnings followed a simple model:

- A Stage One Alert meant that there was a reserve margin of less than 7 percent for power supplies available for the 24 million Californians served by the ISO.

- A Stage Two Alert, in which ISO officials could order service shut down to customers that had agreed to curtail energy in a crisis, meant that the reserve margin was less than 5 percent.

- A Stage Three Alert, which was the last warning the ISO would make before ordering blackouts, meant that the reserve margin was less than 1.5 percent.

In all, the ISO declared power alerts 44 times between the first week of November 2000 and the first week of January 2001. In other words, it declared emergencies two out of every three days.

Shortages, Slowdowns and Panic

Wholesale electricity prices in California had risen more than 900 percent during 2000. The ISO had come close to ordering statewide blackouts during the early summer—the highest use time of the year—but managed to avoid them.

There was one local problem, though. Supply problems in the San Francisco Bay Area led to rolling blackouts there on June 14; the blackouts affected about 90,000 customers and lasted about three hours. But the rest of the state had sufficient power to avoid outages that day.

Still, the close call sparked an explosion of prices on the CPX.

The winter holiday season wasn't normally a peak-use time; but a number of power plants were shut down during December and January for annual maintenance. This reduced available supply—and increased the pressure on the California grid.

A number of people at the utilities and the ISO grumbled that the maintenance schedules were being "gamed" by independent power companies like Enron, Duke and Calpine to create a shortage and maintain high prices. The effect would be something like so-called "sick out" work slowdowns that labor unions (usually highly skilled ones, like airline pilots) use as a negotiating tool.

But the power companies argued—with some cause—that they'd pushed their California plants hard during the summer to avoid blackouts, and they needed time to refurbish the older facilities during the normally slower winter months.

Something needed to be done to avert blackouts. The FERC did its part by unveiling measures that would override parts of the California

Plan and make it easier for utilities to lock in long-term contracts with power generators. This had effectively killed the CPX. But regulators and politicians at the California level criticized the moves as inadequate; they wanted the FERC to order wholesale rate caps that would stabilize electricity prices.

The FERC wasn't inclined to take such an extreme measure—especially since the California Plan had been spawned at the state level. Generally, the Feds felt that California needed to fix its own mess.

Weather Problems

The grid monkeys at the ISO kept things running through December. But the first week of January was rough. A series of Stage Three Alerts were solved by last-minute deals with federal and regional power co-ops. Time, however, was running against their efforts.

Things got especially bad on Thursday, January 11. The day began ominously, when the ISO declared a Stage Three power emergency at 8:50 A.M.—much earlier than usual. A storm had battered the coasts of Central and Northern California. As a result, PG&E's Diablo Canyon nuclear power plant reduced its production by 80 percent—the high surf had washed kelp and other sea life into the plant's cooling system intakes.

Not all of the problems were related to the storm or to scheduled maintenance. Several were emergencies. One plant reported fuel problems; another suffered "excessive vibrations" because of a mechanical failure; and two others reported boiler and condenser leaks.

In all, the California grid was running about 15,000 megawatts below normal capacity. The ISO positioned its people to start rolling blackouts around the state.

Accidental power outages were fairly common—in fact, more than 150,000 customers lost power for short periods on the 11th because of the big storm. The state had resorted to intentional blackouts only once (the June 14 San Francisco Bay Area episode) in recent years.

Otherwise, the last truly statewide outage was during World War II, when the state intentionally shrouded itself in darkness to ward off attacks by Japanese bombers.

Darkness Looms

Dozens of workers were stationed at switching centers from Redding to Fresno, awaiting word from the ISO. Though the utilities would know hours ahead of time about an imminent outage, the final word would come just five or 10 minutes or so in advance, largely in response to immediate demand.

When word came down from the ISO grid managers that a blackout would be needed, the utilities would identify blocks of commercial and residential customers whose consumption matched the necessary savings…and switch off their power. A specific block would lose power for 60 to 90 minutes.

The affected areas weren't necessarily the ones using most of the power. In fact, on January 11, the ISO managers thought they might have to cut power in the San Diego area to make up for heavy use in the San Francisco Bay area.

PG&E's 13 million-plus electricity customers were divided into 14 blocks, based on the load of each circuit. Each block, accounting for about 500 megawatts of usage, covered about 200,000 customers in neighborhoods scattered throughout PG&E's Northern and Central California service area.

The blocks were not geographic and the utilities spread them out so that no community would suffer more than another.

After the ISO ordered a blackout, the utilities would wait to hear whether the savings were still needed 60 to 90 minutes later. If so, they would "roll" the blackout, reinstating the first block and disconnecting another one.

Both SoCal Ed and PG&E had intricate, and largely secret, plans for how they would carry out rolling blackouts. The only people privy to

the plans were municipal and law enforcement officials in the affected areas. (If the locations of blacked-out areas were known in advance, criminals could plan thefts accordingly.)

Some of the smaller members of the ISO didn't agree with this policy. For example, the Sacramento Municipal Utility District said that—if power needed to be shut off—the neighborhoods of Fair Oaks and surrounding communities would be first in line and the city of Folsom would be next.

Generally, police, firefighters, large hospitals and some other essential users of electricity would be spared the blackouts. But, in some scenarios, even their blocks would be switched off.

People who depended on electricity to survive—such as sick people on respirators—were supposed to register with their utility companies as "special users." They would be notified in advance of coming blackouts.

In the end, blackouts weren't necessary on January 11. But all of the problems remained.

The Lights Go Out

After several more days of Stage Three Alerts, the ISO finally ordered rolling blackouts at 11:50 A.M. on January 17, 2001.

With only minutes of warning, sections of San Francisco, Silicon Valley, Sacramento and a few other small communities went dark. Power was shut off to as many as a half-million customers at a time. Passengers were trapped in elevators. Television broadcasts blinked off. Assembly lines stopped. Computer network administrators rushed to turn on backup generators. Traffic lights went dark.

The rolling blackouts—focused in the northern half of the state—ended by the early afternoon. A second wave of blackouts was avoided when the Canadian power producer BC Hydro pumped 900 megawatts of electricity into the state as the grid headed into its evening peak period.

Almost every city in the San Francisco Bay area was affected, according to PG&E.

The immediate cause of the blackouts was the large Duke Energy power plant in Morro Bay—which, unexpectedly (at least to the ISO), went offline Wednesday morning. Also, an expected power transfer from the Bonneville Power Authority (BPA) in Washington state didn't come through. Cold weather in the Northwest drove up demand there at a time when a relatively dry winter limited the amount of electricity the BPA's hydropower plants could generate.

But the showdown in the wholesale electricity market was the real culprit.

Investors and bankers noted that the blackouts came the day after Wall Street slashed the credit ratings of SoCal Ed and PG&E, forcing them to the brink of bankruptcy. The utilities' deteriorating financial condition led suppliers to withhold power from California.

The fact that the blackouts were focused in the San Francisco Bay area highlighted the region's particular vulnerability. The area lacked adequate power plants. Few people knew—before the blackouts— that it was also lacking sufficient power lines to move power in quickly.

Electrical Hardware

The ignorance that people had about the hardware for moving electricity from place to place was striking. Even a basic understanding of how power lines worked would help people in the Bay Area understand why they were the most likely to suffer power outages (intentional or not). Specifically:

- Transmission wires are typically 1- or 1 1/2-inch-thick cables strung in sets of three.

- The high-tension wires can deliver 500 to 2,000 megawatts of electricity, enough to serve 500,000 to 2 million typical homes.

- Cables are generally made of steel and aluminum, not copper, because of cost and weight constraints.

- The cables are strung from steel towers that are, on average, 150-feet high. The towers are usually spaced in quarter-mile increments.

- Utilities have been able to add to the capacity of the lines by "reconductoring" them, meaning replacing half- or 1-inch-diameter lines with thicker cables. The replacement is more economical and quicker than building new lines.

Another Day of Darkness

The next day, the ISO had to shut down power again. The rolling blackouts followed the basic model of the previous day—though they lasted a little longer and they spread to Southern California, too.

After the second day of blackouts, people around the state—and media around the world—made frustrated comparisons between California and third-world countries.

As might be expected, the outages became grist for television comedians and pundits, both read and watched.

The jokes and pre-packaged anger took a particular toll on Gray Davis, who insisted that the crisis was something that he'd only inherited. This was true, of course; but few people made a clear distinction between Davis and his predecessor, Pete Wilson. They blamed "The Governor."

The prospects for the Bay Area weren't getting any better. The ISO predicted that demand was going to remain slightly above guaranteed supply for at least a week.

The ISO was soon going to lose some 300 megawatts of power. The interruptible service deals that PG&E had struck with big commercial users came with an annual 100-hour limit. Since many of these cus-

tomers had lost power for as much as 18 hours a day during the height of the crisis—including the days before the blackouts—they were soon going to reach their limits.

If that wasn't enough of a blow, hydroelectric plants near Fresno were running low on water to power generators, transmission problems were disrupting the flow of electricity from Oregon and power managers were finding less electricity available on the open market than they had anticipated.

Rolling Out of Crisis Mode

The grid monkeys at the ISO were able to avert any further statewide blackouts in January. For the rest of the month, the only power outages in the state were weather-related problems in rural northern counties and a few suburban Southern California spots.

When January came to an end, the middle of the month had seen 10 consecutive days of Stage Three Alerts and two consecutive days of rolling blackouts.

In the weeks that followed, experts at the ISO predicted that California would be able to scrape by for the rest of the winter without more rolling blackouts. A combination of last-minute emergency power supplies from the Northwest and conservation efforts by the utilities' biggest customers would keep reserves at around 5 percent of capacity. This might mean Stage Two or Three Alerts...but it also meant that outages would be unlikely.

By mid-February, the politicians in Sacramento were working feverishly to stabilize energy supplies and head off the threatened bankruptcies of SoCal Ed and PG&E.

The ISO grid monkeys were still scrambling to maintain sufficient power in the state's grid. But the middle of February brought them some major relief: After a month of maintenance work and repairs, the Duke Energy plant at Morro Bay was back up and running with its 750 megawatts of power.

The Bonneville Power Administration said it was boosting its power generation through the end of February to meet the soaring demand from the West Coast cold snap.

On February 20, the ISO eased its Stage Two Alert to a Stage One for the first time since January 8. From January 16 through February 16, California had endured a record 32 consecutive days of Stage Three emergencies.

Super Price Signals

Some experts, wringing their hands with worry, weren't looking forward to the summer. With energy-burning air conditioners running through the hot months, the California grid could run shortages of 3,000 to 5,000 megawatts—three to five times the size of the January shortfalls.

Unless changes were made, blackouts could become a regular occurrence from July to September.

A Cambridge Energy Research Associates study released in late February predicted that California would endure a minimum of 20 hours of rolling blackouts during the summer.

The point had been made with Californians. Their power system didn't work; their expectations of cheap prices and reliability were unrealistic. Something was going to have to change.

And something did. Within a few months, independent energy producers were negotiating contracts as low as $50 per megawatt-hour— only a little higher than prices from the first half of 2000. And far below spot-market prices that spiked to $1,500 per megawatt-hour in the midst of the January crisis.

As January 2001 faded into the background, some people still wondered why the blackouts had to happen. Why had the system, which had been surprisingly robust despite fundamental economic problems for most of 1999 and 2000 suddenly melt down? And, once it had

melted down, why did the blackouts last only two days—when even seasoned experts were predicting many days of blackouts?

People in the financial markets did make a strong note of the fact that the blackouts occurred in the days immediately after the main rating agencies downgraded SoCal Ed and PG&E bonds to near-bankrupt status.

The logical conclusion of this notice would be that the blackouts were a sort of super price signal. Since the California Plan had prevented traditional price signals, something more dramatic was necessary to impress on everyone—politicians, bureaucrats, utility executives and generators—how dysfunctional the system was.

A Celebration of Inefficiency

So who organized this massive price signal? No one involved in the California energy market, from the CPUC to the utilities, admitted that there was any sort of conspiracy to make a public point. In fact, people from just about all corners actively denied such scheming existed.

If so, then the organizer might well have been the ghost of Adam Smith. Or at least his invisible hand.

The appeal of free markets is that they are more powerful than any specific collusion. Over the course of time and region, they press for the most efficient use of capital. The California Plan was a celebration of inefficiency; the invisible hand of better effect was pushing against AB 1890 for years, looking for a weak spot in its application. That weak spot was January 17 and 18, 2001.

The blackouts didn't require a mastermind. All they required was for various players in the arena to recognize problems and take some small measure of response—announcing the downgrade in PG&E's bond ratings, keeping a power plant closed to complete repairs properly, making sure locals had enough juice before transferring surplus to California. The final result might seem to be collusion—but it was

independent decision-makers contributing separately to an efficient response.

That's the power of Smith's invisible hand. True deregulation frees it to operate; bad regulation channels it to more extreme outbreaks.

The California Plan was bad regulation.

19

There were rumblings about conspiracies and schemes hatched by the utilities and/or the power generators and/or the regulators since AB 1890 was signed into law. In the early years of the California Plan, these rumblings were dismissed as consumerista paranoia.

But the blackouts of January 2001 made the rumblings seem slightly reasonable. A growing number of people thought there was something rotten afoot. More than one pundit dusted off the old Adam Smith quote about industry collusion from *The Wealth of Nations*:

> People of the same trade seldom meet together, even for merriment and diversion, but the conversation ends in a conspiracy against the public, or in some contrivance to raise prices.

Polling the People

In January, the Los Angeles *Times* had released the results of a poll that asked Californians what they thought was going on with the electricity problems.

A surprising 54 percent echoed what might be called the *Lone Gunman bias*. They didn't believe there was an actual shortage of electricity in California. They suspected that the crisis was a concoction made by the utilities or, if not the utilities, by the state legislature and the CPUC.

The *Times* poll interviewed 575 Californians (not so many, really) and had a margin of sampling error of plus or minus 4 percentage points. Other conclusions it found:

- two out of three respondents considered the California Plan a mistake;

- four out of five said they had been following news of the state's chaotic energy situation (a record for *Times*' polls);

- respondents favored re-regulation of the electricity industry by a 2 to 1 margin; and

- asked to explain their doubts, many asserted that greed on the part of utility companies, rather than a lack of available electricity, was responsible for exploding prices.

Quite a few pundits noted a psychological element to the prevailing cynicism that Californians had about the electricity crisis. Their doubt reflected the complexity of the whole episode. It didn't offer any easy villains—like the Organization of Petroleum Exporting Countries in the 1970s—or Nixon or Ollie North or Clinton. There were just vague culprits, faceless interest groups, who caused consumers to feel resentment about the whole routine.

Even people in the energy business showed despair at the collapse of the California Plan. Many political and business leaders were left mumbling that electricity was a unique commodity that couldn't be subject to free-market competition.

Of course, there was no proof of this. The only thing that the January 2001 blackouts proved was that half-baked deregulation didn't work. Adam Smith could have told everyone that $20 billion earlier.

The fact remained that in February 2001, when it came to the energy crisis, conspiracies were on most Californians' minds.

Multi-Level Marketing Companies

Allegations and insinuations that utilities and generators tried to scam the public started as early as the fall of 1997, when the CPUC allowed marketers to start pitching to Californians.

While many of the marketers were too aggressive in their promises, it was probably a bit too much to call them crooks.

The problem with the California Plan was that the whole thing was such a scam that it's tough to single out some single marketing company as more crooked than the giant energy firms or the state agencies at the top of the corporate food chain.

To many industry insiders, the surest sign of trouble was the arrival of multi-level marketing companies. These businesses expanded by recruiting new members to sell services; the new members benefit by recruiting still more members to sell services.

"Be among the first in your area or state to have an opportunity to capture a massive customer base and receive 5 percent of all their monthly electric bills," read a flier circulated around Southern California in later 1997 by a multi-level marketing company called Boston Finney. "Electric power will be the hottest product through the first decade of the 21st century."

The pitch went on to encourage to sign up others and take a cut—much like an Amway salesman—of their electric bills. Ultimately, companies like Boston Finney cared less about the service they were selling, and more about the number of people who would join their network.

Knowledge Is Power

The CPUC worried about the scammers warping the legitimate ends of the California Plan. So, it ran a series of television commercials in October and November of 1997 that aimed at letting Californians know what was coming in early 1998; the ads had the tag line "Knowledge is Power."

But they had the unintended effect of angering the California Highway Patrol.

One of the "Knowledge is Power" spots showed a patrolman on his motorcycle, laying in wait for speeders behind a billboard. The pa-

trolman was so engrossed in reading about his options for buying electricity that he lets three speeding cars blast past.

After the ads ran, the head of the California Highway Patrol fired off an angry letter to the CPUC for portraying patrolmen as Keystone Kops. The spot was pulled.

Hyperbole in Their Offers

Speaking of Keystone, one of the energy marketers selling electricity in California and raising questions about propriety was Los Angeles-based Keystone Energy Services. It paid for a glowing profile as stock pick of the month in the November 1997 issue of an online investment magazine called *Future Super Stock*. The price for this placement: 35,000 shares of Keystone stock. *Future Super Stock* revealed the payment in a disclaimer at the end of its profile.

This was a common practice in the go-go world of the late-1990s Internet stock promotion. But it slopped an unsavory sheen on the California electricity market.

This was the tenor of most of the sleazy business going on during the early days of the California Plan. The bad practices had more to do with exaggeration and truth-stretching than outright theft. The offers seemed simple and attractive enough: Check the box below. Switch your electricity service to Energy Marketer X. Save 10 percent on your electric bill.

But the message was incomplete...and misleading. Everyone covered by AB 1890 got a 10 percent discount—even if they stayed with their traditional utility.

But these sorts of blustery sales pitches didn't really constitute a conspiracy. They were more like the hard-sell nuisances that plague most businesses. If there were a serious market manipulation, it would have to lie somewhere else.

Parental Conspirators

A pattern of questionable deals between the utilities and their parent companies seemed like a more likely conspiracy.

Between the summer of 1996, when Pete Wilson signed AB 1890 into law, and April 2000, the last month in which revenue from fixed consumer rates covered their cost of buying power, SoCal Ed and PG&E moved billions of dollars from their operating units to their corporate parents.

A 2001 audit commissioned by the CPUC found that Edison transferred $4.8 billion to its parent company between 1996 and November 1997; it found that PG&E transferred $4.7 billion to its corporate parent during the same period.

Where did this nearly $10 billion come from? From the bonds sanctioned by the state for the purpose of reducing rates. And from the sale of power plants.

The audits concluded that the utilities' executives knew that the California Plan was going to squeeze the energy market to the point of insolvency. So, they consulted with lawyers and determined that they could protect their resources best by moving any cash they had up (to the corporate parents) and out (to investors as dividends). This practice allowed the utilities to pay dividends, even though their main businesses weren't making enough profit to sustain them.

The transfers meant that no money was held in reserve against the worst-case scenario, in which power costs would actually exceed the frozen rates and start draining the utilities' resources. Essentially, this left the utilities judgment-proof—too broke to be held liable for big losses.

Consumer advocates argued that PG&E and SoCal Ed overstated their troubles.

SoCal Ed countered that the $4.8 billion transferred to its parent company was used almost exclusively to pay dividends and buy back

stock to boost its price—essentially what it would have been used for had the California Plan never occurred.

The audits didn't accuse the utilities of transferring the money illegally or of concealing the transfers, which were disclosed to federal regulators in public statements and filings. The transfers were legal. In fact, the utilities' disbursement of the money was considered normal—even mandatory—at the time.

Because deregulation forced them to downsize by selling off most of their generating plants, it made perfect fiscal sense for them to shrink the amount of stock and debt they had outstanding by repurchasing shares and retiring bonds.

Dividends Amid the Crisis

In a larger sense, the money flow raised questions about whether the companies' shareholders and bondholders would fully share the burden of what was evolving into a massive miscalculation by the state. By contributing to pay dividends even when they weren't making sufficient profit, the utilities were insulating their investors from the realities of the marketplace.

Another issue raised by the CPUC was whether the utilities could have managed their cash better as the energy crisis gathered momentum.

When it approved a temporary rate increase for the utilities in January 2001, the CPUC criticized PG&E for declaring a third-quarter 2000 dividend—a pay-out to its parent company—a month after problems in the wholesale electricity market in California emerged.

The dividend came to nearly $100 million and helped fund the parent's subsequent dividend to shareholders of $116.1 million. Around the same time, SoCal Ed also declared a third-quarter dividend of $97 million. Its corporate parent subsequently declared a quarterly dividend worth $91 million to its shareholders.

Consumeristas argued that the utilities knew enough about the deterioration in the wholesale electricity market to foresee the need to conserve cash earlier.

Both companies did suspend their fourth-quarter 2000 dividends.

Ring-Fencing

Throughout the California Plan, the corporate parents not only spent money on dividends, but both also embarked on a buying spree of power plants and other assets—much of this outside California. SoCal Ed's parent, for example, built its subsidiary Edison Mission Energy into an independent power company with $15 billion in assets. A considerable portion of Edison Mission's assets were purchased with the parent's cash and equity, at least some of which was derived from SoCal Ed's operations.

SoCal Ed took steps to shield Edison Mission's assets from being used to cover its utility cousin's red ink, a process known as ring-fencing. Although the step succeeded in bolstering Edison Mission's credit rating as its parent's crumbled, it raised protests from consumeristas.

And, while the transfers raised few eyebrows in financial circles, they radicalized one key California politician. Senate President John Burton of San Francisco called the transfers "outrageous" and a scandal. But Burton channeled his outrage into a protracted negotiation with Gray Davis and other California pols over the size and shape of the pending bail-out of the utilities.

In the end, the dealings between the utilities and their corporate parents were legal and logical. They might not have been the most altruistic transactions—but they weren't the scams.

Hunting for Criminals

The other direction in which billions of dollars moved was laterally, from the utilities to the power generators that sold electricity to the CPX and ISO through 2000.

AB 1890 required the investor-owned utilities in California to sell off most of their power plants and buy wholesale energy from the CPX. This was a process that only an investment bank could love. And it opened the generators to charges of price gouging.

In his 2000 state of the state speech, Gray Davis landed on power generators as the source of California's discontent:

> We have surrendered the decisions about where electricity is sold, and for how much, to private companies with only one objective: maximizing unheard-of profits. ... Worst of all, there's evidence that some generators may be purposely withholding electricity from the California grid to create artificial scarcity, which in turn drives up the price astronomically.

The strong statement was leavened with conditional phrases ("some generators" and "may be purposely withholding") typical of a split-the-difference pol like Davis. But the governor had committed himself to vilifying independent electricity generators.

He also had company among pols and bureaucrats. Consumeristas insisted that power companies were gouging consumers by jacking up wholesale rates during periods of peak summertime demand. Lots of political hacks followed this theory.

U.S. Senator Barbara Boxer—never a deep thinker on matters of potential consumer protection—called upon Attorney General Janet Reno to investigate "potential collusion and any other unlawful acts by generators in the electricity market."

Loretta Lynch, the new head of the CPUC, blamed the energy crisis on "price actions by merchant generators, not a lack of supplies."

Lynch's CPUC concluded that the California Plan wasn't working and that "enough evidence of questionable behavior" existed to warrant an investigation by the state's attorney general.

The City of San Francisco filed a lawsuit in state court, accusing several generating companies of "artificially manipulating supplies to keep

prices high." Among the 13 defendants were Southern Energy, Duke Energy and Reliant—charged with violating the California Unfair Competition Act by conspiring to restrict supplies and drive up prices.

No Smoking Gun

The generating companies denied such charges. A Reliant spokesman said the company entered the California market in 1998 to make a profit. Its added windfall came as a result of the state's poor deregulation bill, bungling by regulators and the state's difficulty getting new power plants built.

Davis proposed criminal penalties for generators who deliberately withheld power. Following this sensibility, state inspectors made unannounced visits to California generating facilities, including dozens of unannounced visits to Duke Energy's four plants, seeking evidence of power withholding. They didn't find any.

At that point, suspicious minds turned to the wholesale power market—where suspicions grew that power companies were gaming the market by manipulating rates during periods of peak demand.

Subsequent investigations by the California attorney general and state and federal officials turned up no evidence of illegal activity, but authorities were quick to note that generators could still be driving prices higher without necessarily breaking the law.

For their part, the power generators—accused of price gouging—remained reluctant to supply energy to utilities that might not be able to repay them.

The California rate structure, coupled with tight capacity, gave many suppliers market power to get dramatically higher prices. "Some may call that gaming.... Some would call it maximizing profits, taking advantage of an opportunity," said outgoing FERC Chairman James Hoecker. "The allegations of a conspiracy to rip off the consumers in California, I think some of those claims are overblown."

No Price-Fixing Pattern

No fewer than five state and federal agencies investigated California's market to find out whether there had been collusion among power suppliers or other unethical activity aimed at manipulating prices.

Independent electricity generators figured out how to circumvent California's price caps and rate freezes. In some cases, the merchant generators simply sent their power across state lines and then resold it back into the California wholesale market. The FERC had the power to stop this "megawatt laundering" but refused. It wasn't illegal.

The FERC couldn't find a pattern of price fixing during the summer of 2000. In a November 2000 report, the agency said a study of market bids, prices and sales last summer "does not suggest substantial or sustained attempts to manipulate prices in these markets."

Privately, officials with the California grid operator expressed frustration that so much brain power was being applied to market analysis instead of implementing fixes.

One impressive fact: Throughout the energy crisis, Californians used roughly the same amount of electricity. The deregulated wholesale electricity market was full of speculation and gaming...and the same amount of power cost the utilities $5 billion more between the end of 1999 and the beginning of 2001.

In the cynical scenario being suggested by some Sacramento insiders, Davis would continue to cap retail electricity rates and the utilities would accumulate a huge debt in a special account and then, once Davis was safely reelected, he'd allow rates to rise to pay off the utilities. As Davis did this, he'd make all the appropriate populist noises about protecting consumers from the big bad utilities and the bigger and badder federal regulatory commission.

Davis's biggest reason to do otherwise: He had ambitions for running for President in 2004. And he couldn't do so as the man who'd stiffed an entire state.

Legal Scamming

The charges of price gouging remained.

Profits doubled and tripled for several of the for-profit companies during the summer of 2000's run-up in electricity prices. So, the companies' profits were higher than anyone expected. The high profits spawned lawsuits and claims that generators were intentionally manipulating the market by shutting down plants and colluding to fix prices.

The FERC issued a report that found wholesale power prices in California were "unjust and unreasonable" but turned up no strong evidence that out-of-state power generators had actively manipulated the market.

Charges of price gouging are often a sign that the person making the accusation is an economic idiot. Prices are supposed to go up when supplies are scarce—whether the market is for electricity or for taxicab service in a rainstorm.

Besides, the gougers—if they really existed—were a diverse group. Not all were from out of state; and not all were private companies. One of the biggest profiteers during 1998 and 1999 was the LA DWP. It happily sold power into the California grid for astronomical prices.

Was that the scam?

The response that came up time and again was that, while some activities might have been questionable, most were legal. In other words, actions that might have been abusive to the CPX and the ISO might not have been illegal.

A good example of this: The number of power plants that seemed to go down for maintenance just as peak periods approached.

With a total capacity to generate 55,000 megawatts of electricity, California should have had no trouble meeting its peak demand of

about 31,000 megawatts. But, at any given time between 1998 and 2000, about 12,000 megawatts were not available because of power plant shutdowns around the region.

This rash of unscheduled power plant maintenance raised the shackles of politicians, who immediately suspected that power sellers withheld supply to boost prices in California's market.

Generators roundly denied those charges, arguing instead that the state's growing shortfall of electricity created scarcity that drove up prices. At most, a few generators admitted they'd engaged in "tactics" that may have gone too far. Sometimes it was difficult to know what "too far" meant.

Cinergy's "Lean on the Ties"

In July 1999, engineers noticed that a substantial amount of power was being taken from the grid for which there was no explanation. They contacted the North American Electric Reliability Council (NERC), the industry group charged by Congress with overseeing the grid since the late 1960s.

The NERC determined that Cinergy Corp., an Ohio-based utility, had surreptitiously taken enough power over a three-day period—about 9,600 megawatt hours—to light a small city for a month.

Cinergy had underestimated power demands. Rather than buy electricity on the open market at absurdly high prices or cut power to Cincinnati, it borrowed power from the system when demand was peaking and later replaced it when demand wasn't so high.

James E. Rogers, Cinergy's chief executive, received a letter from A.R. Garfield, the chairman of the NERC's regional power-coordination center, accusing his company of showing "blatant disregard" for the rules and of using the grid "as a supplemental resource without regard to the reliability or integrity of the system."

But Cinergy paid no fine. It ran its own transmission "control area" and was trusted to enforce the NERC's voluntary rules, even when it was

the violator. Smaller utilities in Cinergy's area, by contrast, faced contractual penalties of as much as $35,000 per megawatt for unilaterally borrowing from the grid (the practice was known as "leaning on the ties" in utility circles).

Rogers pointed to old rules that permitted utilities to borrow power during emergencies. "We were very careful to make sure, when we leaned on the ties…we didn't bring the whole system down," he said.

Leaning on the ties was only one trick that larger power companies could use to their advantage. Others came from the modular nature of the U.S. power grid. While there were plenty of routes to get electricity from outlying power plants into big cities, there were relatively few routes connecting regions. That made it possible for some big companies to shut out competitors.

Missouri-based Aquila Energy hit that sort of bottleneck when it tried to use a transmission corridor owned by Louisiana-based Entergy Corp. to move electricity to a buyer in East Texas. Entergy granted the request initially—but later canceled, saying it didn't have sufficient space on its lines.

Without access to Entergy's lines, Aquila was forced to compensate the buyer and lost nearly $300,000 on the deal. From whom did the Texas customer end up buying the power? A unit of Entergy—and for a higher price than it would have paid Aquila.

After analyzing transmission-capacity data, Aquila complained to the FERC contending that Entergy did have enough space on its lines…and was breaking a rule that required it to provide transmission-line access whenever possible.

The FERC, however, sided with Entergy, ruling that that company was within its rights to restrict access because, in this case, it was having transmission problems on the disputed lines. The FERC warned Entergy about its habit of not offering transmission to smaller companies. Again, the timing of the maintenance was the thing that drew scrutiny.

But do these dirty tricks amount to a scam…and systemic corruption or fraud? Again, they seem to fall a little short.

Banking a Tangled Web

A better bet for systemic corruption and fraud was the elaborate web of relationships between power companies, the investment banks that financed them and the various tranch of bonds issued over various years.

In January 2001, Wall Street investment banks with big financial stakes in the success of energy deregulation were playing important behind-the-scenes roles as officials in California struggled to fix the state's troubled electric power system.

Bankers from Goldman, Sachs—which owned an energy trading operation and a long-standing banking relationship with PG&E—met in Sacramento and held conference calls with state officials to discuss becoming the state's financial adviser in the crisis.

Credit Suisse First Boston, whose clients included independent power companies that sell electricity in California, was retained by the speaker of the state Assembly to help draw up legislation intended, in part, to ensure such companies were paid the $12 billion they were owed by California utilities.

A spokesman for Credit Suisse said the firm "provided advice strictly on a pro-bono basis at the request of [Assemblyman] Bob Hertzberg, based on our expertise in this area," but declined to say if it would seek paid business with the state related to the energy situation.

In addition, Robert Rubin—the former Treasury secretary who went on to be a senior executive with Citigroup, Inc.—advised Gray Davis on strategies for dealing with the state's energy crisis. It was unclear what advice Rubin gave Davis; but state officials said the two men spent perhaps 25 hours in conversation about the months-long crisis.

The Salomon Smith Barney unit of Citigroup was a frequent adviser in deals between utilities and power companies.

Incestuous Conflicts of Interest

The investment bankers' business interests in the California energy crisis took many forms. If the state proceeded with another bond sale, it would need to hire an investment bank—a job that could be worth millions of dollars in fees.

The banks had another interest: In many cases, they brokered many of the purchases of generating plants by independent power companies from utility companies ordered to shed them as part of the restructuring of the power industry.

One Goldman, Sachs executive said the bank was still assessing whether its various banking relationships would cause so many conflicts that it could not accept a role advising the state.

Goldman, Sachs was clearly not a disinterested party in the California situation. But that kind of self-conflict was so widespread in the investment banking business that the key to dealing with it was simply full disclosure.

Credit Suisse also had a variety of interests in how the energy crisis was resolved. Its client list included many power companies that generated or sold electricity to California's enfeebled utilities. Credit Suisse created further mayhem by stating on its Web site that the blackouts plaguing California were a tactic "likely intended to soften up the Legislature and the voters to the need for a rate increase."

The whole process of investment bank involvement in the California Plan was secretive. Government-sanctioned secrecy has cloaked price manipulation and greedy corporate exploitation of bad government policy.

The few times neutral observers were allowed to look into the dark world of power negotiations, they found disturbing indicators of price manipulation.

Investigative Walls and Finger-Pointing

The investment banks weren't the only ones who looked suspicious. Several state investigations to determine who was at fault for the January blackouts were thwarted because the targets of the probes erected roadblocks. For example: The CPUC delayed for months before giving the Bureau of State Audits documents and access to officials.

Sharon Reilly, the state auditor's top lawyer, wrote in a January 2001 letter to the CPUC that "the bureau has not received the level of cooperation" it expects from the commission and that subpoenas might be used to force its hand.

The CPUC whined legalistically that it didn't believe the Bureau had the authority to launch its probe. The CPUC's delays prompted threats of subpoenas from the Bureau. Both sides admitted the tussle was a "communications breakdown" and held meetings to clarify what documents and people the Bureau needed in order to complete its work.

The CPUC launched its own investigation into the blackouts—and the allegations of price-fixing and market manipulation. It had already issued subpoenas to non-cooperative power companies. Even after the subpoenas were issued, the companies still weren't cooperating. According to one of the commissioners, the CPUC wasn't able to draw any useful conclusions.

Commissioner Carl Wood said the CPUC considered seeking help from law enforcement to give the subpoenas that were issued some teeth. The generators and marketers had turned over some information, but nothing sensitive.

On their end, the power generators asked the FERC to prevent the release of information requested by both the state attorney general and the CPUC for its investigations into the energy crisis. They claimed the information was proprietary and related to competitive secrets.

The FERC, which had ordered disclosure in earlier cases, considered the dispute a blame game that it preferred to avoid. It was hesitant to make any decision. A FERC spokesman said:

There is a possibility that people are trying to avoid blame. We approved the [California] Plan, so even we bear some of it. It's a dysfunctional market and prices are outrageously high. There is clearly a lot of finger-pointing going on.

Perhaps most pathetically, the California Plan's main author denied any responsibility for the results.

"Steve Peace was assigned to deregulation by default. He was chair of the energy committee. And the CPUC and (former Governor Pete) Wilson were going to do it with or without the Legislature," said Peace's Chief of Staff Dan Howle. "Steve built in some consumer protections—an immediate 10 percent rate decrease. But this was not his plan."

It was hard for Peace to distance himself from deregulation. He presided over all the meetings, urged fellow lawmakers to support the final deal and was beaming on the floor of the Senate the night deregulation was approved.

Was a revolving game of political hot potato suggestive of any sort of conspiracy or scheme? Again, no. It's more a reflection of the void that existed at the center of the California Plan.

A Powerful Takeover

In the end, the most intriguing conspiracy theory is one that everyone in a position to acknowledge has denied. (Of course, following the "lone gunman" bias method, this only confirms the theory.....)

The failed California Plan suggested a more economic conspiracy. Call it the David Stockman strategy—after the maverick director of the Office of Management and Budget under Ronald Reagan. Stockman argued that the best way to defeat an opponent's policies is to enact them fully...and let their inherent flaws wreak political havoc.

There was plenty of political havoc. Along with scarcity, near-bankruptcy and soaring prices, the California Plan produced another surprise: a proposed state takeover of part of the power business.

Sacramento pols, who once wanted out of electricity regulation, now wanted a piece of the action. There were many good reasons to be doubtful about such a takeover, given the state's pitiful record in energy regulation. Still, the severity of the situation invited radical solutions.

One plan called for the state to take ownership of 26,000 miles of transmission lines that served as energy highways. In exchange, major utilities would be paid $4 billion to $8 billion, with the proceeds paying down debts created by deregulation losses.

It was a strange turnabout. Deregulation tried to shuck off state rules by injecting competition and diminishing government controls. Now the opposite may happen: a state-run agency wheeling electricity up and down California.

If loosening controls on power prices was the state's original aim, then the current thinking was a complete flip-flop.

Conspiracy Theories Circle to Regulation

Could the California Plan have been a brilliant effort on the part of pro-regulation pols? Could it have been designed to fail completely—and give deregulation a bad name for generations?

The various polls published in early 2001 suggested that Californians blamed utilities and state pols for the blackouts. The conventional wisdom seemed to be that deregulation was simply too crude a tool for dealing with complex systems like a state's power grid.

This conclusion existed, even though the California Plan was only a bastardized experiment in partial deregulation. It wasn't deregulation in any coherent sense; yet it turned most Californians against deregulation.

Conspiracy theorizing is usually a waste of effort. As David Freeman, chairman of the LA DWP and an opponent of deregulation, told the New York *Times*: "It's not all that complicated—we just have a shortage. All the conspiracy theories—you don't need to go there."

20

April 2001:
Using Bankruptcy
as a Bargaining Tool

On April 6, 2001, PG&E filed for reorganization under Chapter 11 of the U.S. Bankruptcy Code in San Francisco court. While the move wasn't entirely unexpected, its timing caught many of the people who'd been working with PG&E by surprise.

PG&E said it was taking the action for several reasons:

- its unreimbursed energy costs, which were increasing by more than $300 million per month;

- the impact of actions by the CPUC on March 27 and April 3 that created new payment obligations for the company and "undermined its ability to return to financial viability";

- lack of progress in negotiations with the state to provide recovery of $9 billion in wholesale power purchases PG&E had made since June 2000, which were not recoverable in frozen rates;

- the adoption by the CPUC of "an illegal and retroactive accounting change" that eliminated PG&E's "true uncollected wholesale costs"; and

- the "now unmistakable fact that negotiations with Governor Gray Davis and his representatives are going nowhere."

Bankruptcy Explained

Clearly, from all of the shots at the CPUC and Gray Davis, the filing was intended as a sign of…something…to the bureaucrats and politicians.

PG&E Chairman Robert Glynn offered a more detailed explanation:

> We chose to file for Chapter 11 reorganization affirmatively because we expect the court will provide the venue needed to reach a solution, which thus far the State and the State's regulators have been unable to achieve. The regulatory and political processes have failed us, and now we are turning to the court. …Statements by the Governor and other public officials since last September gave us reason to believe that a solution could be reached outside the context of Chapter 11 that would restore the utility's financial viability and enable it to meet its financial obligations equitably. However, these statements have not been followed up by constructive actions, and a reorganization in Chapter 11 is now the most feasible means of resolution.

The company was careful to stress that only the utility unit was filing for bankruptcy. The corporate parent, PG&E Corporation, and its other units—including the National Energy Group—were not directly involved in the legal maneuver.

PG&E then proceeded to argue that, in October and November 2000, it had asked the CPUC and other government agencies to approve a rate stabilization plan. The request was never acted upon. If it had been, PG&E argued, various problems would have been averted:

- PG&E would have remained creditworthy;
- it would have been able to enter into long-term power purchase contracts at prices lower than those announced by the state;
- the state would not have had to spend billions of dollars to purchase electricity for PG&E customers; and

- the state would not have had to issue billions of dollars in bonds to cover power purchases.

PG&E planned to use its existing resources to continue operating its business during bankruptcy, including paying vendors and suppliers in full for goods and services received after the filing. It would pay electric commodity suppliers as provided by law; and it intended to continue normal electric and gas transmission and distribution functions during the Chapter 11 process.

Stopping the ISO and Its Purchasing Power

A few weeks later, on May 3, PG&E asked the U.S. Bankruptcy Court to order the ISO to stop billing PG&E for wholesale power that the ISO purchased. Specifically, PG&E asked the court to prohibit the ISO from requiring PG&E to pay costs that the ISO "has incurred and continues to incur" to purchase wholesale power on PG&E's behalf.

Of course, buying energy on PG&E's behalf was the ISO's job. So, PG&E's bankruptcy filing was really an attempt to undo the California Plan.

PG&E's request was based on a legalistic—but likely valid—reading of bankruptcy law. The law imposes an "automatic stay" to prevent parties from taking actions that will "interfere with the estate or property of the estate of a Chapter 11 debtor." By purchasing power at costs higher than existing retail prices, and then sending the bill to PG&E, the ISO was violating the automatic stay provision.

Recently, the ISO had sent PG&E a bill for January and February 2001 spot market purchases that totaled nearly $1 billion.

In addition, on April 6, the FERC had ordered the ISO to stop buying electricity for PG&E—because the ISO could only buy power on behalf of creditworthy entities. PG&E pointed out that, by continuing to purchase power on behalf of PG&E, the ISO was in violation of its own rules, FERC orders and federal law.

Day of Reckoning

In many ways, it was surprising that PG&E hadn't filed for bankruptcy protection earlier. Tactically, it was in a better negotiating position as a bankrupt company than as a solvent one. Why? For one thing, bankruptcy—a federal process—forced a reckoning between federal and state laws.

The state's energy laws were so screwed up that they'd be trumped every time.

SoCal Ed and PG&E had both flirted with—or, more accurately, threatened—filing bankruptcy throughout the period from when AB 1890 was passed into law until…well, until this book went to press. They used bankruptcy and the prospect of bankruptcy as a negotiating tool for extracting financial concessions from the government—both federal and state.

And then PG&E filed, anyway.

There was more to the hints, threats and gossip than the usual business page fascination with sanitized failure. If the California Plan was dysfunctional, the investor-owned utilities were willing participants in the problems. And that willingness colored their retreats, as it had their advances.

The utilities could have made things easier by filing bankruptcy in 2000 (PG&E had its lawyers looking into the matter as early as August 2000), when they'd blown through all of their cash and run down their credit. But they were determined to grind their way through the restructuring…and grind they did.

SoCal Ed's Stephen E. Frank

In late January 2001, just weeks after the first California blackouts, SoCal Ed's Chairman, President and CEO Stephen E. Frank gave testimony to the U.S. Senate Committee on Energy & Natural Resources. Frank's purpose was to make the case for a government bail-

out of his company. But he couldn't avoid slipping some menace in his appeal:

> Eight months ago, my company was financially healthy. Our credit rating was A+ and our market capitalization was approximately $6.5 billion, based on a share price of $20. Today, our credit rating is deeply speculative grade or "junk." We have temporarily suspended payments for borrowed funds totaling $480 million. In addition, we also deferred making power purchase payments totaling approximately $360 million. . . . We have eliminated common dividend payments to our shareholders for the first time in our 100-year history.
>
> . . . we had to buy wholesale electricity at artificially high prices and resell at artificially low prices. As a result, we incurred $4.5 billion in undercollections as of the end of 2000. We initially financed this massive revenue shortfall by borrowing in unprecedented amounts. However, we have now exhausted our credit, and have limited cash reserves. As a result, we have suspended payment for power and some of our outstanding debts. We are implementing major cost reduction measures totaling nearly half a billion dollars annually, which will reduce our workforce by approximately 1,850 positions and limit critical investments in the electric system. If sustained, these reductions in staff and operating budget will certainly jeopardize the reliability of our system and our ability to adequately serve our customers.
>
> In 1999, the bill for areas served by the Independent System Operator (ISO) was $7.4 billion; in 2000, it rose to $28 billion. As staggering as this increase is, it does not reflect the true cost of the electricity crisis to California. The high prices we have been paying have not ensured adequacy of supply. Power emergencies have become an everyday occurrence. . . . Without dramatic action to accelerate the provision of new supply to the market, the problem has the potential of continuing for years.

A top executive with Calpine said other generators might force the two utilities into bankruptcy if the state didn't address the issue of

unpaid bills quickly. But he was quick to emphasize that Calpine wouldn't be the one.

Likewise, Oklahoma-based natural gas supplier Williams Companies said it wouldn't be the one to cause the problems. In fact, Williams went one step further—it agreed to continue supplying electricity (up to 4,000 megawatts through the CPX) and natural gas to the California utilities, even though it had no guarantee of payment.

Keith Bailey, Williams' CEO, said that forcing California's investor-owned utilities into bankruptcy would not be the best approach to recovering its costs. He favored sizeable increases in consumer rates.

But the creditors would eventually have to do something more than shrug their shoulders and put their hands in their pockets.

Calling a Spade a Spade

SoCal Ed and PG&E knew that their banks and creditors didn't want to see any bankruptcy filing. That's usually the case in any tough business climate—but it was especially true in this one. The various parties had all participated in a screwy system, with the tacit understanding that the state would subsidize any catastrophic results.

After the January blackouts, the catastrophe had come...but the state was behaving truculently about the subsidies.

The utilities were trying to force the hand of state officials by intentionally provoking an emergency order. In effect, they may have been looking for a good excuse to declare bankruptcy—an opportunity to tell shareholders and creditors that they had no choice but to file because of the state's inaction.

Everyone involved in the California Plan knew this; so, no one wanted to be the one that pushed either SoCal Ed or PG&E over the edge. The banks—such as JP Morgan, Chase and Bank of America—that had loaned the utilities the most money knew that if they ran out of patience the results would send a chilling effect through the whole California economy.

Electrifying Debts

In the days after the January blackouts, SoCal Ed and PG&E were as close to bankruptcy as functioning companies could be. SoCal Ed missed a payment on $596 million in interest payments and wholesale electricity bills; its credit rating was lowered to junk status.

The situation really was impossible. SoCal Ed had previously announced plans to cut costs by $465 million a year through layoffs and reduced service and maintenance. But those cuts—as deep as they might have been—wouldn't do much. At current electricity prices, the savings were equal to about two weeks of power purchases for SoCal Ed's 11 million customers.

The credit-rating cuts triggered automatic default provisions on some of the utilities' credit lines and bank loans. These provisions meant that the lenders could demand full payment of the loans—something SoCal Ed could not begin to cover.

Some creditors complained that SoCal Ed was playing a high-stakes game of chicken with California politicians and regulators; they pointed out that the company had more than $1 billion in cash on hand, which meant it was *choosing* not to pay bills.

In a filing with the Securities and Exchange Commission, SoCal Ed admitted that it was trying to hold on to its cash "to continue to maintain customer service while a legislative and regulatory solution, which involved state and federal authorities, is finalized." The utility said it would pay its bills "once a permanent solution to the energy crisis is developed."

The game of chicken worked, at least on a few fronts. In later January, the FERC granted SoCal Ed a last-minute extension on $215 million (part of the $596 million due that month) that it was supposed to pay to its electricity suppliers for electricity purchases in December.

At that point, SoCal Ed was negotiating with its bankers for a 30-day grace period while the bureaucrats and politicians hashed out a way to repair California's electricity mess.

The industry rumor mill said that some of Edison's lenders might be willing to make last-minute loans to Edison to keep it out of bankruptcy…or to provide additional funds after a bankruptcy filing.

Few Options, High Panic

In early February, three independent energy generators—citing slow progress in California's efforts to sort out its energy crisis—announced that they were forming a creditors committee to maximize their chances of getting paid by SoCal Ed and PG&E.

A creditors committee is usually the first step in a forced bankruptcy filing.

Reliant Energy, Dynergy and Mirant said their committee would "explore options for receiving payment from the California Independent System Operator (ISO) and California's investor-owned utilities."

So far, this sort of legal posturing hadn't worked. Reliant and Dynergy had been involved in some legal hearings in the U.S. District Court in Sacramento; and the results hadn't been good for them. A federal judge had issued a temporary restraining order requiring them to continue selling electricity to the ISO for at least another 30 days.

Again, the point of this extension was to give California politicians and bureaucrats a chance to arrange some sort of bail-out.

The most viable plan being considered in the California legislature would have a state agency—the California Department of Water Resources (CDWR)—buy electricity on behalf of SoCal Ed and PG&E. This would use the state's relatively strong credit to assure low-cost electricity for the grid.

But even this temporary solution was progressing slowly. As the Legislature debated its strategy, LA DWP General Manager S. David Freeman confirmed that his department had retained a high-powered New York law firm to protect its interests in the event of a SoCal Ed bankruptcy.

Of course, Freeman made the obligatory qualification that he hoped a bankruptcy could be avoided and that the LA DWP would continue to sell energy that could be used by the utility. He pointed out that, under bankruptcy reorganization, the utilities might be forced to sell their few remaining power plants. Freeman said he wouldn't want to see out-of-state suppliers allowed to "own the rest of the power."

Bad Press, Political Fallout...and Davis

The situation seemed to be slipping away from SoCal Ed.

There were still some tactical maneuvers left, though. Even if creditors sued to put SoCal Ed and PG&E into involuntary bankruptcy, that didn't automatically mean that the utilities' business operations would come under the supervision of federal bankruptcy court.

There still would be a chance to negotiate a deal to avert full-fledged bankruptcy; federal law would grant Edison and PG&E 20 days after receiving their court summonses during which they could indicate whether they planned to contest the bankruptcy case. And they could seek extensions to buy even more time.

Meanwhile, they could operate freely and have some of the protections of bankruptcy law. Specifically, they'd be temporarily shielded from creditor lawsuits and from having to pay their accumulated debts.

If the creditors wanted to take a hard line against the utilities, they'd petition for Chapter 7 liquidations instead of Chapter 11 reorganizations. Edison and PG&E would have the right to contest the petitions—and ask that they be converted to Chapter 11. But the public relations effects would be damaging.

The PR effects cut both ways. Political fallout, according to one SoCal Ed executive, was the utilities' best defense:

> The governor and the independent power companies were both afraid of political backlash. They knew, if the bankruptcies became a major media issue, they were going to be cast as the bad guys. And they didn't want that.

Put another way, it was guilt. The pols and the generators had prof-ited—in either political capital or capital capital—from a system that was destined to fail. When the failing started, they didn't want to be associated with it.

Gray Davis was certainly against the filings:

> Bankruptcy would mean that millions of Californians would be sub-ject to electricity blackouts. Public safety would be jeopardized. Businesses would close. Jobs would be lost. Investment would flee the state. And our economy would suffer a devastating blow.

So, most people in the energy industry noted, would his presidential aspirations.

Davis's words were supposed to be answering the threat of bank-ruptcy with a threat of his own: that he'd seize power plants and have the ISO operate them. The power generators didn't make this threat too seriously. Meanwhile, an informal "community of creditors" repre-senting many billions of dollars in utility debt was being organized by a Santa Monica-based investment bank. The group was not a formal creditor committee because it cut across several classes of creditors. Its purpose, unlike most committees, was not to prepare for the pos-sibility of a bankruptcy filing but to help organize and inform those owed money so that a rogue creditor didn't push the utilities *into* bank-ruptcy.

Getting Ready for the Fall

SoCal Ed and PG&E both realized that their creditors were afraid of the political fallout of bankruptcy filings, so for several months during the spring of 2001 they pressed for every advantage they could wring out of the regulatory system.

In other words, they started testing the limits of what they could get away with.

Word circulated to the ISO and the CDWR that the utilities might unilaterally start rolling blackouts.

The rumor was that the utilities planned to offer customers only as much power as each could generate by itself—which was about half the state's average need. Such a move would leave as many as 5 million utility customers statewide in the dark for hours at a time.

This made state regulators livid. The CPUC immediately issued an administrative order prohibiting SoCal Ed and PG&E from taking such actions on their own.

The heads of SoCal Ed and PG&E promptly issued statements saying that their companies had never made any such plans and that they were insulted by what the CPUC's action implied.

Industry insiders, however, speculated that this was all an elaborate charade being played out by the utilities to secure more favorable terms for possible bankruptcy. Attorneys for the two utilities went to court to win even higher rate increases than the CPUC was considering. SoCal Ed sought an increase of about 1 cent per kilowatt-hour over three years—to avoid what its lawyers called "imminent bankruptcy."

The investor-owned utilities complained that the rate increases proposed by the CPUC in early January were useless. The hikes translated into increases of about 7 percent for small businesses, 12 percent for medium commercial customers and 15 percent for large commercial and industrial customers.

PG&E had requested an immediate 26 percent rate increase; SoCal Ed had asked the CPUC for a 30 percent hike. They wanted larger rate increases—because big moves would give strong signals to investors and banks that the utilities' financial future was better.

A federal judge in Los Angeles turned down the request; and he hinted that he would toss out a more general lawsuit challenging the CPUC's rate caps before it got to trial.

PG&E's $6.6 Billion Loss

Even though the utilities lost that court battle, they still proceeded aggressively. They had very little to lose—and any setback would simply stir more rumors about bankruptcy. This, in turn, scared the banks and creditors into agreeing to more extensions.

In February, PG&E announced that it was only going to pay its suppliers about 15 percent of what they were owed that month. This constituted a default on about $726 million in payables and short-term commercial paper.

In filings with the SEC, PG&E said it would make a partial payment, totaling $161 million, on a pro-rata basis to qualifying generators, the CPX and the ISO. The utility also said it expected to do the same in March, which would mean defaults of about equal size.

PG&E could not pay more than $1 billion that it owed immediately for power bought on the open market and sold at lower, regulated prices. That number included $611 million owed to the CPX and ISO, plus $437 million owed to independent power generators. Moreover, the $1 billion was just what it owed in February; in all, PG&E estimated that it had lost $6.6 billion in high wholesale electricity costs that the California Plan wouldn't let it recoup.

In response, PG&E's banks gave it extra time to repay various short-term loans. Its creditors agreed to give PG&E until March 6 before they would seek remedies for the default.

Like SoCal Ed, PG&E had cash—half a billion dollars of it. But its bills from power suppliers totaled more than that, so the company held onto its cash to avoid...or at least delay...bankruptcy.

Seeking Forbearance

The key word in all of the utilities' negotiating was "forbearance." They sought it—either literally from lenders or figuratively from regulators—until the politicians offered some form of bail-out.

Through the spring of 2001, SoCal Ed remained in discussions with its bankers about giving it more time to make good on a $230 million default.

The utilities' unsecured creditors—including large power plant owners and hundreds of small electricity generators whose debts are not backed by utility assets—were more anxious than the banks, which had many incentives to be forbearing.

At a meeting in Washington D.C. that included politicians, regulators from the state and federal levels, executives from the investor-owned utilities and the generators, the generators agreed in principle to the forbearance—for as long as three months. But they made their stand on the matter of the amounts owed; they insisted that they wouldn't cancel any debts.

In Sacramento, the Assembly approved stopgap legislation to make the state a massive purchaser of electricity at fixed, long-term prices. This was the plan that would use CDWR credit to make electricity purchases for the investor-owned utilities. The move amounted to a dramatic admission that the California Plan had failed.

Businesses and homeowners served by SoCal Ed, PG&E and SDG&E would continue to receive bills from them, but the utilities would essentially be acting as bookkeepers for the state. The state would sell the electricity at cost, and in five years legislators would review the state's role.

The reaction to this plan among the independent generators was decidedly mixed. The state's guarantee was a good thing; but most were hoping that their forbearance would lead to more immediate results. Besides, there were limits to what forbearance could accomplish. Circumstances were moving toward some kind of reckoning.

The credit-rating agency Standard & Poor's warned that California's own credit rating could be downgraded because the state planned to spend $400 million to buy power for SoCal Ed and PG&E.

The CPX said it was laying off staff and beginning an "orderly transition out of this market," signaling a further dismantling of the state's deregulatory/regulatory structure.

Some experts noted that the entire process was stumbling toward the hot summer months, when millions of air conditioners throughout California would be switched on…and the power grid would be pushed to the breaking point.

In the end, the focus on utility solvency missed the point, anyway. Regulators and generators needed to be more worried about the most efficient way to allocate scarce electricity supplies. The financial strength or weakness of SoCal Ed and PG&E wouldn't add one megawatt of electricity to the grid.

Declaring Failure

PG&E tipped its hat when it applied to the FERC for permission to undergo a corporate restructuring that—in the event of a bankruptcy—would shield many of its assets from creditors.

The FERC tipped its hat when it quickly approved the plan.

The moves drew immediate fire from Davis and other state politicians. California Attorney General Bill Lockyer filed a petition with the FERC to block PG&E from shifting assets. The FERC had failed to give notice of the request to Davis or the CPUC, as required by law, Lockyer said. He went on to complain:

> Given all the talk about potential bankruptcy, we are concerned that PG&E used a stealth move to shield assets. The hasty approval sought and obtained by PG&E without a public hearing prevented the interests of California consumers from being represented in the FERC review process.

But the approval stood.

One staffer with the CPUC characterized the episode in an interesting way:

The whole dynamic had changed. In the late 1990s, we were the leading edge of utility regulation. The Feds were following us. After the blackouts, everything crumbled. We were getting jacked around by the utilities. And you got the feeling that they were laughing at us in Washington.

PG&E drove that point home when it filed for Chapter 11 reorganization.

For its part, SoCal Ed didn't declare bankruptcy—though it did negotiate a series of deals with the state that allowed it to restructure its debts and go through a kind of quasi-bankruptcy reorganization.

Undoing the California Plan

Months later, with the electricity crisis passing safely out of the memory of voters and consumers, PG&E resolved the last vestiges of the California Plan.

In September 2001, PG&E filed for Chapter 11 reorganization in U.S. Bankruptcy Court. The plan would allow PG&E to pay all valid creditor claims in full. The official creditors' committee supported the plan.

The plan reorganized PG&E and its parent corporation into two separate, stand-alone companies no longer affiliated with one another. The reorganized PG&E would continue to own and operate its existing retail electric and natural gas distribution system; the parent company would be an independent power generator, keeping the electric generation, electric transmission and natural gas transmission operations. The companies would split the employee base into roughly equal parts; otherwise, most of the workforce would be unaffected by the plan.

The plan restructured certain existing bonds and used $3.3 billion in cash on hand to satisfy creditor claims. In total, the plan would provide creditors with about $9.1 billion in cash and $4.1 billion in long-term notes.

The parent corporation would sell its power back to the reorganized PG&E under a 12-year contract at a stable, market-based rate.

Following the reorganization, the CPUC would continue to regulate the reorganized PG&E, while the FERC would continue to have jurisdiction over most of the reorganized parent corporation's activities.

In addition to resolving creditors' claims and maintaining stability for customers and employees, the plan also provided long-term benefits to the state. Most importantly: It offered the state a way to exit the business of buying power for customers—by identifying conditions under which PG&E would be able to reassume the procurement responsibility being fulfilled at that point by the CDWR.

Just about all of the parties with a financial interest in PG&E—creditors, employees and management—supported the plan. The CPUC and several consumerista groups didn't.

The critics made three main arguments:

- the plan was an attempt by PG&E to avoid regulation;
- the deal to sell power between the two reorganized companies was a sweetheart deal for the parent corporation; and
- the plan violated California law.

The consumeristas built their objections around breathless allegations of a $20 billion consumer rip-off from the reorganization plan. They also argued that PG&E had tried to play both ends of the California Plan—supporting when it was being drafted and then using bankruptcy protection to avoid the effects when the California Plan failed.

PG&E argued against the first claim strongly. It let the second claim slide.

The CPUC made its objections in court, insisting that it could offer an alternate reorganization plan that would be better than PG&E's. The CPUC's main argument was that creditors should be paid in cash

only—and not asked to carry notes. But, asked by the court to submit an alternate plan, the CPUC struggled.

PG&E head Robert Glynn offered his assessment:

> This plan, without raising retail rates, provides a safe, reliable and long-term electric supply to California customers. It enables our company to maintain a qualified workforce. And it enables us to keep our generating assets intact and integrated, rather than selling them piecemeal to pay creditors.
>
> Employees will see all of these assets placed with California companies, that will employ essentially the same skilled teams of employees who already know how to run them safely and reliably.

The state will not be asked to provide a bail-out, and will be provided a clear path to exit the energy procurement function if it wishes to do so. Creditors will be paid 100 cents on the dollar, with interest, for all of their valid claims.

Several weeks later, as part of a speech on the status of the California electricity market, Glynn offered a more detailed post-mortem:

> In California, actual electricity consumption this year has been about 5 percent below last year.... This lower consumption, we believe, was due to energy conservation and the economic slowdown in commercial and industrial sectors, combined with cooperative weather. These same factors, together with several new power plants across the state, were the basis for avoiding blackouts last summer.
>
> As to wholesale prices, in January 2001 the average peak-load hour electric price for Northern California was about 25 cents per kilowatt-hour. In January, it sold for about 3 cents. Forward prices for summer 2002 are currently about 4.6 cents.

Answering the Question that Begs

And what of the complaint that PG&E profited from the California Plan as long as it could—passing billions up and out through its corporate parent—and then ran to court when things got tough?

Formally, the company answered the question with a prepared text about the virtues of its reorganization plan. Privately, its executives had a more succinct answer:

"Yeah. That's what we did."

21

May 2001:

Gray Davis and

the Bail-Out

In early 2001, SoCal Ed and PG&E were so mired in debt that they were aiming the gun of bankruptcy at their own heads.

For several weeks running, the State of California spent as much as $45 million a day to keep electricity flowing.

Somebody was going to have to do something to stop the losses. Most of the players who bolted together the California Plan were still standing around with their hands in their pockets.

A Split-the-Difference Dealmaker

The focus fell to Gray Davis, who'd succeeded Pete Wilson as California's governor.

The events that led to California's energy crisis began before Davis took office. But the consequences were unfolding on his watch—and most polls indicated that voters blamed him for the problems. This threatened to become a bigger problem just as Davis prepared to run for reelection.

By law, there wasn't much that Davis could do about the electricity crisis. His authority was limited. And there was always the chance that short-term solutions could make things worse in the long run.

In practice, Davis was the one person who could do something.

Davis was no free-market theorist; he was no government-regulation theorist. He was no theorist at all. He was a split-the-difference career politician with presidential ambitions—much like his predecessor had been. Moreover, like his predecessor, Davis had a petulant streak that ran against the laid-back ideal of California leaders.

But Davis was smarter than Wilson, and he would count on his smarts—both academic and practical—to craft a solution to the electricity mess.

Before the January blackouts, Davis had been seeking a "transition to deregulation" that would include the price cap, a modest rate increase to consumers and stepped up conservation measures.

In an infamous November 2000 episode, Davis showed up at a San Diego meeting of the FERC, sounding like a grammar school teacher and scolding the Feds about dire consequences if they didn't follow his instructions. He told the FERC members that they needed to cap wholesale electricity prices or risk igniting a consumer revolt that could prompt California to try to reregulate the industry.

After the blackouts, Davis gave up on the transition and set about undoing the deregulation.

The hippies in Berkeley, Santa Cruz and the editorial offices of the San Francisco *Chronicle* were demanding a return to classic commodity-market regulation—frozen rates, controls on output and regulation at the point of finance. Some argued for state seizure and ownership of the entire electricity system, from plants to meters.

Davis, always cautious, was unlikely to go that far. Instead, aides said, he was looking for short-term relief with wholesale rate caps while exploring what he could do to accelerate the construction of new power plants. The perfect split-the-difference solution.

Eventually, Davis hoped that supply would again exceed demand—as it had when AB 1890 was assembled. In the meantime, he was riding out the storm along with all of the retirees who invested in utilities.

A Radical Circumstance

The California energy crisis was the perfect threat to someone like Gray Davis. He was an inherently conservative (but not conservative) politician who lived in fear of radical circumstances. The California Plan was a radical circumstance.

Davis seemed undone by the criticism that he had contributed to the meltdown of the state's two largest electric utilities by neglecting a repeatedly suggested strategy for stabilizing wholesale prices.

In early February 2001, a divided California legislature agreed to let the state buy as much as $10 billion worth of power over the next 10 years. This was part of the state's effort to find a way to head off the bankruptcies of SoCal Ed and PG&E.

But its efforts created problems of their own. At least one major power supplier—Texas-based Reliant Energy—said that it would fight any state order that it sell electricity to the ISO.

Reliant was rightly uncertain about whether the ISO could pay its bills. It filed suit in U.S. District Court in Washington contending that the ISO didn't have the legal authority to compel generators to keep selling power to the state.

The CDWR Takes Over

By mid-February, the state was spending so much money buying electricity to keep the lights on from day to day that it could burn through the $10 billion fund designed for setting up long-term contracts by May 1—the earliest date by which the state could sell the bonds. The pace of the losses had gotten ridiculous.

The state had no contingency plan if it exhausted the $10 billion allowance. Even a split-the-difference deal maker could see that something more would be necessary to fix the problem.

Davis issued an emergency order authorizing the California Department of Water Resources (CDWR) to take over the power-buying

responsibility for the utilities from the ISO. The CDWR was a state agency; the ISO wasn't.

The utilities said they'd amassed more than $12 billion in debt buying electricity during 2000—and they could not recoup these losses from consumers because rates were frozen in the transition to a deregulated energy market. State officials said they hoped power prices would drop in the spring and would keep the tab for short-term purchases from growing dramatically.

Davis hoped the CDWR arrangements would buy enough time for any of several possible solutions to materialize.

Always Needing More

An emergency rate increase averaging 9 percent was expected to be made permanent, and the state's 1996 deregulation law allowed for an additional 10 percent hike (really, just the reinstatement of the original 10 percent reduction) in March 2002. The total increase would be 19 percent—but no one expected that that would be enough to keep up with wholesale electricity prices that had risen nine-fold between 1998 and 2000.

So, the suggestion that California take an equity ownership stake in SoCal Ed and PG&E didn't seem like such a hot idea. Many in the utility industry and politics—including some members of Davis's own party—didn't think quick profitability would be possible. They argued that the solution was simply to allow the utilities to raise rates to cover their costs.

Some problems were basic. For example, the size of the utilities' debts was still in dispute. By some estimates, they were more than $10 billion—but more recent audits had revealed that the parent companies had received billions of dollars in payments that might be applied against supposed losses.

In short, the utilities were reluctant to give up equity because their management felt strongly that the California Plan had left them with no

choice but to run up debt. And the state was reluctant to take equity because it might end up worthless.

Davis, looking ahead to a summer energy crunch expected to be even worse than the winter's, issued an executive order that would add enough electricity for five million homes by July 2001.

How? The state would provide $30 million in bonuses and speed up the approval process for small natural gas or renewable-fuel power plants that ran only during peak hours of the day, if those facilities would be operating by summer.

Davis asked President Bush to direct federal agencies to issue permits for small plants within the same time frame. Bush shrugged his shoulders and said his agencies hadn't been the source of delays.

Wall Street analysts who met privately with Davis in New York near the end of February 2001 called his moves a good step toward solving the energy crisis, but said more had to be done.

The state's consumer price caps had shielded voters from billions of dollars in higher power charges. But they'd bankrupted the investor-owned utilities—companies that one California politician called "school girls in a whorehouse."

The CPUC had tried to address this problem by allowing the investor-owned utilities to enter long-term contracts with generators. By the spring of 2001, only four such contracts were announced for a supply of 500 megawatts—a total that one state lawmaker rightly called "a drop in the bucket." Generators were reluctant to make long-term deals with the state without its guarantee that the money owed by the utilities would be paid.

So, Davis was back to square one. He needed to keep the utilities solvent; bankruptcy for either SoCal Ed or PG&E could lead to large, sudden rate increases for millions of California residents and businesses ordered by a federal court.

He couldn't keep doing things piecemeal; he needed to wrap various elements of reform into one large package. And he'd probably need the state legislature to sign off on this.

Piecing a New Plan Together

Davis assembled a reform plan out of the pieces of several proposals that had been circulating around Sacramento and Washington D.C. for a year or more. The plan had three basic parts:

- a power authority armed with a budget of $5 billion to finance new electricity plants;

- an up-to-$7 billion state purchase of the portion of the power grid owned by SoCal Ed, PG&E and SDG&E; and

- a $10 billion bond issue to lock up long-term power contracts.

The proposal to create a state power authority that would replace the ISO passed the California Senate in late February.

The idea came from California State Treasurer Phil Angelides (who ended up as a sort of gadfly, offering alternative plans to Davis's and pushing the governor to act more decisively). The five-member authority would have the ability to sell revenue bonds. With that money, the authority would act as a low-interest lender to power generators that want to build in California.

Angelides said any loans to generators would come with strict conditions; if the state loaned part of the money needed to build a plant, the owners would have to agree to sell power to state customers first.

John Burton, the state senator who was the bill's sponsor, claimed that creating a power authority would give the state more control over the wholesale market. Among other things, the power authority would have the authority to seize plants by eminent domain during times of crisis or if the owners showed bad faith.

This wasn't a power that anyone would be excited to use. If the state started seizing plants, it could deter private companies from building

new facilities in the state—the opposite effect of what lawmakers were trying to achieve.

Generally, consumer groups, environmental interests and unions liked the idea of the new power authority.

Changing of the Guard

The most intriguing of the three main reform proposals was the state's acquisition of the power grid. The ISO had been running the grid for several years—but the utilities still owned the actual power lines and transfer stations.

Davis proposed that the state pay SoCal Ed and PG&E as much as $7 billion (Davis refused to be specific about the amount he'd pay) for legal title to the 26,000-mile network. The utilities could use the money to pay off their debts to generators and bank loans; the state would take possession of a money making asset.

The grid generated about $1 billion in fees a year, mostly from power companies other than SoCal Ed and PG&E paying for the transmission of their electricity.

Davis said that the acquisition would "make sure the taxpayers get some value" in the form of long-term electricity price stability and just about ensure that the utilities avoid bankruptcy.

But the deal wasn't perfect. The grid needed ongoing maintenance—and some immediate repairs. Experts at the ISO, who'd been working with the system, estimated that the state would need to spend about $1 billion in addition to the purchase price to make repairs.

And there was some haggling going on among the sellers.

SoCal Ed officials said they would prefer a deal that included all three investor-owned utilities...but might agree to sell their share of the transmission lines alone, as long as they were not held responsible for any of PG&E's debts. (As a member of the ISO, SoCal Ed had agreed to pay a share of any default by any other member.)

To finance the deal, the state would issue more bonds. These would be paid back over years through consumer utility charges. The plan, strictly speaking, wouldn't require new rate increases.

Although it would cost billions and bring the state directly into the electricity business, there was an elegance to the idea of buying the grid. State agencies were already administering the system—though the $1 billion a year in fees were flowing back to the utilities. There couldn't be a more clear example of an externality—the kind of big, public good that even free marketers agreed government should provide—than the power lines that moved energy around the state.

Some California lawmakers questioned the wisdom of acquiring the network of power transmission lines across the state, saying the financial risks of upgrading and managing them could exceed the reward of owning them.

Buying the Lines

In late February, the state agreed to buy SoCal Ed's lines for $2.7 billion—twice their book value. But it was unable to work out a similar deal with PG&E, whose participation was crucial.

As part of the deal, SoCal Ed also agreed to:

- protect 20,000 acres of watershed lands it owns for 99 years;
- drop a federal lawsuit that challenged consumer rate caps;
- transfer $420 million in overpaid taxes from the parent company back to the utility to help it pay off its multi-billion dollar debt; and
- ensure that it produced power at its dams and sold it for the cheapest rates available in the state for at least 10 years.

In return, SoCal Ed would also be allowed to sell new bonds of its own to recover a "substantial portion" of its claimed losses. These bonds would be repaid over several years from customer payments. Critics predicted that the arrangement would lead to rate increases; but Davis said he thought that the bonds could be repaid without boosting ratepayers' bills.

John Bryson, head of SoCal Ed's parent company, said:

> While we continue to believe that as a matter of law and equity we are entitled to be fully reimbursed for the cost of purchasing power on behalf of our customers, this agreement is far preferable to perhaps years of protracted litigation for our ratepayers, shareholders, creditors and employees.

The FERC would need to approve the sale.

Consumeristas could rant about the deal being "a ruse to funnel money to the utilities without the political repercussions of a direct bail-out" and the bonds being an excuse for SoCal Ed to raise rates. But, as usual, they missed the real issue.

Davis and other politicians spoke about buying the grid as though it would—by itself—solve pricing problems. But owning the power lines wouldn't give the state the authority to cap wholesale prices.

Some economists and industry executives said buying the grid was just a shell game. The purchase would do nothing to increase power supply—and could have the unintended consequence of scaring off investors and exacerbating the state's power supply crisis.

On a more purely economic level, buying the grid would move California closer to complete reregulation of the electric industry, while other states and nations were still opening their energy markets to competition.

The proponents refined their argument: Sure, owning the grid didn't mean instant control over prices, but the state could institute policies that could create incentives for generators to sell at lower prices.

The independent generators didn't like the sound of that, either. They grumbled that the state could rig markets if it owned the grid and was negotiating electricity contracts. It could then develop policies that discriminated against independent businesses.

Defending the Bail-Out

The third main element of the reforms was the biggest and most controversial.

The state had already pledged to spend at least $10 billion in revenue bonds to buy power for customers of SoCal Ed and PG&E, both of which were being denied credit by electricity suppliers.

The form that these state-sponsored purchases took was complex. The CDWR would actually buy the electricity power, on a basis that Davis described as a "bridge to a long-term solution."

The CDWR was a government agency, so its credit was backed by the state. But the utilities were still responsible for paying the bills. In effect, the arrangement was like a parent with good credit buying a car for a child with bad credit—but counting on the child to make the monthly payments.

Also, the CDWR deal permitted long-term contracts with generators. So, it was formally the demise of the CPX.

Davis downplayed these details, including the fact that the CDWR arrangement could end up raising electricity rates for customers of SoCal Ed and PG&E.

His political opponents didn't miss the beat. State GOP leaders and some consumer groups—not normally on the same side of an issue—criticized the proposals as an excessive bail-out of the utilities. One Republican lawmaker called the plan a "complete capitulation" to the utilities' demands and a "bail-out."

Davis took great offense to the term "bail-out." Apparently, the term polled very poorly in focus groups; people inclined to think of the electricity crisis as a scam considered a "bail-out" some sort of after-the-fact proof.

Acknowledging the Reality

This was an overreaction. The governor's reforms did bail the utilities out of an impossible business situation; and they allowed a number of out-of-state generators to collect big profits. But the first outcome was necessary…and the second simply acknowledged a contractual reality.

To assuage consumer advocates and others who said his proposal was just an expensive bail-out, the governor also said he was expecting the utilities' parent companies to make a "substantial contribution" to keep their struggling subsidiaries afloat. The consumeristas weren't satisfied; they scoffed that the contributions were too small to matter.

Davis was a politician. His split-the-difference approach was usually cloaked in consumerista rhetoric. His reform plans also included a number of provisions that were designed to position Davis as an anti-corruption crusader. Specifically, they would:

- restructure the governing boards of the ISO and CPX;
- overhaul the bidding process for electricity, which currently guarantees that every generator is paid according to the highest bid, rather than their own bid;
- streamline the process for utilities to enter into low-cost, long-term contracts for electricity and then apply pressure to the out-of-state generators to supply that power;
- make it a criminal act to deliberately withhold power from the grid;
- provide state regulatory agencies with authority to order any functioning generating facility down for "unscheduled maintenance" to go back online;
- expand the authority available to the governor under a state of emergency in the event of imminent power outages;
- provide $4 million to the Attorney General to investigate and prosecute possible racketeering, market manipulation, price fixing and other potential violations by merchant generators;

- repeal the portion of existing law that encouraged investor-owned utilities to sell their generating facilities; and

- require municipal utilities to sell their excess power to California consumers at reasonable rates.

Most of these measures were political window-dressing.

Auctioning Long-Term Contracts

Even though the reforms were still being reviewed and negotiated by the Sacramento pols, Davis approved an auction in which independent generators would offer long-term contracts that the CDWR could accept to replace the spot market that had caused so many problems.

The auction involved the supply of an estimated one-third to one-half of the state's electricity needs under contracts of as many as 10 years in duration. The state's written request for bids required that offers contain only fixed electricity prices. The state wouldn't accept bids where the price is "subject to change through the term" of the contract, according to the bid solicitation.

The Davis Administration solicited bids over the Internet in a 27-hour process. Officials from the CDWR reviewed several bids from energy generators seeking to sell the state power.

CDWR Director Thomas Hannigan said most of the 39 bidders complied with state specifications. The average of 6.9 cents per kilowatt-hour covered energy use day and night, but not so-called peak-load periods when power demand is highest and electricity is most expensive.

The week that Davis accepted bids, PG&E charged its residential consumers 6.7 cents per kilowatt-hour for electricity (a price that included a recently-approved temporary rate increase). Davis hoped to get bids of around 5.5 cents per kilowatt-hour; but some state bureaucrats said the system could support wholesale prices as high as 7.4 cents.

All those numbers were higher than the 3 to 4 cents wholesalers had charged in early 2000—but they were much lower than the 30 cents a kilowatt-hour the investor-owned utilities were paying in January 2001.

A spokesman for Davis said that the governor was still determined to arrange prices of 5.5 cents or less. This would probably mean longer-term commitments (generally, the longer the term of an energy contract, the lower the kilowatt-hour price). Most generators told the governor that there was little power supply available at 5.5 cents for three years. But significant supply could be available at 5.5 cents under terms as long as eight years.

The length of the contracts could also be an issue because prices for electricity are expected to fall as more power plants come online over the next several years. That might leave the state locked into contracts with prices well above prevailing rates.

The Davis Administration released only sketchy details about the bidding. They left unanswered several key questions: Which companies submitted bids, how much energy they offered to sell and over what periods. They did say, however, that they were turning to veteran public power expert S. David Freeman, head of the LA DWP, to negotiate final deals with the power providers.

Everyone Was Unhappy with Davis

With Davis's plans announced publicly, the politicians in Sacramento hoped that the utilities' creditors would remain patient while the rescue package moved through the Legislature.

But there were so many interested parties in the electricity equation that it was impossible for anything to proceed quietly.

The consumeristas sounded off first. Harvey Rosenfield criticized Davis's plan, calling it a "giveaway" to companies—in this case, he was talking about the utilities—that has gouged consumers and protected their stockholders and parent corporations. According to Rosenfield:

The most outrageous part of this isn't even paying 2.3 times what the lines are worth, but then allowing the parent companies that siphoned off billions of dollars to pay only the tax payment they already owe.

"The governor's been outfoxed by PG&E and Edison," said Harry Snyder of the Consumers Union. "And to lose out to people who lose more than $12 billion in a year, you really have to not be paying attention."

Independent electricity generators and others owed money by SoCal Ed and PG&E were growing increasingly irritated with the slow progress toward a solution.

Sacramento Republicans weren't happy. Davis had not briefed Republican lawmakers about his plans in advance of releasing them. And most Republicans opposed the state's purchase of the transmission grid.

Everyone complained that the plan was fuzzy about who would repay the $10 billion in bonds—the CDWR or the utilities themselves—that the state would issue to purchase electricity.

Not even Davis seemed to know whether his plan to rescue California's cash-poor utilities would leave consumers holding the bag.

Fortunately for 1.2 million SDG&E customers in San Diego County and south Orange County, the package of reforms placed a cap on their electric bills—retroactive to June 2000 and in force until 2003.

AB 1X Passes

Davis's reform plans were assembled in a single energy bill called AB 1X. It was the antidote to 1996's AB 1890. (To be precise, AB 1X modified provisions of AB 1890.)

After much political dickering, it was signed into law during the first week of February 2001.

Davis and energy industry executives had a difficult time mustering support for the bill. The main reason it passed was the provision that allowed for long-term electricity contracts on behalf of the utilities, whose finances were so shaky that energy generators are hesitant to sell them power. Most Sacramento pols realized that the spot market had been a disaster…and that they needed to staunch the costly flow of money—up to $45 million a day—that California was spending to buy energy on the short-term market.

If the state was able to negotiate long-term contracts at a good price, there would be little impact on consumers; if it was sloppy, consumers would likely see higher electricity bills.

In addition to setting up the CDWR credit mechanism, AB 1X also eliminated customer choice, which had been the cornerstone of the state's 1996 reform. Under AB 1890, customers had had the opportunity to lock in lower electricity rates by signing up with a direct service provider, in place of PG&E, SoCal Ed or SDG&E.

The new legislation "suspends the ability of retail customers to select alternative providers of electricity until such time as CDWR ceases procuring power."

The bill was careful about separating the state's credit from the utilities' credit in the CDWR mechanism. (The widely-repeated characterization that the state was "co-signing" loans to the utilities was not—strictly speaking—accurate.)

Neither the "full faith and credit nor the taxing power of the state are, or may be pledged, for any payment under any obligation authorized by the bill."

To be precise, the CDWR would issue bonds and let the utilities use the proceeds to pay off their debts. The bonds would then be paid off by ratepayers over several years. The bond offering would be a large one—worth about $300 of debt for every person in the state.

With interest, the bonds would cost up to $17.5 billion over their 15-year lives. Because the bonds would be taxable—and would not be

backed by the full credit of the state but rather by utility ratepayers—the state had to pay investors about 8 percent interest, rather than 5 percent as on tax-exempt bonds.

And residents still faced the prospect of rate hikes. The measure allowed the CPUC to raise electricity rates to make sure the CDWR power purchases would be paid.

AB 1X also included another $500 million to finance short-term electricity purchases for the utilities, until the CDWR mechanism got started. The bill was signed by Davis shortly afterward and immediately went into law.

Some economists questioned whether it was a good idea for the state to assume power-purchasing authority. The move might seem all right during a crisis—any active response did—but it could cause problems if the state were having budgetary problems of its own.

The most heated criticism concerned the provision that would allow the CPUC to raise rates.

The Conservation Provision

Another provision of AB 1X, designed to encourage conservation, would penalize residential customers with higher rates if they consume 30 percent more energy than a baseline specified by regional climate and energy use.

Initially, some commentators laughed this provision off as more political window-dressing. But SoCal Ed predicted that the provision would be a bigger deal than people realized—about half of its 4.3 million customers would face rate increases under the plan unless they reduced power usage.

Davis agreed, describing the conservation provision as a self-funded program that he hoped would free 3,700 megawatts from the state's stressed-out power grid. To this end, in a step that had few antecedents during peacetime, Davis issued an emergency order requiring

California retailers to cut their outdoor lighting in half or face fines of up to $1,000 for every violation.

Better demand-side management did represent an immediate means of addressing the electricity crisis. One of the worst parts of the old California Plan had been the fact that it disconnected retail energy use from any financial effect.

The consumer price caps had done this. They eliminated any financial reason to conserve energy…so people and businesses left lights on, computers running and old refrigerators leaking cold air.

AB 1X included a conservation program whose budget could rise as high $800 million. Davis used these resources to promote a so-called "20/20 Program" under which people would receive a 20 percent rebate on their electricity bills if they reduced their year-to-year use by 20 percent.

The program also provided cash incentives to Californians to replace inefficient refrigerators, washers and air conditioners with more efficient models. The program proved unexpectedly effective; the state lowered its consumption by 10 billion kilowatt-hours.

Several months later, PG&E's Robert Glynn noted:

> A major reason for the remarkable amount of conservation by residential customers was Governor Davis's very successful 20/20 energy conservation program.
>
> Every month, on average, for June, July, August and September, about 1.3 million—or about 31 percent—of our company's residential customers qualified for the program. This means that they cut their electric use by 20 percent and got a 20 percent rebate on their bill for each month they qualified.
>
> For the summer of 2001, total usage for this group was an astounding 40 percent below their usage in the summer of 2000. This was a remarkably successful program. We can thank Governor

Davis for the program, and millions of Californians for getting on board.

The lower consumption was undeniable—and good. But a free-market economist would wonder whether the changed behavior resulted from Davis's rebates...or the massive, undeniable price signal the state had gotten during the January blackouts.

The Investment Bankers...Again

In retrospect, the sorts of people and companies that influenced the details of AB 1890 suggested the problems that followed. The same might be true of AB 1X. Who influenced it?

Investment bankers.

AB 1X included a revenue bond financing plan written by the investment bank Credit Suisse/First Boston—which was a major player in energy sector stock and bond offerings.

Michael Peevey, a former SoCal Ed executive who'd also started an energy trading company that he'd sold to the big generator AES Corp., was another influence. He was a special advisor to Davis—and pushed hard for the deal under which the state purchased the transmission grid.

A third influence was a New York banker whose company sold billions of dollars in securities for power generators—including the "profiteers" who'd made big profits selling electricity through the ISO. Former Treasury Secretary Robert E. Rubin, chairman of the executive committee at Citigroup Inc., was appointed in January 2001 to advise Davis on bond financing, long-term power contracts and ownership of power plants.

SEC filings showed that Citigroup's Salomon Smith Barney subsidiary was an investment banker for several independent generators that sold electricity in California. Salomon had sold $1.15 billion in securities offered by Calpine and $300 million in securities by AES Corp.

Consumeristas complained that this was a set-up; the investment banks were influencing reforms that would result in big bond offerings...and big fees for investment banks. They said their concerns mounted when they learned that Credit Suisse had been doing more than just offering advice—apparently senior policymakers had asked the company to draft the financing plan for the state's power purchases.

But the lawmakers said the experts helped protect Californians from repeating the kinds of mistakes like AB 1890. For example, AB 1X included a provision that was suggested by a panel of bankruptcy attorneys: The state had planned to buy energy and then sell it to the utilities, but this would have made the state an automatic party in any bankruptcy lawsuit; instead, the state was making sure the energy was delivered to customers without ownership ever shifting to the utilities.

Pollution Credits

Soon after he signed AB 1X into law, Davis traveled about 40 miles north of Sacramento to Yuba City to announce his plan to speed up the process of building power plants.

The governor chose the site of a 500-megawatt plant under construction because it was the kind of smaller plant that could be approved and built quickly. He thought that some 5,000 megawatts of electricity could be brought online by small plants by the summer—in time to avert more rolling blackouts. He wanted another 5,000 megawatts online by the following summer.

Davis issued executive orders to shorten the approval process for new plants. He also promised to pay bonuses to builders who finished small plants before July.

To help build the plants faster, Davis directed the state California Air Resources Board to create a bank of pollution credits.

Gas-fired turbines provide a quick burst of power during peak demand, but they can be heavy polluters. Power companies typically

compensate for the emissions by buying credits from sources that have reduced smog, but those credits are not always available and can be expensive.

The air board would use $100 million in state funds to build the new pollution credit bank; independent generators would also pay into the program. The money would be used to clean up diesel trucks, buses and heavy equipment—ensuring a steady supply of credits for the peak-load power stations.

Keeping SoCal Ed Buoyant

Applying the broad strokes of AB 1X to the specific needs of the California electricity marketplace would require political will and additional effort.

In late August 2001, Davis and Assembly Speaker Bob Hertzberg announced agreement on a proposal that would help SoCal Ed avoid following PG&E into bankruptcy.

The bill included the following key provisions:

- A dedicated rate component for SoCal Ed's undercollection of $2.9 billion to be paid by business customers.
- A five-year option for the state to purchase the transmission lines at two times book value, or $2.4 billion.
- SoCal Ed to resume power procurement by Jan. 1, 2003.
- A tax refund to be applied to the undercollection.
- A limitation on dividend payments.

Business customers, regardless of size, would be responsible for paying off the bonds. SoCal Ed would be forced to absorb the $1 billion it owed to electricity generators for power purchases.

SoCal Ed chief John Bryson said he wasn't sure whether the proposal would restore the utility to financial health; but he considered it an improvement over the status quo and most of the alternative plans he'd heard.

A Giant Game of Chicken

So, did Gray Davis deserve high regard for his efforts to put together a bail-out of the state's spiraling electricity market? Perhaps. But, just as the fault for the mess is impossible to pin on one player, the solution was a multi-variable equation.

Certainly, the federal government—from the White House on down to the bureaucrats at the FERC—could make the argument that, by the spring of 2001, Davis didn't have many choices about how to handle the crisis. And that he merely followed guidelines set by the Feds.

The investment bankers who helped draft AB 1X could take credit for making the deal happen. But they were more interested in taking fees from the bond offering.

Davis's own words betray the reactor that he was at his core. In an interview with the San Diego *Union-Tribune*, he explained his own thought processes:

> I didn't deserve the mess I inherited in energy. I didn't complain. I didn't moan and groan. I didn't say 'Woe is me.' I just rolled up my sleeves and we eventually worked our way through the worst of this problem. …It was a disaster. And I explained time and again, I said this is a theory, it is not working. Our job is to make things work. We shouldn't be slaves to a theory that is not working.

> This is a giant game of chicken. The generators did not have to sell us power. I didn't tell them this, but in my heart of hearts, I was not going to let this state go dark. There were several people, this guy popping up all the time, [University of California Professor] Peter Navarro, saying "Oh, just call their bluff, they'll go dark for two or three days, but then they'll have to sell us the power." They do not have to sell us the power. They can sell it to Nevada, to the Northwest, Arizona.

So, we had to basically start buying power on the spot market. December was high, so was January when we started buying power. In February and March we signed long-term contracts, reduced our cost by 75 percent below the spot market.

Now, we're going to go back and restructure these contracts. If I don't restructure them one penny, no one will see an increase in their rates. In fact, they will see a reduction in their rates about two years out. If I restructure…only some of them, it will further increase the rate reduction.

I kept the lights on. And this sounds a little presumptuous, but I think I should at least get a round of applause. I don't get squat. People just roundly criticize me….

From the tone of those comments, it's not hard to understand why.

22

June 2001:

Cleaning Up

the Mess

June 2001 was a big month for cleaning up the pieces of the California Plan. One utility executive compared to the end of famous movie *The Godfather*—loose ends were tied up. And some people left the scene.

On June 19 the FERC reversed its position of long standing and agreed to impose wholesale price restrictions on electricity sold in California. More than any other single act, this put an end to the energy crisis. It did so just the day before summer officially started.

A Dramatic Reversal

The wholesale price caps ended the predictions from various corners that the summer would see more blackouts. And they really were a dramatic reversal. As recently as April, U.S. Energy Secretary Spencer Abraham had said the Bush administration was "strongly opposed" to the imposition of price controls on electricity markets in California and elsewhere.

Technically, the turnaround took the form of an order authorizing the ISO to limit wholesale prices for electricity sold for immediate delivery to the state at all times of the day. The order would remain in effect until September 30, 2002. It solved the energy crisis—and killed the California Plan.

Choosing to call the action "price mitigation," the FERC ordered the ISO to calculate the cost of each plant to produce power and estab-

lish a price based on the cost of the least efficient generator called on to run. All generators that transmitted power through the California system had to sell available supply when the ISO demanded it. More efficient plants could earn a profit.

And the order was regional. To prevent generators from selling power outside the state to avoid the California controls, the commission required that no western generator receive more than the price the ISO set.

As for the infamous $3,880 megawatt-hours, the commission found that the "just and reasonable" price should have been $273 and ordered Duke Energy and other power companies to return any money collected over that amount. As it turns out, however, there is almost nothing to return. The power companies had been paid much less— only $70.22—for each of those megawatt-hours.

Of course, the price caps drove the last nail through the heart of any pretense that California had a "deregulated" electricity market. The market had never been deregulated; it had merely swapped one set of regulations for another…and then another.

A Chilling Effect

Also, more than any of California's energy follies, the FERC decision sent a chill through deregulation efforts in other parts of the United States. It was a signal from the top of the regulatory pyramid that the electricity business was too complex for patchwork deregulation.

"No one around here will say it publicly, but the decision came down that a free market in electricity wasn't going to happen. At least not any time soon. That's the reason Curt Hebert left," says one FERC staffer. "If there's any chance of deregulation, it's going to start and the federal level. And it's going to happen incrementally."

Former FERC head James Hoecker explained the agency's sometimes unclear response:

Until recently, the FERC was an old style cost-of-service regulator predominantly. We recognized in the late 1990s that was changing and that the Commission will have to be at least as much a market monitor and referee. That means hiring people that specialize, not in calculating depreciation rates for example, but in financial markets and e-commerce and arbitrage, and analyzing market concentration. The Commission's office of Market Tariffs and Rates was created to foster and develop those skills but, as you point out, the competition is great and there is a lot of work ahead.

There was some speculation about exactly why Hebert—George W. Bush's staunch free-market FERC chairman resigned. The timing of his decision suggested that it was in protest to the turnaround on West Coast wholesale price caps.

Among people in the energy industry, there seemed to be a general consensus that Hebert's aggressive pro-deregulation politics made him ineffective in dealing with state problems—and specifically California's problems.

An alternate theory was that the Bush Administration had gotten wind of the problems brewing at Enron Corp. and wanted to back away from aggressive stances on deregulation.

Whatever the reason behind it, Hebert's departure from the FERC was a signal that the Bush Administration was giving up on free market reforms. It was unfortunate that someone like Hebert—a free market advocate whose background was in government work—was flushed out of a policy-making decision because of alleged fraud at Enron and absolute incompetence in Sacramento.

Hebert's successor at the FERC was Pat Wood III, the former chairman of the Public Utilities Commission of Texas and a close friend of the President. Like Hebert, Wood was a free-market advocate who favors deregulation—though Wood was considered more pragmatic and less doctrinaire. He was given the brief to fix the "California problem."

The immediate effect of the turnaround was that several power suppliers suspended sales to California. The drop was enough for the ISO to declare a Stage One Alert. And, under the new rules, a California power emergency initiated price limits to all West Coast markets—from Arizona to Washington.

Important Decisions

Though it may have been bad news for the economy at large, the FERC turnaround was a tactical victory for Gray Davis. Even in victory, however, he sounded ungracious:

> In June 2001, the Federal Energy Regulatory Commission finally woke up, remembered the third name in their title and did something.

Davis said the turnaround didn't go far enough. He also asked the FERC to order $9 billion in refunds from generators. In late February, Davis had told about 35 industry analysts in a private meeting in New York that he would ask the generators who'd sold power at "predatory prices" in California to accept less than the payments they were demanding. He said some generators had offered to take less than full payment.

Duke Energy, for one, said it would cut by $20 million the amount it claims is due for electricity sales in California. According to Duke executives, the company has collected less than 2 cents on the dollar for electricity it sold to California in January and February.

In a separate but equally important decision, the FERC signed off on the state's plan to enable private energy companies to own rights to a key part of California's electrical transmission grid. The plan would expand Path 15, which became even more important to the state because of long-term contracts signed with power generators.

Path 15 was an 85-mile stretch of high-voltage wires in the San Joaquin Valley—owned by PG&E—that moved power between Southern and Northern California. They could carry a capacity of about 3,000 mega-

watts, which had been insufficient at times during the power crisis; that capacity would be expanded by about 800 megawatts.

A company or utility hoping to move electricity along Path 15 would have to pay a fee to the owners of the transmission rights and obey their rules. Soon, the state was going to be the owner.

The Rules Committee

At the same time that the FERC was changing to rules of the business, the Rules Committee of the California Senate was starting an investigation into charges that independent generators had illegally manipulated the wholesale market in late 2000 and early 2001.

These allegations were as dubious and weak as they'd always been, but politicians seemed unable to resist the temptation to strike consumerist poses.

The Rules Committee was using subpoena powers to require eight out-of-state power generators to hand over data related to pricing, bidding and other elements of commerce in electricity. Subpoenas were issued to Reliant Energy, Dynergy Energy Services, Williams Energy, Enron Corp., NRG Energy, Inc., Duke Energy, Mirant Inc. and AES Corp. This was a *Who's Who* of independent generators and deregulation supporters.

Deregulators were on the run in Sacramento and the tone in the legislature had changed substantially in the five years since Steve Peace bolted together AB 1890. Peace announced that he would step down from California politics when his term ended.

On a more positive front, natural gas prices were dropping steadily. Spot prices for natural gas in June had fallen nearly 25 percent. And power plants down for maintenance during the spring had returned to service, expanding generation capacity.

Prices dipped as low as $20 per megawatt-hour. The futures market reflected the trend. The price per megawatt-hour for August electricity was about $200—versus the $700 futures had been in April for August deliveries.

But the good news from the marketplace created some problems for the state. Just a few weeks earlier, it had signed a number of long-term contracts with independent generators (this was part of the complex bail-out deal sort of guaranteed by the CDWR) designed to stabilize capacity and costs for the investor-owned utilities.

In March, Davis had announced that the state had reached 40 long-term contracts and other agreements to supply an average of nearly 8,900 megawatts per year for Southern California Edison and Pacific Gas and Electric customers over the next 10 years.

For the first five years, Davis said, the contracts provide power at an average price of $79 per megawatt hour. After that, the price dropped to an average of $61 per megawatt hour.

When they were signed, these deals looked like good ones. But, with prices falling, they were already looking not-so-good. Once again, circumstances were changing more quickly that the state could keep up.

The Media's Boondoggle

The conclusion of these moves was ultimately good: rotating outages—if they happened at all—would be fewer and shorter during the summer than had been expected. But no good outcome could go unpunished. The media couldn't sink its teeth into the blackouts...so it turned to complaining that the long-term contracts were a $43 billion boondoggle.

The Los Angeles *Times* reported that the state had agreed to buy power at prices up to $154 a megawatt hour during peak hours; by contrast, a mid-June survey by the Bloomburg news service showed peak prices were below $58 a megawatt hour.

California Controller Kathleen Connell admitted that the cost of the state's recently negotiated long-term electricity contracts could exceed the original $43 billion estimate.

According to Connell, costs authorized by the contracts were running between $70 and $200 per hour; she predicted that over the next 10 years they would be much higher than the $69-per-hour guess of the Davis administration. And rates could fluctuate dramatically during the 10-year life span of the contracts.

This was the damned-if-you-do, damned-if-you-don't criticism that made Gray Davis so petulant.

Of course, petulant or ungracious weren't Davis's concerns in all of this. He wanted concessions from the Feds and from the independent generators. Moreover, during the summer of 2001, Davis was on an undeniable winning streak.

Near the end of June, the FERC's head administrative law judge—who would be overseeing refund settlement talks between California and the independent generators—said the energy firms would probably have to pay back overcharges of "several billion dollars."

This was another victory for Davis.

FERC judge Curtis Wagner said Davis's claim that the state was owed $9 billion was too much...but not as ridiculous as it had seemed some weeks earlier. Wagner said:

> I'm hoping to come up with a settlement of the issue of a refund of overcharges—if there are overcharges. My sense is that there probably are.

In March 2001, the ISO had released a report saying that wholesale power generators and marketers overcharged California's utilities $562 million above "just and reasonable" prices during December and January. The ISO believed that this was an amount that the federal government should order refunded.

If June 2001 was like the last scene of *The Godfather*, then—as unlikely as it might seem—Gray Davis was Michael Corleone. The man in the middle of all the action.

The Breakdown of Trust

Truth is the first casualty of war. As SoCal Ed CEO John Bryson explained it, trust had been the first casualty of the California Plan:

> ...in my more than 20 years in the electric utility industry, and as a former President of the Public Utilities Commission, I have never seen less trust between the Commission and investor-owned utilities. A sense of mutual trust has historically been at the very heart of that relationship. It's an essential underpinning of the entire system.

Bryson's rhetoric and logic were shaped by the hothouse in which he had based his career—highbrow consumerista outfit to extremely powerful regulatory body to regulated executive. He had a hard time understanding that deregulated companies might have a contentious relationship with regulators.

> ...we increasingly find ourselves today treated as an adversary and as an enemy—a subject of countless inquiries, data requests, investigations, hearings and even an unwarranted restraining order to remind us of the duties that we have fulfilled for over 100 years. This kind of dysfunctional relationship cannot help our current situation; it can only make it worse. ...no objective observer today can trust that the regulatory environment that currently exists will contribute to restoring the financial integrity of California utilities.

The result was a kind of Alfred E. Newman righteousness. The utility was so clueless about profit-motive business that it was comfortable being uppity about the mistakes it had worked hard to make.

> In that sense, there is a fundamental breach of the trust that has been at the very heart of California's system of delivering electrical energy. Make no mistake about it. Until that breach is repaired, this crisis will linger and its resolution will be delayed. And that will be costly for everyone concerned.

Nowhere was the breakdown in trust more evident than in the accusations that SoCal Ed shareholders had profited from deregulation at the expense of consumers.

According to Bryson, nothing could be further from the truth:

> During the last five years, [SoCal Ed] received cash from all sources of about $42 billion. Almost 90 percent of this cash has been applied to utility operations and utility debt reduction. Less than 5 percent has been applied to ordinary income dividends. The balance is accounted for by...stock repurchases.

The rhetoric of that seemed pretty transparent. Bryson's own statement allowed that more than $4.5 billion had gone to dividends and stock repurchases that benefited SoCal Ed shareholders.

Of course, Bryson had an explanation for why SoCal Ed spent the money as it did:

> As in any liquidation of a business, the proceeds of liquidating our generation business were returned to creditors and investors as the asset base shrunk—just as happens when you sell your house. If we didn't return this investment, then creditors and shareholders would have required a return on these amounts—a return no longer included in rates as we exited from generation as a regulated business.
>
> Indeed, we followed the CPUC's own established guidelines for doing this —to maintain a balanced capital structure of roughly half equity and half long-term debt.... It was very well understood that the shrinkage of the asset base of SCE would be one of the consequences of liquidation of the generation business. Ironically, it was the CPUC's Office of Ratepayer Advocates that suggested that we retire less debt and more equity from the proceeds of the Rate Reduction Bonds....

So, it was the CPUC's fault. According to SoCal Ed.

Rebuilding Trust

There had been three more blackouts since January—one in mid-March and two in early May. These outages were smaller and shorter-lived that the January outages. They seemed to make less of an outraged impression on the public.

But they did compel the CPUC to vote for an immediate increase in retail electricity rates of 3 cents per kilowatt-hour for SoCal Ed and PG&E customers. The rate hike was, technically, intended to cover procurement expenditures of the CDWR…and not the utilities' past procurement costs.

The ruling also made permanent the 90-day "emergency procurement surcharge" of 1 cent per kilowatt hour that the CPUC had authorized in January and directed utilities to allocate a portion of the new sur-charge directly to the CDWR to cover the costs of energy the agency had incurred since it had begun buying power in January.

Executives at SoCal Ed and PG&E grumbled that any rate hike was welcomed; but they argued that the latest increases still weren't enough to fix the pricing problems.

All the CDWR mechanism did was move the losses to a new guaran-tor.

In early May, CPUC president Loretta Lynch made an effort to re-build trust with SoCal Ed and PG&E. She proposed electricity rate increases for residential customers of up to about 60 percent.

Lynch said the proposed rates would affect about half of the utilities' residential users. She said rates for the remainder would not go up if their consumption remained level.

For residential customers, the CPUC adopted a five-tiered rate struc-ture. Separate rates apply to specified increments of monthly usage (tiers) with higher rates for usage in higher tiers. The tiers were all based on an assumed "baseline" amount that was defined by historical averages of use in geographic areas. The tiers were:

1) usage under the baseline assumption;

2) usage between baseline and 130 percent of baseline;

3) usage between 130 and 200 percent of baseline;

4) usage between 200 and 300 percent of baseline;

5) usage over 300 percent of baseline.

The tiered-rate proposal was designed so that consumers who used the most electricity would pay the most, while low-use customers would not be affected.

The baseline was not intended to cover 100 percent of average residential use. It intended to represent a significant portion—typically, 50 to 70 percent—of the reasonable energy needs of the average residential customer.

Rates for SoCal Ed residential customers whose electricity consumption fell in tier two would increase an average of 6 percent. Those whose use fell in tier three would face an average increase of 20 percent. Those whose use fell in tier five would pay an average of 37 percent more.

Rates for small and medium-sized businesses would rise 36 percent. Industrial rates would increase 49 percent and agricultural rates, between 15 and 20 percent.

June bills would reflect the increases, which were retroactive to March 27. The amount owed between March 27 and May 15 would be spread over 12 months of bills, from June 2001 to June 2002.

These increases also pressed the FERC toward its eventual turnaround. Lynch blamed the Feds for failing "to follow federal laws to ensure just and reasonable prices."

At the same time she was proposing the tiered-rate system, Lynch also attacked the independent generators. She told a California Senate committee that out-of-state power suppliers had routinely cut back on generation to drive up prices.

Blaming the shutdowns on equipment failure, the generators had maintained repeatedly that they had not manipulated the power market in any way. But Lynch showed the committee charts of electricity prices and power generation at three plants on a single day in November 2000.

The plants had cut production at mid-day, forcing the state to declare two separate power emergencies. Prices then spiked and the companies abruptly increased production to nearly full capacity to cash in on the higher rates.

She said the inquiry had yielded enough evidence for the state to take the generators to court. The nature of the prospective legal action remained undecided, though.

Trust was still a problem in California, but Lynch was trying to redirect the mistrust to a common enemy.

Another Spike, Another Punch at Davis

In July, the FERC price caps were tested for the first time. Prices in the Western states shot over the caps as temperatures climbed throughout the region.

Wholesale electricity prices reached $106 per megawatt-hour in Southern California, despite the FERC limit of $95. Prices were reported to have hit $135 in Arizona and New Mexico. The ISO issued a Stage Two Alert and the state flirted with the prospect of rotating outages for the first time since May.

Nonetheless, rates clung reasonably close to the $95 limit and capacity held up. Blackouts weren't necessary.

July also saw Gray Davis offer some alternatives for how the state could recoup the $9 billion that he claimed it had been overcharged by the independent generators. One way to handle it, the governor said, would be to renegotiate the long-term contracts that obligated the state to pay a total of $43 billion—a figure critics said was more than the state should have accepted.

But the independent generators didn't like his suggestion. And they weren't alone. The federal mediator blamed Davis and the state for an impasse that prevented resolution.

Curtis Wagner, the FERC's chief administrative law judge, said Davis could not document the claim of $8.9 billion of excessive charges. Wagner said the discussions broke down because California was unwilling to negotiate. Davis countered that the FERC would be acting unconscionably if it did not authorize refunds in the full amount sought by the state.

SoCal Ed's Settlement Agreement

Lynch's efforts at detente with the utilities seemed to have some good effects. In October, the CPUC and SoCal Ed announced the settlement of a lawsuit SoCal Ed had filed in federal court against the CPUC.

The settlement was intended to restore SoCal Ed to creditworthiness, so that it could resume procuring the electricity needed by its customers; limit ratepayers' costs of paying off the debt; and maintain the state's role in regulating the investor-owned utility by enabling SoCal Ed to pay down its back debts over a reasonable period of time.

The terms of the Settlement Agreement included:

- SoCal Ed would use cash on hand, plus all of its revenue over recoverable costs, to pay off its back debt. The CPUC and SoCal Ed agreed that the amount of the back debt to be recovered from ratepayers was the amount of certain outstanding debt SoCal Ed had at August 31, 2001, less the cash on hand on that date and an additional $300 million adjustment. The amount was estimated to be about $3 billion.

- SoCal Ed would not pay any dividends on its common stock through 2003, or until the full repayment of its debt, if sooner. If it hadn't fully repaid its back debt by the end of 2003, the CPUC retained the discretion to determine whether SoCal Ed could pay a dividend in 2004. The company was free to resume paying dividends in 2005. Since SoCal Ed's annual dividend had typically been about $400 million, its shareholders would forgo at least $1.2 billion...and possibly more.

- So Cal Ed would apply 100 percent of any recovery it obtained from refund proceedings at the FERC or litigation against independent generators to pay down the back debt. And it agreed to work with the CPUC and the state's Attorney General in pursuing litigation against the generators.

- The CPUC could direct SoCal Ed to use $150 million each year for other utility purposes, including the provision of additional energy efficiency monies, which would otherwise be used to pay down its debt.

- The CPUC agreed not to lower Edison's retail rates below their current level through the end of 2003—unless the back debts were recovered. However, rates could be reduced as a result of a securitization of the debt or reduced CDWR revenue needs.

- The CPUC agreed to set rates not higher than the current rate, to enable SoCal Ed to recover the remaining amount of the back debt over 2004 and 2005—if the back debt had not been recovered by the end of 2003.

- There were no concessions of the CPUC or state regulations or regulatory authority over SoCal Ed; nor was there any deregulation of transmission and generation facilities.

- SoCal Ed could make up to $900 million in capital expenditures annually.

Lynch characterized the agreement:

> This settlement embodies a fair and judicious way for Edison to become solvent and get back in the business of buying power, while meeting the needs of ratepayers and the state of California. The settlement also ensures that all of the benefits of any refunds arising through litigation against power generators and marketers that profited from unjust and unreasonable energy prices will benefit ratepayers.

The agreement settled a November 2000 federal court lawsuit filed by SoCal Ed against the CPUC, in which SoCal Ed claimed that the

CPUC's failure to provide sufficient retail rates violated federal law and was an unconstitutional taking of its property.

As part of the agreement, SoCal Ed also released the CPUC from all claims in its lawsuit and also withdrew any challenges to the Commission's decisions implementing AB 1X or related reforms.

On a more general note, the state's conservation programs continued to perform better than expected. Prompted by pleas to conserve power so California could avoid shortages during the critical summer months, customers responded in numbers without precedent to SoCal Ed's home energy-efficiency rebate programs, the utility announced.

Through nine months of 2001, SoCal Ed had issued 70,600 rebate checks to residential customers—versus 14,000 in all of 2000. The utility returned almost $8.9 million to customers in 2001. And the utility had fielded inquiries about energy-efficiency programs from 1 million customers, five times more than the prior year.

A More Pleasant Outlook

Adding to the relief, the ISO predicted that it wouldn't need to declare any alerts in the immediate future. New power plants that had come online and continued conservation should be able to prevent the exorbitant electricity prices, power emergencies and scattered service interruptions that had plagued California the year before.

The ISO anticipated a peak power demand of 34,359 megawatts for October and forecasted demand of about 32,000 megawatts through May 2002. Under those conditions, operating reserves would be 2,000 to 2,200 megawatts, yielding a reserve margin of about 7 percent—the minimum stipulated by the Western Systems Coordinating Council, which maintained grid reliability throughout the West.

And even the media backed away from bashing the utilities and the regulators.

A widely-quoted editorial in the Long Beach *Press-Telegram* noted that consumeristas had largely escaped blame for misleading the public on important issues throughout the electricity crisis.

The newspaper criticized these groups, in part, for urging flawed decisions made by the CPUC relative to retail rates, forced power plant sales and long-term power contracting—all of which prolonged the crisis.

When the utilities sought CPUC authority to negotiate long-term power contracts to hedge against wholesale price volatility, the *Press-Telegram* noted:

> ...it was a bunch of self-described consumer advocates—like the Office of Ratepayer Advocates and The Utility Reform Network [that] thwarted efforts by the utility companies to pursue long-term contracts and that, as it turned out, was bad policy.

The paper noted that, in late 2000, when SoCal Ed and PG&E had proposed a relatively mild 10 percent rate increase to stabilize the market:

> ...the Foundation for Taxpayers and Consumer Rights...opposed the increase. With the benefit of hindsight, it is obvious that this was modest, compared to the 40 percent increase the CPUC was required to approve when the market spiraled out of control.

Finally, the editors noted:

> What is most disturbing is that these consumer advocates are the only constituency that seems to have ducked its share of public blame. By escaping scrutiny and accountability, they march ahead with undeserved credibility, empowered to again advocate ill-conceived policies. As we learn our lessons from this deregulation fiasco, we must strive to identify all of its causes. Included among the causes must be those self-proclaimed consumer groups, who clearly did not act in the best interest of consumers.

Renegotiating the Contracts

In November 2001, state officials coordinated their efforts to renegotiate the long-term energy deals.

Davis said he'd held extensive meetings with generators in an attempt to renegotiate. The governor wouldn't identify the specific companies he'd approached—but Sempra Energy, the parent corporate of SDG&E, indicated the governor's office had approached it.

After an appearance in Santa Monica on a panel that discussed the electricity crisis, Loretta Lynch said that, if power generators refuse to renegotiate, the state could sue them. She said the state had sound legal and practical arguments in favor of renegotiation.

S. David Freeman told legislators his new California power authority could give energy companies a powerful financial incentive to renegotiate. The power authority could borrow money at below-market rates, he explained.

This could appeal to firms that must finance the construction of power plants that cost hundreds of millions of dollars to build. In return for the cheaper financing the authority could arrange, the companies would cut the prices in the contracts or give California more leeway to decide when and how much electricity to take.

Freeman sketched the scenario to members of the Joint Legislative Audit Committee in a hearing to help determine the mission of his agency, known officially as the California Power and Conservation Financing Authority. He also indicated to the legislators he was no longer opposed to an effort to restructure his deals. "There seems to be pretty general agreement that these contracts need to be renegotiated," he said.

Price Gaming, Not Collusion

As the wounds of early 2001 healed, a new consensus emerged among the economists and policymakers who influence government approaches to regulatory matters.

According to Alfred Kahn, the Cornell University economist who deregulated the airline industry as chairman of the Civil Aeronautics Board, there are some markets in which companies are able to raise

prices above competitive levels by withholding supply or engaging in other strategic behavior.

This is the same "market power" that had warped the California energy market.

The CPX's hourly auctions made it possible for a small number of generators to manipulate prices to their advantage. Under those rules, generators were allowed to submit up to 10 bids to each hourly auction, each bid for a different batch of electricity. The power exchange would rank the bids from least to most expensive, then go down the list until it had enough bids to satisfy the expected demand for power during the period. The highest bid accepted became the price paid to all bidders.

Through that process, the market for electricity was supposed to mirror the workings of most other commodity markets, in which all generators receive roughly the same price on a given day.

However, according to an ISO report released near the end of 2001, the independent generators—anticipating tight supplies—submitted such lopsided bids that the system failed.

The generators would bid in most of their power at prices that reflected the actual cost of producing power, as would be expected in a competitive market. But for the final one or two increments of power, the companies submitted bids that jumped to levels three, five, even 10 times the competitive bids, knowing that in past rounds that their rivals had done the same. Such strategies guaranteed a lucrative outcome for all the companies whether their last bid was accepted or not.

This is the kind of price signaling that's become a major part of game theory. It's not collusion or price-fixing—strictly speaking; and it's not illegal. But it is a form of cooperation among companies that are supposed to be competing against each other.

Another problem: A competitive market isn't as good at providing reliability. Totally unregulated electricity markets naturally swing between periods of too much capacity and too little. Companies would

tend to wait until there was a shortage looming before adding new plants, and then all rush in with too many plants, creating a glut.

This is why true free marketers didn't panic over the blackouts; they were a natural part of a market correcting itself.

Paying for Reliability

Over time, consumers and businesses can figure out ways to use less power if the price gets too high. But, in the short run, these efforts are hampered by the fact that consumers don't find out what the price is until a month or two after they've consumed it.

And most consumers aren't rugged enough to deal with so steep a cost for long-term efficiency. They are willing to pay a premium—in most cases, a large premium—for reliability.

These are all the reasons that the electric market was traditionally considered a "natural monopoly."

The struggle between reliability and efficiency will always be at the center of electricity deregulation and reform. Technology will help the cause of efficiency. Meters that track real time, hour-to-hour shifts in wholesale costs are part of the solution.

Bills that reflect the constantly shifting price of electricity will also be a big step in the right direction.

Efficiency is served when people reduce energy consumption during periods of peak demand—when supply is scarce and the cost of producing power is the highest. At those peak times, even small changes in supply or demand lead to big swings in prices.

Key Elements to Any Deregulation Plan

The failure of the California Plan pointed to several key elements that need to be part of any successful energy deregulation plan. These include:

- Long-term contracts. While long-term contracts may raise the average price of electricity over the long run, they also prevent much of the price volatility that consumers find difficult to accept.

- Capacity reserves. For a competitive market to deliver reliability, every utility should provide a part of the system's reserve power. The simplest way would be to require each electric company to buy 10 or 15 percent more power than it expects its customers to demand, and include the cost of the power it doesn't sell into the price of the power it does.

- Real-time pricing. Electricity pricing schemes need to encourage households and businesses to use less power when supply is scarce and the cost of producing it is high. New meters, though costly, are available that would allow the utility to charge different rates at different hours, depending on prevailing wholesale prices, while letting customers know what those rates are in real time.

- Independent grid operators. In California and other regions, one reason for shortages and price spikes is that there are not enough long-distance transmission lines to get power from places with too much power to places with too little. The old regulated utilities that own the lines are not eager to expand capacity, or even make existing lines available to competitors, knowing that it will lower prices and profits.

- Vigorous antitrust enforcement. Even the most ardent market-oriented economists warn that the peculiar economics of electricity also require the government to make aggressive, and even novel, use of the antitrust laws.

David Teece, a professor at Berkeley's Haas School of Business, wrote a Manifesto on the California Electricity Crisis that explained the crisis and reiterated the case for well-thought-out deregulation:

Fixed retail prices blocked conservation efforts by insulating consumers from market realities and reduced consumer incentives to turn to competitive retailers. The heavy reliance on spot market purchases, combined with demand that was unresponsive to prices, helped drive prices higher.

For the price mechanism to allocate resources effectively, supply and demand pressures must be allowed expression, and not be impeded by unnecessary rules and regulations. Competition must exist to discipline pricing. Absent these elements, market solutions simply won't produce satisfactory results.

The state's credentials as an astute player in the electricity market aren't impressive, and there is no reason to expect major improvement in the future. Accordingly, emergency state contracts should be avoided if at all possible.

That last suggestion wasn't possible in 2001. The political costs of the January meltdown had simply been too high.

But there would always be political costs of one sort or another. As 2001 came to its calendar end, Davis and the rest of the state officials were still try to renegotiate the long-term contracts they'd signed with power generators during the crisis. If they didn't succeed, Californians would be paying higher prices than other states for electricity— which was exactly where they were in 1996, when the whole process started.

con_{clusion}

The main issue that remains in the wake of California's experiment with electricity deregulation is: Can the electricity business be deregulated? Or is it a "natural monopoly"—a business that requires such huge up-front investment in equipment that competitors have no chance against established players—as utility executives argued for most of the 20th Century?

The events of 2001 and 2002 seem to suggest those utility executives were right.

But that may simply be the result of the Stockman strategy. Maybe the utility executives knew this was going to happen. Perhaps the most effective way for utility executives to prove to the world that they deserved to remain monopolies was to support a deregulation experiment so flawed it was destined to fail.

Is this a "fraud" or "conspiracy" in any actionable way? Probably not. One of the key points of game theory—which applies precisely to a marketplace changing due to deregulation—is that individual players don't have to conspire to act in ways that are mutually beneficial. They only have to react to the rules and each other in a way that puts self-preservation first.

Could the self-preservation instinct of the California utilities translate into an act of economic self-mutilation? Could it be crafty enough to defeat deregulation by supporting a bad version—and suffering, as a

result—to prove once and for all that the utilities are natural monopolies?

The simpler explanation is that utilities…and the executives running them…are what they are. They didn't hatch any master plan to game the system. They simply acted in what seemed to be their best interest at each stage of the regulatory process. When they had to sell power plants, they sold power plants. When it seemed wise to restructure their corporate parents, they did. Only in retrospect does it look like these moves were part of a design.

In other words, they could have used the Stockman strategy without ever explicitly planning it.

Why work so hard to find a method to the mess? The politics of deregulation have always been manipulated heavily by the people, companies and government agencies involved. Coming out of economies in which prices are set and profits built in, no one knows what will happen in the early stages of free markets. And, usually, no one—neither the regulated firms nor the regulating agencies—likes this proposition. So, the firms and the agencies try to influence the mechanics of deregulation.

In the case of the California Plan, this meant that they lobbied hard while Steve Peace bolted together his Frankenstein reform.

And they called the monster "deregulation."

Surely, a well-informed consumer should always treat the word "deregulation" with healthy skepticism. As AB 1890 showed, the word is sometimes applied to systems that aren't true deregulation.

The Savings-and-Loan Comparison

Some critics liked to draw comparisons between California's electricity blackouts of 2001 and the S&L crisis of the late 1980s. Both crises came about because people in decision-making positions (both governmental and industrial) didn't seem to understand the ramifications

of their own actions. And both crises had the ironic effect of seeming to be pro-consumer movements...that hurt consumers.

For most of the 20th Century, the S&L industry was a heavily regulated business that took little risk. The government set a cap on interest rates paid on S&L deposits—usually less than 5 percent. The S&Ls made money by making loans whose interest rates were slightly higher than their cost of funds. For decades this was a simple, steady business.

Then, in the 1970s, two things happened. First, inflation took off, forcing companies and state and local governments to pay higher interest rates to attract money. Also, the big stock brokerages started offering "money market" and similar accounts that paid higher returns to middle-class investors. To compete, S&Ls had to keep pace, so the government deregulated interest rates that S&Ls paid for deposits and charged for loans.

But the S&Ls couldn't charge higher rates on the billions of dollars in old loans in their portfolios—their stranded costs. Most tried to compensate by making riskier loans, for which they could charge higher interest rates. And many moved out of the residential real estate business, investing in things like junk bonds and limited partnerships that promised higher returns.

Regulators knew that this practice was doomed to failure; but the political environment stood behind deregulation. So, they complied.

In the mid-1980s, some S&Ls started to fail. By 1988 and 1989, many were. Congress had to step in and reregulate in a way that ended up killing the S&L industry. The survivors either became or were acquired by banks.

Some consumer advocates screamed "fraud" and "scam"...and there were a few incidents of fraud. But, in the main, the S&L crisis was a matter of economics. Tight supply drove prices up faster than weak demand was willing to pay. The deregulation effort (which was, like the California Plan, partial) merely muddled the price signals that would have kept S&Ls out of high-risk ventures.

A Tangible Crisis

The critical difference between the S&L crisis and the California electricity crisis is that, in the case of electricity, there remains the matter of the power grid and like lines and pipes running into every home. These were literal, physical examples of the externalities—the common good—served by the utility system. And this gets backs, again, to the argument that utilities are different than other regulated businesses. That they are natural monopolies.

It makes sense to have one set of gas pipes, telephone lines and power lines running into a house. That said, it also makes sense to have companies compete to provide the gas, communications and electricity that come across those lines.

The United States has done a pretty good job deregulating the telephone system…though even that took some 20 years to resolve. And, critically, telephone service was regulated primarily at the federal level so only one bureaucracy was involved in its deregulation. There weren't the same turf battles that California experienced with electricity.

The United States has also done a pretty good job of deregulating the natural gas system. Although natural gas isn't quite as completely deregulated as the telephone system, gas prices have gone down steadily since that market was deregulated in the 1980s. This good news is likely to survive the demise of even a big player like Enron Corp.

That leaves the electrical wires. By simple logic, electricity should be deregulatable—if telephone service and natural gas were.

But the failure of the California Plan will set back this effort. In fact, one lingering risk that the California Plan poses is that a backlash will create even larger bureaucracies.

For its part, the Foundation for Taxpayer and Consumer Rights, argued that the California Legislature should reauthorize utilities to build power plants and to create a public utility system like Nebraska's, where there were no investor-owned utilities, in an effort to control power prices.

For example, San Francisco Mayor Willie Brown has called for California's big cities to establish a joint agency that would take over existing power plants, generate electricity and enter into long-term natural gas contracts. This would be something like a large version of the LA DWP, serving several cities in Northern California.

Brown's idea was more radical than the several bail-out proposals being considered in Sacramento. His plan would call for taking over existing power plants, owned by utilities like PG&E or power generators like Duke Energy and Southern Energy.

If the cities and counties were able to use condemnation or eminent domain proceedings on the power plants, they would still have to pay for them. Brown's plan was that the new utility would sell electricity and natural gas at a discount to consumers and use power from the plants for government agencies. (The San Francisco city government already used power produced at several hydroelectric plants located around the Hetch Hetchy dam, which was part of the CPUC.)

If he couldn't get the multi-city utility organized, Brown said he'd consider moving forward with a city-owned utility for San Francisco, built along the lines of the LA DWP.

A Failure of Politics

California considered true deregulation in 1996—but passed because it didn't have the political will to expose voters to the prospect of higher utility bills. In the end, that prospect has to be allowed. True deregulation usually creates lower prices because it exposes consumers to the regular risks of the marketplace. If the risks are hidden or transferred or obscured, the lower prices may not follow.

Despite their reputation for childishness and "Santa Claus politics," Californians did admit in one of the many public opinion polls taken during the worst part of the electricity crisis of 2001 that they would accept occasional blackouts as the cost of low electricity rates. This wasn't childishness at all; it was a mature and realistic take on the low prices that deregulation offers...and the market imbalances that it sometimes requires.

Perhaps it's not the citizens—the "ratepayers"—of California who are childish; perhaps it's the elected pols and unelected bureaucrats.

The California Plan laid bare a lot of basic human impulses. And the results weren't pretty. People wanted a simple villain, a Richard Nixon or an Ivan Boesky. But the villain here was more subtle. It was the impulse in every person—whether a trader at Enron or a ratepayer in Encino—to game the system...to get something for nothing.

The trend toward deregulated consumer markets is real and will continue. The inefficiencies that remain a part of the electrical utility business will call out for deregulation—even another attempt in California, at some point. At that point, perhaps further development in metering and billing technology...and greater sophistication on the part of consumers...will allow true deregulation to flourish.

In the meantime, California and the Western states have to live with higher electricity prices than the rest of the country. These are the consequences of the failure of the California Plan.

And that was a failure of politics, not of deregulation.

index

environmentalist 83-84, 208-209, 211
exit fees 101

financialization 258-259
fixed prices 71, 73, 222
free markets 6, 17, 36, 47, 49, 54, 64, 67, 91, 187, 224, 254, 273

generators 1, 3, 5, 8, 11-15, 19, 21, 27, 33, 36, 39, 47-49, 54-55, 58-59, 69, 75, 81, 87, 95-96, 98, 100, 104, 108-121, 124-126, 134-136, 186, 188-192, 196, 199-200, 205, 208-209, 213-216, 219-223, 226, 229-233, 238-241, 245-248, 254, 260, 263, 266, 268, 271, 273, 297, 300-306, 313-325, 328-331, 334-339, 343-344, 346, 349-350, 353, 359
grid jockeys 114-115, 119-120, 263
grid system 122

hedging contracts 110
hybrid system 73

Independent System Operator (ISO) 83, 88, 109-123, 195-200, 203-205, 209-223, 229, 243, 257-272, 295, 297, 300, 302, 304, 313-317, 321, 328, 333-334, 336, 339, 344, 347, 350
Intermountain Power Agency (IPA) 196-198, 200, 204
investment 181-187, 190, 200, 202-204, 207, 227-228
investment bankers 197, 203, 207, 328, 331
investor 31, 40, 44, 46, 55, 59, 65, 71, 73, 181-189, 192, 195, 226, 251, 254, 261, 303, 319, 326, 341, 357
investor-owned utilities 44-46, 55, 65, 71, 82-83, 87-90, 98, 100-103, 134, 195-196, 200-201, 207, 211, 239-240, 255, 296-298, 300, 303, 305, 315, 317, 322-323, 338, 340, 358

junkets 90
kilowatt-hour 2, 32, 80, 100, 103, 132, 136-137, 221, 227, 233-234, 242, 303, 309, 322-323, 327, 342
loan 25, 63, 196, 200, 207, 299-300, 304, 316-317, 325, 357
lobbyist 43-45, 48-54, 57-58, 61-65, 69-70, 83, 90-91, 104, 138, 197, 216, 220, 227, 254, 257
long-term contracts 23-24, 35, 52, 92, 97-98, 100, 195, 198, 202, 222, 231, 233, 243, 313, 315, 320-322, 325, 332, 336, 338, 344, 348, 352-353

Stage Two Alert 264, 272
state investigation 290
state-backed bonds 85, 203, 206
state-regulated utilities 35, 196
state-run electricity pool 11
stock 30-31, 109, 182-192, 227, 251, 255, 278-280, 291, 323, 328, 355-357
Stockman strategy 291, 355
stranded cost 8, 52-53, 60, 67-68, 70-73, 80, 85, 99, 103, 181-184, 187, 196, 198, 200-202, 215, 220-222, 242, 252, 357
stranded cost bonds 85
strategic misdirection 50
supply 8, 21-24, 30, 59-60, 83-84, 87, 90, 101, 112-117, 120, 135, 192, 198, 211-215, 219-220, 224, 227-234, 238-239, 250, 255-258, 265, 270, 283, 286, 297-298, 309, 312, 315, 319, 321-323, 330, 357
surcharge 72, 102, 106, 108, 126, 191, 203, 222, 228

tax-free bonds 196-197
telephone deregulation 69
transferring assets 46
transition periods 32, 232
transmission capacity 8
transmission system 4, 30, 75, 88, 123, 201, 230
true deregulation 11, 26, 46, 72, 92, 130, 235, 274, 359-360
trustee 197

unregulated market 17, 107, 133
utility affiliates 16-17
utility holding company 17, 205

weather problems 266
wheeling 14, 239, 292
wholesale market 13, 33, 73, 191, 209, 222-223, 231, 249, 253, 257, 259-261, 284, 316
wholesale price 20, 22, 32, 35, 60, 115, 118-119, 189, 243, 309, 313, 319, 322, 333, 352

20% Off Silver Lake Publishing books

Silver Lake features a full line of books on key topics for today's smart consumers and small businesses. Times are changing fast—find out how our books can help you stay ahead of the curve.

[] **Yes.** Send me **a free Silver Lake Publishing catalogue** and a 20% discount coupon toward any purchase from the catalogue.

Name:_____

Company:_____

Address:_____

City:_____ State:_____ Zip:_____

Phone:_____

Silver Lake Publishing • 2025 Hyperion Avenue • Los Angeles, CA 90027 • 1.323.663.3082

slpw

Free Trial Subscription

Silver Lake Publishing introduces **True Finance**, a monthly newsletter dedicated to money and its management. **True Finance** offers more than dry lists of mutual funds or rehashed press releases. It focuses on the trends—technological, economic, political and even criminal—that influence security and growth. It includes columns from the authors of some of Silver Lake Publishing's bestselling books, including **The Under 40 Financial Planning Guide, Insuring the Bottom Line** and **You Can't Cheat an Honest Man**.

[] **Yes.** Please send me **a free trial subscription to True Finance.**

Name:_____

Address:_____

City:_____ State:_____ Zip:_____

Phone:_____

Silver Lake Publishing • 2025 Hyperion Avenue • Los Angeles, CA 90027 • 1.323.663.3082

slpw

BUSINESS REPLY MAIL

FIRST-CLASS MAIL PERMIT NO. 73996 LOS ANGELES CA

POSTAGE WILL BE PAID BY ADDRESSEE

**SILVER LAKE PUBLISHING
2025 HYPERION AVE
LOS ANGELES CA 90027-9849**

BUSINESS REPLY MAIL

FIRST-CLASS MAIL PERMIT NO. 73996 LOS ANGELES CA

POSTAGE WILL BE PAID BY ADDRESSEE

**SILVER LAKE PUBLISHING
2025 HYPERION AVE
LOS ANGELES CA 90027-9849**